BAROQUE
Between the Wars

T0355300

BAROQUE

Between the Wars

Alternative style in the arts,
1918–1939

JANE STEVENSON

OXFORD
UNIVERSITY PRESS

OXFORD
UNIVERSITY PRESS

Great Clarendon Street, Oxford, OX2 6DP,
United Kingdom

Oxford University Press is a department of the University of Oxford.
It furthers the University's objective of excellence in research, scholarship,
and education by publishing worldwide. Oxford is a registered trade mark of
Oxford University Press in the UK and in certain other countries

First published 2018
First published in paperback 2021

Impression: 1

Published in the United States of America by Oxford University Press
198 Madison Avenue, New York, NY 10016, United States of America

British Library Cataloguing in Publication Data
Data available

Library of Congress Cataloging in Publication Data
Data available

ISBN 978–0–19–880877–0 (Hbk.)
ISBN 978–0–19–886775–3 (Pbk.)

Printed and bound by
CPI Group (UK) Ltd, Croydon, CRO 4YY

For Alan Powers and James Stourton

THANKS AND ACKNOWLEDGEMENTS

This book is the product of many years of thought, almost all of them shared with Peter Davidson. Apart from this most obvious debt, there has been a lot of help along the way. The generous and helpful anonymous reviewers selected by Oxford University Press contributed much, as did the editor, Jacqueline Norton. Otherwise, I am particularly indebted to the late 7th Marquess of Anglesey for a sympathetic hearing and for access to Rex Whistler papers; Andrew Biswell and Wil Dixon, for many years of conversation and particularly for the trip we all took to Portmeirion together; Tim Brennan, Hugh and Anne Buchanan, Chantal Buldorini Detaille, Stephen Calloway, Daniela Caselli, Charity Charity, Christie's Ltd, Nicola Coleby, Jane Geddes, Mark Gibson and Shamsu bin Yusof, Harry Gilonis, Jan and Catriona Graffius, Jonathan Gray, Alexandra Harris, Ayla Lepine, Joanna Ling, Sam Lloyd at Port Lympne for opening the house so that I could look at the murals, Keith Lodwick, Jonathan Makepeace, Edward Mendelson, Thomas Messel, John Morison, Joseph Munitiz SJ, Jeremy Musson, Robert O'Byrne, Ralph and Clémence O'Connor, Emma O'Driscoll, Will Paton, Alan Powers, Jane Pritchard, Neil Parkinson, Mary Pryor, Alison Saunders, Michael Schmidt, Peter Simpson, David Stent, Winifred Stevenson, James Stourton, Kyle Tannler, Jelena Todorovič, and Jill and Stephen Wolfe.

Illustration Permissions

ADAGP; Authors League Fund; Christie's Ltd; *Country Life*; DACS; *Dancing Times*; Chantal Buldorini Detaille; Museum Folkwang, Essen; Fondation Le Corbusier; Higher Pictures; Historic England; Mary Evans Picture Library; National Museum of Ireland; New York Public Library; Richard Riss at Pracusa; Royal College of Art; Royal Institute of British Architects; Sotheby's Ltd; Victoria and Albert Museum. Every effort has been made to trace and contact copyright holders prior to publication. If notified, the publisher will be pleased to rectify any errors or omissions at the earliest opportunity.

CONTENTS

List of figures xi

Introduction: The In-Between Time 1

I. SOCIETY

1. Climbing 23
2. Hiding in Plain Sight 39
3. Sitwell Style 66

II. THE CITY

4. Modern Times 89
5. Streams of Consciousness 112
6. Machines to Live In 137

III. ROOMS

7. Outdoor Rooms 157
8. Chinese Wallpaper 168
9. Whiteness 197
10. White and Gold 202
11. Rococo Arcadia 216

IV. UNCANONICAL ARTS

12. Silver Paper 233
13. Self-Fashioning 244
14. Masks 259
15. Four Dozen White Lilies 266

CONTENTS

16. Flowers in the Abstract 277

17. The Ghost of a Rose 281

 Epilogue 295

 Bibliography 303
 Index 307

LIST OF FIGURES

1 The roof garden of the Beistegui penthouse. 9
2 Dody Todd and Madge Garland. 45
3 Eileen Gray, *Une chambre à coucher boudoir*. 59
4 Marie Laurencin, *Femmes à la colombe*. 62
5 Osbert, Sacheverell, and Edith Sitwell. 67
6 The drawing room of the Sitwell brothers' house in Carlyle Square. 77
7 Venetian silver grotto chairs. 80
8 Josephine Baker, fetishistically costumed. 107
9 Djuna Barnes, front cover of the *Ladies Almanack*. 129
10 Monkton House dining room. 145
11 Finella: the front hall. 149
12 The drawing room at Gayfere House. 152
13 High and Over garden. 159
14 Port Lympne gardens. 166
15 Sonia Delaunay: 'Simultaneous' clothes and fabrics. 171
16 Elsa Schiaparelli, her coiffure, dress, pose, and chair referencing Empire style. 183
17 Coco Chanel with two Venetian blackamoors. 189
18 Mirrored bathroom at Gayfere House. 191
19 Entrance hall designed by Allan Walton. 192
20 Baba Beaton posing in Syrie Maugham's sitting room. 198
21 White set design by Oliver Messel for 'Helen's Bedroom'. 200
22 Church of St Magnus the Martyr. 210
23 A dining room for Geoffrey Fry with mural decoration by John Armstrong. 219
24 The drawing room at Mulberry House. 222
25 The view into the Painted Room at Port Lympne. 227
26 Queen Elizabeth, 1939. 237
27 Stephen Tennant. 242
28 Lee Miller, wearing a Vionnet evening gown. 247
29 Shoe Hat, 1937-8. 249

30 Lady Ottoline Morrell, 1927. 252

31 The 'Bright Young People' being 'bright'. 257

32 Miss Laurie Divine in Noël Coward's 'Dance, Little Lady'. 262

33 Atkinson's Scent Shop. 271

34 Constance Spry contemplating an arrangement. 274

35 'Sem', 'Chanel No. 5', watercolour. 279

36 *Les Biches*, 1924: Bronislava Nijinska as 'The Hostess'. 292

37 Rex Whistler, self-portrait as a gardener's boy. 301

Introduction

The In-Between Time

The term 'baroque' was often in the air in the years between the two world wars, particularly in the context of interior decoration. Osbert Lancaster described a style he called 'Curzon Street baroque', but in the parlance of the time 'buggers' baroque' and 'decorators' baroque' were also used to convey the same concept.[1] 'Decorator' was more printable than 'bugger' but was still very much a term with overtones: interior designers, i.e. 'decorators', were assumed to be homosexual, if male, and divorcées, if female. Many of them were. Curzon Street is in Mayfair, so the implication of the adjectival phrase is 'rich, smart, and fashionable'. But it is worth asking why the wealthy and fashionable were refusing to follow where the modernist avant-garde led them, and why any sort of 'baroque' was high fashion in the era of modernism. As well as opening up a rich spread of art and design, the concept of 'baroque' also offers a way of looking at extra-canonical elements of the literary landscape, notably the poetry and prose of the Sitwells, and the camp or fantastical literatures which were such a feature of the decades supposedly dedicated to 'new styles of architecture, a change of heart'.[2]

Buggers, decorators, denizens of Curzon Street: however we inflect 'baroque' in this context, it represents a style which came into being in the 1920s and is associated in equal measure with designers and their clients: with figures such as Stephen Tennant, Edward James, and Mansfield Forbes on the one hand, Syrie Maugham, John Fowler, and Sibyl Colefax on the other, and in between, perhaps, arbiters and impresarios of taste, such as Cecil Beaton and Dody Todd. And as the word 'baroque' asserts, these figures' achievements tend to be playful, camp, and excessive. Also, as the word 'bugger' suggests, it is to a significant extent a queer style.

To me, the word 'baroque' is a clue to a different way of understanding the arts between the wars as a dialectic between a version of neoclassicism, which we call

[1] Stephen Calloway, *Baroque Baroque: the Culture of Excess* (London: Phaidon, 1994), p. 47.

[2] W. H. Auden, 'Petition Poem'.

modernism, and a modern version of baroque, for which there is no equivalently recognizable name. I am not the first to think this, but other writers who have addressed the topic, such as Patrick Mauriès, have not quite ventured to argue that whatever 'not-modernism' is, it constitutes a substantial counter-tendency which affects all the arts of the period.[3] The following chapters pursue a set of interconnected themes, focused by turns on artists, artefacts, clients, places, and publicists, in order to test and explore this idea.

The argument for baroque as a constant is not a new one. As Angela Ndalianis pointed out, in the late nineteenth century Heinrich Wölfflin argued for a binary relationship between classical and baroque art,[4] and in the interwar period itself the Spanish philosopher and art critic Eugenio d'Ors suggested that 'baroque' and 'classical' are not periods, so much as opposing tendencies within European culture:

> The style of civilisation calls itself Classicism. To the style of barbarism (the persistent, permanent underside of culture) do we not give the name of baroque? One calls a great irregular pearl 'baroque'. But more baroque, more irregular still is the water of the ocean which the oyster transforms into a pearl—and sometimes, too, in the case of a happy success, a perfect pearl.... The baroque is a constant in history, which recurs at epochs as distant from each other as Alexandrianism from the Counter-Reformation, or the latter from the 'Fin de siècle'—that is to say the end of the nineteenth century—and that it manifests itself in regions as diverse, as much in the East as in the West. This phenomenon involves not only art but the whole of civilisation.... Far from proceeding from classical style, baroque opposes itself to it, in a way more fundamental than Romanticism (which, itself, is no more than an episode in the unfolding of the constant baroque).[5]

Another way of looking at this might be to suggest that postmodernism and modernism came into being simultaneously, and, on the whole, the version of modernity which established itself in England was modern baroque, an immediate progenitor of postmodernism; this was more pluralist, more eclectic, and less doctrinaire than modernism. If modernism is definable using terms such as functional, useful, masculine, straight, unadorned, and sincere, then modern baroque is covered by the antonyms to these concepts: frivolous, prodigal, feminine, queer, decorative, and equivocal. The canonical heroes of modernism, such as Cézanne, Eliot, Joyce, Le Corbusier, D. H. Lawrence, Picasso, Stravinsky, are mostly straight

[3] Patrick Mauriès, *Shell Shock: Conchological Curiosities*, trans. Michael Wolfers and Ronald Davidson-Houston (London: Thames & Hudson, 1994), pp. 86–9, translated from *Coquillages et Rocailles*).

[4] Heinrich Wölfflin, *Renaissance and Baroque* (1965; originally published in 1888 and revised in 1907) and *Principles of Art History: the Problem of the Development of Style in Later Art* (1932; originally published in 1915). Angela Ndalianis, *Neo-Baroque Aesthetics and Contemporary Entertainment* (Cambridge, MA: MIT Press, 2004), pp. 7–10.

[5] Eugenio d'Ors, *Du Baroque*, trans. Agathe Rouart-Valéry (Paris: Gallimard, 1935), pp. 18, 83.

men. The key figures of modern baroque, on the other hand, mostly aren't: an interwar baroque counter-canon might include, for example, Josephine Baker, Djuna Barnes, Cecil Beaton, Edward Burra, Jean Cocteau, Sergei Diaghilev, Ronald Firbank, Eileen Gray, Edith Sitwell, and Sacheverell Sitwell.

The subject of this book is British, mostly English, culture, with some reference to France, since it is impossible to consider interwar art and style without acknowledging the status of Paris as the cultural capital of the Western world at that time.[6] It brings interior decoration under consideration alongside art and literature, as a manifestation of wider tendencies. Does that mean it isn't about anything important? Are socialites' sitting rooms interesting? I have come to think that the answer to the first question is no, and to the second, yes. One social fact which seems to me important is that the interwar period was still in a continuum with the Renaissance in one crucial respect. Art of all kinds was almost entirely directly supported by individuals as a conscious choice, rather than via taxation. Rich people had to buy paintings, voyage on transatlantic liners, and visit the theatre, while poor people had to buy tea sets and go to the cinema, for the arts to be viable. Therefore taste and fashion provide the context for the production of both art and literature. Other reasons for thinking that decor matters are outlined by the architect Jean Badovici: 'The role of interior decoration is of no small importance in this general revision of values. It not only reflects [the individual's] way of living and his preoccupations, it also helps him get a clearer picture of himself. Interior decoration helps him to strike the necessary balance between his most sacred and hidden desires and the outside world of his daily activities.'[7] Many people go to remarkable lengths to create environments they feel at ease in, and almost nobody is completely indifferent to the space he or she inhabits.

The particular argument I want to make in this book, with the help of the insights offered by interior decoration, is that the story of the mid-twentieth century, that time of accelerated change, was not one of modernism versus muddle; that much of what was going on which was not modernism was an equally cogent set of responses to the problems of modernity, definable as a modern baroque, and witnessed not only by a host of 'minor' writers and artists, but also by how people chose to dress, live, present and entertain themselves, and by what they read; that modernism's refuseniks did not merely reject the direction taken by the avant-garde, but created a perceptible counter-movement. This has already been suggested by Alexandra Harris in Romantic Moderns, a book to which I am ubiquitously indebted.

[6] Almost nothing is directly said in this book about Scotland, Wales, and Ireland: this is because the many Scots and Welsh who appear in this book, such as Duncan Grant, Augustus and Gwen John, Compton Mackenzie, Kenneth Macpherson, Oliver Hill, Patrick Balfour, Bunny Roger, Clough Williams-Ellis, and the Zinkeisen sisters, took themselves off to London. Irish modernists mostly went to Paris. Neither Edinburgh, Glasgow, nor Dublin established themselves as alternative avant-garde centres.

[7] Peter Adam, *Eileen Gray, Architect/Designer, a Biography* (New York: Harry N. Abrams, 2000), p. 165.

One notable feature of modernism is the idea of creating a total environment, clean, healthy, and rational, which is why discussions of modernism often begin with architecture. Some modernist architects aimed to be universal providers, creating an integrated environment in which the exterior, interior, and furnishings of a building were all laid down in the course of the initial design process: the Isokon building in Hampstead (1933–4) is a well-known English example.[8] A key modernist credo in architecture, often attributed to Le Corbusier, is that form should follow function, and in 1908 the Austrian architect Adolf Loos notoriously proclaimed that architectural ornament was criminal. Architectural modernists adopted both these principles, and they are equally relevant to the art of Ben Nicholson and Barbara Hepworth, and the designs of Coco Chanel or Marion Dorn.

A look at Tate Britain's interwar art rooms offers the twenty-first-century enquirer modernism, for the most part. Paul Nash, Ben Nicholson, and Stanley Spencer feature extensively: the overall impression is of minimalist, serious, pared-down structures, the geometry of the paintings very much on view, a classical art of restraint and applied analysis, mostly employing the palette which Paul Nash regarded as characteristic of English art, 'a peculiar bright delicacy of choice of colours—somewhat cold but radiant and sharp in key'.[9] But any consideration of the arts more generally in the interwar period reveals that this agenda of simplification and streamlining does not go unchallenged. Alongside modern art and architecture, there was a lush, tropical growth of design of which none of this is true, a twenties and thirties baroque to set alongside modernism, expressed in painting, but also in a host of ancillary arts, including interior design, photography, ballet, theatre, fashion, and flower arrangement.

One principle of modernism is that it distils, or epitomizes, what it means to live in a particular historical moment; to break away from the past, to make a serious attempt to think through from first principles how one should live. It is therefore analytic, addressing itself to existence as a series of problems, and tends to assume that answers can be found. This radical, analytic, intellectual approach to art and design suggests that modernism is actually a form of neoclassicism. The classical 'now' partakes of eternity: modernism, in jettisoning the past, similarly strove to inhabit a perpetual present. As Jim Reilly writes, 'History itself is anathema to modernism. Modernism's twin opposing temporal categories are the moment and eternity.'[10] But life is lived in a social and historical context; to pretend that this is day one of year one is to live in a state of denial towards both the past and the future.

[8] *Modernism: Designing a New World, 1914–1939*, ed. Christopher Wilk (London: V&A Publications, 2006), e.g. the Schröder house, p. 33.

[9] Paul Nash essay, *Unit 1: The Modern Movement in English Architecture, Painting and Sculpture*, ed. Herbert Read (London: Cassell & Co., 1934), p. 80.

[10] Jim Reilly, 'The Novel as Art Form', in *Literature and Culture in Modern Britain I: 1900–1929*, ed. Clive Bloom (London: Longman, 1997), pp. 55–75, p. 56.

While no sane person would quarrel with modernist goals such as better nutrition, housing, and education for the masses, the modernist vision of a life made hygienic and rational fails to take into account the intractability of the past, both individually and nationally, and its influence on the present. The work of Freud is hugely important as an aspect of modernism because, as it was understood in the thirties, the principle of psychoanalysis was that understanding one's personal past enabled one to rise above it—problems, once correctly identified, would be resolvable. However, not all tigers turn out to be paper. There are problems which remain as problematic as ever, however well they are understood.

One very serious problem with modernist agendas is that they deny alternative points of view, which may well be why so many of the key modernist thinkers are male, straight, upper-class, white, and in most cases, university-educated; such thinkers are convinced, on all these counts, that their perceptions are uniquely legitimate. With a strong belief in the intrinsic virtues of their own caste and gender, they consider it obvious that black people should learn to behave like white people and women to behave like men (up to a point), that homosexuals should become heterosexual, or at least learn to act straight, and that the proletariat should become more bourgeois in its habits. For modernists, 'masculine' is always a term of high praise, and never interrogated. As Lisa Tickner observed, 'A heightened masculine swagger marks the militant rhetoric of avant-garde politics and leaves its traces on the work.'[11] The rigid certainties promoted by modernists look, in retrospect, like a denial of the obvious, since the interwar period was also one in which women, homosexuals of both genders, black and working-class people acquired vastly increased visibility as producers of culture and not merely as consumers; the creators of an 'alternative trajectory', as Tickner calls it, 'a liminal art of eroticism, exoticism, decoration and the body'.[12] Though modernist creators and critics appointed themselves the gatekeepers of high culture, there were subversive currents flowing under and around the citadel.

It's a question whether the prevailing modernist trope of despair at the state of things prevailed quite so strongly among the group to which I refer. On the one hand, baroque fundamentally tends towards optimism, and on the other, these individuals were to a significant extent what the modernists were despairing *about*; partly because they were in various ways in dialogue with a popular culture which modernists dismissed as aimless, futile, and vulgar.[13]

[11] Lisa Tickner, *Modern Life and Modern Subjects: British Art in the Early Twentieth Century* (New Haven and London: Yale University Press, 2000), pp. 202–3, on 'aggressively heterosexual masculinity' as a pose of modernist artists; and see also Monika Faltejskova, *Djuna Barnes, T. S. Eliot and the Gender Dynamics of Modernism: Tracing Nightwood* (New York and Abingdon, Palgrave Macmillan, 2010), p. 16, on its equivalent among writers.

[12] Tickner, *Modern Life and Modern Subjects*, p. 109.

[13] Penny Sparke, *As Long as It's Pink: the Sexual Politics of Taste* (London: Pandora Press, 1995), pp. 68–9.

Those who were not male, straight, white, privately educated, and middle- to upper-class reacted to the opportunities of the twentieth century in ways which confirm a priori suspicions that modernism tended to exalt some varieties of experience and exclude others. In the early twentieth century, practitioners of the highest-status arts engaged in experimental searches for authentic means of expression, what Christopher Reed has called 'a heroic odyssey on the high seas of consciousness'.[14] By contrast, work which was collaborative, responsive to the requirements of a patron, or commercially oriented, was perceived as necessarily compromised and impure, and therefore almost always 'minor'.

Women's presence in the arts was to a significant extent in the younger and less high-status disciplines. While there are important exceptions, such as Barbara Hepworth,[15] women tended not to compete in the highest-status arenas of high modernism, and when they did, they frequently failed: Dora Maar and Lee Miller, for example, are more famous as models and muses than as independent creative talents, and Hope Mirrlees is not remembered alongside T. S. Eliot. Instead, women, especially those who needed to earn a living, tended to become novelists, not poets, journalists, not essayists; they created murals, rugs, and textiles rather than easel paintings; they were designers and decorators, not architects or sculptors. Gay men similarly flourished in the 'minor arts' of decoration, photography, and the theatre. I will not have much to say about the black contribution to interwar culture in this book, apart from in the context of dance, because as far as England and France were concerned, the areas in which black artists made a decisive impact on both high culture and mass culture were musical rather than visual or literary, the areas which are the focus of this study. It is a topic which deserves a book in itself, but it is not one I am qualified to write.

The other major art movement of the interwar period besides modernism in its several subdivisions is surrealism, which was very much friendlier towards alterity and much more willing to negotiate with the past. Insofar as modern baroque, a fundamentally organic phenomenon, has a theoretical basis, this is provided by surrealism. Where mid-twentieth-century baroque differs from earlier varieties is that, while it has a relationship with the past and makes room for multiple perspectives, there is a new sense of the arbitrary and personal quality of connections which emerges from the surrealist movement.

While surrealism was, like modernism, a left-wing movement at its point of origin, born out of an explosive collision between the ideas of Marx and Freud, in

[14] Christopher Reed, 'Introduction', *Not at Home: the Suppression of Domesticity in Modern Art and Architecture*, ed. Christopher Reed (London: Thames & Hudson, 1996), p. 15. See also Walter L. Adamson, *Embattled Avant-gardes: Modernism's Resistance to Commodity Culture in Europe* (Berkeley: University of California Press, 2007).

[15] See *Barbara Hepworth: Sculpture for a Modern World* (London: Tate Gallery, 2015).

contrast to modernism, it insistently points to the intractability of dreams and personal experience. It is equally a response to the modern condition, but one which acknowledges incongruity as an inevitable aspect of urban life. Modernism tends towards the creation of interchangeable, repeating units, whether bentwood stacking chairs, overalled factory workers, or prefabricated metal windows. Modernist form is, in theory, dictated by function, so what something means is supposed to be identical to what it is. Surrealism, on the other hand, involves the arbitrary imposition of meaning upon objects, turning them into a system of signs, meaning which is, of its nature, individual and personal.

Theodor Adorno, in an essay called 'Looking back at Surrealism', picks up Adolf Loos's association between ornament, crime, and disease in an arresting image. Imagine a modern house, white concrete and glass, its interior life made scrutable by large plate-glass windows. At one point, its flat white concrete skin darkens, as if decaying or bruised, and it extrudes a bay window. 'The *Neue Sachlichkeit* [New Objectivity] horror of the crime of ornamentation … is mobilized by Surrealist shocks. The house has a tumour, its bay window. Surrealism paints this tumour, an excrescence of flesh grows from the house.'[16] Adorno concludes: 'Surrealism gathers up the things the *Neue Sachlichkeit* denies to human beings, the distortions attest to the violence that prohibition has done to the object of desire.'

There is clearly some relationship between baroque aesthetics and surrealism, since one stated goal of the surrealists was 'to expand an individual's consciousness to incorporate previously unknown realities into a richer and more complex image of modern life'.[17] In order to achieve this, existing objects were often detached from their original contexts and assigned disconcerting new meanings. As an aesthetic principle, this is wholly compatible with combining modern art and primitive sculpture, which often had specific meanings in its original African or Oceanic context, of which its interwar collectors were entirely ignorant.[18] It is also compatible with collecting European antiques and bric-a-brac. This is where surrealism begins to interact with baroque principles such as copiousness, extravagance, exuberance, and virtuosity. In the thirties, the surrealists began to experiment in various ways with objects as material realizations of unconscious desires. The works and exhibitions which resulted were intended as a critique of commodity fetishism, but the effect was almost the opposite, since surrealism was readily reinterpreted as

[16] Theodor Adorno, 'Looking Back on Surrealism', *Modernism: an Anthology*, ed. Laurence Rainey (Oxford: Wiley-Blackwell, 2007), pp. 1113–16, p. 1115.

[17] Robin Walz, *Pulp Surrealism* (Berkeley and Los Angeles: University of California Press, 2000), pp. 5–6.

[18] See Anna Laura Jones, 'Exploding Canons: the Anthropology of Museums', *Annual Review of Anthropology*, 22 (1993), pp. 201–20, and Shelly Errington, 'What Became Authentic Primitive Art?', *Cultural Anthropology*, 9.2 (May, 1994), pp. 201–26, on this issue, and on how it came to be perceived as problematic only in the 1980s.

a *style* within the worlds of high fashion and design, most notably by Elsa Schiaparelli and her associates, who included Alberto Giacometti and Salvador Dalí.

One particularly interesting instance of the tension between modernism and surrealism is the Paris apartment of the Mexican multimillionaire Charles de Beistegui, a penthouse on the Champs-Élysées which he commissioned from Le Corbusier in 1929. It was perched on top of a perfectly conventional nineteenth-century stone building, a severe, rectilinear, white, minimalist structure so unrelated to the building beneath it that it looks as if it has fallen from a passing airship. The interior had flat white walls, plate-glass picture windows, and a dramatic staircase which unfurled like a scroll of white paper round a glass pillar in the middle of the floor and led up to a flat roof, in keeping with the classically modernist shibboleth of open-air sun worship.

De Beistegui seems to have got bored with it before it was even finished. Between the building's construction and the point where decisions were made about decor, in 1930 or 1931, he changed his mind and submerged the interior in a tsunami of incongruities, as if bringing Adorno's metaphor to life. These included a giant rococo female blackamoor clad in ostrich feathers, crystal chandeliers and girandoles, and neo-rococo furniture by the Cuban designer Emilio Terry.[19] He lit the interior entirely by candles, for aesthetic reasons, though the house was fully equipped with electricity. The roof garden, which was surrounded with a 5-foot high white wall allowing privacy, was given a carpet of grass, and a rococo fireplace in one wall with candlesticks and a clock on the mantelpiece (see Figure 1). There was an elaborately framed oculus above it, where a mirror or painting might be expected, enclosing a view out over Paris. Metal furniture in Louis Quinze shapes, painted white, was drawn up to the fictive fire; it thus became an outdoor room with the formal characteristics of an indoor room, and therefore a somewhat uncanny—indeed, literally *unheimlich*—joke.

The connection between the baroque and the 'surrealist' trompe l'oeil aesthetic of de Beistegui's roof terrace is apparent, and not merely because the furniture references seventeenth- and eighteenth-century objects. Baroque style rejoices in pleasurable shocks and playful deceptions, the fictitious architecture of murals and tapestries, the flowers and birds of Chinese wallpaper, material jokes such as shellwork garlands or feather flowers, and trompe l'oeil effects, all of which were highly fashionable between the wars. Trompe l'oeil itself goes back to antiquity, and was essayed by many painters from the fifteenth century onwards, but it reached a peak of virtuosity in the seventeenth century, notably in the hands of Andrea Pozzo, the great Jesuit master of fictive architecture. It also saw a significant revival in the thirties, by practitioners such as Martin Battersby, Roy Alderson, and Eugène

[19] Martin Battersby, *The Decorative Thirties* (London: Collier Books, 1971), p. 177.

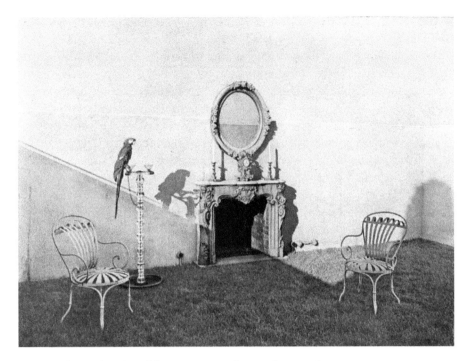

Figure 1 The roof garden of the Beistegui penthouse. Photographer: Marius Gravot. © Marius Gravot et Lucien Hervé; Fondation Le Corbusier. © FLC/ADAGP, Paris and DACS, London 2015.

Berman.[20] Trompe l'oeil is not truly intended to deceive, or rather, as the decorator Nancy Lancaster observed, it is the *momentary* deception of trompe l'oeil which is important.[21] It implies a double take, and lends itself perfectly to visual jokes. When Osbert Sitwell commissioned a wardrobe from Ethel Sands, painted with 'a replica of the inside, shelves of ties, collars, shirts, shoes and shoe-trees, a shiny black tall hat and a long cane with a tortoiseshell handle', the intention was self-evidently playful.[22] Similarly, Lady Sackville's bedroom carpet in her house at 40 Sussex Square, Brighton, was the corporeal equivalent of a pun: it was woven as trompe l'oeil squares of red and white fictive marble, appearance contradicted by texture.[23]

[20] Martin Battersby, *Trompe l'Oeil: the Eye Deceived* (London: Academy Editions, 1973).

[21] Martin Wood, *John Fowler, Prince of Decorators* (London: Frances Lincoln, 2007), p. 71. Similarly, Herman Schrijver said, 'the triumph of trompe l'oeil is of course that it never quite succeeds...in that ambiguity resides the interest and the art of it.' Charles Burkhart, *Herman and Nancy and Ivy, Three Lives in Art* (London: Victor Gollancz, 1977), p. 37.

[22] Osbert Sitwell, *Queen Mary and Others* (London: John Day, 1974), pp. 170–1. It is illustrated in Sarah Bradford et al., *The Sitwells and the Arts of the 1920s and 1930s* (London: National Portrait Gallery, 1994), no. 2.32, p. 64.

[23] Illustrated in Calloway, *Baroque Baroque*, p. 29.

Visual puns are also a key aspect of surrealism: famous examples include Dalí's sofa in the form of Mae West's lips, and his lobster telephone, both designed for the English millionaire Edward James. But the thirties were not the first decade to achieve such playful effects. In the 1770s, the designers of Chelsea porcelain produced tureens and teapots in the form of verisimilitudinous bunches of asparagus or fine fresh cauliflowers; in the following century, Victorian wax and marble fruit plays with the same aesthetic of momentary deception, while featherwork and shellwork bouquets present what, in suitable contexts, becomes a deliberate and therefore surreal antithesis between material and form. All objects of this kind could be effectively integrated into a modern baroque interior. Nancy Lancaster, who was John Fowler's partner at Colefax & Fowler, was one of the first to perceive how well Chelsea porcelain fitted with a sophisticated thirties aesthetic.[24]

One very marked aspect of interwar aesthetics, more so even than trompe l'oeil, is play with light effects and mirrors. Peter Davidson defines baroque art thus:

> In the achievement of the stupendous, categories are bound to become fluid, things are (literally and in the arts of illusion) inevitably going to flow into each other, so that with magnificence and decorum comes an element of the deliberately astonishing, a pleasure in the astonishing, something that might elicit the English words 'flouting', and 'flaunting'. Something perceptible in certain lights—for example, the golden lights from concealed windows of tinted glass which bathe certain silver statues, certain flying stuccoes, in the sunlight of the otherworld—as *queer*. The pleasure of the cabinet of curiosities is also a pleasure in queerness, in juxtaposition, an investigation of the surreal poetry of an expanding perception of the world, in the continuous arrangement of discontinuous objects as though they were connected.[25]

Davidson's round-up of baroque aesthetics links light effects, silver, surprises, a plethora of things, strange juxtapositions, flaunting; the aesthetics of, for example, Virgil Thomson and Gertrude Stein's *Four Saints in Three Acts*.[26] These are also central tenets of avant-garde interwar decoration. Baroness Catherine d'Erlanger's house in London, 139 Piccadilly, was one of many which pursued this central theme of reflection. It was 'full of witch balls, shell flowers, mother-of-pearl furniture, and startling innovations picked up for a song at the Caledonian market'.[27] Other ideas of hers included strings of chandelier crystals used as a door curtain, and silver lamé as a curtain fabric. Silver walls and ceilings, and the use of unexpected materials such

[24] 'Nancy Lancaster', *The Telegraph*, 20 Aug. 1994.

[25] Peter Davidson, *The Universal Baroque* (Manchester: Manchester University Press, 2008), p. 11.

[26] Steven Watson, *Prepare for Saints: Gertrude Stein, Virgil Thomson, and the Mainstreaming of American Modernism* (London and Berkeley: University of California Press, 2000), pp. 224–5.

[27] Cecil Beaton, *The Glass of Fashion* (London: Weidenfeld & Nicolson, 1954), p. 141.

as rubber, synthetics, and exotic hides, were already fashionable by 1925, the year in which couturière Jeanne Lanvin had her lavatory seats covered in leopard-skin.[28]

Other aspects of the arts in the seventeenth and eighteenth centuries also influence the revived baroque of the interwar period. Overscale is part of a baroque aesthetic: the giant consoles which support the frontage of that most baroque of churches, the Gesù in Rome, or the grandiosity of Seaton Delavel, can also be reflected on a domestic scale, in the bold use of some vast detail in a smallish room, de Beistegui's 9-foot blackamoor, for example, a decorator's trick which has also been used by serious artists, as in Ian Hamilton Finlay's Stockwood Park in Luton, where enormous, half-buried pilasters speak of a classical past fragmented but not yet dead, or the colossal fragments made by Igor Mitoraj, such as the vast bronze mask in the forecourt of the British Museum.[29]

Fugacity is another baroque principle. In the seventeenth and eighteenth centuries, aristocratic patrons spent huge sums on purely temporary effects: horse ballets, masques, fireworks, or temporary structures of enormous grandeur. The interwar period was comparatively restrained in this respect, though, a few years too late for this book, Barnum & Bailey's 'Ballet of the Elephants' with music by Igor Stravinsky, choreographed by George Balanchine for 'fifty elephants and fifty beautiful girls' in 1942, must have been one of the most baroque spectaculars since Queen Christina's welcome to Rome some 300 years previously.[30] Spectacular firework displays were still created between the wars and greatly enjoyed,[31] but new kinds of fugitive effects were also achieved and appreciated, notably in the area of party-giving—though in the twenties and thirties, the often-present cameras cock an eye towards futurity as well as satisfying contemporary interest.

Conventional art history and literary history have tended to dismiss all this as mere frivolity. If the proper subjects of the interwar arts are defined, at least in retrospect, as realism, urbanism, and politics, as they are by Valentine Cunningham, then escapism and self-delusion become thought crimes. Interwar baroque style, by contrast, offered fictionality, *fête champêtre* pastoral, and individualism, which suggests that it was, whether consciously or otherwise, a counter-movement. And paradoxically, though many modernist artists aspired to speak for the common man and certainly had a great deal to say about him (though less about the common woman), baroque is more democratic than modernism, because it is less intellectual.

David Peters Corbett, apropos of C. R. W. Nevinson, has written of 'a massive failure of confidence in the capacity of modernism to deal with the full range of

[28] They are now in the Musée des Arts Décoratifs, Paris.

[29] Stephen Bann, 'A Luton Arcadia, Ian Hamilton Finlay's contribution to the English neoclassical tradition', *Journal of Garden History*, 13 (1–2) (1993), pp. 104–12.

[30] Sally Banes, 'Elephants in Tutus', *Before, Between, and Beyond: Three Decades of Dance Writing* (Madison: University of Wisconsin Press, 2007), pp. 344–60.

[31] Alan St H. Brock, *Fireworks & Fetes* (Harmondsworth: Penguin, 1946).

experience in the contemporary world',[32] and many writers have found this tragic or exasperating, according to temperament.[33] However, it is also possible to ask whether this is because, in actual fact, modernism couldn't, and doesn't, deal with a full range of human experience. Fundamentally, modernism assumes that there is only one legitimate point of view, that of an educated male élite, and only one moment, the now. Hence it has difficulty in coping with multiple points of view, with popular culture, and with both the past and the future.

The late Umberto Eco, in his *Apocalittici e integrati*, observed that the 'apocalyptic' intellectual feels disgust at mass communication's supposed debasement of cultural values and consequently withdraws to seek the refined sands of high art in which to hide his, or her, head. This was a position frequently taken by modernist artists; as Andreas Huyssen observed, 'The nightmare of being devoured by mass culture through co-option, commodification, and the "wrong" kind of success is the constant fear of the modernist artist, who tries to stake out his territory by fortifying the boundaries between genuine art and inauthentic mass culture.'[34] The alternative 'integrated' position, Eco's own, is to start from the position that mass culture is an inescapable fact, and rather than retreating from it, to engage with it, analyse it, decode its signs, and explain the competing ideologies that are expressed through it.

An unpalatable fact for left-leaning modernists which revealed itself in the interwar years was that, as soon as people were prosperous enough to express preferences, almost all of them expressed them in the direction of individualism. Given the choice, workers turned away from class struggle and collectivism in favour of domestic comfort and privacy, with, as a concomitant, an accumulation of possessions which were aspired to for reasons other than their design value.[35] The vitriolic responses to uneducated taste on the part of cultural critics such as Paul Nash, who declared that 'modernistic design is entirely meaningless and the product of a venal commercialism', imply a refusal to accept that there is any connection between cheap furnishings sold by Woolworths and in the Curtain Road,[36] middle-market furnishings sold by Heal's, Liberty, and Maple & Co., and very expensive items bought from individual craftspeople selling through galleries. With some ninety years' perspective, it is evident that the extent of trickle-down from what

[32] *The Modernity of English Art, 1914–30* (Manchester: Manchester University Press, 1997), p. 157.

[33] Neil Philip, 'An English manner of going about art', http://adventuresintheprinttrade.blogspot.com, 15 Jan. 2010.

[34] Andreas Huyssen, 'Mass Culture as Woman: Modernism's Other', in *After the Great Divide: Modernism, Mass Culture, Postmodernism* (Indiana: Indiana University Press, 1986), p. 51.

[35] Paul Nash, *Room and Book* (London: Soncino Press, 1932), p. 39. See also Humphrey Carpenter, *The Brideshead Generation: Evelyn Waugh and his Generation* (London: Faber & Faber, 1990), pp. 297–30, and, for an alternative perspective, Leif Jerram, *Streetlife: the Untold History of Europe's Twentieth Century* (Oxford: Oxford University Press, 2011), pp. 161–2.

[36] Curtain Road, Shoreditch, was London's centre for wholesale distribution of new, cheap furniture. Battersby, *The Decorative Twenties* (New York: Walker, 1969), p. 196.

was thought appealing by wealthy contemporaries with strongly held views on decor is considerable, and much of what trickled was a recidivist taste for items that looked antique. It was not only the poor and visually illiterate who liked Jacobethan furnishings, as E. F Benson's *Mapp and Lucia* novels, for example, bear witness.

Ordinary people were grateful for modernist council flats and houses which were not infested with bugs or rats, and were significantly easier to heat and clean than older building types, but they also wanted to display their grandmothers' candle-sticks, holiday souvenirs, and bric-a-brac attesting to individual and familial identity. In England, if their lives were stable enough to venture into homeownership, they wanted suburban semis with Tudoresque detailing.[37] To the more doctrinaire modernists and especially, for obvious reasons, those of the post-revolutionary communist bloc, this refusal to discard the past and engage absolutely with the present constituted a sort of recidivism, or even apostasy.

But baroque, however extraordinary, is also vulgar, in the original meaning of that word, because it connects up with what ordinary people like. Barbara Jones has written illuminatingly of the essentially baroque qualities of vernacular, or popular art, by which she means not 'folk art', which modernists valued, but the objects chosen or made by working-class people in England's cities:

> Popular arts have certain constant characteristics. They are complex, unsubtle, often impermanent, they lean to disquiet, the baroque, and sometimes terror.... When all the jollity percolated down from the courts to the common man, his less trained and subtle taste fastened firmly on the most elaborate and energetic of the available patterns and, with the addition of extra gloss and gilding, he produced a nice rich debased baroque. It held the field of popular entertainment, absolutely unchallenged by the gothic or classical revivals, until the second quarter of this [the twentieth] century.... One factor is constant through all the vernaculars: energy. There is always vitality to replace a lack of selection, technique or taste.[38]

In the interwar period, one of the serious painters who interacted most effectively with vernacular baroque was Edward Burra. Osbert Lancaster, a contemporary, perceived his art as directly informed by it:

> Burra, whether he knows it or not, is a traditionalist. His kinship … is with those anonymous masters who until a few years ago decorated merry-go-rounds and ice cream carts with the last genuine examples of baroque art in Europe.[39]

[37] These were always, and remain, more popular than semis in a modern idiom: this is a genuine preference. Helen Barrett and John Phillip, *Suburban Style: the British Home, 1840–1960* (London: Macdonald Orbis, 1987), p. 132.

[38] Barbara Jones, *The Unsophisticated Arts* (London: Architectural Press, 1951).

[39] Osbert Lancaster, 'The Chosen Eleven', *Architectural Review*, 74 [451], June 1934, pp. 211–12.

This is condescending, implying that Burra's art is naïve and, therefore, not art but decoration. But Burra's eye and taste were as educated as those of Paul Nash or Henry Moore, if not more so. However, his genuine relationship with the baroque tradition is shown by his interest in surfaces rather than structures, and his taste for using perspective expressively. It is also shown by his openness to pop culture of all kinds, from Mexican kitsch to Walt Disney, and by his refusal to acknowledge a hierarchy of high and low art forms, something for which thirties England lacked an effective critical vocabulary.

However, because of the long-standing baroque tendencies of vernacular culture, those who could not afford silver could find early nineteenth-century silver lustreware. If eighteenth-century Venetian silvered grotto furniture was out of one's reach, Victorian shellwork was not. In the thirties, the objects that could be picked up for a song from the Caledonian Road market or the Portobello Road (and their equivalents in other cities, such as the Paris flea market, loved by the French surrealists) included Victorian black papier-mâché furniture inlaid with mother-of-pearl, milk-glass mantelpiece lustres hung with winking, triangular glass prisms, witch balls, and glass paintings.

Much of this book will look at the personal taste of the wealthy, but this does not imply that the ideas it contains are only relevant to a minute and privileged élite. Coco Chanel, interviewed in *Vogue* when she reopened her couture house in 1953, observed that 'a widely repeated fashion, seen everywhere, cheaply produced, must start from luxury.'[40] From a woman who did more to revolutionize twentieth-century dress than any other, this is a statement worth considering. Aesthetes whose spare income was measured in shillings, not guineas, could and did achieve recognizable versions of a high style on a low budget. At its most full-blooded, interwar baroque is a style of extreme wealth, of tapestries and opulent flower arrangements. But it is also an attitude or an idea. Cecil Beaton's house, Ashcombe, was decorated with enormous style and considerable ingenuity: 'Since bona fide antiques were beyond my financial reach, ingenuity and the Caledonian market had to come to my rescue for the furnishing of the house.... Materials were put to uses never intended. "Animal baize", as the felt is called which covers pantomime zebras and leopards, provided excellent carpeting, and other theatrical materials ... have to stand the test nobly as curtains and sofa coverings.'[41] It helped to have rich friends. Frederick Ashton's first house, at 24 Wharton Street, EC1, was partly furnished with cast-off black and gold Regency pieces which had belonged to his friend Alice von Hofmannsthal, but also, like Beaton's, with tat foraged from Saturday-morning trips

[40] Elizabeth Wilson, *Adorned in Dreams: Fashion and Modernity* (London: Virago, 1985), p. 89.
[41] Cecil Beaton, *The Wandering Years* (London: Weidenfeld & Nicolson, 1961), p. 223.

to the Caledonian Road.[42] Because Beaton et al. were 'news', this modern baroque style was exposed to the general public via the cinema and magazines.

The question of whether realism and fact-facing were the only correct response to the zeitgeist is also worth asking. The first novel to feature World War II is probably Evelyn Waugh's *Vile Bodies* (1930),[43] but by the mid-thirties the sense that there was another war on the way was widespread. Robert Graves and Alan Hodge observed, from the retrospective of 1941, that 'the phrase "the next war" was used without any calculation as to who would be fighting whom. It was merely felt that competitive rearmament would automatically result in the guns going off.'[44]

Some writers and artists responded by direct engagement to the sense that their world was careering helplessly towards an apocalyptic final conflict between fascism and communism, most notably by volunteering for the Spanish Civil War. Others opted to dance while they still could. There is an eighteenth-century, rococo flavour to interwar baroque, which is sometimes modulated by an explicit awareness that the *ancien régime* ended with the French Revolution; Dorothy Sayers, for example, voices this through her hero Lord Peter Wimsey, who imagines his elderly and disreputable future self, in *Strong Poison*, as 'the only aristocrat who escaped the guillotine in the revolution of 1960. We keep him as a pet for the children.'[45] It is worth noticing the extraordinary success of Nigel Playfair's revival of John Gay's eighteenth-century *Beggar's Opera*, with its cast of highwaymen and whores, which ran for more than four years from 1920. Evelyn Waugh, at eighteen, thought it 'simply perfect'.[46]

One subgroup who had particular reasons for avoiding the strident clarities of modernism were homosexuals. The association of avant-garde style with homosexuality is more than vulgar prejudice. A statistically implausible number of men and women important in the interwar arts, especially to the new and minor arts, were gay. One possible reason is suggested by Georg Simmel, a German sociologist of the later nineteenth century, who associated the iconoclasm, outrage, and defiance of fashion with the deviant, dissident, and outsider: 'The fact that the demi-monde is so frequently a pioneer in matters of fashion is due to its peculiarly uprooted form of life. The pariah existence to which society condemns the demi-monde produces an open or latent hatred against everything that has the sanction of law, of every permanent institution, a hatred that finds its relatively most innocent and aesthetic striving for ever new forms of appearance.'[47] The importance of

[42] Julie Kavanagh, *Secret Muses: the Life of Frederick Ashton* (London: Faber & Faber, 1996), p. 242.

[43] Samuel Hynes, *The Auden Generation* (Princeton: Princeton University Press, 1972), pp. 60–1.

[44] Robert Graves and Alan Hodge, *The Long Week-End: a Social History of Great Britain 1918–1939* (London: Reader's Union, 1941), p. 271.

[45] *Strong Poison* (1930), ch. 8.

[46] Paul Fussell, *Abroad* (New York: Oxford University Press, 1980), p. 13.

[47] Wilson, *Adorned in Dreams*, p. 138.

courtesans to fashion is beyond doubt, but this analysis, which implies that a demi-monde is going to be not merely at an angle to straight society, but self-consciously defiant of its mores and in some ways hostile to it, is at least as true of homosexuals in an era of outlawry and persecution as it is of prostitutes, and is also true of feminist women.

The queerness of interwar baroque style may also relate to the widely attested sense of an approaching apocalypse. Fascists and communists were in opposition, but both were opposed to homosexuality, whether as a symptom of decadence, a refusal to step up to one's allotted place in life, or a manifestation of bourgeois individualism. If one is certain that the future will have no room for one, why not, in the meantime, the in-between time, dance the last waltz in style?

> Times are so bad and getting badder
> Still we have fun
> There's nothing surer
> The rich get rich and the poor get laid off
> In the meantime, in between time
> Ain't we got fun?

So went the lyrics of a foxtrot, popular in the early thirties, the era of the Great Depression, a great favourite of Rex Whistler's. Modernism assumes that it is possible to plane off a crust of irrelevant detail in order to arrive at an underlying truth, form dictated by function. Clarification is achieved by simplification. But baroque truth is rarely pure and never simple. Many of the individuals discussed in these pages consciously reinvented themselves and successfully imposed a revised and improved version on the world. Fictionality is also important.

The labile aspects of social identity may perhaps have been particularly evident to homosexuals, since they faced a particularly acute mismatch between the individual's sense of his or her essential self and contextual social expectations, which had to be fought through with bitter determination, and often at great cost. 'Facing facts' can result merely in despair if facts are against you. C. F. G. Masterman observes, in *England After War* (1922), that self-delusion has a purely pragmatic aspect: 'No race in the world has been so successful as the English in putting "realities" aside and refusing to face facts which might paralyse action.' For example, Frederick Ashton experienced a moment of *éclaircissement* as a 13-year-old in Lima, Peru. Sitting watching Anna Pavlova, he realized that 'I wanted to dance like *her*'. As an ambition, becoming a world-famous ballerina was perfectly hopeless. Apart from the inherent problem of not being a girl, he had no money and no connections, and, like his eventual muse, Margot Fonteyn, and his friend and rival Robert Helpmann, he was growing up on the wrong side of the world (Fonteyn was brought up in Shanghai, Helpmann in Adelaide). None of them had facts on their side. But all the same,

Ashton ended up as a choreographer and director of the Royal Ballet, a being who was a stupendous work of artifice built up in delicate, nacreous layers round the hard grit of a central determination.[48] The same, in their several ways, can be said of Helpmann and Fonteyn.

Since it first evolved, modern baroque has refused to go away. One way of looking at this is, as Christopher Reed hints, to recognize that 'modernity' and 'postmodernity' are not so much sequential, but a dialogue going back to the twenties: 'To attempt to return to the 1920s on its own terms is to discover a culture flourishing with many of the transgressive pleasures—of wit, mass culture, self-conscious performativity—that postmodernism later claimed for itself.'[49] And in fact, modernist art owes modern baroque a good deal, because the style is, above all else, eclectic. For purists such as Paul Nash, modern art required modern interiors, and if that had been a general assumption, then the client base would have been too small to support experimental art. In his *Room and Book*, a plea for modern design in domestic interiors, Nash complained, 'Just as the modern Italian has revolted against the idea that his country is nothing but a museum, so we should be ashamed to be regarded by the Americans as a charming old-world village. They do not respect our modernity because we have no pride in it ourselves.'[50]

Nash was infuriated by the refusal of the wealthy to commit to modernism. In the history of taste before the interwar period, style tended to be expressed, where possible, by replacing one complete ensemble with another: Queen Anne walnut furniture was exiled to the servants' quarters to make room for rococo giltwood. But in the twenties, very few people were prepared to make the total break with the past that Nash calls for in *Room and Book*.

Baroque, on the other hand, because it was eclectic and absorbent, created a space for modern art. Gabon masks and Giacomettis could coexist with Spanish altar candlesticks made into standard lamps, Knole sofas, and the family silver: many abstract pictures did not end up in austere rooms furnished with rectangular chairs by Denham Maclaren and Marion Dorn rugs decorated with elliptical blobs; they were acquired by aficionados of the new baroque, such as the Sitwells, and kept strange company. Constant Lambert, himself an eclecticist who introduced jazz elements into his formally composed music, observed in 1934:

> It is a mistake to think that modern taste is really represented by Corbusier rooms, furnished with fitting mechanical austerity. Modern taste is to be found far more in the

[48] His story is told by Julie Kavanagh, *Secret Muses: the Life of Frederick Ashton* (London: Faber & Faber, 1996).

[49] Christopher Reed, 'A Vogue that Does Not Speak its Name: Sexual Subculture during the Editorship of Dorothy Todd, 1922–26', *Fashion Theory*, 10.1/2 (2006), pp. 39–72, p. 41.

[50] Paul Nash, *Room and Book* (London: Soncino Press, 1932), pp. 27–8.

typical post-war room, in which an Adam mantelpiece is covered with negro masks while Victorian wool-pictures jostle the minor Cubists on the walls. In such a room a Picasso reproduction is not considered 'amusing' unless flanked by pampas grass or surrounded by a Gothic frame made out of walnut shells, any more than a Brancusi bird is considered 'amusing' unless set off by a cage of stuffed tits, and an effigy of Queen Victoria.[51]

The use of the word 'amusing' here signals another way of looking at the phenomena I am defining as modern baroque. Christopher Reed identified the era's camp eclecticism as 'the amusing style', because the word was so often used at the time,[52] and in 1926 Geoffrey Webb attempted a definition of what his era meant by the word: 'It seems to stand for a demand for something "extra", a quality superadded to formal merits, some touch of wit in association, which at its best seems to arrive from the typically English love of fancy and "conceits", or less reputably, from a fear of emotion.'[53] Webb therefore suggests that, as a stance, 'amusingness' partakes of both sprezzatura and camp, but the word choice is also strategic. It is a plea *not* to be taken seriously; it deflects any implication that the user is offering any kind of a challenge or subverting orthodoxies. Therefore it may be an aspect of what I will discuss in chapter 2 as 'hiding in plain sight'.

Many of the elements of the new baroque coalesced before the First World War. Cecil Beaton suggests that it was, in its origin, a courtesan's style, combining the utmost luxury and magnificence with conscious exoticism and deliberate shock, thus arriving at the same conclusion as Georg Simmel, quoted above, from a different direction. A drawing room in the demi-monde was not supposed to replicate haut-monde taste, but to challenge it, for the enjoyment of the men who paid for both. The most successful of the Parisian cocottes practised the arts of conspicuous consumption in the grand style. As Colette observed wryly, 'Their homes...were all of a "crushing" splendour. They had to be, since it was always a question of somebody crushing somebody else.'[54] Beaton points to Cécile Sorel in particular as a strong influence on subsequent decorative taste, above all in her use of colour, opulent textures (red velvet, gold lamé, leopard-skin), and dazzlingly eclectic combinations:

She possessed some rare pieces of furniture, including a particularly beautiful chaise longue shaped somewhat like a gondola, upholstered in a wonderful old green-blue

[51] Constant Lambert, *Music, Ho!* (1934), p. 76.
[52] Christopher Reed, *Bloomsbury Rooms: Modernism, Subculture and Domesticity* (New Haven and London: Yale University Press, 2004), p. 237.
[53] Geoffrey Webb, 'Regency Architecture: Notes on Some Recent Revivals and Tendencies', *Vogue* (Jan. 1926), p. 58.
[54] Colette, *My Apprenticeships* (written 1936), trans. Antonia White (London: Penguin Books, 1967), p. 15.

velvet.…The fine boiseries were of eggshell blue and gold. Against a magnificent Coromandel screen she placed a couple of Jacob fauteuils covered in lobster-scarlet velvet…but it was the dining-room that perhaps displayed her sense of grandeur to the best advantage. The floor, of white and pigeons'-blood marble squares, was spread with leopard skins, while the marble walls, of an eggshell brown, were hung with medallions of carved stone. The dining table of marble was copied from one at Versailles and was covered with a cloth of gold tissue. For her dinner parties, fat garlands of scarlet poppies or red carnations, raised at given points to attach themselves to a huge still life of purple grapes, were hung in festoons the length of the table.[55]

The arrival of the Ballets Russes in Paris brought Cécile Sorel's colour sense out of the demi-monde and made it fashionable in high society. After separating from her husband, Lady Cunard acquired 20 Cavendish Square in 1911 (the year the Ballets Russes first arrived in London), and brazened out her somewhat ambiguous status with a defiantly avant-garde decor: her dining-room walls were covered in arsenic green lamé, her table was lapis lazuli, and her other furniture mostly gilt, and Louis Quinze.[56] Lady Victoria Sackville decorated a bedroom for her daughter Vita Sackville-West at her Sussex Square house in 1913–14, which she described in her diary: 'Her walls are shiny emerald green paper, floor green, doors and furniture sapphire blue; ceiling apricot colour. Curtain blue and inside curtains yellowish. The decoration of the furniture mainly beads of all colours painted on the blue ground… six bright orange pots on her green marble mantelpiece and…salmon and tomato colour cushions and lampshades.'[57] It must have been something of a relief to Vita to put out the light, but this colour scheme bears witness that the first challenge to lilac-and-beige timid good taste in Edwardian London came from aristocratic women who liked to think of themselves as patrons of the arts and arbiters of fashion. Lady Sackville opened a decorating shop, Spealls, in South Audley Street in 1911.[58] Unlike their menfolk, 'society ladies' had no scruples about combining their business interests with their social lives, which allowed the evolution of a wide variety of mutual benefit pacts, discussed in chapter 1.[59]

Outside England, one of the most notable monuments of the style is Helena Rubinstein's house in Paris, put together between 1934 and 1937. Rubinstein was another entirely self-created individual. The critically minded complained that she had rifled everything 'from Byzantium to the flea market', and described the result as 'an offensive of baroque taste'. The decor included modern paintings, including her

[55] Beaton, *The Glass of Fashion*, p. 72.

[56] Anne Chisholm, *Nancy Cunard* (London: Sidgwick & Jackson, 1979), p. 27.

[57] Victoria Glendinning, *Vita: the Life of Vita Sackville-West* (London: Weidenfeld & Nicolson, 1983), p. 95.

[58] Stephen Calloway, 'The Wider Influence of Russian Ballet', in Jane Pritchard (ed.), *Diaghilev and the Golden Age of the Ballets Russes 1909–1929* (London, V&A Publishing, 2010), 126–7, p. 127.

[59] Pamela Horn, *Country House Society* (Stroud: Amberley Publishing, 2015), p. 236.

own portrait by Edith Sitwell's favourite protégé, Pavel Tchelitchew, and one of the first great collections of Oceanic and African art, modern and modernist items which were easy companions with a splendid rococo shell settee and a Venetian blackamoor.[60]

Yet great wealth and conspicuous consumption are not the whole of the story. Lady Ottoline Morrell was a great deal less wealthy than her Bloomsbury friends and enemies believed, but she had a sumptuous sense of colour. She drew on memories of the sea-green and gilt rooms of the seventeenth-century Duke and Duchess of Newcastle's fantasy castle at Bolsover to make her manor house at Garsington a monument to an Italianate taste which was also formed by indigenous English baroque. One sitting room was sea green, the other Venetian red, with gold lines round the panelling and gilded ceiling beams. Her study was green and gold, and much of the furniture was Italian, and eighteenth century. Other elements of her decor, besides the colour scheme, were items which will appear again and again in these pages: she displayed a black-and-gold Coromandel screen, Venetian pier glasses, and Italian cassoni, while the walls were hung with modern pictures.[61] In Lady Ottoline's case, it was all achieved with a great deal more style than money: the bathrooms had linoleum on the floor, there was no mains water or electricity, the curtains, though sumptuous-looking, were, like Cecil Beaton's, made of inexpensive materials. 'It is indeed a damnably difficult thing to live fully, richly, gorgeously and yet courageously,' she wrote. 'To live on the grand scale.'[62]

[60] Patrick Mauries, *Shell Shock: Conchological Curiosities* (London: Thames & Hudson, 1994).
[61] The house described in ch. 2 of Aldous Huxley's *Crome Yellow* is a sketch of Garsington.
[62] Miranda Seymour, *Ottoline Morrell: Life on the Grand Scale* (London: Hodder & Stoughton, 1992), p. 476.

I

Society

1

Climbing

L ord Berners, complaining of insomnia, blamed it on having been given a room
next to Sibyl Colefax, because 'she never stopped climbing all night'.[1] Both
Berners and Colefax were middle-aged, and neither had any pretensions to looks.
The 14th Baron Berners was an Old Etonian, diffident, musical, homosexual, and
rich. Sibyl, on the other hand, was born no one in particular, had no schooling
worth speaking of, and was married to a bore. But she was energetic and deter-
mined. That is why the two of them were at a house party in adjacent rooms.

Lord Berners and Sibyl Colefax represent two significant groups discernible in the
interwar world of the arts: on the one hand, the mountains—the wealthy, titled, and
socially acceptable—on the other, the mountaineers. This is an essential social fact.
The Council for Music and the Arts, subsequently the Arts Council, was a product of
the Second World War. Before the rise of public funding, the majority of artists had
to struggle to attract the interest of individual patrons in the first instance, and it was
a long, hard road to one's first one-man show, or equivalent. The instability of a life
lived for one's art is stressed by Sybille Bedford, who was frequently dependent on
the generosity of friends: 'For many of us in the shrinking West the Twenties and
Thirties were hard times, restricting times, beginning with much hope, moving on
to loss of work, inflations here, financial crashes there, covert, soon open fears.'[2]

The interwar art market was either corporate or individual. As Clement Greenberg
says, 'No culture can develop without a social basis, without a source of stable
income. And in the case of the avant-garde, this was provided by an elite among the
ruling class of that society from which it assumed itself to be cut off, but to which it
has always remained attached by an umbilical cord of gold. The paradox is real.'[3]
The nearest thing to public funding was the enlightened patronage of great corpor-
ations, most notably the deliberate decision of Frank Pick, CEO of London's Under-
ground, to use it to educate the people in modern art and architecture. It was thanks
to Pick that 'the art galleries of the people are not in Bond Street but are to be found

[1] Mark Amory, *Lord Berners: the Last Eccentric* (London: Chatto & Windus, 1998), p. 71.
[2] Sybille Bedford, *Quicksands: a Memoir* (London: Hamish Hamilton, 2005), p. 9.
[3] Clement Greenberg, 'Avant-Garde and Kitsch', *Partisan Review*, 6.5 (1939), pp. 34–49.

in every railway station', as Frank Rutter observed,[4] and his patronage of artists did much to familiarize Londoners with the conventions of modern painting.[5] A few other large companies, notably the General Post Office, the Cunard Steamship Company, and Shell-Mex, followed his lead.

Much writing about the twenties focuses on the Bright Young People, their parties, jazzing, cocktails, and cocaine,[6] and, often enough, the summative voice is that of Evelyn Waugh, because he had been in his early days a Bright Young Person. But Waugh was a satirist, not a historian of his times. The all too familiar narrative of 'gyrating ninnies in Mayfair' is the story of a very small, interconnected group, bohemian enough to kick over the traces and rich enough to wear fancy clothes and have drug habits. But they had an importance Waugh does not acknowledge: they were among the people rich enough and enterprising enough to buy avant-garde art. They were also celebrities in that first era of tabloid journalism, and therefore news, which gave their creative protégés a chance of being written up; this consequently gave them importance as patrons.[7] Also, while people such as Elizabeth Ponsonby, the model for Waugh's Agatha Runcible, were quite as useless and shallow as he suggests, others were adventuring to some purpose: Waugh himself, for example, or the 'compellingly respect-worthy' Nancy Cunard, who supported both causes and individuals, founded the Hours Press, and became passionately committed to the fight against racism.[8] One of her many friends said, 'She was the least vulgar person I have ever known, and she had been in prison, she told me, in eleven countries.'[9]

The motives of private patrons were various. There is an element of the disinterested support of talent, but for many there seems also to be a distinct enjoyment of the power vested in becoming an arbiter or gatekeeper. Sir Edward Marsh encouraged many poets as editor of *Georgian Poetry*, and also became a major figure in the contemporary world of British painting, encouraging and helping to support John Currie, Mark Gertler, John and Paul Nash, and Stanley Spencer.[10] A discreet but influential figure in London's homosexual community, Marsh also helped to establish Ivor Novello. Another arbiter, Matthew Pritchard, a specialist in Byzantine art,

[4] Michael T. Saler, *The Avant-Garde in Interwar England: Medieval Modernism and the London Underground* (Oxford: Oxford University Press, 2001), p. 99.

[5] Oliver Green, *Frank Pick's London: Art, Design and the Modern City* (London: V&A Publishing, 2013).

[6] For example, D. J. Taylor, *Bright Young People: the Rise and Fall of a Generation: 1918–1940* (London: Chatto & Windus, 2008).

[7] Stephen Gundle, *Glamour: a History* (Oxford: Oxford University Press, 2008), pp. 141–3; Taylor, *Bright Young People*, p. 149.

[8] The description of Cunard is Sylvia Townsend Warner's: *With the Hunted: Selected Writings* (Norwich: Black Dog Books, 2012), p. 223. By contrast, D. J. Taylor focuses on Elizabeth Ponsonby, an alcoholic, in a way that implies she is typical of the 'Girls of Nineteen-Twenty-Six'.

[9] Charles Burkhart *Herman and Nancy and Ivy, Three Lives in Art* (London: Victor Gollancz, 1977), p. 16.

[10] *An Honest Patron: a Tribute to Sir Edward Marsh* (London: Bluecoat Gallery, 1976).

possessed, T. S. Eliot said, 'an influence out of all proportion to his public fame', which he chose to exercise on behalf of Matisse.[11]

Alongside people like Marsh and Pritchard, for whom art was of central import-ance, the socialite mothers of Bright Young People such as Nancy Cunard and the Jungman sisters were also lent significance by their need to seem up with the newest thing. Patronage was a way of raising one's social capital, and thus hostesses could often be persuaded to countenance self-invented arrivistes. For an avant-garde writer or artist without an independent income, promotional networking and 'being taken up' were necessary for survival. Even as uncompromising an individual as D. H. Lawrence was helped by Lady Asquith and Lady Ottoline Morrell, among others,[12] while James Joyce was supported by Harriet Shaw Weaver for more than twenty years, having been recommended to her by Ezra Pound, and he received further subsidies from Sylvia Beach and Bryher (Annie Winifred Ellerman).[13] Stanley Spencer was incapable of promoting himself but found a patron, Henry Lamb, prepared to act on his behalf, and thus attracted the more powerful patronage of Edward Marsh.[14] He had another faithful buyer and supporter in Wilfred Evill, a London solicitor who filled his house in Welbeck Street with Regency furniture and modern pictures from 1925 onwards.[15] Lady Ottoline Morrell told T. S. Eliot to read Charles Williams's *War in Heaven* and *The Place of the Lion*, and shortly afterwards, in 1934, she invited Williams to one of her London tea parties to meet him. This is why Williams's last two novels were published by Faber.[16]

As Spencer's life suggests, some writers and artists had people—professional agents, dealers, or friends—who were prepared to network on their behalf out of self-interest or conviction, but others had to interact socially with potential spon-sors in order to make an impression, which meant they had to be in the right places, look right, and sound right. Passing for a gentleman was no easy task. Edith Olivier, who was not rich or titled but most definitely well connected and socially present-able, had this to say about William Walton, who was her guest at the time, along with a rich and headstrong American girl: 'Willy adores flirting with Alice tho', with some purpose, he told us the story of his life so that we should realise that he rose from the ranks and so far has made no money, so isn't marriageable. This made clear, he can let himself go and is having great fun....[He] looks a piteable [*sic*]

[11] Hilary Spurling, *Matisse* (London: Penguin Books, 2009), p. 197.

[12] Miranda Seymour, *Ottoline Morrell: Life on the Grand Scale* (London: Hodder & Stoughton, 1992), pp. 289, 335.

[13] William Wiser, *The Twilight Years: Paris in the 1930s* (London: Robson Books, 2001), pp. 19–29.

[14] Paul Gough, *Stanley Spencer: Journey to Burghclere* (Bristol: Sarson & Co., 2006), pp. 21–2.

[15] Evill's collection was sold at Sotheby's in 2011 for a total of £37,464,300. See Kenneth Pople, *Stanley Spencer: a Biography* (London: Collins, 1991), p. 193.

[16] Humphrey Carpenter, *The Inklings: C. S. Lewis, J. R. R. Tolkien, Charles Williams and their Friends* (London: George Allen & Unwin, 1978), p. 97.

little cad—a diseased one too, rather like a maggot—but I believe he has more character than appears.'[17] 'Cad', to Edith, had the sense in which the word was used by contemporary Etonians, i.e. 'lower-class'; not villainous, necessarily, merely other, and not a 'person like oneself'. Similarly, when the society hostess Emerald Cunard described Noël Coward as 'the Artful Dodger of Society', she meant that he was 'not one of us'—and perhaps also, that she was not convinced by his carefully acquired vowels.[18]

But the reason Walton was frisking at the Daye House, a handsome building on the Wilton estate which the Herbert family let Edith Olivier live in more or less free because she *was* 'one of us',[19] is not only because he had a good deal of character, as well as talent, but also because he had acquired backers. His father was a music teacher in Oldham: Walton escaped from the provinces via Christ Church Cathedral School, and a brief spell as a Christ Church, Oxford, undergraduate. Since he never paid much attention to anything but music, he failed his general examinations. He had, however, managed to stay there long enough to pass an examination of a different kind. He played some of his work in progress, a piano quartet, to Sacheverell Sitwell, a fellow undergraduate at Balliol, and convinced first Sacheverell, then his richer brother Osbert, of his genius. After his failure at Oxford, he was invited to stay with the Sitwells in Swan Walk, Chelsea, and was taken to Italy by them. His income in the twenties, £250 a year, was made up by the Sitwells, the dean of Christ Church (who had sponsored him at school when the family could not afford to keep him there), Lord Berners, and Siegfried Sassoon. Apart from the dean, Walton's sponsors are crucial figures in the story of British modernism.

An essential part of this story is the social history of the arts between the wars: the way that the sons of artisans and small businessmen learned, somehow, to walk the walk and talk the talk, and got given a leg-up into the haut monde. Examples include Rex Whistler, son of a builder, Cecil Beaton, son of a timber merchant, and John Betjeman, son of a cabinetmaker. Frederick Ashton's grandfather was also a cabinet-maker. To get on in society, one had not only to say the right things, but say them in the right accent, and for those not born to received pronunciation this was a hurdle in itself. In the case of another great English choreographer, Anthony Tudor, né William Cook, son of a butcher in Smithfield Market, it was Marie Rambert who took on his formation. And, though the Ballet Rambert was conducted on a shoestring, she insisted he go to a speech therapist in Wimpole Street who 'cost a

[17] 16–17 June 1929, *Edith Olivier from her Journals*, ed. Penelope Middelboe (London: Weidenfeld & Nicolson, 1989), p. 98.

[18] Philip Hoare, 'Something Mad About the Boy', *Independent*, 11 Apr. 1998.

[19] Lady Gray, mother of Stephen Tennant, described her thus to Cecil Beaton: 'Miss Olivier comes of an old Hugenot [*sic*] family and is a figure in the archaeogical [*sic*] and ecclesiastical life of Wiltshire'. Beaton, *The Wandering Years*, p. 164.

fortune for half an hour to an hour' until his East End accent was eradicated.[20] Italia Conti, proprietrix of a famous stage school, 'scolded and drilled' the actress Gertrude Lawrence out of her native cockney, and presumably did the same for Noël Coward, who also studied elocution there.[21]

Marie Rambert evidently considered herself in loco parentis to a variety of talented youngsters, but often an actual mother may be discerned in the background, propelling her son upwards by getting him into a public school via rickety combinations of bursaries, loans, and sponsors, an experience which, often enough, provided him with little in the way of academic education, but turned him out equipped with connections and the all-important accent and cultural reference points of the élite. Those who went to Marlborough also got an education in the academic sense, and Etonians seem to have had a remarkable freedom to develop their individuality. Another very important ladder was provided by Oxford (far more so than Cambridge), where scholarship boys such as Walton could learn to stop saying 'serviette' and 'lounge' and reinvent themselves. Several of Betjeman's best-known poems, notably 'How to get on in society' (the one which begins 'Phone for the fish knives, Norman'), deal with precisely this set of social hurdles, with which he himself was only too familiar.[22]

Traps abounded: Cecil Beaton, an Olympic-standard social climber, accidentally met Lady Ida Sitwell when they were both visiting her son Sacheverell's wife Georgia, ill in a nursing home. She upbraided him angrily for photographing her daughter Edith lying on the floor, and his efforts to placate her were not advanced by his addressing her as 'Lady Sitwell' rather than by her correct title—as a baronet's wife, she was 'Lady Ida'.[23] Unfortunately, the Lady Idas of the interwar period cared a great deal about such distinctions, and were not forgiving. Beaton was mortified; it is clear from his early diaries that, in his twenties, he agonized over such moments, lest he make one slip too many, the floor would open beneath him, and he would drop back into the middle class from which he had so effortlessly emerged.

The high visibility of homosexuals in interwar society may have a specific social relation with the problem of passing for a gentleman. The odds were heavily stacked against girls, since social convention still policed women with considerable rigour unless they had jumped the tracks completely. Unmarried girls had little freedom of movement, mistresses were not received in good society, and few men were prepared to marry down unless they were marrying serious money. Edith Olivier, who, despite being a devout Anglican, was unfazed by a coterie of young men—including Stephen

[20] Judith Chazin-Bennahum, *The Ballets of Anthony Tudor* (New York and Oxford: Oxford University Press, 1994), p. 25.

[21] Gertrude Lawrence, *A Star Danced* (London: W. H. Allen, 1946).

[22] Carpenter, *The Brideshead Generation*, pp. 100–1, 261–2.

[23] Sarah Bradford et al., *The Sitwells and the Arts of the 1920s and 1930s* (London: National Portrait Gallery, 1994), p. 114.

Tennant, David Herbert, and Cecil Beaton—who never went anywhere without a powder puff, reacted with class-based anger towards Cecil's temporary experiment with heterosexuality, in the elegant form of Doris, Lady Castlerosse:

> Cecil said he was 'alone with Gerald [Lord Berners]', but no, we found them sitting in the courtyard. . . . 'We' always includes her. It makes me feel I can never go there again. There is nothing there but a common little demi-mondaine and why should one put oneself out for her . . . nothing but a woman with physical attraction which she exploits in a mercenary way.[24]

Doris, née Delavigne, was a gold-digger of Belgian extraction, born in Streatham. At one time she had dealt in second-hand clothes, but by the time Beaton knew her, she had contrived to marry an obese Irish peer and gossip columnist. She was musical, but her principal talent was apparently sex. Her lovers included Randolph Churchill and Sir Alfred Beit, but it was the very rich Mrs Eleanor Flick Hoffman who gave her the Palazzo Venier dei Leoni, now the Guggenheim Museum, on the Grand Canal in Venice.[25] The effective patronage of women was often by other women, whether or not it was sexually motivated; Bryher, for example, helped Edith Sitwell constantly, with furs, jewellery, books, and cheques, and in 1950 gave her £3,000 for a house.[26]

Some men were also disinterested supporters of the talented: Walton's relationship with Sacheverell and Osbert Sitwell was not sexual. But in the nature of things, homosexual men had particular reasons for noticing aspirant youngsters, and the male protégé, as long as the nature of the relationship was not too obvious, could make good use of his opportunities. The adolescent Beverley Nichols, son of a provincial solicitor, found himself attractive to older men and made the most of it, while his parents remained unsuspicious of a relationship between their attractive adolescent son and a wealthy male neighbour who habitually wore rouge and lipstick.[27] Noël Coward's background was even more unpromising than Beverley Nichols's. His father was a failed piano salesman, and his mother kept a lodging house. He somehow made the acquaintance of a society painter, Philip Streatfeild (Streatfeild family legend has it that Mrs Coward was his charlady), and he was taken on a Cornish holiday by Streatfeild and his pederastic friend Sydney Lomer at the age of 14. Extraordinarily, when both men enlisted in the Artists Rifles the following year, they also took the boy with them as 'regimental mascot' while they were on exercises in Hertfordshire.[28] The ability of his parents to overlook the obvious is quite remarkable.

[24] *Edith Olivier from her Journals*, p. 147.

[25] Hugo Vickers, *Cecil Beaton: the Authorised Biography* (London: Weidenfeld & Nicolson, 1985), pp. 162, 217.

[26] Victoria Glendinning, *A Unicorn among Lions* (London: Weidenfeld & Nicolson, 1981), p. 297.

[27] Bryan Connon, *Beverley Nichols: a Life* (London: Constable, 1991), p. 45.

[28] Philip Hoare, *Noël Coward* (London: Sinclair-Stevenson, 1995), pp. 32–6.

Coward, for his part, seems to have been pragmatic.[29] He was learning how to pass for a gentleman, what to read, and how to present himself. Another of his admirers actually launched him on his career: this was Edward Bootle-Wilbraham, 3rd Earl of Lathom, stage-struck and wildly generous, who persuaded the impresario André Charlot to put on Coward's first revue, *London Calling*, and backed it. He also backed Beverley Nichols and Ivor Novello, among others. The better-looking painters similarly benefited from the patronage of gay artists and art lovers such as Eardley Knollys, Rex Nan Kivell, Sir Francis Rose, Sir Edward Marsh, and Peter Watson.[30]

Furthermore, the young, gifted, and queer had another set of chances at a leg-up: a goodly number of middle-aged ladies besides Edith Olivier had, then as now, a soft spot for winning young homosexuals with nice manners and a gift for repartee. Streatfeild was stricken by tuberculosis when Noël Coward was 15, and on his deathbed asked his wealthy friend Eva Astley Cooper to look after the boy, which she did. It was during prolonged visits to Hambledon Hall that Coward learned about knives and forks and dressing for dinner, and also where he read Saki, whose mouthpiece, Clovis Sangrail, provided a template for the public persona which Coward was constructing for himself. He also quite literally followed his hostess about with a notebook, scribbling down her bons mots, many of which came in very handy when he began his career as a playwright.[31]

Frederick Ashton was another climber who learned by watching, absorbing upper-class manners and mannerisms as fast as he could. His blue-blooded friend Olivia Wyndham—albeit that she was lesbian, alcoholic, and addicted to both heroin and cocaine—was, in a social sense, properly brought up. She sometimes took him with her when she went to see her father, and on one occasion, when the three of them were dining with a group in a restaurant, Ashton reached out to touch the arm of 'a Viscountess' to ask her to repeat a remark. Subsequently, he encountered Colonel Wyndham in the Gents, who told him, 'You're a very nice boy, but I think you must learn that one doesn't touch ladies in public.'[32] He never had to be told that kind of thing twice.

In a moment of youthful self-doubt, Cecil Beaton once asked a friend, 'What on earth can I become?' 'I shouldn't bother too much', he was advised. 'Just become a

[29] In a short story which seems to embody a good deal of autobiography, he writes: 'I don't see that it's anybody's business but your own what you do with your old man providing that you don't make a beeline for the dear little kiddies, not, I am here to tell you, that quite a lot of the aforesaid dear little kiddies don't enjoy it tiptop. I was one myself and I know.' 'Me and the Girls', in *Noël Coward, The Complete Stories* (London: Methuen, 1985), pp. 467–98, p. 474.

[30] Julian Machin, *Adrian Ryan: Rather a Rum Life* (Bristol: Sansom & Company, 2009).

[31] Hoare, *Noël Coward*, pp. 39–43. [32] Kavanagh, *Secret Muses*, p. 72.

friend of the Sitwells and see what happens.'[33] Good advice, which he took. His friend Allanah Harper brought Edith Sitwell and Madge Garland to lunch with him on 7 December 1926, and afterwards Edith spent the first of many afternoons posing for photographs.[34] It was thanks to an intervention from Osbert that Beaton's first book, *The Book of Beauty* (1930), was commissioned by Thomas Balston of Duckworth.[35] Beverley Nichols similarly scraped acquaintance with Osbert and Sacheverell Sitwell at the Café Royal, and insinuated himself into their circle,[36] while Constant Lambert, aged 18, simply invited the brothers to attend the first performance of two of Sacheverell's poems, set to music by himself, in 1923.[37]

One reason that it was particularly well worth knowing the Sitwells is that all three of them worked very hard for their protégés. For example, in 1929 Sacheverell seized the chance offered by a letter Diaghilev sent him about eighteenth-century music: 'I must tell you', he added, having supplied the required information, 'that there is a twenty-two-year old artist called Rex Whistler, who is extremely talented. He is an exceptionally clever *pasticheur*. Don't go to see his frescoes in the Tate Gallery. He has done much better things since.'[38] The Sitwells had met Whistler in 1926 at Wilsford, Stephen Tennant's house, in the company of Edith Olivier. 'Stephen owes a great deal to Rex,' Lady Aberconway observed to Osbert Sitwell. 'The other way round, you mean,' he replied. Both were true.[39]

Frederick Ashton was another protégé who grabbed his chances with both hands. Like Anthony Tudor, he got much of his education in how to pass for a gentleman from Marie Rambert, who told him what to read and taught him how to behave at dinner parties. In one of his last interviews, he said that Rambert was 'an extraordinarily cultured woman, well-read and ... her presence alone was a constant source of stimulation'.[40] Rex Whistler, similarly, learned something about how to present himself from his public school, Haileybury, but a great deal more from Edith Olivier. Without such tutelage, neither man could have been, as they both were, launched on a social trajectory which included personal invitations to stay with the King and Queen.

According to Stephen Tennant, Beaton was fascinated by Edith: 'She was Cecil's Egeria, Erda. She was all the muses to him.' Actually, she taught him, as she taught Whistler, how to pass for a gentleman.[41] One of the truly mortifying experiences of

[33] Laurence Whistler, *The Laughter and the Urn* (London: Weidenfeld & Nicolson, 1985), p. 99.

[34] Vickers, *Cecil Beaton*, p. 83. [35] Bradford et al., *The Sitwells*, p. 110.

[36] Connon, *Beverley Nichols*, p. 55.

[37] Richard Shead, *Constant Lambert* (London: Simon Publications, 1973), p. 43.

[38] Richard Buckle, *Diaghilev* (London: Hamish Hamilton, 1984), p. 519.

[39] Whistler, *The Laughter and the Urn*, p. 81.

[40] H.-T. Wohlfahrt, 'Der Tänzer muss mit der Technik Gefühle übertragen', *Ballett-Journal/Das Tanzarchiv*, 5.1 (Dec. 1988), p. 56.

[41] *Edith Olivier from her Journals*, p. 50.

Whistler's short life was accepting an invitation from Lord Berners to stay for five weeks at his Rome house, no. 3 the Forum. Someone who looked and sounded as Rex did by 1930 should have been able to speak French, and when an Italian contessa with no English came to lunch, he had to reveal, to his profound embarrassment, that he couldn't. 'I could have kicked myself for not being able to speak it properly,' he wrote miserably to his mother. 'I *must*. Have you heard of a good teacher?'[42]

Passing was all-important. Frederick Ashton remembered: 'The hostesses of that period were *powerful*. They were patrons. If they took you up, they could do something for you.'[43] Margot Asquith told him at a party in 1931 that she admired his work, and asked whom she could introduce him to. 'I said I'd like to meet [Max] Reinhardt, and she said, "No good to you at all." "Well, [Charles] Cochran, then." And she said, "I'll bring him to see you next Sunday."'[44] She did, and through the straitened times of the thirties, it was putting together numbers for Cochran revues and dancing in Cochran cabarets that kept Ashton afloat financially. Sibyl Colefax similarly introduced young people to those they might find helpful.[45] Emerald Cunard, once memorably described as looking like a canary of prey, was a great figure in the world of the arts, opera in particular.[46] She would also buy a dozen copies of a book by an unknown author she had taken a fancy to, and give them to opinion-formers.[47] Waugh's character Julia Stitch in *Scoop* (1933), shown in action creating a job for her protégé Henry Boot, is a verbal caricature of such women, not greatly exaggerated.[48]

Cecil Beaton is a mine of information about climbing. The attractive and vivacious Zita and Baby Jungman were daughters of Mrs Richard Guinness by a previous marriage, and their mother's house was one of the places where artists could meet potential patrons socially. Beaton spotted them at the first public performance of Edith Sitwell's *Façade*, and met Zita again in Venice rehearsing for a ball. 'They certainly would get into the papers … so very saleable', he noted in his diary. Zita and Baby, for their part, were keen to establish themselves as fashionable beauties, so they promptly joined Beaton's stable of models. On the strength of his acquaintance with her daughters, Mrs Guinness issued an invitation, to his delight: 'I feel that she will very likely be a great help to me, and I'm delighted to have got in

[42] Whistler, The Laughter and the Urn, p. 142. [43] Kavanagh, Secret Muses, p. 266.

[44] Kavanagh, Secret Muses, p. 145.

[45] Michael Colefax (her son), 'Sibyl Colefax: a Human Catalyst', Oxford, Bodleian Library, MS Eng.c.3188, f. 15.

[46] Daphne Fielding, Emerald and Nancy: Lady Cunard and her Daughter (London: Eyre & Spottiswoode, 1968), p. 70.

[47] Martin Green, Children of the Sun (London: Constable, 1977), p. 104; Grace and Favour: the Memoirs of Loelia Duchess of Westminster (London: Weidenfeld & Nicolson, 1961), p. 116.

[48] Humphrey Carpenter suggests that Waugh's specific target was Lady Diana Cooper (The Brideshead Generation, p. 310).

with her.'[49] The delight had nothing to do with the pleasure of her company. She was known in her circle as Gloomy Beatrice, and was once overheard telling a modiste, 'I want a hat for an ugly middle-aged woman whose husband hates her.'[50] But at one time or another Beaton, Noël Coward, David Cecil, and Oliver Messell all used her as a social stepping stone.

Fashionable hostesses such as Mrs Guinness and Lady Cunard had their own reasons for picking up bright young Beatons and Cowards. They were mutually competitive, though each had her specialties: Mrs Colefax collected the intelligentsia, as did Syrie Maugham, while the Hon. Mrs Ronald Greville went in for royalty and politicians.[51] But whatever their particular focus, all of them needed a coterie of reliable young men with a talent to amuse, partly because their social lions sometimes turned out to be crashing bores when exhibited. These youngsters occupied an ambiguous status between guests and entertainers, and, like the hostesses, had their specialities. Frederick Ashton and his friend/rival Robert Helpmann had a remarkable talent for improvised skits, while Noël Coward and Ivor Novello were quick off the mark with an epigram or a put-down. As Coward wrote in *Bitter Sweet*,

> Our figures sleek and willowy,
> Our lips incarnadine,
> May worry the majority a bit.
> But matrons rich and billowy
> Invite us out to dine,
> And revel in our phosphorescent wit.

Another reason for acquiring a stable of amusing bachelors was that society hostesses also needed 'spare men': every female guest required a male to take her into dinner, and the widowed, divorced, and single therefore presented a social problem, as did those women whose husbands preferred dining at their clubs to attending parties. Having a few presentable young men on hand who knew how to behave and would jump into evening dress on request came in very useful.

Climbers had to be thick-skinned. Beaton noted that 'in certain circles it was considered smart to be rude', something which Nancy Mitford illustrates in *Love in a Cold Climate*.[52] It was also smart to be unkind. Lord Berners once sent the following

[49] Vickers, *Cecil Beaton*, p. 83. [50] *Grace and Favour*, p. 117.

[51] Ross McKibbin, *Classes and Cultures: England 1918–1951* (Oxford: Oxford University Press, 1998), p. 26. Mrs Greville was the illegitimate daughter of the Scottish brewer William McEwan. She had a poisonous tongue, and divided her talents between running McEwan and Co., following the deaths of her father and husband, and entertaining royalty as frequently as possible. Pamela Horn, *Country House Society* (Stroud: Amberley Publishing, 2015), p. 196.

[52] Hoare, *Noël Coward*, p. 148.

invitation to Sibyl Colefax: 'I wonder if by any chance you are free to dine tomorrow night? It is only a tiny party for Winston and GBS. I think it important they should get together at this moment. There will be no one else except for Toscanini and myself. Do please forgive this terribly short notice.' Berners made both his name and the address on the envelope completely illegible, and told all his friends, all of whom gleefully envisaged Mrs Colefax writhing on the floor in frustration. He also owned a Victorian toy, a japanned blackamoor head, which he had adapted to spew a flood of Mrs Colefax's invitations from its mouth at the touch of a button.[53] Lord Berners' own social position was impregnable, but as far as the bright young bachelors were concerned, though it was important to be 'outrageous' when outrage was required, it was also important not actually to go too far, as Noël Coward sometimes did. For a young man with ambition and no money, if a hostess such as Elsa Maxwell or Sibyl Colefax dropped you or, even worse, took against you, the climb back was difficult and might even be impossible.

Ashton was particularly clever, because he created a version of himself which permitted the odd solecism. As Julie Kavanagh perceptively observes, 'The persona he had begun to cultivate of "a middle-class boy at sea in such grand surroundings" was more than a little calculated: he knew it amused people and it made him appear unthrusting. As he often said, "I fitted in because I never tried to be one of them."'[54] Climbers had to watch their step. After Cecil Beaton had endured an afternoon of merciless teasing on a transatlantic liner, Noël Coward condescended to give him some advice, from queer to queer: '"Your sleeves are too tight, your voice is too high, and too precise. You mustn't do it. It closes so many doors. It limits you unnecessarily, and young men with half your intelligence will laugh at you.... It's hard, I know."...He cocked an eye at me in mockery.'[55] Beaton swallowed his pride and did as he was told. The enforced intimacy of Atlantic crossings meant that scraping up a first-class fare was an investment which might open a whole new set of doors. Coward was making good use of this voyage: he managed to make acquaintance with both the Douglas Fairbankses and the Mountbattens, two very different types of interwar royalty.[56]

In addition to those, such as Walton and Ashton and Beaton, who used their rich friends to set them on the path of merited fame, the names of innumerable slightly talented protégés turn up in contemporary diaries and letters. John Banting, painter and decorator, was one of the more ubiquitous: a gay, working-class Londoner of considerable physical charm. At 28, he was holidaying in the South of France with Edward (Eddie) Sackville-West, 5th Baron Sackville (this was 1930). His sitters included Nancy Cunard, Brian Howard, Edith Sitwell, and Harold Acton, and his

[53] Daphne Fielding, *Emerald and Nancy*, pp. 101–2. [54] Kavanagh, *Secret Muses*, p. 197.
[55] *The Wandering Years*, p. 187. [56] Hoare, *Noël Coward*, p. 125.

'surrealist' work attracted at least as much attention as it deserved. He and Brian Howard worked together on the paintings attributed to 'Bruno Hat', a famously elaborate hoax intended to deceive the newspaper columnists of the day, which it did, up to a point.

Exoticism seems, in many cases, to have lent enchantment. Edith Sitwell fell for a temperamental, mystical and homosexual Russian called Pavel Tchelitchew, and though she had barely enough to live on herself, did her very best for him by talking him up: she pulled every string she possessed to get him a one-man show at the Claridge Gallery in 1928, and to ensure that reviewers turned up to it.[57] Emerald Cunard acquired, among many other protégés, a bisexual Chilean painter, poet, drug addict and amateur boxer called Alvaro Guevara, known as 'Chile'.[58] He ended up marrying the heiress Meraud Guinness, something of a coup, and perhaps an encouragement to other society hostesses blessed with daughters to cultivate homosexuals. Emerald Cunard's daughter Nancy followed in her mother's footsteps as a patroness: she acquired, among other hangers-on, Michael Arlen, the future author of a hugely popular novel of the day, *The Green Hat*, whose heroine is based on her.

Cecil Beaton's early career depended on three things: packaging his fortunately attractive sisters as models of a new kind of glamour invented by himself, collusion with the wealthy, arty, and self-obsessed Stephen Tennant in the role of reflecting mirror to Stephen's Narcissus, and photographing the Sitwells. How he got started was by ringing the leading London society photographer of the 1920s, Hugh Cecil, claiming to be from *Vogue*, and asking for a portrait of Mrs E. W. H. Beaton (his mother). The photographer promptly invited Mrs Beaton over for a sitting, and since anyone photographed by Hugh Cecil was 'interesting', a photo was published in *Vogue*, on the slender basis of which more photos of the Beatons were published, and more, and more. It was this which allowed Beaton to approach the Jungman sisters, Alannah Harper, and the Sitwells. 'Have you seen the December Vogue?' Edward Burra asked dryly in a letter of 1927. 'It's Cecil Beaton Baba Beaton Annie Beaton Mrs Beaton Father Beaton Lizzie Beaton Beaton Beaton and even one of those amusing drawings by Cecil Beaton of Cecil Beaton impersonating a fragrant old Staffordshire piece representing Apollo.'[59] It is of course also part of the distinctive texture of the twenties that someone like Burra was reading *Vogue*, which at that time kept readers abreast of the latest in art and ideas as well as couture. He probably saw it at David Tennant's Gargoyle Club, where he went in order to read it.

[57] Bradford, *The Sitwells*, p. 122.

[58] Diana Holman-Hunt, *Latin Among Lions—Alvaro Guevara* (London: Michael Joseph, 1974).

[59] Edward Burra, *Well, Dearie! The Letters of Edward Burra*, ed. William Chappell (London: Gordon Fraser, 1985), p. 40 (9 Dec. 1927).

Having thus made himself a figure, Beaton became an impresario of the English Arcadia; his group portraits of the Bright Young People, the defining image of their collective style. His achievement was extraordinary. Loelia, Duchess of Westminster, observed that 'Cecil Beaton's photographs undoubtedly influenced taste for the better'.[60] Philip Core is more analytic: 'That Beaton's place in these coteries was professional as much as personal was a sign of the times, like the emergence of the decorator as arbiter of taste, and marks the arrival of the photographer as a power in the history of ideas.... Beaton by the late Twenties was in the vanguard of figures whose work for other people appeared to be personal selectivity but was actually a wide-scale commercialization of the role of *arbiter elegantarium*.'[61]

For the arrivistes, those twenties parties must have been hard work. Frederick Ashton, a profoundly professional partygoer, wrote of Burra's and his friend Barbara Ker-Seymer, with utter seriousness, 'I havent seen Baby for years [a year, in fact] but Im sure she is well now that she has a circle of her own liking around her. She has reached her pinnacle of friendship with Eddy and Brian she can't get grander in her set.' Eddy was Edward Gathorne-Hardy, son of the Earl of Cranbrook and Waugh's model for Miles Malpractice, and Brian was Brian Howard, model for Anthony Blanche, and both were rich homosexuals. But Ashton's social antennae had deceived him: Ker-Seymer was not setting her cap at Brian Howard, because she didn't have to. Though her parents had separated and her mother was not well off, she was, like Edith Olivier, well connected. She was presented at court in 1927 along with Meraud Guinness, who later married 'Chile' Guevara. She had in fact known Brian from childhood, and was one of the very few of his friends whom his alarming mother Lura approved of.[62]

As Edith Olivier's reaction to Lady Castlerosse suggests, it was much more difficult for a girl to be a social climber other than through marriage, though some women, like Sibyl Colefax, donned their crampons and headed for the heights in middle age. Barbara Ker-Seymer's early career is an instructive case of a young woman who found a way of striking out into genuinely independent living without acquiring a husband. In her early twenties, she was evidently anxious to get away from her mother's house. A lesbian protégée could pass, like her gay male counterpart, for a 'secretary' or 'companion'. She was also blessedly unworried by the nightmare which hung over the independent flapper with a boyfriend: unwanted pregnancy. Norman Haire, an eminent Harley Street gynaecologist, made a great part of his considerable income from fitting the Gräfenberg intrauterine ring, which was to the twenties what the Pill was to the seventies, but a girl had to be able to

[60] *Grace and Favour*, p. 100.

[61] Philip Core, *The Original Eye: Arbiters of Twentieth Century Taste* (London: Quartet Books, 1984), pp. 105, 111.

[62] Marie-Jacqueline Lancaster, *Brian Howard: Portrait of a Failure* (London: Timewell Press, 2005), p. 136.

afford Harley Street and, indeed, to have heard that such a thing was possible, which in the state of sex education at the time was an issue in itself.[63]

Ker-Seymer reported to Burra in September 1928: 'My dear I have been ordered out of the house since "The Well of Loneliness" was found accidentally left lying on the piano, I'm in coventry now & my bed sitting room has been confiscated so that I have to sleep in the box room.'[64] Shortly afterwards, she moved into lesbian bohemia. By October, Burra is signing off a letter to Bar, 'love to Olivia and Sophie', an indication of whom she was seeing by then, and another insight into how socialites, homosexuals, and serious artists interacted. Bar's lover Olivia Wyndham was a central figure in the world of upper-class London lesbians. She was also a cousin of David Herbert and Stephen Tennant. Though the Wyndham fortunes took a battering after World War I, she had an allowance from her father and had been brought up to spend money. She lived independently at 19 King's Road, Chelsea, where the very wealthy 'Joe' Carstairs and her girlfriend Ruth Baldwin were part of her coterie. Olivia, a photographer, worked for a time with the avant-garde American photographer Curtis Moffat, who was married to the 'poet-actress-adventuress' Iris Tree, a daughter of the actor–manager Herbert Beerbohm Tree.

By contrast, the 'Sophie' of Burra's greeting is Sophie Fedorovitch, a Russian who escaped to Paris, penniless, after the revolution, moved to London in 1920, and became an enormously accomplished ballet designer.[65] Shy, gruff, and self-contained, she wore short hair and mannish clothes, and though she had a very discreet male protector, Captain Mordaunt Goodliffe, whom she had met when she was driving a taxi in Paris,[66] she had many lesbian friends, of whom Olivia Wyndham was one. Gossip suggests she may also have been one of the numerous women romantically involved with Madge Garland of *Vogue*.

Bar's pocket diary survives from 1929, when she was 24, and reveals her social circle, in which the creative and the wealthy interacted. She was seeing Banting's lover Eddie Gathorne-Hardy, but Heather Pilkington was a far more regular contact. Pilkington's high visibility in lesbian London is indicated by her central role as 'Bracken Dilator' in *Jam To-Day*, Marjorie Firminger's 1931 roman-à-clef. Her lover Wyn Henderson, whom Bar also knew, was a friend and collaborator of Nancy Cunard's, and later ran the Guggenheim Jeune Gallery in London. Other friends

[63] Ethel Mannin, *Young in the Twenties: a Chapter of Autobiography* (London: Hutchinson, 1971), p. 64.

[64] Tate Gallery Archive 974.2.1.54; Barbara Ker-Seymer to Edward Burra, 18 Sept. 1928. An indication of the rock-solid respectability of her antecedents is that her grandmother, Gertrude Clay Ker-Seymer, had been a friend of Sir Arthur Sullivan (of Gilbert and Sullivan), who dedicated the tune of 'Onward Christian Soldiers' to her.

[65] Elizabeth McLean, 'Influences and Inspirations: the Ballet Designs of Sophie Fedorovitch', *Research in Dance Education*, 13.2 (2012), pp. 197–213.

[66] Simon Fleet, 'Sophie Fedorovitch, a Biographical Sketch', tipped into *Sophie Fedorovitch: Tributes and Attributes* (London: privately printed, 1955), pp. 5–6.

included Olivia Plunket Greene, one of the 'Bright Young People', and Nora Holt, a black American singer, composer, and friend of Carl van Vechten.

The world in which a debutante of good family such as Barbara Ker-Seymer might end up with friends like this was deeply suspicious to conventional people. Apart from the fact that girls on the loose constituted a social threat, and so, for those prepared to face the issue, did lesbians, one of the real problems with the 'Bright Young People' was that young men and women of good family were associating promiscuously with riff-raff and bounders, not all of them even white. Charm, looks, personality, and talent all acted as passports to a subculture which was, for that very reason, perceived as subversive. Viva King, a true bohemian at heart, reflected artlessly: 'Perhaps because I have always been a rock for spongers to cling to, I have never understood why scorn is heaped upon those who are often clever enough to take with grace what is usually freely given.'[67] But the rigid boundaries of social class were not supposed to be permeable. The press, and popular culture more generally, were censorious: Noël Coward's 'Poor Little Rich Girl' (1925) touched a nerve with its audience, as did his play The Vortex (1924), and there is a small genre of contemporary fiction, moralistic, sentimental, and attitudinizing, which elaborates The Waste Land's panorama of modern futility by populating it with Bright Young People.[68] Michael Arlen's The Green Hat (1924), Beverley Nichol's Crazy Pavements (1927), Evelyn Waugh's Decline and Fall (1928) and Vile Bodies (1930), and Bryan Guinness's Singing Out of Tune (1933) are all harshly judgemental: the smart set are portrayed as empty-souled, decadent, avid seekers after sensation, despoilers and corrupters of innocence.

A further indication of the anxieties raised both by the 'Bright Young People' and by baroque interior decoration is to be found in the plot lines of interwar detective fiction, a genre which, of its very nature, speaks for order and stability. Dorothy L. Sayers's Murder Must Advertise (1933) turns on the smart set as sexually promiscuous abusers of cocaine, alcohol, and fast cars: a scene in her novel in which a group of bohemian revellers gatecrash a formal evening reception makes an explicit contrast between stability and disorder. A much less distinguished story, Richard Keverne's William Cook – Antique Dealer (1928), demonizes another of the new types thrown up by this world, that of Sibyl Colefax herself, the hard-as-nails woman decorator. Naturally, Mrs 'Bill' Cook turns out to be the villain of the piece, a thoroughgoing crook and faker.

Interestingly, whenever significant talismans of buggers' baroque taste appear in detective fiction, they seem to signify villainy. Nicholas Bentley's neat round-up of the clichés of the genre, Gammon and Espionage (1938), includes the boudoir of a beautiful lady spy: 'A room filled with more pickled pine and bastard baroque

[67] Viva King, The Weeping and the Laughter (London, Macdonald & Jane's, 1976), p. 79.
[68] An observation Hynes makes with respect to Vile Bodies, in The Auden Generation, p. 58.

furniture than Syrie Maugham had ever dreamed about. There was a coloured lithograph by Marie Laurencin on the wall...standing on a glass topped table against the wall was an enormous bowl of red poinsettias and white geraniums and tiger lilies...and there were piles of cushions everywhere which were cut from the gaudy threadbare copes of old Spanish prelates.' The boudoir, incidentally, is just off Curzon Street.

2

Hiding in Plain Sight

The twenties were marked by a moral panic around the interconnected issues of homosexuality, degeneracy, and what was referred to as 'race suicide'.[1] This was exacerbated by the suspicion, fuelled by Wilde and Diaghilev, that the arts were in the hands of a 'pack of pansies', which was, to a surprising extent, the case. Most of the work done by these men is a poor fit with high modernism, and much of it is more straightforwardly seen as one form or another of modern baroque.

The significance of homosexual men as creators and consumers of art in the interwar period is beyond dispute. 'Homosexuality', says Christopher Reed, 'was inextricably linked with the development of avant-garde art in the twentieth century.'[2] But the whole topic of gay men, especially creative gay men, in earlier twentieth-century England has to be seen in relation to the Wilde trial, which ensured that the public were made aware that there was such a thing as sodomy, though inarticulate references to 'filth' and 'beastly practices' in the public press ensured that, to many, Wilde's crimes were as vague as they were awful. Beverley Nichols, looking back, observed that even 'the word "homosexual", in the twenties, was unknown by the man-in-the-street'.[3] Public naïvety is witnessed by Robert Graves and Alan Hodge, who rather staggeringly opined that 'homosexuality had been on the increase among the upper classes for a couple of generations, though almost unknown among working people'.[4] This suggests at once the high visibility of gay aesthetes, and the continuing invisibility of other gay men. One contingent result of Wilde's emergence as the type of the male homosexual, given his dandyism and strongly expressed views on interior decoration, is that in the English popular press, fin-de-siècle decadence, homosexuality, and aesthetic decor were inextricably

[1] Richard Overy, *The Morbid Age: Britain between the Wars* (London: Allan Lane, 2009), p. 98. See also Joseph Bristow, *Effeminate England: Homoerotic Writing After 1885* (Buckingham: Open University Press, 1995).

[2] Christopher Reed, *Art and Homosexuality* (Oxford: Oxford University Press, 2011), p. 112.

[3] Laura Doan, *Fashioning Sapphism: the Origins of a Modern English Lesbian Culture* (New York: Columbia University Press, 2001), p. xx.

[4] Robert Graves and Alan Hodge, *The Long Week-End: a Social History of Great Britain 1918–1939* (London: Reader's Union, 1941), p. 101.

linked (hence the term 'buggers' baroque'), which made life considerably easier for gay men who didn't fit the stereotype, such as Siegfried Sassoon.

As it happens, London has had a gay male community since the late seventeenth century: its pick-up and meeting points, its coteries, and even some aspects of its aesthetics, were not creations of the fin de siècle.[5] All the same, in the period immediately before the First World War, gay aesthetes created a defiant subculture, more visible, and consequently more provoking, than the 'molly houses' and Turkish baths of previous eras. Partly because Diaghilev was openly homosexual, and partly because of the extreme glamour of the artists, the Ballets Russes became a rallying point for queer culture, both before and after the war. *Vogue*'s drama critic, Herbert Farjeon, commented in July 1928: 'The Russian Ballet has returned to London, and once again in the long intervals...the corridors of His Majesty's Theatre are crowded with sweet seasonable young men....The clientèle of the Russian Ballet may now be distinguished by the beautiful burgeoning boys.'

Noël Coward made the same point, in his own way, in the revue he wrote for C. B. Cochran the same summer, *This Year of Grace*. In one sketch, a booking clerk and newspaper vendor are chatting on a railway platform, when a young man minces in to buy a ticket to Queen's Gate. 'Arry,' says Fred, once he has swished out again, 'that's wot the Russian Ballet's done for England.'[6] Coward himself was very careful how he presented himself, and was never outed by the popular press. His style, both verbal and sartorial, was widely imitated, and he thus became a key figure in making camp fashionable in interwar England: 'Men enjoyed imitating the exaggerated, clipped manner of certain leading actors and adopted the confident manner of those who are aware of their charms,' as Beaton put it.[7]

It was much easier to live an openly homosexual life in Paris than it was in London, and along with Diaghilev, a trio of gay Frenchmen—Proust, Cocteau, and André Gide—exerted considerable influence in aesthetic circles. One of the books which Osbert Lancaster recalled as fashionable reading for Oxford undergraduates in the early twenties was Gide's memoir, *Si le grain ne meurt*, the second half of which recounts his discovery of his homosexuality during a trip to Algeria, part of which was undertaken in the company of Oscar Wilde himself. Berlin and Vienna were also notorious for sexual libertarianism, including a relatively relaxed attitude towards homosexuality. This created problems of its own for gay Englishmen once Britain and Germany went to war, since homosexuality became associated with 'the Huns', as John Buchan reveals in *Greenmantle* (1916), which features a homosexual

[5] Leif Jerram, *Streetlife: the Untold History of Europe's Twentieth Century* (Oxford: Oxford University Press, 2011), pp. 247–94.

[6] Philip Hoare, *Noël Coward: a Biography* (London: Sinclair-Stevenson, 1995), p. 193.

[7] Hoare, *Coward*, pp. 41, 85.

German army officer, Colonel Ulric von Stumm. The German gay scene of the thirties was memorialized by Christopher Isherwood in *Goodbye to Berlin*.[8]

In the rest of this chapter, I want to focus primarily on a less-well-explored aspect of cultural history—the contribution of gay women to the interwar arts.[9] A surprising proportion of the women who made their mark in some creative capacity were sharing their lives with other women, or, like Virginia Woolf, Colette, Elizabeth Bowen, Mary Butts, and Constance Spry (many names could be added here), had affairs with women as well as men, though before 1928, the year of the *Well of Loneliness* trial, only a tiny minority of Britons—a contemporary suggests, the most sophisticated 2 per cent—were even aware that sexual relations between women were possible.[10]

For the first time since the era of Sappho herself, there were enough highly visible lesbians about to constitute a distinct and powerful bloc within modernist culture, particularly that of Paris, which was itself a small world. Several important patrons of the arts were lesbians, among them Gertrude Stein, Winnaretta Singer, Bryher, and Natalie Barney. Barney's Paris salon brought together expatriate modernists with members of the French Academy; it was thus almost the only context for both avant-garde and establishment men in which both these groups of male taste-formers were forced to treat women as independent creators.

Joan Schenkar has argued strongly that 'Natalie Barney was the radical sustainer of an unprecedented community of art-making women in Paris who formed by their work and their relations with each other the only serious critique of Modernism as it was practised by male artists in the twentieth century'. Alternative modernists who frequented the rue Jacob included Mina Loy, who was the token heterosexual, Djuna Barnes, Gertrude Stein, Eileen Gray, and Marie Laurencin. In a world where it was hard for women to attract patronage, the richer members of Barney's circle were generous to the ones with no independent resources.[11] The only lesbian in the arts in England who was rich and generous enough to play a similar role was Bryher (née Annie Winifred Ellerman), who at various times gave money to Djuna Barnes, Sylvia Beach, Edith Sitwell, and Dorothy Richardson, among many others. Less-well-off women also put hands in their own pockets. Sybille Bedford gratefully remembered that 'Allanah Harper...made over a part of her income to

[8] Discussed in some detail in Philip Hoare, *Oscar Wilde's Last Stand: Decadence, Conspiracy, and the Most Outrageous Trial of the Century* (London: Duckworth Overlook, 1997), pp. 25–30, and Jerram, *Streetlife*, pp. 275–9.

[9] Peter McNeil has also observed the surprising number of decorators and designers who were gay women; see '"Designing Women": Gender, Sexuality and the Interior Decorator c.1890–1940', *Art History*, 17.4 (1994), pp. 631–57.

[10] Doan, *Fashioning Sapphism*, p. 25.

[11] Joan Schenkar, *Truly Wilde: the Unsettling Story of Dolly Wilde, Oscar's Niece* (London: Virago, 2000), pp. 169, 190.

me for three years—"so that you can get on with your Mexican book".... She herself was not well off and the money going to me seriously clipped her financial wings.'[12] Harper, the founder and editor of the Anglo-French quarterly review *Échanges*, was another friend of Natalie Barney's, and one of the great networkers of the period: she was also a friend of Edith Sitwell, and of Dody Todd and Madge Garland.[13]

In this context of an almost total public ignorance of lesbian lives, a variety of writers in the twenties were interested in exploring women's relationships, including their sexual relationships, with other women, and it is an interesting comment on the times that this mostly passed unobserved by guardians of the nation's moral tone. In 1928, the year of Radclyffe Hall's *The Well of Loneliness*, four other prose writers, both mainstream and experimental, published books about love between women, causing Daniela Caselli to describe the year as 'the alternative *annus mirabilis* of modernism'.[14]

In that year Virginia Woolf published *Orlando*, written as a love letter to Vita Sackville-West, and Djuna Barnes wrote *The Ladies Almanack* for Natalie Barney, out of more complex emotions.[15] Elizabeth Bowen's *The Hotel* also appeared, as did an ill-tempered comic fiction by the popular novelist Compton Mackenzie, *Extraordinary Women*, in which almost all the characters were rich lesbians. The principal reason why Hall's book caused a furore and the others did not is that *The Well of Loneliness* was a stylistically accessible realistic novel written in a traditional form which has one woman's sexual feelings for another as its central theme, while the other authors covered their tracks in one way or another. The *Ladies Almanack* is vastly more sexually explicit, but the prose is archly archaizing to the point of obscurity, and it was published in Paris. Bowen and Mackenzie's novels can be received by the unaware as stories about emotionally intense friendships.[16]

The success of *Orlando* is interesting. It was Virginia Woolf's most popular work. Leonard Woolf noted that it sold twice as many copies in six months as *To the*

[12] Sybille Bedford, *Quicksands: a Memoir* (London: Hamish Hamilton, 2005), p. 15. At a flush moment, Esther Murphy also gave Sybille a large loan or gift to allow her to finish her second book, the novel *A Legacy*, and she promoted it too—notably by giving Nancy Mitford a copy and asking her to pass it on to Evelyn Waugh, whose review saved the novel from obscurity in England and effectively launched Sybille's career. Lisa Cohen, *All We Know: Three Lives* (New York: Farrar, Straus & Giroux, 2012), p. 130.

[13] AnnKatrin Jonsson, 'In the Backdrop of Modernism: Allanah Harper and *Echanges*', *Journal of Modern Periodical Studies*, no. 2 (2011), pp. 185–211.

[14] Afterword, in Djuna Barnes, *Ladies Almanack* (Manchester: Carcanet Press, 2006), p. 90.

[15] Sherron E. Knopp, '"If I Saw You Would You Kiss Me?": Sapphism and the Subversiveness of Virginia Woolf's *Orlando*', *PMLA*, 103.1 (Jan. 1988), pp. 24–34; Phillip Herring, *Djuna: the Life and Work of Djuna Barnes* (London: Penguin Books, 1995), pp. 149–53.

[16] Though a *New Statesman* review, 25 Aug. 1928, quoted in Florence Tamagne, *A History of Homosexuality in Europe: Berlin, London, Paris* (New York: Algora Publishing, 2004), p. 154, did acknowledge the lesbian subject matter and concluded that Mackenzie's message was that 'women cannot fall in love with other women while remaining healthy and decent beings'.

Lighthouse had done in a year.[17] Its attractiveness springs, above all, from its playfulness. *Twelfth Night*, Shakespeare's comedy of shifting sexual and social identity, is the principal literary reference point, and it is no accident that Orlando is born in the age of Elizabeth. Woolf wrote in her diary, 'Satire is to be the main note—satire & wildness....My own lyric vein is to be satirised. Everything mocked.'[18] This in itself is a form of camouflage; unlike Hall, Woolf is demanding *not* to be taken seriously; her subject matter is asking to be received as airy fantasy, a defensive ploy—being 'amusing', in fact. Orlando, of course, spends most of his/her long life as a male, and his sexual adventures with women are heterosexual. Vita Sackville-West, however, though she gave Woolf permission to write about her, was terrified that Woolf might put some explicitly sapphic episode into the narrative, since Orlando was so obviously based on her. Given that Hall's pompous, quasi-biblical 'and that night, they were not divided', the only reference to actual love-making in *The Well of Loneliness*, was received as riotous obscenity, her concern is understandable, and Woolf had to be very careful.[19] In fact, like *Twelfth Night* itself, *Orlando* defuses the anxieties about sexual identities it has raised by ending with marriage, indeed with the joyful return of a long-absent husband to the wife he left waiting for him, a motif which could hardly be more traditional.

Within their social circle, Sackville-West's lesbianism was an open secret. When Woolf first met her, she already knew she was 'a pronounced Sapphist' about whom scandalous stories were in circulation,[20] but this was only true within that circle. Ronald Firbank went to the heart of the problem when he sketched Sackville-West as 'Mrs Chilleywater', an ambassador's wife, in *The Flower Beneath the Foot* (1923), and finished the paragraph with 'the Hon. Harold Chilleywater had been gently warned that if he was not to remain at Kairoulla until the close of his career the style of his wife must really grow less *virile*'.[21] Therein lay the essential issue. It had to be borne in mind that the *Well of Loneliness* trial had recently concluded by banning the book as obscene, and had thus focused London literary minds on lesbianism. If a reviewer both identified Orlando as Vita and went on to draw the obvious conclusion that the book was a lesbian roman-à-clef, the Nicolsons would, like Oscar Wilde, have been forced to sue for libel, which would in turn have put paid to Harold's diplomatic career, whether they won or lost. Woolf confided to her diary (22 October 1927): 'I am writing Orlando half in a mock style very clear and plain so people will

[17] Knopp, 'If I Saw You', p. 28.

[18] Adam Parkes, 'Lesbianism, History, and Censorship: *The Well of Loneliness* and the Suppressed Randiness of Virginia Woolf's *Orlando*', *Twentieth Century Literature*, 40.4 (winter 1994), pp. 434–60, p. 447.

[19] Knopp, 'If I Saw You', p. 27.

[20] Knopp, 'If I Saw You', p. 25: she wrote to Jacques Raverat about 'My aristocrat...[who] is violently Sapphic, and contracted such a passion for a woman cousin, that they fled to the Tyrol....To tell you a secret, I want to incite my lady to elope with me next.'

[21] *The Complete Firbank* (London: Gerald Duckworth & Co., 1961), p. 541.

understand every word. But the balance between truth and fantasy must be careful.' The critical reception of *Orlando* is witness to the fact that she was sufficiently careful, even though the identification of Orlando with Vita Sackville-West was immediately made.[22]

But while the literary world was busy debating *The Well of Loneliness* and people such as Leonard Woolf's old mother expressed amazement—'I am seventy six—but until I read this book I did not know that such things went on at all'—the London popular theatre accommodated a sizeable lesbian subculture hiding in plain sight.[23] Noël Coward himself, Ivor Novello, Terence Rattigan, Somerset Maugham, and Beverley Nichols were among the highly successful male playwrights and songwriters who were gay,[24] but other playwrights of the time were lesbian. In 1930, Aimée Stuart, prominent in London's lesbian circles, had a successful play, *Nine Till Six*, put on, about women in the 'man's world' of work; and another lesbian actress/playwright, Audrey Carten, succeeded with a variety of dramas, including one called *Gay Love*, which was filmed in 1934, starring Sophie Tucker. Many of Noël Coward's closest professional associates were lesbian or bisexual women, including Teddie Gerard, Gladys Calthrop, and Beatrice Lillie.[25] Other high-profile lesbian actresses in interwar London included Gwen Ffrangcon-Davies, and 'Mickey' Jacob, who wore men's clothes and a short-back-and-sides haircut.[26] Coward's lyrics for 'Up, Girls and at 'em', in *This Year of Grace* (1928), were a broad in-joke, and the character of Madame Arcati in *Blithe Spirit* (1941) was a look back at the world he grew up in, 'a raving English sapphist of the old school'.[27] Two of the black women jazz singers who caused such a sensation in twenties London, Alberta Hunter and Edna Thomas, were lesbians. The latter took the photographer and socialite Olivia Wyndham back home to Harlem with her, and in Harlem itself a number of star singers were openly gay, most notoriously Gladys Bentley, while 'Ma' Rainey sang, 'Went out last night with a crowd of my friends, they must'a been women, 'cause I don't like no men.'[28]

[22] Raymond Mortimer, 'Virginia Woolf and Lytton Strachey', *Virginia Woolf: the Critical Heritage*, ed. Robin Majumdar and Allen McLaurin (Boston: Routledge, 1975), pp. 238–43, p. 241.

[23] *The Letters of Virginia Woolf*, ed. Nigel Nicolson and Joanne Trautmann, 6 vols (New York: Harcourt, 1975–82) III, p. 555.

[24] See Alan Sinfield, 'Private Lives/Public Theater: Noel Coward and the Politics of Homosexual Representation', *Representations*, 36 (autumn 1991), pp. 43–63.

[25] Terry Castle, *Noël Coward and Radclyffe Hall: Kindred Spirits* (New York: Columbia University Press, 1996).

[26] Jane Dunn, *Daphne Du Maurier and her Sisters* (London: William Collins, 2013), pp. 100–1, 188–91.

[27] Castle, *Noël Coward*, pp. 68, 101. She was also partly based on the playwright Clemence Dane, who was given to obsolete schoolgirl slang and apparently inadvertent double entendres. Dane herself appears to have had an unhappy emotional experience with another woman, reflected in her first novel, *Regiment of Women*.

[28] 'Prove It On Me Blues', 1928.

Figure 2 Dody Todd and Madge Garland: one of the few surviving photographs of the two women together. Photographer: unknown. © Madge Garland Archive, Royal College of Art.

Edward Burra may serve to illustrate the obtuseness of all but the best informed to this state of affairs. In 1927, aged 22, at art school, would-be sophisticated and consciously 'modern', he wrote in complete innocence, 'It still rankles not knowing what occurred at Varangeville of course says Birdie in Lesbia a friendship between women is not complete without things we wot not of, I dont suppose I wotted either.'[29] 'Birdie' was an older, married woman, the wife of the painter Henry Rushbury, and the friend to whom Burra wrote these words, Barbara Ker-Seymer, was herself a lesbian, though perhaps not yet aware of the fact. It was a couple of years later that she, and through her, Burra himself, would become part of the London upper-class lesbian scene. The Varangeville party, attended by a mutual friend, Lucy Norton, was hosted by London's most conspicuous lesbian power couple, Dody Todd and Madge Garland, respectively editor and fashion editor of British *Vogue* (see Figure 2). Burra's letter suggests that even though Todd and Garland lived together, in 1927 the nature of their relationship was still curiously invisible.

[29] Tate Gallery Archive 974.2.2.27; Burra to Barbara Ker-Seymer, 27 Aug. 1927.

The social context which permitted this state of affairs owes a good deal to the rudimentary sexual sophistication of the average Briton in the 1920s. The criminalization of 'gross indecency between female persons' was discussed in the context of the Criminal Law Amendment Bill in August 1921, on the grounds that 'this vice does exist and it saps the fundamental institutions of society', and the Commons was in favour (by 3:1), but the bill was thrown out by the House of Lords, the Earl of Malmesbury having sensibly observed that criminalization would 'increase the opportunities for blackmail without in the slightest degree decreasing the amount of vice'.[30] The enormous loss of male lives in the First World War is also relevant. For purely demographic reasons, there were many 'surplus women', widows, and spinsters who could never marry.[31] The familiarity of all-women households living together for companionship and economy camouflaged the existence of those women who would in any case have lived together by choice.

Another issue which contextualizes how lesbians were perceived in the culture at large is the vexed question of women and modernity more generally. Women, Huyssen has pointed out, are modernism's 'Other'.[32] Penny Sparke has brought into focus the pervasive, unselfconscious misogyny of modernist statements about design.[33] Modernist criticism 'consistently and obsessively genders mass culture and the masses as feminine...high culture is a privileged realm of male activity', while the masses are irrational and primitive.[34] Furthermore, because Victorian and Edwardian ladies had gone through their lives corseted and helplessly laden with frills and furbelows in order to fulfil their social duty of conspicuous consumption, the social construction of femininity was, in a modernist context, highly suspect. Feminine taste was stigmatized as false, misguided, trivial, and unduly influenced by fashion. Due to lack of proper education and intellectual rigour, women were likely to become helpless victims of commodity culture and consumerism.

It was therefore widely agreed that in order to become modern, women would have to become less feminine. Even such eminently middlebrow writers as John Buchan use 'boyish' as a term of high commendation: Buchan's short-haired, simply dressed, fresh-faced heroines hunt, fish, drive cars, hold down jobs, and are physically

[30] Rose Collis, *Colonel Barker's Monstrous Regiment* (London: Virago, 2001), pp. 66–8.

[31] Virginia Nicholson, *Singled Out* (London: Viking, 2007). Martin Pugh, *We Danced all Night: A Social History of Britain Between the Wars* (London: Vintage, 2008) has challenged the factual basis of the idea that there was an unusual number of spinsters (p. 126), but there is no doubt that people believed it at the time: on 30 June 1919 the *Daily Mail* was bewailing 'Our Surplus Girls' and, on 5 February 1920, 'A Million Women Too Many'. This therefore helped to make female households socially acceptable, whether or not the perception was justified.

[32] Andreas Huyssen, *After the Great Divide: Modernism, Mass Culture, Postmodernism* (Basingstoke: Macmillan, 1986).

[33] Penny Sparke, *As Long as It's Pink: the Sexual Politics of Taste* (London: Pandora Press, 1995).

[34] Huyssen, *After the Great Divide*, pp. 44–62, p. 47; Nigel Whiteley, 'Whitewash, Ripolin, Shop-Girls and Matière: Modernist Design and Gender', in *Modernism, Gender and Culture: a Cultural Studies Approach*, ed. Lisa Rado (London and New York: Garland, 1997), pp. 199–228.

adventurous. All of this is, of course, compatible with falling into the arms of a square-jawed tweedy hero on the penultimate page, but nonetheless it implies that a degree of androgyny had achieved wide acceptability as an ideal feminine type.

As a matter of social fact, during the First World War women, both lesbian and straight, donned uniforms, drove ambulances, motorbikes, and other vehicles, and learned to smoke, and by and large this unfeminine conduct was tolerantly regarded.[35] The lavish feminine fashions of the Edwardian era became obsolete for reasons of wartime safety and convenience: *Vanity Fair* noted in May 1917 that although the theatres were still open in Paris, women no longer wore evening dress because there were no taxis to be had, the Métro stopped running at ten, and you couldn't walk home in a hobble skirt and high heels.[36] Meanwhile, in England *The Daily Express*, seldom to be found leading the vanguard of social experiment, cooed that '[the war girl] has the grace of the athlete...and the reality and sanity of her charm fit her to be the ideal girl of today and mother of tomorrow'.[37]

By the twenties, flat-chested, short-haired girls were driving, even racing, motor-bikes, cars, planes, and yachts, and the term 'boyette' was in circulation, by which journalists meant nothing more sinister than that a girl was athletic and fun-loving. This was perfectly socially acceptable. As an American popular song of 1926 suggests, there was a fashionable conspiracy against sexual dimorphism:[38]

> Girls were girls and boys were boys when I was a tot,
> Now we don't know who's who, or even what's what!
> Knickers and trousers, baggy and wide,
> Nobody knows who's walking inside.

The song was popular in England as well as the States—the lesbian singer/comedienne Gwen Farrar was among those who performed it.[39] Incidentally, 'knickers' in twenties America were what the English called plus fours, not female undergarments. A cartoon by 'Fish', in *Vogue* in 1925, shows two towel-clad individuals in the all-male environment of a Turkish bath: one is goggling in horror at the other who, at first glance, appears to be female but is, of course, an effeminate young man.[40]

The actual avant-garde was sometimes even more positive about the implications of linking modernity with androgyny and queerness.[41] Walter Benjamin asserted

[35] Kate Summerscale, *The Queen of Whale Cay* (London: Fourth Estate, 1997), pp. 45–60.
[36] Mary E. Davis, *Ballet Russes Style: Diaghilev's Dancers and Paris Fashion* (London: Reaktion, 2010), p. 197.
[37] Doan, *Fashioning Sapphism*, p. 68.
[38] Edgar Leslie and James V. Monaco, 'Masculine Women! Feminine Men!'.
[39] Jane Dunn, *Daphne Du Maurier and her Sisters* (London: William Collins, 2013), p. 58.
[40] 'His Error', *Vogue* (late Oct. 1925), illustrated in Christopher Reed, 'Design for (Queer) Living: Sexual Identity, Performance and Décor in British *Vogue*, 1922–1926', *GLQ*, 12.3 (2006), pp. 377–403.
[41] Elisa Glick has also suggested that the queer subject is the true embodiment of modernity; 'The Dialectics of Dandyism', *Cultural Critique*, 48 (spring 2001), pp. 129–163, p. 131.

that 'the lesbian is the heroine of modernism'—by which he seems to have meant that she is androgynous, and combines masculine grandeur with feminine allure.[42] Laura Doan similarly cites the 'new woman' heroine of Olive Moore's *Spleen* (1930), outraged by her experience of wifehood and motherhood, and comments, 'What Moore fundamentally conveys is that to be modern is in effect to be a lesbian.'[43] She was not unique in this. It is hard to find an interwar woman novelist who is prepared to say a good word for motherhood, other than the ones who were upper-class enough to assume that children were dealt with by nannies.[44]

However, what most facilitated the sexual and social experiments of adventurous women in the twenties was, above all, inexplicitness. During the early twentieth century, there was no fixed vocabulary and no clear definition for female same-sex desires. Women could therefore live outside the bounds of conventional hetero-sexuality without being defined, or even self-defined, in an obvious way.[45] As long as nobody said in so many words that two women were sexually connected, their relationship did not break the placid surface of normal social convention, since it was acceptable for female friends to exhibit intense mutual fondness, share living quarters, and even share a bed.

Lesbianism, whenever it was dragged into the light, was perceived as culturally deviant, medically degenerate, and in some contexts, legally criminal—providing, however, that it was perceived at all. Thus it was readily believed that lesbians 'leave their prey gibbering, writhing, sex-sodden shadows of their former selves', but, as the 1931 novel from which this sentence is taken implies, even post-*The Well of Loneliness*, women's intimate friendships still tended to be perceived as 'innocent' unless proved guilty.[46] The mutual association of modernity and androgyny created a shadow territory in which alternatively minded women could distance themselves from traditional femininity and define this in positive ways, while successfully resisting stigmatization.

It was the prosecution of *The Well of Loneliness* in 1928 that brought an abrupt end to this public innocence. Radclyffe Hall, in her dinner jacket, monocle, and sombrero, was suddenly and painfully visible as a specimen invert, as Wilde had been in the previous generation, whereas before that moment lesbianism was not generally connected with any particular style or image. To be sure, before the trial queer women might recognize *each other* by means of tokens such as dinner jackets and

[42] Walter Benjamin, *Charles Baudelaire: a Lyric Poet in the Era of High Capitalism*, trans. Harry Zohn (London: New Left Books, 1973) p. 125.

[43] *Sapphic Modernities: Sexuality, Women and National Culture*, ed. Laura Doan and Jane Garrity (Basingstoke: Palgrave Macmillan, 2006), p. 4.

[44] The exceptions who come to mind are Nancy Mitford and Naomi Mitchison.

[45] Jasmine Rault, *Eileen Gray and the Design of Sapphic Modernity* (Aldershot: Ashgate, 2011), p. 8.

[46] G. Sheila Donisthorpe, *Loveliest of Friends!* (Paris: Boulevard Library, 1931). Note that this is post-*Well*, and was published in Paris; it was an attempt to cash in on the recent moral panic.

monocle-wearing, but this signalling was not observed by society at large.[47] After mid-1928, the Radclyffe Hall look was perceived as a display of perverted decadence, but in the years just before, though women hardly ever wore trousers in public except on the beach, an evening ensemble consisting of dinner jacket, black tie, high collar, and pencil skirt, with very short hair, was daring but elegant, and mainstream fashion. Ethel Mannin remembered that 'the most heterosexual of women appeared in severely tailored suits worn with shirts and ties', and Hall, appearing thus dressed at theatrical 'first nights' and such events, was reported in the fashion pages as a dashing example of modern feminine taste.[48]

However, in 1929, post-*Well*, James Laver's satirical insider's account of a Chelsea party in his *Love's Progress*, which came out that year, includes the following description:[49]

> One woman wore a short, divided skirt,
> A black tie and a very stiff, white shirt
> As if to show herself a thing apart,
> And tell the world she carried in her heart
> All Messalina's wild desires, or worse,
> And everything of Sappho—but her verse.

Similarly, Marjorie Firminger, one of the 'Bright Young People', published an opportunistic novel in 1931 called *Jam To-day*, about the London lesbian community, in which one woman says to another, 'I *was* looking a chap, I know, but I haven't joined the brigade.'[50] Confirming this new stigmatization of what had recently been fashionable dress, Evelyn Irons, who was a lesbian, complained: 'The minute [*The Well*] came out, if you wore a collar and tie, "Oh, you're Miss Radclyffe Hall, Miss", the truck drivers used to call on the street.'[51] A mildly ironic side effect of this new public image for 'the lesbian' was that, as had been the case with Wilde and the manlier varieties of male homosexual, it had the incidental effect of rendering the deviant sexuality of femme women such as Madge Garland, Loie Fuller, Marie Laurencin, and Elsie de Wolfe effectively invisible.[52]

[47] Doan, *Fashioning Sapphism*, p. xiv. There was a lesbian bar in Paris called 'Le Monocle'.

[48] Ethel Mannin, *Young in the Twenties: a Chapter of Autobiography* (London: Hutchinson, 1971), p. 71.

[49] James Laver, *Love's Progress* (London, 1929), p. 84, Bloomsbury: The Nonesuch Press, by permission of David Higham.

[50] Marjorie Firminger, *Jam To-day* (Paris: Vendôme/Obelisk Press, 1931), p. 11. It is worth noting that the subject was perceived as so 'daring' that this pedestrian and poorly written book was published by Jack Kahane, an avant-garde literary entrepreneur and pornographer.

[51] Doan, *Fashioning Sapphism*, p. 123.

[52] Lisa Walker, 'How to Recognise a Lesbian: the Cultural Politics of Looking Like What You Are', *Signs*, 18.4 (summer 1993), pp. 866–90. The blurred boundary between feminine identity and 'masquerade' is

British *Vogue* is very much part of the story of why this came to be the case. Twentieth-century fashion was articulated by magazines. Condé Nast created a British *Vogue* in 1916, because the parent magazine, based in New York, was becoming quite successful in Britain, but wartime restrictions on shipping made it difficult to send bulky magazines across the Atlantic. Post-war, it continued to have a semi-independent existence, with a small staff of its own. From the beginning, its recruits were surprisingly highbrow. The first editor, Elspeth Champcommunal, known as 'Champco', was married to a French artist and friendly both with the Bloomsbury set and with Nicole Groult, sister of Paul Poiret, who was herself a designer with many connections with the Paris art world, and was particularly close to Marie Laurencin.[53] Champco's staff included Dorothy Wilde, niece of Oscar, Aldous Huxley, and Raymond Mortimer, as well as an obscure young woman who had quarrelled with her parents and was determined to live alone and make her mark on the world, Madge McHarg, better remembered, ironically, by her married name, Madge Garland.[54]

When Champco quit *Vogue* to run a couture house in Paris, her position as editor was taken by Dorothy Todd, who nailed her colours to the mast in a 1925 editorial:

> *Vogue* has no intention of confining its pages merely to hats and frocks. In literature, drama, art and architecture, the same spirit of change is seen at work, and to the intelligent observer the interplay of suggestion and influence between all these things is one of the fascinations of the study of the contemporary world.[55]

Vogue was not unique in this desire for intelligent content: *Harper's Bazaar* and *Vanity Fair*, both based in Paris, also thought that smart women needed to know about fashionable ideas, and published writers such as Edmund Wilson and Jean Cocteau;[56] but *Vogue* was the first magazine based in England to publish Gertrude Stein's writing, and photographs of Cocteau's paintings and the architecture of Le Corbusier and Walter Gropius.[57] Among other commissions of the Todd era, Nancy Cunard was invited to write an occasional letter from Paris, which alerted readers to

discussed by Martha Gever, *Entertaining Lesbians: Celebrity, Sexuality and Self-Invention* (New York and London: Routledge, 2003), pp. 32–3.

[53] Guillaume Garnier, *Paul Poiret et Nicole Groult: maîtres de la mode art deco* (Paris: Musée De La Mode et Du Costume Palais Galliera, 1985), pp. 120–1. Her clients included Virginia Woolf, Dorothy Parker; the Vicomtesse Marie-Laure de Noailles, and Madge Garland. See also Douglas K. S. Hyland and Heather MacPherson, *Marie Laurencin: Artist and Muse* (Birmingham, AL: Birmingham Museum of Art, 1989), p. 66.

[54] Lisa Cohen, *All We Know: Three Lives* (New York: Farrar, Straus & Giroux, 2012), pp. 233–5.

[55] *Vogue*, early Apr. 1925, xiv; Christopher Reed, 'A *Vogue* that Does Not Speak its Name: Sexual Subculture during the Editorship of Dorothy Todd, 1922–26', *Fashion Theory*, 10.1/2 pp. 39–72, p. 47. Champco's shop on the rue Penthièvre, decorated with murals by Pedro Pruna, is described in Thérèse and Louise Bonney, *A Shopping Guide to Paris* (New York: Robert McBride & Company, 1929), pp. 31–3.

[56] Martin Green, *Children of The Sun* (London: Constable, 1977), p. 242.

[57] Cohen, *All We Know*, p. 249.

the extreme avant-garde, Dada, and surrealism, as well as to another cultural earthquake, the debut of great black performers such as Josephine Baker.[58] Even D. H. Lawrence could be tempted to review for *Vogue*.[59] Edith Sitwell was asked for essays on modern poetry and poetry by women, and reviewed Katherine Mansfield, Dorothy Richardson, and Gertrude Stein,[60] while in-house, Madge Garland was promoted to fashion editor.

This was a position of real power, since the fashion editor of *Vogue* directly influenced which dress designs would be copied. A good fashion editor was 'the pivot around which revolved the whole complicated apparatus of launching a new idea'.[61] Half a century later, Hardy Amies still remembered the exact moment when Garland encouraged him to open his own maison de couture, in 1935. Similarly, it was an article by Dody Todd in *The Architectural Review* (1932) which was the catalyst in making Marion Dorn the most influential designer of rugs for modern interiors: Todd had regularly featured her work in *Vogue* from the mid-twenties.[62] Todd and Garland were tremendous networkers and kept extremely eclectic company. When Allanah Harper took Cecil Beaton to have tea with them in 1926, they found that the company included the painter William Rothenstein, the composers William Walton and Constant Lambert, and Sacheverell Sitwell with his wife, the actress Georgia Doble.[63]

Rebecca West, looking back on the era, wrote:

> Todd was a fat little woman, full of energy, full of genius, I should say. Good editors are rarer than good writers, and she was a great editor, and Madge Garland was her equal....Together these women changed *Vogue* from just another fashion paper to being the best of fashion papers and a guide to the modern movement in the arts. They helped Roger Fry in firmly planting the Post-Impressionists in English soil and they brought us all the good news about Picasso and Matisse and Derain and Bonnard and Proust and Jean Cocteau....They also gave young writers a firmer foundation than they might have had by commissioning them to write articles on intelligent subjects at fair prices. There never was such a paper.[64]

[58] Anne Chisholm, *Nancy Cunard* (London: Sidgwick & Jackson, 1979), p. 80.

[59] Paul Fussell, *Abroad* (New York: Oxford University Press, 1980), p. 86: Lawrence reviewed Robert Byron's book on his journey to Mount Athos, *The Station* (1928).

[60] Aurelea Mahood, 'Fashioning Readers: the Avant Garde and British *Vogue*, 1920–9', *Women: A Cultural Review*, 13.1 (2002), pp. 37–47, pp. 43–6.

[61] Cohen, *All We Know*, p. 284.

[62] Christine Boydell, *The Architect of Floors: Modern Art and Marion Dorn Design* (Coggeshall and London: Schoeser and British Architectural Library, 1996), pp. 25–6, 45.

[63] Vickers, *Cecil Beaton*, p. 80.

[64] Anne Pender, ' "Modernist Madonnas": Dorothy Todd, Madge Garland and Virginia Woolf', *Women's History Review*, 16.4 (2007), pp. 519–33.

As West indicates, British *Vogue* was read by the avant-garde, and not just by the fashion-conscious. Being mass-market, it was far more influential than the little literary magazines, and it was able to pay much better, which put Todd and Garland in a position of power as both opinion-formers and patrons. On the one hand, 'they were arbiters of a new kind of taste, mixing the outré with the respectable, bohemia and "Society"';[65] on the other, it was being published in *Vogue* which launched the careers of, among others, Cecil Beaton, Syrie Maugham, and more surprisingly, Robert Byron, from whom Todd commissioned two articles on the monasteries of Mount Athos.[66]

The creative partnership of Todd and Garland also helps to explain why the assertively masculine dandy style favoured by a number of twenties lesbians went uncriticized because it was fashionable: *Vogue* had played a pivotal part in defining what was fashionable in the first place. Lovely ladies in tuxedos feature surprisingly often in its pages in the twenties, including bisexual and lesbian women such as Tallulah Bankhead, Gwen Farrar, Gwen Ffrangcon-Davies, Marda Vanne, Teddie Gerard, and indeed, Radclyffe Hall. Marie Laurencin's paintings were promoted, notably in an article by Mary Anderson, who hints broadly that 'in the new poetic world' of Marie Laurencin's imagination, 'there are slim girls, horses, dogs and birds, but never a man'.[67] Eileen Gray's design work was also covered, and Garland was instrumental in persuading Curtis Moffat to sell Gray's rugs in his London gallery.[68]

Vogue 'adored' and abhorred, telling its readers what it was chic to admire; it adored Alice Delysia's innuendo-ridden patter, found Violet Vanbrugh in a terrific melodrama screamingly funny, and found, by contrast, tragic elements in the sexually suggestive lyrics of Sophie Tucker, all of which amounted to an education in camp taste and thus helped to redefine camp as high fashion.[69] In Stella Gibbons's satire of 'loam and love child' rural novels, *Cold Comfort Farm* (1932), *Vogue* is her heroine Flora Poste's weapon of choice for transforming the lives of female cousins entrapped by biology and tradition: it is capable of convincing even mad old Aunt Ada Doom to have a nice time and not a nasty one.[70] Ultimately, Condé Nast, uneasy at the direction British *Vogue* was taking, sacked Todd and Garland, but by that time the 'amusing' style was unstoppable. Post-*Vogue*, Garland worked for a series of lesser magazines, but still went out of her way to support creative women. When she was at *Britannia and Eve*, she wrote one of the first articles on Constance Spry, materially advancing the latter's career, and in 1932, as editor of the *Bystander*,

[65] Cohen, *All We Know*, p. 247.

[66] James Knox, *Robert Byron* (London: John Murray, 2003), pp. 98–9.

[67] Reed, 'A *Vogue* that Does Not Speak its Name', p. 45.

[68] Cohen, *All We Know*, p. 283.

[69] Reed, 'A *Vogue* that Does Not Speak its Name', pp. 57–8; see also his 'Design for (Queer) Living'.

[70] Stella Gibbons, *Cold Comfort Farm*, ch. 22 (London: Penguin Classics, 2006), p. 222.

she created a well-paid job for the Irish painter Norah McGuinness, who drew fashion designs and decorations.[71]

That gay women were conspicuous in relatively traditional female fields such as writing, acting, fashion, and entertainment is not surprising, but a lesbian and/or feminist counterculture was also expressed in the traditionally male field of architecture. An interesting instance of how 'sapphic modernity' was articulated, and how it goes against the grain of canonical modernism, is the dialectic which evolved between the architect and designer Eileen Gray and the architect and painter Le Corbusier. Le Corbusier's 'A Coat of Whitewash, The Law of Ripolin' argued for a world where 'every citizen is required to replace his hangings, his damasks, his wallpapers, his stencils, with a plain white coat of ripolin. His home is made clean. There are no more dirty dark corners. Everything is shown as it is. Then comes inner cleanness.... Once you have put ripolin on your walls you will be master of yourself.' He takes it for granted, naturally, that the self-determining individual is male.

This call for scrutability is effectively a call for control, as the more extreme concept of entirely transparent buildings reveals. In Yevgeny Zamyatin's We (1921), set in a glass city of the future, the state spies on every detail of citizens' life and enforces total conformity,[72] and later in real-life East Germany, the goal of Erich Mielke, head of the Stasi, was to create a city where everyone lived 'behind glass', suggesting an unacknowledged link between Le Corbusier's call for purity and transparency and the punitive visibility of Jeremy Bentham's Panopticon.[73]

Modernist houses for women further reveal that men are the watchers, women the watched: for example, Adolf Loos, unasked, designed a house for Josephine Baker. At its centre was a swimming pool, complete with portholes for voyeurs, to which the aptest response is a comment by Baker herself: 'The white imagination sure is something when it comes to blacks.'[74] An extreme example of a panoptical dwelling which was actually built, Mies van der Rohe's post-war Farnsworth house, ignored Edith Farnsworth's wants and left her living in what was effectively a glass

[71] Cohen, All We Know, p. 274; Marianne Hartigan, 'The Commercial Design Career of Norah McGuinness', Irish Arts Review (1984–1987), 3.3 (autumn 1986), pp. 23–5, p. 24.

[72] The novel was completed in 1921, and first published in English translation by E.P. Dutton (New York, 1924). See also Detlef Martins, 'The Enticing and Threatening Face of Prehistory: Walter Benjamin and the Utopia of Glass', Assemblage, 29 (Apr., 1996), pp. 6–23, p. 10.

[73] Andrew Keen, The Internet is Not the Answer (London: Atlantic Books, 2015), p. 166. For the Panopticon, see Gertrude Himmelfarb, 'The Haunted House of Jeremy Bentham', Ideas in History: Essays Presented to Louis Gottschalk by his Former Students, ed. Richard Herr and Harold T. Parker (Durham, NC: Duke University Press, 1965), pp. 199–238, and Janet Semple, Bentham's Prison: a Study of the Panopticon Penitentiary (Oxford: Clarendon Press, 1993).

[74] Beatriz Colomina, 'The Split Wall: Domestic Voyeurism', Sexuality and Space (Princeton: Princeton University Press, 1992), pp. 73–128. Elana Shapira, 'Dressing a Celebrity: Adolf Loos's House for Josephine Baker', Studies in the Decorative Arts, 11.2 (spring–summer 2004), pp. 2–24. Baker's mot is quoted by Rose, Jazz Cleopatra, p. 81.

box, since, in van der Rohe's view, a single woman could have no private life. She complained, 'Mies talks about "free space", but his space is very fixed. I can't even put a clothes hanger in my house without considering how it affects everything from outside.'[75]

Homosexual life could not be lived like this.[76] It was lived in shadow, and needed its dark corners.[77] Terry Castle notes that, in 1930, 'shadow' was 'a common euphemism at the time for women who loved other women'. The distinguished French novelist Marguerite Yourcenar maintained a rigorous discretion about her own life, preferring to leave her relationship with Grace Frick and other women in 'the shadows that suit the essential things in life so well'.[78] Women who found themselves explicitly recognized as lesbians often found that this made life difficult or even impossible: an exotic dancer called Maud Allan was pilloried in 1918 in a muckraking article titled 'The Cult of the Clitoris' for taking the part of Salome in Oscar Wilde's play. Like Wilde before her, she had no choice but to sue, and though she was not imprisoned, it irreparably damaged her career.[79] The misfortunes of Radclyffe Hall need no rehearsing; but even in France, where lesbians on the whole found life a great deal easier, when Colette and her partner Missy, the quondam Marquise de Belboeuf, kissed on stage in 1907, they got into a good deal of trouble and the show was closed by the police.[80]

Shadows—ambiguities, contradictions, equivocation, and absence of clarity— were necessary for these women if they were to live, love, and work. Djuna Barnes's *Nightwood* (written c.1932) makes this point explicitly: at the centre of this novel is Robin Vote, ex-wife of Felix Volkbein, lover of Nora Flood and then of Jenny Petherbridge. Felix, as a Jew, and Nora and Jenny, as lesbians, are in their different ways disqualified and excluded from becoming the heroes of anything, even their own stories. They are 'night creatures, who are only allowed to wander and live in the night, sheltered by the darkness that shadows their bodies, their being, and their sexuality'.[81] 'The light in Natalie [Barney's] *pavillon*', where she entertained her

[75] Alice T. Friedman, 'Domestic Differences: Edith Farnsworth, Mies van der Rohe, and the Gendered Body', *Not at Home: the Suppression of Domesticity in Modern Art and Architecture*, ed. Christopher Reed (London: Thames & Hudson, 1996), pp. 179–92.

[76] Philip Johnson's Glass House (1949) might seem to contradict this statement; but it was built in parallel with a Brick House, windowless and enclosed: complete transparency is an illusion.

[77] Terry Castle, *The Apparitional Lesbian: Female Homosexuality and Modern Culture* (New York: Columbia Press, 1993), p. 48.

[78] Erin G. Cawston, *Thinking Fascism: Sapphic Modernism and Fascist Modernity* (Stanford: Stanford University Press, 1998), p. 81.

[79] The complex politics of this affair are disentangled by Hoare, *Oscar Wilde's Last Stand*. After Allan's disgrace, Lady Asquith subsidized her by paying her rent.

[80] Judith Thurman, *Secrets of the Flesh: a Life of Colette* (London: Bloomsbury, 1999), pp. 171–2.

[81] Monika Faltejskova, *Djuna Barnes, T. S. Eliot, and the Gender Dynamics of Modernism: Tracing Nightwood* (New York and Abingdon: Routledge, 2010).

lesbian friends, 'is always characterised as aquarium light: aquatic, shadowed and mysterious.'[82] Such people *need* shadows. Le Corbusier's call for clarification is like a policeman shining his bullseye lantern on a couple embracing at the dark end of the street.

A crusade against shadow and ornament is thus homophobic by implication, as well as imbued with profound, unexamined gender stereotyping and misogynist prejudice.[83] It is this which underlies the mutual challenge between Le Corbusier and Eileen Gray. Le Corbusier attacks the sorts of luxury materials which Eileen Gray and their contemporary Jean Michel Frank, also a homosexual, worked with, in an essay called 'The Decorative Art of Today', specifically singling out Gray's distinctive craft, lacquerwork. 'The final retreat for ostentation is in polished marbles with restless veins, paneling of rare woods as exotic to us as hummingbirds... lacquers copied from the excesses of the Mandarins... what shimmering silks, what fancy, glittering marbles, what opulent bronzes and golds! What fashionable blacks, what striking vermilions, what silver lamés from Byzantium and the Orient! Enough. Such stuff founders in a narcotic haze. Let's have done with it....It's time to crusade for whitewash and Diogenes.'[84] These vague references to drug-taking, Byzantium, and the East, tossed about with journalistic randomness, clearly signify decadence: they amount to nothing more than generalized obloquy with homophobic overtones.

The underlying, unacknowledged problem that Le Corbusier had with Eileen Gray is that both as architect and as interior decorator she offered designs for lesbian living. The Duchesse de Clermont-Tonnerre, one of the many lovers of Natalie Barney, saw 'interiors suited to our existence...and in accordance with our aspirations and feelings'.[85] Gray's architecture is an engaged, conscious critique of Le Corbusier's own architecture and design principles. She wrote, 'A house is not a machine to live in. It is the shell of man, his extension, his release, his spiritual emanation. Not only its visual harmony, but its organisation as a whole, the whole work combined together, makes it human in the most profound sense.'[86]

[82] Joan Schenkar, *Truly Wilde: the Unsettling Story of Dolly Wilde, Oscar's Niece* (London: Virago, 2000), p. 177.

[83] See David Batchelor, *Chromophobia* (London: Reaktion, 2000), Nigel Whiteley, 'Whitewash, Ripolin, Shop-Girls and Matière: Modernist Design and Gender', *Modernism, Gender and Culture: a Cultural Studies Approach*, ed. Lisa Rado (London and New York: Garland, 1997), pp. 199–228, and Penny Sparke, *As Long As It's Pink: the Sexual Politics of Taste* (London: Pandora Press, 1995).

[84] Quoted in Batchelor, *Chromophobia*.

[85] Jasmine Rault, *Eileen Gray and the Design of Sapphic Modernity* (Aldershot: Ashgate, 2011), p. 51; Charlotte Perriand, *An Art of Living*, ed. Mary McLeod (New York: Harry N. Abrams, Inc., 2003), p. 31.

[86] Peter Adam, *Eileen Gray, Architect/Designer: a Biography* (New York: Harry N. Abrams, Inc., 2000), p. 309. See also Jennifer Goff, *Eileen Gray: Her Work and Her World* (Sallins: Irish Academic Press, 2015), pp. 255–311.

One respect in which her praxis challenged that of Le Corbusier is she was far more interested in interiors than in what the place looked like from outside. She was critical of the fact that 'external architecture seems to have absorbed avant garde architects at the expense of the interior, as if a house should be conceived for the pleasure of the eye more than the well being of its inhabitants', whereas Le Corbusier declared that 'architecture is the skilful, accurate and magnificent play of masses seen in light'. It will be remembered that he initially trained as a painter.[87]

As well as defining the building, so often white-walled, as it is seen from without, light floods the actual rooms, both in Le Corbusier's writing and in his buildings. It is a principle of his that windows should be big enough to ensure that direct light will penetrate to the back wall, and his rooms are light-traps, in the interests of mental and physical hygiene.[88] Gray writes about light very differently. She advises, 'Work often with the psychology of light. Bear in mind that in our subconscious, we know that light must derive from one point—sun, fire, etc. A need deeply anchored in us. To understand this explains the morose impression which indirect light creates.'[89] Light from a point implies shadow.

What was peculiar and different about Gray's interiors was that they took issue with normally unexamined assumptions about a gendered and hierarchical use of space in the home, above all, access to personal privacy and freedom from interruption. They were designed for people who were living together as equals. Rault comments: 'Gray's elimination or merging, of gendered domestic space was unprecedented.... In 1928, a woman's claim to traditionally masculine privileges of privacy, to be out of sight and uninterrupted in domestic space, was indeed a radical statement.'[90] In the first house she built, E.1027, designed for Jean Badovici, editor of *L'Architecture Vivante*, the vestibule on to which the front door opens gives no glimpse into the interior. There is no 'study', where a privileged (male) householder can retire for uninterrupted thought, but every bed or divan is potentially a study area, with a reading light and storage space for books. Equally, there is no 'living room', a space where women sit together, interrupted by one another, children, visitors, and servants. Every room has a hidden door to the interior and a private exit on to the garden or the deck; one can slink quietly in and out, unobserved. Le Corbusier was so disturbed by the building that he metaphorically raped it, writing to Badovici that he had 'a furious desire to dirty the walls', and covering them with bright murals,

[87] Mark Wigley, *White Walls, Designer Dresses: the Fashioning of Modern Architecture* (Cambridge, MA: MIT Press, 1995), p. 212.

[88] Raymond McGrath and A. C. Frost, *Glass in Architecture and Decoration* (London: Architectural Press, 1937), pp. 154–5.

[89] Adam, *Eileen Gray*, p. 283.

[90] Rault, *Eileen Gray*, p. 101. See also Caroline Constant, 'E.1027: The Nonheroic Modernism of Eileen Gray', *Journal of the Society of Architectural Historians*, 53.3 (1994), pp. 265–79.

somewhat against his own white-Ripolin principles.[91] Gray considered this intervention vandalism, and it was her resultant quarrel with Le Corbusier that caused her to be written out of architectural history.[92]

Gray's work as architect and designer exemplifies what Alice Friedman noticed about the subtly revolutionary demands that New Women were making of their living space. One of the most unusual new domestic types sought by independent women clients was the house for a group of friends, or a female couple. These women who wanted, and could afford to commission, avant-garde architecture were almost always professionals who worked both within and outside the home. They often did not require space for formal eating and entertaining, since formal hospitality was strongly gendered.[93] They needed privacy and community, perhaps a common living area, but fully enclosed private spaces; no master bedroom, but two or more private suites of equal status: Natalie Barney and Romaine Brooks went even further when they had a country house at Beauvallon, near St-Tropez, built to their specifications in 1930: it was known as the Villa Trait d'Union (Villa Hyphen), and had two completely separate living and working quarters joined by one common room and a loggia.[94]

There were also Englishwomen who commissioned houses designed to accommodate unorthodox lifestyles. Sissinghurst is one, where husband and wife had separate bedrooms and studies, and the children were in a different building.[95] Friedman writes: 'The conviction shared by modern architects and their women clients [was] that the essence of modernity was the complete alteration of the home—its construction, materials, and interior spaces.... Not only did women commission avant-garde architects to provide them with houses in which to live out their visions of a new life, but these visions rested on a redefinition of domesticity that was fundamentally spatial and physical. A powerful fusion of feminism with the forces of change in architecture thus propelled these projects.'[96]

There is some evidence that male contemporaries were surprisingly sensitive to the expression of alternative lifestyles through interior design and architecture in the

[91] Goff, *Eileen Gray*, pp. 361–3. [92] Goff, *Eileen Gray*, pp. 362–7.
[93] Alice T. Friedman, *Women and the Making of the Modern House: a Social and Architectural History* (New Haven and London: Yale University Press, 2006), p. 18.
[94] Diana Souhami, *Natalie and Romaine: the Lives and Loves of Natalie Barney and Romaine Brooks* (London: Quercus, 2013), p. 18.
[95] Anne Scott-James, *Sissinghurst: the Making of A Garden* (London: Michael Joseph, 1983), p. 54; Bridget Elliott, '"Honoring the Work": Women Artists, Modernism and the Maison d'artiste', *Women Artists and the Decorative Arts, 1880–1835*, ed. Bridget Elliott and Janice Holland (Aldershot: Ashgate, 2002), pp. 176–96; and Bridget Elliott, 'Art Deco Hybridity, Interior Design and Sexuality between the Wars: Two Double Acts: Phyllis Barron and Dorothy Larcher/Eyre de Lanux and Evelyn Wyld', in Laura Doan and Jane Garrity, eds., *Sapphic Modernities: Sexuality, Women and National Culture* (New York: Palgrave Macmillan, 2006), pp. 109–32.
[96] Friedman, *Women and the Making of the Modern House*, p. 16.

early twentieth century. The so-called 'Cubist House' of 1912 caused a furore. Though at the distance of a century it seems timidly conventional, it was attacked as parodic and/or degenerate, essentially due to its unorthodox arrangement of public and private space: Nancy Troy points out that 'the Cubist artists involved in its creation effectively confused every gendered code that they evoked'.[97] The four roundel paintings of women's heads by Marie Laurencin which appear over long mirrors in the four corners also seem to have been oddly upsetting in context.[98] Eileen Gray's 'Bedroom/boudoir for Monte Carlo', exhibited in the fourteenth Salon des Artistes Décorateurs in 1923, similarly, though much admired in Holland, notably by the neo-baroque architect Sybold van Ravesteyn and by J. J. P. Oud,[99] was seen in France as 'decadent', or even 'maddening'; journalists and cultural commentators clearly could not put their finger on quite what was wrong with it, but instinctively perceived some alien quality in the design (see Figure 3).[100] The reviewer in *Art et Décoration* summed up, baffled: 'It is comical and it is abnormal, but it exudes an atmosphere and one cannot deny its harmony.'[101]

The problem seems to centre on the room's evident multifunctionality and, as with the Cubist House, its confused gender signals. None of its components had any kind of repeating pattern, and it used luxurious materials: zebra wood (for the bed), lacquer, thick rugs, fur, and a palette of strong colours, which included dark blue and brown, silver, grey, and red. This appears to be a room for a very well-off individual in a position to consult her own taste, a taste which did not include pastel colours, small-scale patterns or, indeed, anything conventionally 'feminine' whatsoever;[102] in fact, the sort of person who might become one of Gray's customers at the shop, Jean Desert, where she sold her lacquer screens, rugs, and furniture—women such as the cabaret singer Damia, who became Gray's lover as well as her customer, or Romaine Brooks, women who lived their lives with a certain grandeur, with an absence of fussy detail, and without men.[103]

[97] Nancy J. Troy, 'Domesticity, Decoration and Consumer Culture: Selling Art and Design in Pre-World War I France', *Not at Home: the Suppression of Domesticity in Modern Art and Architecture*, ed. Christopher Reed (London: Thames & Hudson, 1996), pp. 113–29, p. 119.

[98] Elizabeth Louise Kahn, 'Engendering a Scandal: the Cubist House and the Private Spaces of Modernity', *Modernism, Gender and Culture: a Cultural Studies Approach*, ed. Lisa Rado (London and New York: Garland, 1997), pp. 175–98.

[99] Stewart Johnson, *Eileen Gray: Designer, 1879–1976* (London: Debrett, 1979), 33–6, Adam, *Eileen Gray*, p. 138.

[100] Rault, *Eileen Gray*, pp. 30–1.

[101] Adam, *Eileen Gray*, p. 132.

[102] Eyre de Lanux and Evelyn Wyld similarly designed interiors with no concessions to conventional femininity. See Jasmine Rault, 'Losing Feelings: Elizabeth Eyre de Lanux and her Affective Archive of Sapphic Modernity', *Archives of American Art Journal*, 48.1/2 (spring 2009), pp. 56–65, p. 62, and Isabelle Anscombe, 'Expatriates in Paris: Eileen Gray, Evelyn Wyld, and Eyre de Lanux', *Apollo*, 115 (Feb. 1982), pp. 117–18.

[103] Jean Desert was run by Gabrielle Bloch, the partner of Loie Fuller. The shop stayed open until 1929, when Gray turned to architecture.

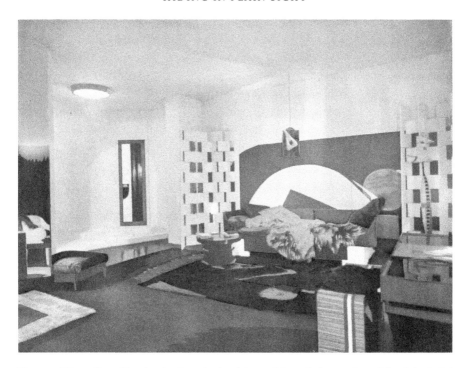

Figure 3 Eileen Gray, *Une chambre à coucher boudoir pour Monte-Carlo exposée au Salon de la Société des artistes décorateurs*, Paris, 1923. Photographer: unknown. © National Museum of Ireland.

Thus Eileen Gray and Romaine Brooks, who used the austere grey/black/white interiors of her own home as backdrops in many of her portraits, are salient examples of a gay female aesthetic which many found alarming and transgressive, partly because the spatial organization and decor of their interiors did not express conventional gendered hierarchies, and partly because they had no time for daintiness and prettiness.[104] However, a number of very successful decorators whose work was *not* perceived as countercultural were also women who lived with women.[105] Some of them raise a different set of questions about sapphic modernity, because they produced and inhabited interiors not so much feminine as femme.

One figure who looms large in this context is Marie Laurencin. Feminists have had a great deal of trouble with Laurencin's work, because it's so 'feminine'.[106]

[104] See, for example, Bridget Elliot, 'Housing the Work: Women Artists, Modernism and the Maison d'artiste: Eileen Gray, Romaine Brooks and Gluck', *Women Artists and the Decorative Arts 1880–1935: the Gender of Ornament*, ed. Bridget Elliot and Janice Helland (Aldershot: Ashgate, 2002), pp. 176–96.

[105] Peter McNeil, 'Designing Women, Gender, Sexuality and the Interior Decorator, c. 1890–1940', *Art History*, 17.4 (1994), pp. 631–57.

[106] Elizabeth Louise Kahn, *Marie Laurencin, 'une femme inadaptée' in Feminist Histories* (Aldershot: Ashgate, 2003).

Bridget Elliot, however, has noticed that criticism of Laurencin has a problematic tendency to echo traditional definitions of ornament as inessential, superficial, and morally suspect.[107] If one looks at contemporary reactions to her work, one fact which leaps to the eye is that Dody Todd and Madge Garland found her intensely interesting. Todd wrote of Marie Laurencin in 1928, 'Yet she is a feminist, probably the strangest feminist the world has ever seen';[108] while Garland made the point that Laurencin sees the world from the perspective of a daughter, an empowered young woman, the product of a self-sufficient female world.[109] Another *Vogue* writer of the Todd/Garland era, the Bloomsburyite Mary Hutchinson, writing under the pseudonym Polly Flinders, described Marie Laurencin as 'the sister of Sappho'.[110]

Laurencin's paintings were taken very seriously by contemporaries. They were handled by a major modernist dealer, Paul Rosenberg (who also represented Picasso, Braque, and Matisse), for nearly thirty years.[111] In 1932, Laurencin was featured in the French magazine *Vu* with Colette and Anna de Noailles as one of the three most famous women in France. All three were bisexual. Her softly coloured work now brings to mind fashion-plate illustrators such as Paul Iribe and George Lepape, but her contemporary André Salmon specifically warns against this connection: 'First, she is not a Cubist. Second, she is not what he names a fantaisiste, third, she is not an auxiliary for our decorative artists.'[112] Roger Allard, who published a book on Laurencin in 1921, agrees: 'M. André Salmon...has quite rightly said that her painting can be spoken of seriously, by which he means that, beneath an appearance of frothy frivolity, her art conceals a power of strange and profound seduction. Nothing could be more true.'[113] John Quinn, a major American collector, thought Marie Laurencin and Gwen John 'the two best woman painters living': these are not names which would readily be associated today.[114] Laurencin's work was more often bought by women than men, and it may be the case that displaying her paintings sometimes acted as a discreet signal of sexual preference, though it is

[107] Bridget Elliot, 'Arabesque: Marie Laurencin, Decadence and Decorative Excess', *Modernist Sexualities*, ed. Hugh Stevens and Caroline Howlett (Manchester: Manchester University Press, 2006), pp. 92–113, p. 93.

[108] Dorothy Todd, 'Exotic Canvases Suited to Modern Decoration', *Arts and Decoration*, June 1928, p. 92, cited in Elliott and Wallace, *Women Artists and Writers*, pp. 113–16.

[109] Madge Garland, 'The World of Marie Laurencin', *The Saturday Book* 23, ed. John Hadfield (London: Hutchinson, 1963), pp. 45–59.

[110] *Vogue*, late Jan. 1925, p. 40. 'Polly Flinders' is a heroine of nursery rhyme.

[111] Douglas K. S. Hyland and Heather MacPherson, *Marie Laurencin: Artist and Muse* (Birmingham, AL: Birmingham Museum of Art, 1989), p. 13.

[112] Kahn, *Marie Laurencin*, p. 49.

[113] Roger Allard, *Marie Laurencin* (Paris, Editions de la Nouvelle Revue Française, 1921), p. 9, quoted in Elliot, 'Arabesque'.

[114] Hyland and MacPherson, *Marie Laurencin*, p. 62. John Quinn (1870–1924), a second-generation Irish-American corporate lawyer in New York, was an important patron of both post-impressionism and literary modernism.

certainly the case that straight women, Helena Rubinstein among them, also went to her for portraits, because they were flattering.

Garland, rather than seeing Laurencin as a useful adjunct to the work of designers, perceives her as a powerfully influential figure; and her phrase 'For Ladies Only' is a broadish hint by this most discreet of writers:

> The world she created around her was an orderly, feminine one, in which it was difficult to imagine the male. Had she not been a great artist she could have been a very successful decorator, 'For Ladies Only'. Her influence on interior decoration was very marked in the Exposition des Arts Décoratifs of 1925, where many fabrics and wallpapers bore witness to her taste.[115]

Laurencin's colour sense was shared by André Mare, who designed the furniture for the Maison Cubiste, who exhorted his collaborators: 'Return to very fresh, very pure, very daring colours...have a vigorous and naïve drawing technique.'[116] Paul Poiret, the couturier most famous for his orientalist, post-Ballet Russe designs from the early part of the century, also helps to provide a context for the acceptability of Laurencin's decorative style, since in 1912 he founded 'Atelier Martine' as a design studio, drawing for inspiration on the work of untutored working-class girls. Martine textiles and furnishings were also characterized by pure colour and naïve decoration. One of Laurencin's closest personal friends, the couturière Nicole Groult, was Poiret's sister. The decor of Groult's shop was focused round two of Laurencin's paintings, framed in silver (see Figure 4).[117]

This context of a design tradition in which a 'feminine' style and palette is identified with Frenchness and chic obfuscated the extent to which Laurencin's work was not so much feminine as separatist. If her paintings had not been quite so winsome, it might perhaps be more obvious that, apart from the portraits, they were of Amazons, goddesses, and women entwining in twos and threes; and that a 1932 painting called 'What do young women dream about' is quite provocatively titled, given that if it answers its own question, she is saying that they dream of pools, houses, wooded landscapes, horses, and each other.

Another woman who might be seen as using the conventions of femininity to express a far from conventional personality is one of the first really famous women decorators, Elsie de Wolfe. She was born in 1865, and in 1887 she encountered a fellow New York socialite, Elizabeth Marbury, at Tuxedo Park, a luxurious country club. They became a couple: Marbury, stout and somewhat masculine in appearance,

[115] Madge Garland, 'The World of Marie Laurencin', in J. Hadfield, ed., *The Saturday Book* (London: Hutchinson, 1963), pp. 46–7.

[116] Troy, 'Domesticity, Decoration', p. 118.

[117] Thérèse and Louise Bonney, *A Shopping Guide to Paris* (New York: Robert McBride & Company, 1929), p. 42.

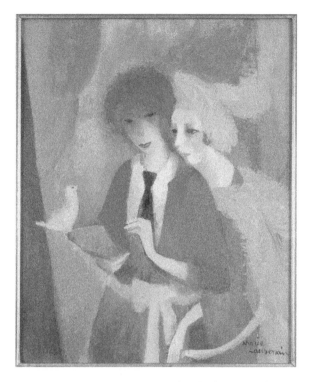

Figure 4 Marie Laurencin (1885–1956), *Femmes à la colombe*, 1919, oil on canvas, a double portrait of herself with Nicole Groult. Photographer: unknown. © Estate of Marie Laurencin. © ADAGP, Paris and DACS, London 2015.

de Wolfe slim, fluttering, and decorative. Marbury's interests were theatrical and, like de Wolfe, she was in the process of mapping out the parameters of a new profession, that of an agent. She represented a variety of major European and British writers, including Wilde and George Bernard Shaw, and secured American rights for them.[118] Though Marbury and de Wolfe were treated as a couple by contemporaries, a third wealthy New Yorker was very close to both women: Anne Tracy Morgan, daughter of the financier John Pierpont Morgan.

Marbury and de Wolfe bought the Villa Trianon, near Versailles, in 1903, and the three ladies spent the summers there until the First World War split them up. Marbury and Morgan went back to America, where Marbury remained, while de Wolfe showed another aspect of her essential steeliness by caring for burn victims under appalling conditions, and earning the Croix de Guerre and Legion of Honour. De Wolfe had a very strong feeling for the Villa Trianon, and returned to it after the war, having bought out Marbury's investment in the property and saying of the

[118] Philip Core, *The Original Eye: Arbiters of Twentieth Century Taste* (London: Quartet Books, 1984), pp. 49, 53.

initial acquisition, 'The house, unlived in as it had been for decades, spoke to us with regret and resignation of the passing of an old grandeur. For it had belonged to the Duc de Nemours, the son of Louis Philippe. And the outbuildings had been part of the *hameau* of Marie Antoinette.'

It may be relevant that Marie Antoinette was a major figure in the lesbian iconography of the early twentieth century, due to the stories of her passionate friendships with the Princesse de Lamballe and the Comtesse de Polignac which circulated during the French Revolution.[119] It may also be relevant that the idea of the Trianon is of a fantasy building, a space for self-fashioning and fancy dress, where the French queen acted out her notorious dream of pastoralism.

In 1905, de Wolfe decided to become a decorator. The first public design work of hers to attract attention was the Colony Club in New York (1907), founded by a group of powerful New York women, Anne Morgan and Elizabeth Marbury among them, as the city's first women-only club: a private space in public for the wealthy and privileged. Rather than imitating the dark leather and Victorian opulence which characterized men's clubs, she used so much glazed chintz that she became known as 'the Chintz Lady', and a much lighter, brighter, softer colour scheme. The club's tiled floors, muslin curtains, white paint, pale walls, and rooms decorated with trellis had a strongly eighteenth-century feeling, perhaps suggested by the lavish use of treillage in the gardens at Versailles, which were, of course, deeply familiar to her.

The decor and garden of de Wolfe's own Villa Trianon were updated eighteenth-century, respecting the character of the house. In 1931 she bought a flat in Paris on the avenue d'Iéna which was treated more experimentally and centred on a mirrored bathroom with painted reflecting glass, low coffee tables, a zebra-hide-upholstered divan, and a fantasy bath with swan's-head taps. Photographs suggest there were also eighteenth-century gilded furniture and Venetian blackamoors.[120] This was also, perhaps, an updating of the protocols of the eighteenth-century French court and the royal levee as practised by Louis XIV—though de Wolfe did not, as far as history records, actually receive in her bath.

Penny Sparke remarks on de Wolfe's 'softer, overtly feminine domestic aesthetic characterised by chintz and pale colours, old rose, grey, ivory and pale blue'—the colours of Marie Laurencin's paintings.[121] 'Overtly feminine' is a term which bears investigation, since it borders on an oxymoron. The result was rooms which, though they did not mount a direct challenge to normal social expectations, were spaces in which men might not feel particularly comfortable and might indeed feel out of place, indirectly a persuasion to move on.

De Wolfe's influence on interior design was enormous. In all kinds of ways, she got there first: apart from pale rooms with an eighteenth-century feel, and the use of

[119] Castle, *Noël Coward*, p. 46. [120] Core, *The Original Eye*, p. 60.
[121] Penny Sparke, *As Long As It's Pink: the Sexual Politics of Taste* (London: Pandora Press, 1995), p. 148.

chintz, muslin, and trellis, it was also she who pioneered the use of mirrored walls, leopard skin, cowhide, and zebra, as well as black-and-white. She had a head start, since, though she gave a spirited impression of agelessness in later life, she was, after all, born in 1865, and the Trianon adventure had begun in 1903. Her relationship with Marbury gave her many ramifying connections among the immensely wealthy of both genders on both sides of the Atlantic, and useful connections with the world of the theatre. The women remained friendly after they had gone their separate ways. When Cecil Beaton arrived in New York for the first time in 1927 and called on Marbury, clutching a letter of introduction from Osbert Sitwell, he found that de Wolfe was of the party.[122] After the First World War, Syrie Maugham, a divorcee in need of a career, looked at de Wolfe's work and learned from it; and indeed, with her love of white, antique furniture subordinated to modern rooms, and mirrors, in many ways she followed where de Wolfe had led. Syrie Maugham was fifteen years younger, and her professional life began only in 1922.

Though it is anything but 'decadent', de Wolfe's white paint, muslin, and chintz expressed an aesthetic so feminine that it had in fact ceased to express heterosexuality. But, since it was the style embraced by Radclyffe Hall which had been publically identified as 'abnormal', to contemporaries there was nothing apparently queer about it. In fact, just as much as the more obviously transgressive decor of Eileen Gray, a room by Elsie de Wolfe was an environment in which a woman could display herself and live on her own aesthetic terms. Every woman's room, she declared, should include some kind of table or desk to write at: social correspondence, perhaps—or perhaps not. De Wolfe's own take on the sexual politics of design is uncompromising: 'It is the personality of the mistress that the home expresses,' she said. 'Men are forever guests in our homes, no matter how much happiness they may find there.'

This is a far more radical statement than it seems, especially from a woman born in 1865. Until the twentieth century, women did *not* control their domestic environment. In the nineteenth century, at the levels of society where choice could be exercised in any effective sense, a firm was hired to decorate the house when a man decided to marry, and the bride was installed in a new home which was not, in the sense which de Wolfe asserts, an expression of her own personality at all.[123] Because fin-de-siècle aesthetes such as Wilde, Rossetti, and Morris thought decor was important, they took charge of it themselves.[124] Ironically, claiming the domestic environment as an arena for female self-expression starts off as a feminist idea.[125] In

[122] Hugo Vickers, *Cecil Beaton: the Authorised Biography* (London: Weidenfeld & Nicolson, 1985), p. 110.

[123] Pauline Metcalf, *Syrie Maugham* (New York: Acanthus Press, 2010), p. 18.

[124] Victoria Rosner, *Modernism and the Architecture of Private Life* (New York: Columbia University Press, 2005), p. 26.

[125] Metcalf, *Syrie Maugham*, p. 23.

The House in Good Taste, de Wolfe rewrites history with aplomb. She asserts that the art of interior decoration has an entirely female history, beginning with Isabella d'Este in 1496. The next decorator worth mentioning is the Marquise de Rambouillet. Then comes Madame de Pompadour, and 'the modern woman', in effect, herself. Typically, she does not acknowledge Edith Wharton's pioneering work, *The Decoration of Houses* (published in 1897), which has much in common with her own.[126] More insidiously than the startling rooms of the lesbian avant-garde, de Wolfe's design work took for granted women's control over the environment they lived in. Decorative schemes in this tradition were often made by independent women—*Vogue* pronounced in 1921 that 'a woman is either happily married or an Interior Decorator'—and they were frequently made for female clients. This will be revisited in chapter 8.

As the years went by, de Wolfe herself, having made a great deal of money, became (apparently) younger and younger, thinner and thinner, and terrifyingly chic, exquisitely coiffed and made up, and dressed by Mainbocher, an American whom she sponsored, Chanel, and Schiaparelli. Like Madge Garland, who eventually became Lady Ashton, ditched the husband, but kept the title, she married a well-connected English diplomat, the press attaché in Paris, late in life, and subsequently insisted on being known as Lady Mendl. This union was not based on sexual attraction: years later, Mendl told a friend, 'For all I know, the old girl is still a virgin.' But it may have been a meeting of true minds, and it was certainly a highly judicious amalgamation of address books.

She took up the higher body culture as she got older, and was notorious for showing off her surprising lissomeness by doing gymnastics in public, tastefully garbed *pour le sport*, as Noël Coward observed:

> We talked about growing old gracefully
> And Elsie, who's seventy-four,
> Said, 'A, it's a question of being sincere,
> And B, if you're supple you've nothing to fear.'
> Then she swung upside down from a glass chandelier,
> I couldn't have liked it more.[127]

[126] Elsie de Wolfe, *The House in Good Taste* (New York: The Century Co., 1913), pp. 9–11.

[127] She also features in Cole Porter's 'Anything Goes': 'When you hear that Lady Mendl standing up | Now turns a handspring landing up- | On her toes, | Anything goes.'

3

Sitwell Style

F. R. Leavis famously pronounced in *New Bearings in English Poetry* that 'the Sitwells belong to the history of publicity, rather than that of poetry'. Major differences of temperament and philosophy prevented him from seeing any point to the Sitwells. Whether in poetry, prose or *arredamento*, theirs was a baroque aesthetic, polysemic, playing with contexts, surface decoration, extravagance, and wit. Leavis's grand project was to slice away at the exuberant mass of writing in English so as to leave only a thin, bony core of masterpieces. In retrospect, this now seems an even more curious enterprise than that of the Sitwells, since, unlike Greek or Latin, English has never defined the language of a privileged century as 'classical'.

Viewed from the perspective of a contemporary publicist, the Sitwells were major figures (see Figure 5). In 1924 *Vogue*, which probably means Dody Todd and/or Madge Garland, who were friendly with all three Sitwells, nominated them for its 'Hall of Fame', for an interesting collection of reasons:

> Because they have created a new style in prose, poetry and decoration: because of their intense interest in all the arts: because they are the children of Sir George Sitwell and Lady Ida Sitwell: because they are all great travellers: because they have all written poems: because in addition to this Mr Osbert Sitwell has stood for Parliament, written satires, and is about to publish a book of short stories: because Miss Sitwell edited 'Wheels' and has just published a new poem, 'The Sleeping Beauty'. Because Mr Sacheverell Sitwell's book on Southern Art has had the most appreciative reviews of any book published this year: because of their witty contributions to 'Who's Who': because of their production of 'Façade' at the Aeolian Hall last year: because they have been caricatured by Max Beerbohm: because they are serious artists who know how to be amusing: because they are such admirable hosts and have such an interesting collection of pictures.[1]

The history of publicity is not as unimportant as Leavis thought. 'I do feel your actual presence in England would help the cause. It is quite undoubted that a personality does convince half-intelligent people,' Edith wrote to Gertrude Stein in

[1] Anonymous, 'We Nominate for the Hall of Fame', *Vogue* (late May 1924), p. 49.

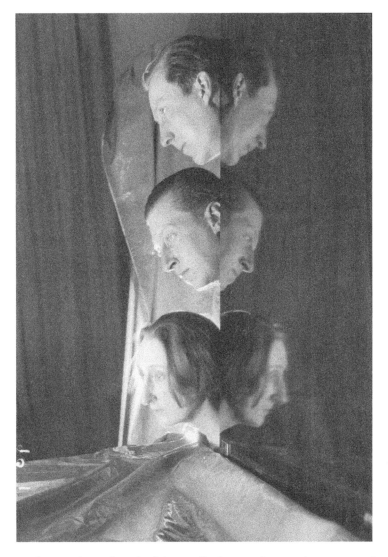

Figure 5 Osbert, Sacheverell, and Edith Sitwell. Photographer: Cecil Beaton. © The Cecil Beaton Studio Archive at Sotheby's.

1925, trying to persuade her to come to England. She was right, of course, and in this instance ultimately successful.[2] Promotion was as essential to canonical literary modernists as it was to the Sitwells.[3] The Sitwells' determination to insert

[2] Glendinning, *A Unicorn*, p. 116.
[3] Aaron Jaffe, *Modernism and the Culture of Celebrity* (Cambridge: Cambridge University Press, 2005), pp. 3–6.

themselves into a central position in the world of the arts was combined with serious attention to building up the reputations of their protégés; Wyndham Lewis and Pound had done much the same.[4]

When it came to promoting causes and individuals, all three Sitwells were extremely active. Osbert and Sacheverell helped to organize one of the first exhibitions of modern art in England, at Heal's in 1919, and adopted William Walton as a protégé. Edith, for her part, started *Wheels* with Nancy Cunard, which has, among its credits, bringing Wilfred Owen to public notice.[5] Aldous Huxley wrote of a party after a poetry reading at the house of Lady Colefax which included the then little-known T. S. Eliot: 'The best part of the affair was dinner at the Sitwells' afterwards, when...we all got tight to just the right extent.'[6] They also kept at it, decade after decade. Bryher, no mean supporter of the arts herself, paid tribute more than a quarter of a century later:

> During the war when writers were considered 'useless mouths', Osbert and Edith had fought to keep a skeleton of the arts alive. They gave parties to help the strays among us, they assisted those who were suffering not only from lack of funds but extreme isolation, and though they did not agree with their views, they did their best to keep conscientious objectors out of prison.[7]

It was assumed by avant-gardists that well-off aristocrats could never be artists; their role was necessarily to support impecunious genius. All three Sitwells were mindful of this aspect of the social contract. The list of those materially helped by support from the Sitwells is long and surprising: apart from Walton, Diaghilev, Rex Whistler, Pavel Tchelitchew and Cecil Beaton, it includes John Piper, Dylan Thomas, José Garcia Villa, and Tom Driberg. Much of this assistance consisted of publicity, or free gifts of their time—letter-writing, party-giving—but some of it was straightforward financial support. Edith's finances were precarious in the extreme, but among her papers are many letters from writers still poorer who had been sent a small cheque to cover some difficulty.[8]

Osbert and Sacheverell are important to the history of English music, most notably because of their support of William Walton, but they were more than just patrons. Walton's first major success was his setting of Edith's *Façade*, and in 1931 he wrote the oratorio *Belshazzar's Feast* to a libretto composed by Osbert from the Old Testament. Constant Lambert set Sacheverell's poem *The Rio Grande*, from a poetry collection called *The Thirteenth Caesar*, in 1929: like *Belshazzar's Feast*, the work was

[4] Victoria Glendinning, *A Unicorn among Lions* (London: Weidenfeld & Nicolson, 1981), p. 52.
[5] Glendinning, *A Unicorn*, p. 61. [6] Glendinning, *A Unicorn*, pp. 54, 56.
[7] Bryher, *The Days of Mars*, quoted in Glendinning, *A Unicorn*, p. 240.
[8] Glendinning, *A Unicorn*, p. 297.

popular, and frequently revived. The brothers were also personally friendly with Lord Berners, with whom they collaborated, and 'Peter Warlock' (Philip Heseltine).

Osbert was also among the relatively few modernists who discovered the Ballets Russes before World War I.[9] Before the war, artists and intellectuals considered ballet and opera to be old-fashioned, aesthetically bankrupt art forms; rich men's toys. They do need a lot of money, and Diaghilev needed to persuade the wealthy of the importance of his enterprise, since he had to maintain a small army of performers without the imperial sponsorship which had allowed their art to flourish in tsarist Russia. When he came to London, he exercised his formidable charm successfully on wealthy socialites, but he also needed to reach opinion-formers. Lady Ripon, Lady Cunard, Lord Rothermere, and Lady Ottoline Morrell all played a part in publicizing the Ballets Russes, but it was the Sitwell brothers above all who engineered the Russian ballet's contact with advanced English taste.

> Osbert invited Diaghilev and two of his principal dancers, Massine and Lydia Lopo-kova, to Swan Walk.... The night of the party happened to coincide with the Armistice celebrations.... [Virginia Woolf] came, bringing with her Roger Fry, her sister Vanessa, and Maynard Keynes. This constellation of coincidences had consequences for Keynes who, meeting Lopokova for the first time with the Sitwells, fell in love with her, and later married her. And the Sitwells, in their happy position as hosts to the stars, took on Bloomsbury from a position of strength.[10]

Virginia Woolf made an ingenuous diary note that evening: 'It's strange how whole groups of people suddenly swim complete into one's life.'[11]

While both Osbert and Sacheverell were among those who paved the way for Diaghilev's tremendous impact on the interwar arts in England, they also became sufficiently convinced about ballet as an art form to involve themselves in the emergence of a native British ballet. Constant Lambert persuaded Osbert that Frederick Ashton was worth his attention, and the choreographer, then at the beginning of his career, was taken up as a Sitwell protégé.[12] The first direct result of this was Ashton's successful ballet based on *Façade*.

Sacheverell was principal devisor of a ballet for Diaghilev, *The Triumph of Neptune*, inspired by nineteenth-century English pantomime, which was choreographed by George Balanchine to music by Lord Berners, and premiered on 3 December 1926 at the Lyceum. Constant Lambert's setting of Sacheverell's poem *Rio Grande* also became the basis of a ballet in 1931, choreographed by Ashton. Five years later, Osbert himself devised a short ballet called *The First Shoot*, staged in Cochran's 1936

[9] John Lehmann, *A Nest of Tigers* (London: Macmillan, 1968), p. 50.
[10] Glendinning, *A Unicorn among Lions*, p. 52. [11] Lehmann, *A Nest of Tigers*, p. 50.
[12] Julie Kavanagh, *Secret Muses: the Life of Frederick Ashton* (London: Faber & Faber, 1996), p. 128.

revue, *Follow the Sun*, with music by William Walton, designs by Cecil Beaton, and choreography by, once more, Frederick Ashton.

Sitwell style embraced the English vernacular baroque of theatre prints. They were the first aesthetes since Robert Louis Stevenson to observe their charm. For *The Triumph of Neptune*, Sacheverell devised a set and costumes based on toy-theatre decor, realized by Diaghilev's immensely competent scene painter, Prince Aleksandr Shervashidze, and the costume designer Pedro Pruna.[13] With their use of scaled-up cross-hatching, they prefigure David Hockney's famous designs for the *Rake's Progress*. Edith's liking for Victorian 'penny plain, tuppence coloured' theatre prints is evidenced in *Façade*, notably in 'Polka', where 'Mr Wagg like a bear' is based on one, 'Mr Pitt as Charley Wag', produced in connection with a melodrama of 1860 which starred an anti-hero of the 'penny dreadfuls', a burglar and murderer. In the print, he is shown firing off his pistol, wearing magnificent side whiskers, top hat, and a coat of brightest blue gouache. The poem also refers to English heroes such as Wellington and Byron, who also featured in this naïve art. A version of the poem was printed in *Vogue* in 1926.[14]

Though their influence on English ballet is not negligible, Osbert and Sacheverell were even more important as champions and patrons of modern art. Both had a discriminating eye for modern painting, and there were furious jousts between the brothers and their father throughout the twenties, as they tried to persuade him to stump up for art he neither liked nor approved of. Apart from themselves buying paintings by living artists such as Modigliani, Juan Gris, William Roberts, Wyndham Lewis, and de Chirico, in the summer of 1919, the brothers organized an exhibition of modern French painting—Picasso, Modigliani, Vlaminck, Soutine, Suzanne Valadon, Léger, Utrillo, Derain, and Dufy—at the Mansard Gallery in Heal's. It was London's first sighting of what the French had been up to since the outbreak of war in 1914, and caused a furore. That spring, Sacheverell had been in Paris, where he visited the poverty-stricken Modigliani, and bought two full-length oil paintings at £4 each and some drawings at £1. When Modigliani died in 1920, his dealer and friend Leopold Zborowski offered Sacheverell the entire contents of the studio for £100, but Sacheverell could not persuade his father to lend him the money, a lost opportunity on which he was inclined to brood when he was hard up later in life.[15]

An even greater missed opportunity shows the scale of the Sitwells' ambition as patrons. During the same visit to Paris of 1919, Sacheverell and Osbert, who had met and admired Picasso, came up with a plan that the painter should fresco the *gran sala* at the Italian castello their father had bought in 1909, Montegufoni. Picasso, who had recently married a Ballets Russes dancer intent on dragging him into the haut

[13] Richard Buckle, *Diaghilev* (London: Hamish Hamilton, 1984), p. 478.

[14] British *Vogue* (late Apr. 1926), p. 50.

[15] Sarah Bradford, *Splendours and Miseries* (London: Sinclair-Stevenson, 1993), p. 91.

monde and was keen to earn money, was not unwilling. 'In the autumn we saw Picasso in Paris and talked over the project. There were to be painted balconies over the doors, with Italian musicians, and big painted landscapes in the style, I hoped, of Benozzo Gozzoli.'[16] Quite how the Sitwells hoped for murals which would evoke fifteenth-century Florentine painting from Picasso of all people is far from clear, but the results would certainly have been interesting, and would rapidly have become extremely valuable. The brothers' chance of sponsoring a major work of art appears to have been fumbled in a Sitwellian comedy of errors.

According to Osbert, who is not reliable on the subject of his father, Sir George obstinately refused to commission murals from Picasso because, ironically, he did not think the work would hold its value. His sons returned to the attack, and tried to persuade him to commission an alternative painter, the Italian Gino Severini, whom they were championing—Severini had a considerable reputation among contemporaries. Some time passed, then Sir George suddenly said, 'What sort of work does Mancini do?', to which Osbert replied, accurately but misleadingly, 'Sargent has always admired Mancini's paintings tremendously.' Sir George, who had himself commissioned a group portrait from John Singer Sargent, was thereupon satisfied that he would receive value for money. Unfortunately, he had confused Severini with Antonio Mancini (1852–1930), an Italian Impressionist and personal friend of Sargent's. Since he could never admit to having made a mistake, when Severini turned up and started work, nothing more was said.[17] It is, of course, equally possible that the story is a fiction, designed to offset the fact that this was a commission with frankly unimpressive results.

Sir George, or 'Ginger' as the younger Sitwells called him after he grew a reddish beard in later life, was an extremely difficult parent, intelligent, but solipsistic to the point almost of insanity. He had nothing whatever in common with his spoiled, beautiful wife, who disintegrated in a miasma of gin and self-pity. Loathing one or both parents was something of a period affectation, practised by, among others, the Mitfords, John Betjeman, and Nancy Cunard. Madge Garland said of the twenties, 'The mass of people went on doing the same thing, but the few of us that didn't, we absolutely rejected everything our parents had and that our parents stood for.'[18] Thus Nancy Mitford's heroine in an early novel, *Highland Fling* (1930), 'always spoke of them [her parents] as though they were aged half-wits with criminal tendencies, whose one wish was to render her life miserable'. The Sitwells evidently meant it, and Osbert's accounts of 'Ginger'-baiting do not make attractive reading. Quite apart from the fact that he kept all three of his offspring, in the financial sense, throughout their adult lives, their intelligence, the use they made of it, and even their taste, have a

[16] Bradford, *Splendours and Miseries*, p. 91.
[17] Osbert Sitwell, *The Scarlet Tree* (London: Macmillan, 1946), p. 52.
[18] Lisa Cohen, *All We Know* (New York: Farrar, Straus & Giroux, 2012).

great deal in common with those of their father, to an extent which is uncharacteristic of their generation.

One of the Sitwells' major grievances against their exasperating parent was that he spent money extravagantly on the art he liked himself: it would have been far more appropriate, in their view, to give it to them to lay out judiciously on modern painting. 'That old beast of a father of mine has just paid £600 for a fake Italian picture. I can't tell you what I feel about him,' Edith exploded. 'When I think of an artist like Pavlik [Pavel Tchelitchew], and then see that old horror of mine throwing money away like that! Of course he hates anything real, or new.'[19] In terms of sheer monetary value, Osbert and Sacheverell, at least, had cause to be irritated, though Sir George's old master was probably a better bet than anything by Pavlik: if the brothers had been in a position to back their hunches in the twenties, Sacheverell's granddaughter would be the happy inheritor of a fabulously valuable collection of modernist art, mostly French.

But at nearly a century's distance from the scratchy, incessant feuding between father and sons, it is the common ground which seems obvious. As represented by his children, Sir George was a monstrous egotist, cold-hearted and self-willed. Much the same could be said of Osbert. And it was Sir George who had fallen in love with a gaunt Italian castello which possessed a grotto room with statues in niches, a scagliola marble floor, and elaborate silvered plasterwork, culminating in a frame of silver shells around the richly coloured painted ceiling—not very well painted, to be sure, but with the rich blues and russet-umbers of Titian and Veronese. Nothing could have been more to Osbert's and Sacheverell's taste.

In dismissing the Sitwells, Leavis also overlooked Sacheverell's genuine import- ance as a critic. Two of his early books were profoundly influential on the visual arts in England. The first is *Southern Baroque Art* (1924), the second *German Baroque Art* (1928). Both treat the specific qualities of a visual culture which English aesthetes united in scorning, but in Osbert Lancaster's account of Oxford in the twenties he observes that *Southern Baroque Art* was one of the books everyone he knew had read, along with *The Waste Land*, *Si le grain ne meurt*, Robert Graves's war memoir *Goodbye to All That*, and the writings of Wyndham Lewis.[20] Beverley Nichols, another barom- eter of the zeitgeist, gives the hero of his *Crazy Pavements* (1927), intended as a 'modern young man', a library of nine books, of which *Southern Baroque Art* is one.[21]

[19] Edith Sitwell to Stella Bowen, 12 Apr. 1929, *The Letters of Edith Sitwell*, ed. Richard Greene (London: Virago, 1997), p. 103.

[20] Osbert Lancaster, *With an Eye to the Future* (London: John Murray, 1968), p. 86.

[21] *Crazy Pavements* (London: Jonathan Cape, 1927), p. 229. The rest of the library consists of *Cranford* and *Barchester Towers* (to indicate the hero's fundamental soundness of heart), Saki's *Beasts and Superbeasts*, Theodore Dreiser's *The Financier*, and a variety of French works—the symbolist poet Henri de Regnier, plays by François de Croisset and Pirandello, and a racy novel by Clement Vautel, *Madame ne Veut pas d'Enfant*.

The Sitwells' taste was developed by their travels, unusually extensive for English people of their generation, which began early under their father's auspices. In 1904, the 7-year-old Sacheverell was taken abroad for the first time, to San Remo on the Ligurian coast. There were other family holidays at San Remo, and in 1909 both sons joined their father in Venice. When Sacheverell wrote of 'the blue skies and sunny architecture that I had discovered for myself', he forgot, or did not care to acknowledge, that it was his father who first took him there.[22] After the First World War, the brothers travelled together, and it was with Osbert that Sacheverell made the expeditions to Naples and Sicily which prompted *Southern Baroque Art*.[23]

The book is important because, in the twenties, very few people had seen what Sacheverell saw—literally, since few went to southern Italy or Germany for their visual culture, or metaphorically, in terms of what he appreciated. Previous books had covered similar territory, such as Martin S. Briggs's *In the Heel of Italy* (1910) and Vernon Lee's *Studies of the Eighteenth Century in Italy* (1880), but they had not thereby changed English suspicion of the baroque. Briggs assumes that even the word is unfamiliar, and gives it a footnote: '"Baroque" (Fr.) = irregular, uncouth, strange'. He goes on to explain the concept in a way which reveals why Sacheverell's work came as a culture shock: 'This period of Italian architecture is known as baroque, from its prevailing tendency to be overflorid, regardless of accepted canons, even to the point of ugliness.'[24] Sacheverell, by contrast, wrote about beauty and strangeness, without a hint of apology. 'In a single volume the whole was changed,' wrote Kenneth Clark, looking back. '*Southern Baroque Art* created a revolution in the history of English taste.'[25]

The immense success of the book is partly due to the fact that it opens up an unfamiliar world, but also to the idiosyncrasy of Sacheverell's treatment. He was intensely responsive to architectural effects, pictures, and decorative schemes, but he was not an art historian, a discipline he could have pursued in Germany but not in Britain when he was of undergraduate age, and his historical knowledge was sketchy. He had worked reasonably hard at Eton, and came second in the competition for its Rosebery history prize in 1915, but he left Oxford after a year, finding it dull. In any case, Oxford in the 1920s was a place where education was possible rather than obligatory. In *Southern Baroque Art*, he presents the art of seventeenth- and eighteenth-century southern Italy and the Spanish world, with enormous verve and persuasiveness, in terms of its effect on himself, as preposterous, melancholy, grotesque, and splendid. He invites the reader to enjoy an art which conventional criticism treated as unbalanced and hysterical, by going along with it in a spirit of playfulness, as one might in participating in make-believe with a child; treating it, in fact, as 'amusing'.

[22] Bradford, *Splendours and Miseries*, p. 36. [23] Bradford, *Splendours and Miseries*, p. 106.
[24] *In the Heel of Italy*, pp. 15, 16. [25] Bradford, *Splendours and Miseries*, p. 124.

His technique has a considerable amount in common with Edith's verse, as do some of his actual ideas; the 'rough rude sun' in his 'Nightingale' chapter embodies the same perception as the 'rough satyr Sun' in Edith's 'Country Dance', one of her *Façade* poems (1922). Description segues imperceptibly into fantasy. Similes flow into one another and take on a surreal life of their own: 'The trees seemed to wind up again like springs: they were spinning once more like tops along each side of the avenue.'[26] Metaphors riot out of control: a king descending a grand staircase surrounded by his entourage is likened to getting an iceberg over Niagara, and for the rest of that page the king remains an iceberg, the ceremonial route, a river. *Southern Baroque Art* tells the reader almost nothing about the art, and most certainly nothing about its cultural context or its original meaning. The focus is on Sacheverell's subjective chains of association, which flow like arabesques, one fantastic scroll emerging from another. Synaesthesia is his principal weapon; music may be described in terms of architecture, or vice versa, and the lush effect is, depending on taste, either unreadable or a unique variety of prose poetry.

His approach is, in fact, fundamentally camp, as Fabio Cleto defines it: 'Camp is a style—of objects, or of the way objects are perceived, favouring exaggeration, artifice, and extremity. It exists in tension with popular or consumerist culture. The person who recognises camp is outside the cultural mainstream,' which certainly applies to Sacheverell.[27] Susan Sontag's writings on camp are also relevant to Sacheverell's treatment of southern baroque art. 'Camp art is often decorative with emphasis on texture, sensuous surface and style at the expense of content,' she writes, and also comments on 'a love of the exaggerated, the "off", of things being what they are not'.[28] Thus, although Sacheverell was heterosexual, he expresses a sensibility more common in gay writers. However, the immense success of his work in Oxford and arty circles has to do with its aristocratic flavour as well as with the fact that many Oxonian aesthetes were homosexual. Camp appreciation of painters such as Luca Giordano combines shocking the bourgeoisie with shocking the literal-minded, including the doctrinaire modernists with their passion for flat surfaces and white Ripolin. The persuasiveness of Sacheverell's vision is demonstrated by Christopher Isherwood, who simply assumes that baroque *is* camp: 'High Camp is the whole emotional world of the Ballet, for example, and of course of Baroque art.'[29] Another feature which Sacheverell's writing has in common with camp, as Sontag defines it, is that it is apolitical.

[26] Sacheverell Sitwell, *Southern Baroque Art*, p. 94.

[27] Fabio Cleto (ed.), *Camp: Queer Aesthetics and the Performing Subject* (Edinburgh: Edinburgh University Press, 1999), p. 11.

[28] Susan Sontag, 'Notes on Camp', in Cleto, *Camp*, pp. 53–65, pp. 53, 56.

[29] Christopher Isherwood, 'The World in the Evening', in Cleto (ed.), *Camp*, p. 51.

German Baroque Art continues the grand narrative, though the book is more factually based and more extensively researched than its predecessor. In the court architecture of eighteenth-century Germany, Sacheverell argued, 'The imaginative possibilities of architecture have been developed into a really suitable setting for that mixture of fabulous elegance and bucolic coarseness from which the German Eighteenth Century was composed...the high clipped hedges, the staircases that moved with cascades as though part of their machinery, the lacquered, mirrored, or tapestried walls of rooms, all these things show certain of the human senses carried to their highest pitch of perfection and then strengthened and made more subtle by the illusion of the theatre.'[30]

Specifically, he observed the queerness of Frederick the Great's palace buildings at Potsdam: 'The boiseried rooms decorated in silver are quite inconceivable in their loveliness; many of the doors have a wave-like, waterfall treatment which is again echoed in some of the wall-panels in two shades of gold, or with a greenish silver that gives variety to that more conventional shade of moonlight....Pictures by Watteau can surely have never found a more congenial environment.'[31] In the prince-bishops' palace at Würzburg, apart from the amazing Tiepolo ceiling over the grand staircase, he took particular note of 'a most beautiful mirror-room in green lacquer with a stuccoed and gilded ceiling'.[32]

However, it is Venice, not the Spain of El Greco, the art of Bourbon Naples, or South German churches, that is at the heart of Sacheverell's reactions to the baroque. In a book about something else entirely, he produces a passionate manifesto of the impact of eighteenth-century Venice on his personal taste:

> At the time of which I am speaking [*c*.1920] I could think of nothing else but the paintings of Tiepolo....But, as well, I was entranced by the beaked and masked figures of the Venetian carnival, in the baüta of black silk or gauze, over which they wore the white mask or volto, as seen in in Guardi's paintings....Venetian painted and lacquered furniture was my obsession, and the stuccoed walls and inlaid marble floors of the little casinos or private gambling dens.[33]

While the Sitwells might be pejoratively considered 'decorators' in terms of their literary production, their relevance to interwar baroque also lies in their activities as decorators in a more literal sense, where they were extraordinarily influential. However, it was Sir George who had originated the baroque revival, at least domestically, which Osbert and Sacheverell carried forward. Sir George not only bought Montegufoni, he bought a painted room for it from a Venetian dealer for £1,450 in the late twenties and, characteristically, refused to pay Edith's fare home to

[30] Sacheverell Sitwell, *German Baroque Art*, p. 89. [31] *German Baroque Art*, p. 63.
[32] *German Baroque Art*, p. 67. [33] Sacheverell Sitwell, *British Architects and Craftsmen*, p. 112.

England the same summer on grounds of poverty. He filled the rooms of his large and forbidding Derbyshire mansion of Renishaw with oversized Italian baroque palazzo furniture, some of it superb, a taste he had inherited from his mother.[34] He also remodelled its gardens in an emphatically Italian taste based on his extensive and detailed knowledge of Italian gardens.

Both Osbert and Sacheverell were great writers of memoirs, from which it is clear that such academic education as came their way made little impression on them, but that they were strongly influenced by the houses they grew up in, particularly Renishaw. Edith Olivier, visiting for the first time, noted that '[Renishaw] is lovely and haunted, filled with pictures and tapestries and lovely beds. Mine is a marvel with great red plumes at the corners of the canopy, rising out of vases elaborately painted in green and grey and blue . . . there was this feeling of mystery and madness. They say the house is haunted but the ghosts are the living people.'[35]

The most important formative item for Sitwell taste in Renishaw was a suite of five magnificent seventeenth-century tapestries by Judocus de Vos, bought by Sir Sitwell Sitwell around 1800, representing an opulent, faintly melancholy, make-believe world, in which the three lonely children escaped their baffling parents and lost themselves.

> They portrayed five triumphs, of such abstract qualities as justice and commerce; but it was a world of Indian suavity and opulence, and Indian in the poetic sense, for it was the East before artists had learned the difference between India, China, and the El Dorado of America, and so it contained subtle exaggerations of what the designer considered as the mean level of this trebly-distilled land of beauty. There were elephants and black slaves, bell-hung pagodas and clipped hornbeams; in the background were clouds tacking like fleets of sailing ships, and, lower down, terraces with pots of orange-trees upon their balustrades, and continual fountain jets that gave a cool note to the hot summer portrayed in every other symbol.[36]

Another key to the development of their taste is found in Sacheverell Sitwell's rhapsody on rococo silver in his *British Architects and Craftsmen*. He describes three silver ginger jars, European imitations of the porcelain jars produced in China: 'The covers and bases of the silver jars bear conventionalised palm and acanthus leaves, but the body of each jar depicts cupids playing and wrestling with the stems and foliage of such plants as never knew the light of day, but are purely imaginative, and seemed appropriate to the fabulous quarter of the world known, indifferently, as

[34] Desmond Seward, *Renishaw Hall: the Story of the Sitwells* (London: Elliott & Thompson, 2015), p. 90.

[35] *Edith Olivier from her Journals*, ed. Penelope Middleboe (London: Weidenfeld & Nicolson, 1989), pp. 79–80.

[36] Sacheverell Sitwell, *All Summer in a Day* (London: Duckworth, 1926); Seward, *Renishaw*, p. 56.

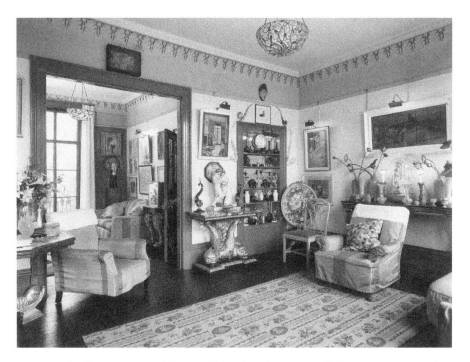

Figure 6 The drawing room of the Sitwell brothers' house in Carlyle Square. Photographer: Millar & Harris. © RIBA.

India or China to their minds. The whole effect of the jars, not in detail, but as a whole, is of a shimmering, tufted, floreated richness.'[37] It is this effect which is the key to interwar baroque, and it is the essence of Sitwell style.

In November 1919 the Sitwell brothers moved into 2 Carlyle Square, Chelsea, and proceeded to realize their highly personal notion of style, which had few antecedents except perhaps the home of a queer couple of the previous generation, Charles Ricketts and Charles Shannon.[38] The house was full of baroque extravagances in eclectic coexistence with a collection of modernist pictures. Their colour choices were sumptuous. The back room on the ground floor had pink walls and red lacquer woodwork, and the drawing room was blue, pink, and violet (see Figure 6). Osbert liked Bristol blue glass, which was also taken up by other aesthetes of the time, and, very unfashionably, certain kinds of Victoriana, particularly ingenious imitations, the antithesis of modern-movement aesthetics. Unconcerned with functionalism, he described a 'modern' sensibility as one that made new

[37] Sacheverell Sitwell, *British Architects and Craftsmen* (London: Macmillan, 1973), p. 72.
[38] John Potvin, *Bachelors of a Different Sort: Queer Aesthetics, Material Culture and the Modern Interior in Britain* (Manchester: Manchester University Press, 2014), p. 106.

meanings from old modes, using, for example, 'Victorian objects displayed for qualities other than those which the Victorians themselves admired in them'.[39] His idea that the imposition of arbitrary meaning is modern aligns his activity as collector and decorator with surrealism. The newness of this approach to decoration is suggested by Wyndham Lewis's philistine reaction to it in *The Apes of God* (1930), a book dedicated to settling scores with everyone he disapproved of, in which the Sitwells loom large.[40]

To Harold Acton, by contrast, the Carlyle Square house was a 'shrine of eighteenth-century shell furniture, sailing ships of spun glass, humming birds under globes, petit-point screens, porcelain spaniels ... so many and so varied that at moments one felt one was in an aquarium (the walls had a subaqueous iridescence), at others in an aviary.' Acton's own aesthetic was similar, a Victorian revivalism assumed in order to shock the modernists, and this was much to his taste. It was remarkable enough to be news: it was written up in *Vogue* in 1924—'Unity in Diversity—the house of Mr Osbert and Mr Sacheverell Sitwell'—and, perhaps more surprisingly, in *The Illustrated London News*, which ran a feature on it in 1926.[41] An illustration of the drawing room shows gilded Regency console tables, one supported by a pair of dolphins and probably Venetian, and a Victorian chair upholstered in petit point. Chinese gilt flowers are arranged in Bristol blue glass vases on either side of a glass dome protecting a white flower arrangement made out of feathers. However, the room was also hung with uncompromisingly modern paintings: above the feather flowers hangs a monochrome painting of London roofs by C. R. W. Nevinson, *From an Office Window*. A picture by Wyndham Lewis is also visible, and the skirting board and other woodwork are painted dark turquoise.[42] Other drawing-room furnishings included a Tchelitchew portrait of Edith flanked by ebony African sculptures, and gouaches by Gino Severini. But the most noteworthy room in the Carlyle Square house was the long and narrow dining room, a separate structure in the garden: 'With its rich blue and silver tapestry wall-coverings, its shells, and its shell and dolphin furniture, the room resembled a grotto under the sea.' It had silvered Italian grotto chairs like opened shells, and a dining table with a marble top which came from a monumental mason's yard, and reflected the light.[43]

This *arredamento* is one of the first in which eclecticism is actually a principle. There had been antiquarians' rooms in earlier generations containing a hotchpotch of different items, but such rooms had not also exhibited modern art. Humble

[39] Osbert Sitwell, *Nobel Essences* (London: Macmillan, 1950), p. 63.
[40] *The Apes of God* (London: Grayson & Grayson, 1931), p. 491.
[41] Anonymous, 'Unity in Diversity', *Vogue* (late Oct. 1924), p. 53.
[42] Bradford, *The Sitwells and the Arts*, 2.33, p. 64.
[43] Osbert Sitwell, *Queen Mary and Others* (London: Macmillan, 1974).

interiors have always evolved over time, because useful items are kept and used from one generation to another, and in them ornaments are often retained because of personal associations. But consciously elegant interiors, expressing money and educated taste, had, in previous eras, tended to be consistent. In 1927 the couturier Jacques Doucet acquired a villa at Neuilly, where he surrounded himself with paintings by Picasso, Braque, and Modigliani, and furniture and objects by designers such as Eileen Gray.[44] But he sold his famous collection of neoclassical furniture before becoming a patron of the modern; he did not try and combine the two. In both London and Paris one could go to a design studio and get a complete deco look, from furniture to textiles to ceramics, sure they would 'go' harmoniously.[45] Mixing styles and periods according to a completely personal aesthetic, having old pictures and new furniture, or new pictures and old furniture, demands more confidence and a better-educated eye. The Sitwells' self-belief was therefore compelling.

The eclecticism of the Sitwell brothers' style was not, of course, unique to them, though in 1919 there were few similar rooms in London, and those that there were belonged to other members of the bohemian haut monde. Lady Ottoline Morrell was an independent seeker after a similar concept of beauty, and the Ballets Russes-influenced decor of Lady Sackville and Emerald Cunard had aspects in common with their style. But Sacheverell's prose was highly persuasive, and it trained a much wider circle—that of his many readers—in the perception of new kinds of beauty, at the same time as Noël Coward and Dody Todd were training them in alternative aspects of camp sensibility. The shimmering, tufted, floreated richness he admired was particularly evident during rehearsals for *Façade* at Carlyle Square, when the garden of the square outside was covered with snow, which performed a similar aesthetic function to the water of Venice's canals, uplighting, reflecting, and diffusing. 'Inside, the room, with its tones of pink and blue and white and violet, seemed filled with polar lights from windows and tropic lights from fires: for all the glass objects, of which there were many, and the doors lined with mirror, glittered with redoubled vehemence.'[46]

Several key elements of interwar baroque style were in place in 2 Carlyle Square: silvered furniture, shells, glass surfaces of all kinds, iridescence, antique furnishings used in a subjective, individualistic manner. The Sitwells' prized eighteenth-century silver grotto chairs were perfect modern baroque items—perversely indifferent to economy and functionality, inexpensive, redundantly curvaceous, catching the light

[44] Dan Klein and Nancy McClelland, *In the Deco Style* (London: Thames & Hudson, 1987), p. 110.

[45] Klein and McClelland, *In the Deco Style*, p. 48. The major Parisian department stores opened design studios in the early twentieth century. In London Serge Chermayeff headed Waring & Gillow's Modern Art Studio, and Fortnum & Mason offered a Contemporary Decoration department under the auspices of Syrie Maugham. See Ghislaine Wood, *Surreal Things* (London: V&A Publications, 2007), p. 48.

[46] Lehmann, *A Nest of Tigers*, p. 8.

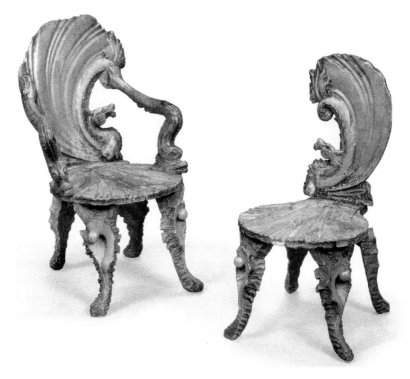

Figure 7 Venetian silver grotto chairs. Photographer: unknown. © Christie's Images Limited, 2016.

in odd ways, capriciously representational, off-message (see Figure 7). In their original context, they had been garden furniture of the grandest kind, and in Carlyle Square, they were reappropriated and assigned new meanings. They were even, perhaps, a joke: who but Venus sits in a half-shell?

By 1927, when William Acton, brother of Harold, was doing up a house in Lancaster Gate, Sitwell style had evolved into a recognizable aesthete's mode of decoration. He 'had a Venetian silver ballroom, which he filled with Venetian shell figures and eighteenth-century mirrors, cupids and Negro figures [i.e. Venetian blackamoors, discussed in chapter 8]'.[47] The influence of Sitwell style was considerable, and went well beyond the British Isles. In France, Patrick Mauriès acknowledged the Sitwells' centrality to the twenties 'retour du baroque'; and both Coco Chanel and Elsa Schiaparelli lived among an eclectic mixture of antique and modern furnishings, as did the influential hostess and patron, Marie-Laure de Noailles.[48]

[47] Green, *Children of the Sun*, p. 252.

[48] Linda Simon, *Coco Chanel* (London: Reaktion, 2011), p. 61; Philip Core, *The Original Eye: Arbiters of Twentieth Century Taste* (London: Quartet Books, 1984), pp. 120–1.

Alfred 'Chick' Austin, a major figure in the introduction of modernism to America, was happy to acknowledge the formative influence of Sacheverell Sitwell on his taste.[49] His house in Hartford, Connecticut, at 130 Scarborough Street, was based on a Palladianesque villa in the Veneto. The living room was decorated with eighteenth-century wall paintings, and a whole end of the dining room was an Austrian rococo niche, but the dressing room was modelled on one in Gropius's house in Dessau, and the house was furnished with modern French furniture and German lighting fixtures.[50] As a museum director, Austin championed both modern art, particularly the surrealists and neo-romantics, and seventeenth- and eighteenth-century Italian painting.[51] He even contributed to a book on one of Sacheverell's favourite baroque painters, Monsù Desiderio.[52] He mounted America's first extensive exhibitions of Italian baroque painting (1930), surrealism (1931), and Picasso (1934), and, in a highly Sitwellian manner, his interests also extended to modern music and ballet.[53]

Another collector who followed where the Sitwells led is Arthur Tilden Jeffress, American by origin but born in England in 1905 and educated at Harrow and Cambridge. He was homosexual, very much one of the Bright Young People, for whom he gave the infamous Red-and-White Party in 1931, and after the Second World War he became a successful gallery owner. The personal collection he left to Southampton art gallery after his death shows the Sitwell-schooled eclecticism of his taste; it includes eighteenth-century Italian pictures by artists such as Stefano Orlandi and Aldo Pagliacci, alongside Eugène Berman and Tchelitchew.

In England, Sitwell style rapidly diffused beyond advanced circles and was picked up by the decorators. Gertie Lawrence, revue star and professional 'lovable Cockney', needed to be up to date. 'I had one of the first drawing rooms in London to be done in mirrors, and a white dining room with silver sequin curtains,' she claimed in her occasionally reliable autobiography. 'I had gradually collected some fine old Bristol glass, and some pictures, including a Gauguin.' This is Sitwell style by numbers, and the year is only 1929.[54]

In 1935 the wealthy arriviste 'Chips' Channon, married to a Guinness heiress, wanted the most stupendous dining room in London for his Belgrave Square

[49] Patrick Mauriès, *Le Trompe-l'oeil de l' Antiquité au xxᵉ Siècle* (Paris: Gallimard, 1976), pp. 15, 299.

[50] A. E. Austin Jr, *A Director's Taste and Achievement* (Sarasota and Hartford: Wadsworth Atheneum, 1958), pp. 39–40.

[51] Austin, *A Director's Taste*, p. 15.

[52] Alfred Scharf (text) and A. E. Austin Jr (introduction), *The Fantastic Arts of Monsù Desiderio* (Sarasota: The John and Mable Ringling Museum of Art, 1950).

[53] Nicholas Fox Weber, *Patron Saints: Five Rebels who Opened America to a New Art* (New Haven and London: Yale University Press, 1995), pp. 136–76.

[54] Gertrude Lawrence, *A Star Danced* (London: W. H. Allen, 1945), p. 172. See also 'Ancient and Modern Settle Down Together', *Vogue* (30 Mar. 1932), pp. 56–7.

mansion. He turned to Stephane Boudin of the great decorating firm of Jansen.[55] The means that Boudin selected to express his client's requirements says much about the impact of the Sitwells' championship of baroque and rococo. Rather than any kind of modernism, even the elegant *luxe pauvre* of Jean-Michel Frank, Boudin suggested a version of the Hall of Mirrors in the Amalienburg. In 1928, in his *German Baroque Art*, Sacheverell had written a rhapsodic description of this very room:

> The room, which is in reality circular, with a domed roof, has had its walls converted into an octagon…and each wall has a great central mirror made of square pool-like panels. Above these mirrors and round the cornice there is an unimaginable richness and delicacy combined, for the silver stucco-work in its elaboration has taken on the most varied and far-fetched motives, musical instruments, weapons of war, trophies of the chase…diapered work, drums and flags, and sprays of flowers all combining under this magical touch, which is like the hand of hoar-frost on tree and flower, and is yet not so much cold as cool, a refreshment for hot weather. It has something indescribably temporary in its appearance as though the whole of this scene had been easily and quickly made out of the two coolest things known to the senses – a field of snow and a waterfall. It possesses the ease and swiftness of some divertimento or serenade by Mozart, and may well end as gently, fading away from the eyes before one can understand how it ever stood there to be inhabited.[56]

In Boudin's London version, the walls were pargeted with rococo scrollwork panels, shells, and birds; huge shells rose up from the picture rail in the four corners of the room, and all of this was silvered. There were large mirrors set into the walls and mirrored double doors; the rococo dining table was also mirrored, and the chairs were silver, upholstered in aquamarine silk damask, also used for the curtains. Any paint there was room for was also aquamarine. A Venetian blackamoor and Chinaman flanked the door, and a vast Venetian chandelier hung over the table. The whole enterprise cost £6,000. While the lavishness was, for London, unprecedented, the decor can hardly have offered the shock of the new.

Another important aspect of the Sitwell brothers' work as taste-makers is that, alongside their support for contemporary painters, they also worked to keep baroque art visible. Together with the Finnish art historian Tancred Borenius, they founded the Magnasco Society, which held annual exhibitions of seventeenth- and eighteenth-century paintings from 1924 onwards, at Thomas Agnew & Sons in Old Bond Street. The recognizability of 'Sitwell taste' is suggested by Angus Wilson's *No Laughing Matter* (1967), in which an aesthete of the twenties, making conversation at a party,

[55] James Archer Abbott, *Jansen* (New York: Acanthus Press, 2006).

[56] *German Baroque Art*, p. 58. The house is an eighteenth-century rococo hunting lodge created for the Wittelsbachs in the grounds of Nymphenburg Palace in Bavaria.

says, 'Jack's buying two wonderful Kandinsky compositions this year. And a marvellous, inventive, sad Paul Klee. And if there's anything over he's promised to buy those Cardinals in a Vault of Magnasco that Sachie found.' This, like much the Sitwells championed, was genuinely surprising to contemporaries. James Stourton, in his history of collecting in England, observes: 'It is difficult today to understand the depth to which Seicento painting, as the Italian seventeenth century is generally known, had fallen in critical acclaim. Critics from Winckelmann through to Ruskin had ridiculed it and by the 1860s the National Gallery in London stopped buying it.'[57] Osbert and Sacheverell had acquired the taste from Sir George, who went his own way in this as in other respects and bought a Francesco Solimena and three Magnascos.[58]

The Sitwells' aristocratic background was crucial to the Magnasco Society enterprise: the paintings exhibited were lent to it, mostly by the owners of great houses in which they had hung unregarded for a couple of hundred years. For the most part, they had been brought to England in the grand tour era, before the Napoleonic Wars. The 1926 Magnasco Society exhibition included a Giovanni Battista Pittoni, *The Holy Family*, which belonged to Osbert himself, and a painting of St Stephen by Domenico Fetti lent by David Horner, who some years later became Osbert's lover. Horner, like Osbert, was brought up with inherited art, at Mells Park.

The other key figure in the Magnasco Society gave it some intellectual stiffening. Tancred Borenius was a Finnish scholar, whose doctoral thesis had been on *The Painters of Vicenza, 1480–1550*: he was thus interested in post-Renaissance Italian art. It was this, and his friendship with Roger Fry, which drew him into the Sitwell orbit. Borenius had first come to England in 1906, whereupon Fry introduced him to the London art world. The Sitwells were well aware of Fry, not only as an art critic but also as the organizer of the landmark *Manet and the Post-Impressionists* exhibition (1910–11), which they were to emulate in their equally important *Modern French Paintings* exhibition of 1919.

Osbert and Sacheverell had multiple opportunities to cross paths with Borenius, who became professor of fine art at University College, London, in 1922, expert adviser on old-master prints at Sotheby's in 1923, and also catalogued a variety of important private collections. As men with a real knowledge both of old masters, particularly Italian, and of contemporary art, Borenius and the Sitwell brothers were natural allies. There was also a slightly surprising social connection between them: in 1922 Borenius became the trustee of Dolly Wilde, who was very much part of Osbert's circle at the time. He even proposed to her, she claimed, 'with the sudden bravado of a suppressed nature. He was infinitely relieved when I refused him.'[59]

[57] James Stourton, *Great Collectors of Our Time: Art Collecting since 1945* (London: Scala, 2007), pp. 300–3.
[58] Seward, *Renishaw*, p. 119.
[59] Joan Schenkar, *Truly Wilde: the Unsettling Story of Dolly Wilde, Oscar's Niece* (London: Virago, 2000), p. 104.

Another voice raised in defence of the baroque from within Osbert's social circle was that of the same Harold Acton who admired the brothers' taste in *arredamento*. Acton, the son of a cosmopolitan artist, interior designer, and dealer in art and antiques, brought up at the splendid villa of La Pietra in Florence, was a precocious aesthete who began to make his mark as a poet and critic while still at Eton. An essay in the second number of the undergraduate magazine he founded, *The Oxford Broom* (April 1923), 'The Gruesome Apotheosis of the Seicentismo', is almost certainly his work, since few other undergraduates of his time could have acquired the requisite knowledge and experience. It reviewed the previous summer's exhibition at the Pitti Palace. 'Critics', it says, 'are now claiming that Guido Reni, Caravaggio, Caracci and so on are modern in feeling, analogous to Fascismo and Futurismo. But the one really impressive figure among these painters is Alessandro Magnasco, ... he is like El Greco in the farouche technique with which he depicts monks suffering crises de nerfs in caverns.' The condescending appreciation of this passage has much in common with *Southern Baroque Art*, but also highlights that book's distinctive poetic quality, which won it, and the art it championed, an audience that effortless superiority could not achieve.

The Magnasco Society had only a limited effect on the rediscovery of the seicento, but Sir Denis Mahon, who was instrumental post-war in giving it the position it now holds, is happy to give it credit—'They got things moving'.[60] Apart from Mahon, William Gaunt, Anthony Blunt, and Ellis Waterhouse were among the serious art historians who studied post-Renaissance Italian art, but the pioneering work of the Sitwells in this area is not negligible.

Edith has not been part of this chapter to any great extent. It is only too easy to see the Sitwells, as she once tetchily reflected, as 'an aggregate Indian god, with three sets of legs and arms, but otherwise indivisible', but their tastes and lifestyles were very different. Like her brothers, she was interested in modern art and strongly partisan, though much less informed. Unlike Osbert and Sacheverell, her aesthetic responses were essentially musical rather than visual, and her feelings about paintings were subjective, strongly bound up with her feelings about the painters. The first artist she was really interested in was Walter Sickert, who was kind to her when she met him as a young woman, and Sickert, in turn, introduced her to the criticism of Roger Fry.[61] Since she was attracted to Alvaro 'Chile' Guevara, she was easily convinced of the merits of his work and, later, adored Pavel Tchelitchew and therefore his paintings, though on the other hand she came to detest the work of Wyndham Lewis, because they quarrelled while she was sitting for him.

Also, though interior decoration interested her brothers greatly, Edith was either indifferent to her environment or could not afford to entertain views about it. Her

[60] Stourton, *Great Collectors of Our Time*, p. 303.
[61] Richard Greene, *Edith Sitwell: Avant-Garde Poet, English Genius* (London: Virago, 2011), pp. 69, 75.

own great project in visual terms was herself, discussed in chapter 13. Perhaps she might have taken more interest in her surroundings if she had not been so poor. When Brian Howard visited her as a rich and supercilious 17-year-old, he saw Moscow Road, where she lived, as 'an uninviting Bayswater slum'. As he wrote fastidiously to his friend Harold Acton:

> I don't like her apartments, or, rather, room. It is small, dark, and I suspect, dirty. The only interesting things in the room are an etching by [Augustus] John, and her library, which is most entertaining. The remainder seems to consist of one lustre ball and a quantity of bad draperies.[62]

At least there was a witch ball and some drapery to keep the family side up. It did not occur to the Eton schoolboy that she might not have been living thus entirely by choice, but she was certainly not in a position to develop her taste. She had been rejected from infancy by her parents, on the grounds of being female, funny-looking, and too intellectual.[63] While Osbert and Sacheverell were perennially convinced that Sir George was mean, compared to her brothers Edith lived on a pittance—£400 a year as against Osbert's £2,000. In 1914 she was working at the Pensions Office in Chelsea for 25 shillings a week.[64] Where Osbert offered his guests claret and the Café Royal, Edith offered tea and penny buns, but many of those she entertained honoured her for what she attempted and for her not inconsiderable achievements.

> Those tea-parties of hers really were one of the most extraordinary literary affairs of the twenties when you think of them. For there she was, all but penniless in a dingy little flat in an unfashionable part of London. All she could offer was strong tea and buns. Yet, because of who she was, she attracted to that flat almost every major literary figure of the twenties.[65]

[62] Bradford, *Splendours and Miseries*, p. 76.
[63] As an indication, her father presented her with a copy of *How to be Pretty, Though Plain*, by Mrs C. E. Humphry (London: J. Bowden, 1899).
[64] Lehmann, *A Nest of Tigers*, p. 45. [65] Geoffrey Gorer, quoted in Bradford, *The Sitwells*, p. 74.

II

The City

4

Modern Times

One of the defining facts about the twentieth century is that, for the first time in human history, the majority of people lived in cities rather than in the country, even in Africa.[1] The fact that humanity had become preponderantly proletarian rather than peasant provoked a wide range of reactions. One was panic, especially when mobilization for imperial wars revealed that 'sturdy peasants' had become 'puny degenerates'. David Lloyd George, for example, complained, 'It's not possible to run an A1 empire with a C3 population,'[2] and this alarm might be expressed through Marxism or socialism, or alternatively through eugenics. Nostalgia was another reaction, a perception that the world we have lost was more moral, orderly, and dignified than modernity, rarely shared by ex-peasants. This nostalgia readily shaded into fascism and Nazism.

There was also a vast range of practical and aesthetic attempts to come to terms with the new situation. The great cities of the nineteenth century expanded spontaneously, creating unprecedented problems of organization and hygiene. The poor crowded into inner-city 'rookeries', or dreadful, unserviced suburban shanty towns. The new industrial wealth created by this proletarian army was spent on, among other things, huge schemes of architectural aggrandizement.

Cities did not get off scot-free in the First World War. The two most important to this narrative, Paris and London, were respectively shelled and bombed from the air; and other cities suffered to a greater or lesser extent. Nonetheless, whatever the political will for a new and better world, and however much the avant-garde on the art-war front called for change, in 1918 London and Paris as physical entities, though somewhat battered, stood much as they had in 1914.

Consequently, any call to realize the new visions of glass and crystal towers, or rationally laid-out, streetless cities had to take cognizance of the basic fact that individual property rights remained undisturbed in all their intricacy, while the

[1] Eric Hobsbawm, *Age of Extremes* (London: Michael Joseph, 1994), pp. 289–91.
[2] Richard Overy, *The Morbid Age: Britain between the Wars* (London: Allen Lane, 2009), p. 98.

infrastructure of life still existed and was more or less fit for purpose.[3] They could evolve, and issues of public health made it imperative that they *should* evolve, but neither could start from scratch. The extent of physical destruction in Germany and many parts of Eastern Europe, and perhaps the experience of defeat, seem to have increased the appetite for thought-through, rationalized rebuilding there, especially in regions where this coincided with social revolution.[4] Modris Eksteins observes that 'Berliners, unlike the natives of other German cities and other European capitals, seemed to be fascinated by the very idea of urbanism and technology, and even developed, as Friedrich Sieburg put it, a romanticism from "railway junctions, cables, steel, and track...noisy elevated trains, climbing towers".'[5]

Cities are ambiguous friends to modernism. They are the location and character-istic product of modernity. Artists, even those, such as Barbara Hepworth or W. H. Auden, for whom a specific rural landscape was of formative importance, gravitated to capitals, as did critics.[6] Modern cities are places of straight lines, angles, and plate-glass windows, so that walking down an urban street is potentially a cubist experience of seeing fragments of oneself from different angles, bounced back by reflecting surfaces. But at the same time a great city, like it or not, is not a tabula rasa but a memory palace. A modern state is inevitably concerned about its citizens' allegiance, and among the obvious tools for imparting a sense of collective identity are public art and architecture. The sights of London, for instance, include the Tower, which enjoys the dubious honour of having been a tourist destination for a thousand years, Trafalgar Square, Buckingham Palace, and Marble Arch; among those of Paris, the buildings of the Île de la Cité, the Arc de Triomphe, the Louvre; strongholds, memorials of military victory, palaces.

Apart from state-sponsored memorials, any major European city surrounds its inhabitants with objects of memory, many of which have long since lost their meaning or acquired new ones. For example, Rome's 'Pasquino' is a battered statue from the third century BC which nearly 2,000 years later acquired a name and became the recognized site for posting satires against the pope or papal government.

[3] 'The twentieth-century modernist project for the city was rather different—a plan for the total environment, for the separation of pedestrian and vehicle, for the futuristic skyscrapers of the garden cities pioneered by Le Corbusier, and the thruways of Robert Moses (Le Corbusier's motto was "We must kill the street").' Elizabeth Wilson, *Adorned in Dreams: Fashion and Modernity* (London: Virago, 1985), p. 141.

[4] Modris Eksteins, *Rites of Spring: the Great War and the Birth of the Modern Age* (London: Bantam Press, 1989), p. 81.

[5] Eksteins, *Rites of Spring*, p. 75. German enthusiasm for avant-garde buildings and decor precedes the First World War: see Peter Thornton, *Authentic Décor: the Domestic Interior, 1620–1920* (London: Weidenfeld & Nicolson, 1983), pp. 368, 372–7, 384–5.

[6] Michael T. Saler, *The Avant-Garde in Interwar England: Medieval Modernism and the London Underground* (Oxford: Oxford University Press, 2001), pp. 44–60, discusses the influence of a Yorkshire mindset on the development of English modernism.

Or there is London Stone, still extant at 111 Cannon Street, which seems to have been a landmark since the eleventh century. Because to walk in the public areas of a city is to be bombarded with rhetorical statements, since even the names of streets, precincts, and stations convey and evoke meaning, it is also to take a journey along paths of memory. They may be personal memories, if you have lived in that city for some time, and even if you are a stranger they are reminders of the national past and evocations of current and recent cultural phenomena—unofficial graffiti, posters and flash mobs, or grand public statements such as the Olympic Games. 'The city remains the main book in which history can be written and, above all, read,' Bruna Mancini observed.[7]

Freud, one of the most influential thinkers of the interwar years, perceived human consciousness as a sort of palimpsest; he believed that 'forgotten' past experience was not lost, but simply covered up by the layers of more recent experience and often recoverable in a therapeutic context.[8] Whether or not this is true of the human brain, it is certainly true of old European cities, where rectilinear modern blocks sometimes still follow medieval street-lines, and a Roman temple may turn up in the course of digging foundations for a new building; these are places where the past lives in the present, as Mary Butts describes in a story about Paris in the twenties, 'Mappa Mundi'.[9] One of Freud's followers actually offered the city as a direct metaphor for human consciousness, writing in 1913: 'The mind is like a city which during the day busies itself with the peaceful tasks of legitimate commerce, but at night when all the good burghers sleep soundly in their beds, out come these disreputable creatures of the psychic underworld to disport themselves in a very unseemly fashion.'[10] He thus takes it for granted that the city has its criminals, night people, street people; that it can never be entirely rationalized. It was for these reasons that Le Corbusier and his followers were deeply hostile to the city, above all to the street, and called for a profound reorganization of human living arrangements.[11]

Peter Wollen observes that 'the history of modernism is caught between two poles of attraction: on the one hand, a visionary utopianism, built round an ideal of mass production, rational organisation and machine technology harnessed to an aestheticised sense of civic purpose, on the other hand, a fascination with the urban vernacular, with the entertainments, environment and lifestyles that grew up in the

[7] C. Bruna Mancini, 'Writing and Reading the Urban (hyper)text of London', *Prospero* 10 (2003), pp. 167–78, p. 168.

[8] Sigmund Freud, *Civilization and its Discontents* (1930).

[9] Mary Butts, *With and Without Buttons* (London: Carcanet, 1991), pp. 188–201.

[10] Oron J. Hale, *The Great Illusion: 1900–1914* (New York: Harper & Row, 1971), p. 99.

[11] Sigfried Giedion, *Space, Time and Architecture: the Growth of a New Tradition* (Cambridge, MA: Harvard University Press, 1941), p. 832, and see Robert Fishman, *Urban Utopias in the Twentieth Century* (New York: Basic Books, 1977).

unplanned and chaotic milieu of the modern city.'[12] The one pole is modernism, the other surrealism or, as I would argue, modern baroque.

Michel de Certeau argues for the ineluctable baroqueness of old European cities, with their deep roots into the pre-modern and pre-mechanical, in terms strangely reminiscent of Theodor Adorno's essay on surrealism, with its evocation of the cancerous pollution of a white, clean, modern building by a decorative detail from the past.

> Already, within the grid pattern of functionalist planners, obstacles sprang up, 'resist-ances' from a stubborn past. But the technicians were supposed to make a tabula rasa of the opacities that disrupted the plans for a city of glass...yet some old building survived, even if they were caught in its nets. These seemingly sleepy, old-fashioned things, defaced houses, closed-down factories, the debris of shipwrecked histories still today raise up the ruins of an unknown, strange city. They burst forth within the modernist, massive, homogeneous city like slips of the tongue from an unknown, perhaps unconscious, language....Ancient things become remarkable. An uncanni-ness lurks there, in the everyday life of the city. It is a ghost that henceforth haunts urban planning.[13]

Further, de Certeau follows Baudelaire, Walter Benjamin, and the surrealists in positively embracing this intractability: 'More than its utilitarian and technocratic transparency, it is the opaque ambivalence of its oddities that makes the city livable. A new baroque seems to be taking the place of the rational geometries that repeated the same forms everywhere, and that geographically clarified the distinction of functions (commerce, leisure, schools, housing, etc.) Indeed, the "old stones" already offer this baroque everywhere.'[14] For Benjamin and the surrealists, this disruptive energy implicit in the city itself is to be linked with the private and individual energy of sexual preference.[15]

The tendency of European cities to be overt aspects of a national project has made it extremely difficult for anyone to claim that this is day one of year zero. The purest examples of modern cities are in the former Soviet bloc or the USA, where, on the one hand a revolutionary state had a vested interest in destroying continuities, and on the other the landscape was, in terms of urban development, a tabula rasa. Stalin's iron-and-steel city of the thirties, Magnitogorsk, did not need to respect any

[12] Peter Wollen, *Raiding the Icebox: Reflections on Twentieth Century Culture* (London: Verso, 2008), p. 104.

[13] Michel de Certeau, Luce Giard, and Pierre Mayol, *The Practice of Everyday Life II: Living and Cooking*, trans. Timothy J. Tomasik (Minneapolis and London: University of Minnesota Press, 1998), 'Ghosts in the City', pp. 133–43, p. 133.

[14] De Certeau, 'Ghosts in the City', p. 135.

[15] Dianne Chisholm, 'Obscene Modernism: Eros Noir and the Profane Illumination of Djuna Barnes', *American Literature*, 69.1 (1997), pp. 167–206.

aspect of the small pre-Revolution mining settlement which preceded it, any more than the planners of the American steel city of Gary, Indiana (founded in 1906), on which Magnitogorsk was modelled, needed to concern themselves with the ways in which Native Americans had made use of the area.

Magnitogorsk's problems were not all down to modernism, except in the sense that a planned total environment is intrinsically less robust than an organic accretion of people and buildings. However, it illustrates the principle that, again and again, dwellers in planned environments tend to subvert them in search of autonomy and independence. At Magnitogorsk, people preferred unofficial turf-roofed shanties to communal dormitories, wretched privacy to, also fairly wretched, collectivism.[16] However, modernist urban planning denied this appetite for individual choice. For example, Austria's first professional woman architect, Grete Schütte-Lihotzky, designed a prefabricated kitchen in 1926, which was built and installed in 10,000 new working-class apartments. Her project was to teach the users what they ought to want. Like many modernist designers, she asked, 'How can we overcome... the irrational and the primitive?'[17] The planned-for were not consulted, and her design was educative, even coercive. Even the storage containers were built in, ready-labelled, directing the cook in what she should buy and in what quantities. But Schütte-Lihotzky's faith in her own capacity to prescribe was remarkable, since despite her gender her personal experience was nil: she had never cooked for herself or anyone else. 'I designed as an architect, not a housewife,' she commented much later.[18]

Not all planners were modernists. The lively intellectual culture of Vienna produced a theorist of architecture who started from the opposite premise, Camillo Sitte. His *Der Städtebau nach seinen künstlerischen Grundsätzen* (*City Planning According to Artistic Principles*) of 1889 offered the thesis that architecture should emerge from the experience of the individual, championed medieval irregularity and planning only on the large scale, leaving the infill of small private buildings to personal enterprise.[19] But Sitte's was a minority voice: for most of those involved with planning cities, the dream of social control was seductive.

Turning now to the users, not the planners, of cities, it is clear that one group with a particular stake in resisting a fully planned modern city was its sexual dissidents.

[16] Leif Jerram, *Streetlife: the Untold History of Europe's Twentieth Century* (Oxford: Oxford University Press, 2011), pp. 346–9.

[17] Jerram, *Streetlife*, p. 341.

[18] Margarete Schütte-Lihotzky: 'Sie haben gedacht, ich würde verhungern', *dieStandard.at*, 18 Jan. 2005. 'Es wird Sie überraschen dass ich, bevor ich die Frankfurter Küche 1926 konzipierte, nie selbst gekocht habe. Zuhause in Wien hat meine Mutter gekocht, in Frankfurt bin ich ins Wirtshaus gegangen. Ich habe die Küche als Architektin entwickelt, nicht als Hausfrau.'

[19] The conflict between modernists such as Otto Wagner and Camillo Sitte is explored in Carl E. Schorske, *Fin-de-siècle Vienna* (New York: Knopf, 1980).

The anonymity of city life, and the absence of the social policing inescapable in small communities, drew heterodox lovers to cities, where they were faced with the problem of mutual recognition. George Chauncey and Matt Houlbrook, writing about New York and London respectively, chart the codification of dress, speech, and style by which gay men recognized one another. Gay women, of course, also had their own codes.[20] These communities, along with others such as racial and religious minorities and career criminals, form invisible sub-cities within urban life, each with its own landmarks, meeting places, monuments, and language, all of which resist what de Certeau calls the modernist 'City Practical'. 'Rational organization', he observes, 'must thus repress all the physical, mental and political pollutions that would compromise it.' Deviance, criminal or sexual, or even social, must be eradicated, straightened out, and left with nowhere to hide. For de Certeau, an invisible city of the like-minded manifests itself not through its own products, 'but rather through its ways of using the products imposed by a dominant order'. This is relevant to the cultural production of gay people, so Noël Coward, Marie Laurencin, or W. H. Auden might at the same time be successful and popular in a general sense, and be received in particular ways by those who were attuned to homosexual nuances in their work.[21] Noël Coward was described by a gay fan as 'the Mount Everest of double entendre', and the same might have been said of Gwen Farrar. Beatrice Lillie, a lesbian, used 'There Are Fairies at the Bottom of Our Garden' as one of her signature songs, and found that her fans insisted on it at every performance.[22]

Just as the cities themselves evolved but endured, the forms and locations of popular culture and entertainment underwent evolution but remained in a continuum with the past. The circus, music hall, and pantomime were among the established forms of entertainment which might claim up-to-dateness while retaining significant continuities. Although cinema, comic strips, and cartoons were art forms arising from new technology, the vocabulary of slapstick comedy and melodrama which they employed developed out of the expressive techniques of Victorian theatre, which itself had roots in older disciplines such as the Italian Comedy.

The Sitwells were not alone in enjoying at least some aspects of popular culture. The circus and pantomime were great levellers; but so, in their different ways, were Charlie Chaplin, Fantômas, the Marx Brothers, Mickey Mouse, and Krazy Kat, all of whom were not only vastly popular but also admired by a wide variety of artists and

[20] George Chauncey, *Gay New York: Gender, Urban Culture, and the Making of the Gay Male World, 1890–1940* (New York: Basic Books, 1994); Matt Houlbrook, *Queer London: Perils and Pleasures in the Sexual Metropolis, 1918–1957* (Chicago and London: University of Chicago Press, 2005); Lisa Walker, 'How to Recognise a Lesbian: the Cultural Politics of Looking Like What You Are', *Signs*, 18.4 (summer 1993), pp. 866–90.

[21] Michel de Certeau, *The Practice of Everyday Life I*, trans. Steven Rendall (Berkeley: University of California Press, 1984), pp. xii–xiii, 94. See also Alan Sinfield, 'Private Lives/Public Theater: Noël Coward and the Politics of Homosexual Representation', *Representations*, 36 (autumn 1991), pp. 43–63, p. 53.

[22] Chauncey, *Gay New York*, p. 288.

intellectuals in Britain, France, and America.[23] However, what Kirk Varnedoe and Adam Gopnik have called 'the paternalistic puritanism of the left' had considerable difficulty in coming to terms with this.[24] The influential American critic Clement Greenberg voices an extraordinary disdain for popular culture:

> Losing…their taste for the folk culture whose background was the countryside, and discovering a new capacity for boredom at the same time, the new urban masses set up a pressure on society to provide them with a kind of culture fit for their own consumption. To fill the demand of the new market, a new commodity was devised: ersatz culture, kitsch, destined for those who, insensible to the values of genuine culture, are hungry nevertheless for the diversion that only culture of some sort can provide.[25]

This sort of thinking harks back to Plato's *Republic*: that the only people capable of making valid judgments are a highly educated group of philosopher kings, while the uneducated masses would be better off being told what's good for them.

Greenberg's definition of 'kitsch' includes 'popular, commercial art and literature with their chromeotypes [sic], magazine covers, illustrations, ads, slick and pulp fiction, comics, Tin Pan Alley music, tap dancing, Hollywood movies, etc., etc.'; apparently, any art form which achieved any kind of mass distribution. It draws on an established critique of 'chromo-civilization' by an American elite which felt itself challenged from below.[26] But although Greenberg assumes that there is some sort of wall separating authentic art from mass entertainment, some 'high culture' artists were intensely responsive to artists working in popular media. Consider Loie Fuller, for example, a technologically innovative abstract dancer and a star of the Folies-Bergère. Her influence on the Ballets Russes will be discussed in chapter 17, but her 'Fire Dance' inspired Yeats's 'Byzantium', she was admired by Cocteau and many other major cultural figures, and she was a pioneer in the use of film and stage lighting.[27] Does that make her work 'culture', or did the fact of performing for the Folies-Bergère make it 'debased entertainment'?

[23] The *Fantômas* novels and the subsequent films were highly regarded by the French avant-garde of the day, particularly by the surrealists, as I discuss later in this chapter. Krazy Kat is praised by Gilbert Seldes in *The Seven Lively Arts* (New York: Harper & Brothers, 1924), pp. 231–45.

[24] Kirk Varnedoe and Adam Gopnik, *High and Low: Modern Culture and Popular Art* (New York: Harry N. Abrams, Inc., 1991), p. 187.

[25] Clement Greenberg, 'Avant-Garde and Kitsch', *Partisan Review*, 6.5 (1939).

[26] Michael Clapper, 'The Chromo and the Art Museum: Popular and Elite Art Institutions in Late Nineteenth-Century America', in *Not at Home: the Suppression of Domesticity in Modern Art and Architecture*, ed. Christopher Reed (London: Thames & Hudson, 1996), pp. 33–47, pp. 40–1, quoting 'Chromo-Civilisation', *The Nation*, 3 (24 Sept. 1874), pp. 201–2.

[27] Rhonda K. Garelick, *Electric Salome: Loie Fuller's Performance of Modernism* (Princeton: Princeton University Press, 2007); Kavanagh, *Secret Muses*, p. 46.

As the example of Fuller suggests, the line between culture and kitsch is hardest to draw in the case of arts based on bodily movement. Vaslav Nijinsky, for example, was fascinated by Harry Relph, better known as 'Little Tich', whose speciality was a dance performed in 28-inch-long boots. Lady Juliet Duff records Nijinsky's passion for Little Tich: 'If his idol were performing, seats would immediately be booked and he and Diaghilev would sit gazing spellbound.' The French playwright and impresario Sacha Guitry also considered Little Tich 'the world's greatest genius'.[28] The surviving film of Little Tich's Big Boot dance has been described by Jacques Tati as 'a foundation for everything that has been realised in comedy on the screen'.[29]

Little Tich has been more or less forgotten except by theatre historians, but Greenberg's blanket assertion that art which is popular cannot be authentic is reckoning without Charlie Chaplin, who remains instantly recognizable. He could not, and cannot, easily be dismissed. His popularity was astounding. Graves and Hodge described Chaplin as 'the main cause why half the population of Britain went to the pictures twice a week'.[30] Because his medium was the silent film, his work crossed all boundaries, and it was wildly popular anywhere a projector could be set up. One possible reason for this, other than Chaplin's enormous talent for expressive mime, may be that his screen persona embodied a major folktale archetype: the poor, small and cunning hero who outwits the king, the giant, or the proud princess—or at the very least, lives to fight another day.

Chaplin was a genuinely proletarian artist who emerged from London's underclass. His father was an alcoholic, his mother went mad under the stress of poverty and malnutrition, and most of such formal education as he received was via the workhouse. One of the more illuminating remarks in his highly fictive autobiography is, 'Unlike Freud, I do not believe sex is the most important element in the complexity of behaviour. Cold, hunger and the shame of poverty are more likely to affect one's psychology.'[31] This is the remark of someone who, unlike Freud, knew what starvation felt like, as well as of a heritor of the relaxed sexual mores of the English urban poor. Though he was sufficiently a man of the left to be turfed out of America in the McCarthy era, in his life and his art he was an incarnate opposition to modernist visions of interchangeable, faceless proletarian workers.[32]

[28] Richard Buckle, *Nijinsky* (London: Penguin Books, 1975), p. 304; James Harding, *Cochran: a Biography* (London: Methuen, 1988), p. 83.

[29] Jacques Tati and Mary Tich, *Little Tich: Giant of the Musichall* (London: Elm Tree/Hamish Hamilton, 1979). The film was made by Clément-Maurice for the Phono-Cinéma-Théâtre in 1900.

[30] Robert Graves and Alan Hodge, *The Long Week-End: a Social History of Great Britain 1918–1939* (London: Reader's Union, 1941), p. 154.

[31] Charles Chaplin, *My Autobiography* (London: Penguin Books, 1975), p. 206.

[32] Garrett Stewart, 'Modern Hard Times: Chaplin and the Cinema of Self-Reflection', *Critical Inquiry*, 3.2 (winter 1976), pp. 295–314.

This is reflected in an eerie, strangely beautiful song with a jaunty, musical-box tune, which was a hit during World War One:

> And the moon shines bright on Charlie Chaplin,
> His boots are cracking for t' want of blacking,
> And his little baggy trousers they want mending,
> Until they send him to the Dardanelles.

In this song, Chaplin's alter ego, 'The Tramp', has become the embodiment of the little man caught up in the machine—fragile, pathetic, woefully unprepared and under-equipped, as were so many young men who were fed into the mincing machines which were the theatres of the Great War.

Chaplin's Tramp is part of the complex of twentieth-century baroque art, because his art descends directly from the commedia dell'arte via the London harlequinades of the nineteenth century. Chaplin was a great-grandson-in-art of Joe Grimaldi and a son of Little Tich, and while the baggy trousers, little hat, and big shoes of the Tramp show strong features of the circus clown, his consistently subversive conduct and acrobatic eloquence make him a plain-clothes harlequin, and his expressive, yearning, frequently lovelorn eyes are those of Pierrot. 'Harlequin and Charlie are archetypal proletarians,' David Madden comments, the embodiment of streetwiseness, instantly recognizable characters whose means of expression is acrobatic.[33] Jean Cocteau, who adored Chaplin, calls him a 'modern Punch [who] speaks to all ages, to all peoples'.[34]

Ben Hecht observed of Chaplin in 1916: 'He is absurd; unmanly; tawdry; cheap; artificial. And behind his crudities, his obscenities, his inartistic and outrageous contortions his divinity shines. He is the Mob God. He is the child and a clown. He is a guttersnipe and an artist....He is the mob on two legs. They love him and laugh.'[35] This sketch highlights Chaplin's popular appeal, but he was recognized as an unquestionably unique talent by, among others, the great tragic actors Sir Herbert Beerbohm Tree and Minnie Maddern Fiske. Fiske wrote, 'Charles Chaplin appears as a great comic artist....If it be treason to Art to say this, then let those exalted persons who allow culture to be defined only upon their own terms make the most of it.' Interestingly, the American actress here echoes the phraseology of the eighteenth-century American lawyer Patrick Henry's famous defiance of the tyranny of George III.[36]

[33] David Madden, 'Harlequin's Stick, Charlie's Cane', Film Quarterly, 22.1 (autumn 1968), pp. 10–26, p. 13.

[34] Francis Steegmuller, Cocteau: a Biography (Boston: Little, Brown, 1970), p. 201; Jean Cocteau, Carte Blanche (Paris: Mermod, [1952]), p. 201.

[35] In The Little Review, quoted in David Robinson, Chaplin: His Life and Art (London: Penguin Books, 2001), pp. 74–104.

[36] Harper's Weekly, 6 May 1915. On 30 May, Henry gave his maiden speech in the American colonial assembly, criticizing not only Parliament, but also the king. 'Caesar had his Brutus, Charles the First his Cromwell, and George the Third....' At that point he was interrupted by cries of 'Treason!' from delegates

Nijinsky, from a different perspective, told Chaplin, 'Your comedy is balletique, you are a dancer.'[37] Their mutual affinity was recognizable to an educated eye: Lady Ottoline Morrell, a personal friend of Diaghilev and Nijinsky before the First World War, said, 'Many years later I found in Charlie Chaplin something of the same intense poignancy as there was in Nijinsky.'[38] Chaplin, for his part, was highly responsive to ballet. He loved Anna Pavlova, intensely admired Nijinsky, and was bowled over by the latter's *L'après-midi d'un faune*, which he perceived, interestingly, as a great tragic performance due to the faun's inability to communicate.[39] He confirmed Nijinsky's perception that his own work had something in common with ballet in a conversation with Beverley Nichols, who noted that Chaplin told him that, with each film, he had a particular melody running in his head: 'It would be too much to say that I set everything to that melody, because one cannot set such a diversity of action to music. But at least it means I achieve a unity of mood and rhythm.'[40]

Charlie Chaplin's 1936 masterpiece, *Modern Times*, engages directly with modernity. The Tramp finds employment as one of the faceless, interchangeable workers in a modern factory, tending a giant machine. But he finds it impossible to surrender his individuality: inevitably, his personality asserts itself; he breaks down, and this breakdown, caused by the cruel automatism of the incomprehensible work he is forced to do, results in the destruction of the machine. The Tramp, naturally, proves the more durable of the two.

The Marx Brothers' verbal comedy could not achieve Chaplin's universal appeal, but they were phenomenally successful among English-speakers. Constant Lambert observed a strong connection between their work and the surrealist movement, observing, 'There must be few surrealists and transitionists who do not feel that the Marx Brothers have stolen their thunder and sent it rolling uproariously round the room in Lewis Carroll fashion.... It has been remarked before that the most striking feature of the art of our time is the way in which the popular, commercial and lowbrow arts have adopted the technical and spiritual sophistication of the highbrow arts.'[41] In their several ways, the strip cartoon Krazy Kat and the cinema cartoons Betty Boop and Mickey Mouse (in the earliest of his adventures) also evidenced a strong tendency towards dreamlike, associational shifts of meaning and register, and towards realized metaphors in which surrealism was expressed if

who recognized the reference to assassinated tyrants. Henry paused briefly, then finished his sentence: '...may profit by their example. If this be treason, make the most of it.'

[37] *My Autobiography*, p. 192. [38] Quoted in Buckle, *Nijinsky*, p. 306.

[39] *My Autobiography*, p. 193.

[40] Bryan Connon, *Beverley Nichols: a Life* (London: Constable, 1991), p. 133.

[41] Lambert, *Music, Ho!*, pp. 261, 266.

not necessarily intended. All of them, as a by-product of their own commercial agendas, insidiously familiarized surrealism as a movement in art.

While the Marx Brothers' comedy expressed, or embodied, surrealist principles, the idea that art might emerge from the unconscious operations of popular culture was floated by the surrealists themselves. In this they differed from modernists, who characteristically resisted contamination from below.[42] Walter Benjamin observed the surrealists' openness to chance encounters, places, and the art of the people: André Breton bumped into a mentally ill woman, spent several days wandering about Paris encountering her periodically, and wrote *Nadja* on the basis of this experience; Marcel Duchamp produced his 'readymades' from objects spotted in ironmongers;[43] and the surrealist magazines *La Révolution Surréaliste* and *Minotaure* juxtaposed surrealist artworks and theory with all kinds of items never intended as 'art'.

One specific creation of pop culture who was taken enormously seriously by the French surrealists was Fantômas. Boris Kochno, in his introduction to an expensive coffee-table book on Nijinska's ballet *Les Biches*, wrote, 'En Grèce, le touriste consulte Homère. Ici, Fantômas me dirige de salle en salle.' (In Greece, the tourist turns to Homer. Here, Fantômas directs me from room to room.)[44] In the France of 1924, Fantômas clearly required no explanation, though he needs some introduction now.

Fantômas was one of the great anti-heroes of Francophone popular culture, a Napoleon of crime. His counterpart in England in terms of popularity might be Sherlock Holmes, but they are, as it were, stories in which Moriarty is the hero and the detective is eternally foiled. More than five million copies of the thirty-two Fantômas novels were published, and surrealist interest began almost as soon as they started to come out in 1911. Max Jacob and Guillaume Apollinaire founded a Société des Amis de Fantômas. Juan Gris, Yves Tanguy, and, above all, René Magritte painted Fantômas-related canvases, while Louis Feuillade directed five Fantômas films.[45] The craze lasted into the post-war period, since in 1933 the poet Robert Desnos broadcast an epic *Complainte de Fantômas*, set to music by Kurt Weill.[46]

The peculiar fascination of Fantômas for the surrealists has to do with his creation: the authors, Pierre Souvestre and Marcel Allain, undertook to produce more than 380 pages of text a month for 32 consecutive months. The first book appeared in 1911. As the surrealist Philippe Soupault realized, the resultant drivel

[42] Andreas Huyssen, *After the Great Divide: Modernism, Mass Culture, Postmodernism* (Basingstoke: Macmillan, 1986), p. 53.

[43] Jeffrey Weiss, *The Popular Culture of Modern Art: Picasso, Duchamp, and Avant-Gardism* (New Haven and London: Yale University Press, 1994), pp. 107–64.

[44] *Les Biches*, ed. Boris Kochno (Paris: Editions des Quatre Chemins, 1924), no pagination.

[45] Randall Conrad and Georges Franju, 'Mystery and Melodrama: a Conversation with Georges Franju', *Film Quarterly*, 35.2 (winter 1981–2), pp. 31–42, p. 37.

[46] Robin Walz, *Pulp Surrealism* (Berkeley and Los Angeles: University of California Press, 2000), p. 43.

could not have been produced without submission to 'an absolute psychic automatism'.[47] The uncensored nature of Souvestre and Allain's writing made it a mirror of reality in the sense that it is wildly fantastic, rambling, and inconsequential: a waking dream, in which identity is constantly confused, and anyone can be mistaken for anyone else. 'At bottom, all masks and disguises are signs of Fantômas, but Fantômas is simultaneously anyone and no one.'[48] As a purveyor of random death and atrocity, he is a modern myth who stands for the darkness and arbitrary terror of city life, a spectre haunting Paris, and an inadvertent realization of the surrealist project.

A fundamental lack of respect for the police and the state helps to account for the popularity of villain-centred narratives in interwar France. The two apparently egregious exceptions, Simenon's Maigret and Hergé's Tintin, are Belgian, and in France, even when the investigator is the hero, as he is in Feuillade's *Les Vampires*, he tends to be, like Tintin, a journalist. The very different temper of England between the wars is shown by the immense popularity of fictions of order. In the nineteenth century, triumphant villains such as Spring-heeled Jack and Varney the Vampire populated the 'penny dreadfuls', but such figures gradually lost their share of the mass market in the twentieth century. The last bestselling English anti-hero, E. W. Hornung's Raffles, the gentleman thief, acquired a distressing tendency towards Robin-Hood-esque virtue, and he was finally awarded a heroic and redemptive death in the Boer War. By the First World War, the penny dreadfuls had evolved into comics, and the great survivor among nineteenth-century stock characters was on the side of bourgeois righteousness—Sexton Blake.[49]

The reporting of murder and weird incidents (*faits divers*), which also provided grist for the French surrealists' mills, was certainly to be had in England in publications such as the *News of the World*, which had a rising circulation of between two and three million between the wars, but tastes in popular fiction were notably less useful to those of a surrealist temper. Fantômas is realist in its steadfast rejection of the purposive and providential, but although thrillers acknowledge the dangerous and chaotic aspects of city life—typically, gangs of international criminals establish themselves in the heart of the metropolis, unsuspected or for some reason untouchable; drugs are distributed, lives ruined, plots plotted, plans stolen, etc.—the city is mysteriously on the side of right. Some coincidence drops a piece of essential information into the hands of a total stranger, who is enabled, by further coincidence, to bring the gang to justice. Arthur Machen expresses this trope when he writes of 'a street of grey houses and blank walls, and there, for a moment, a veil

[47] Walz, *Pulp Surrealism*, p. 53. [48] Walz, *Pulp Surrealism*, p. 61.

[49] Peter Haining, *The Penny Dreadful: or, Strange, Horrid and Sensational Tales!* (London: Victor Gollancz, 1975); John Springhall, '"Disseminating Impure Literature": The "Penny Dreadful" Publishing Business since 1860', *Economic Historical Review*, 47.3 (1994), pp. 567–84.

seems drawn aside... a clue, tangled if you like, has been placed in our hands; it will be our business to follow it up.'[50] Agatha Christie's *The Man in the Brown Suit* (1924) is a classic example, as is John Buchan's *The Three Hostages* of the same year. Like Machen, Buchan draws attention to the mechanics of coincidence: the reader can trust that the labyrinth will always have clues, which differentiates this type of fiction completely from *Fantômas* and, indeed, from reality.[51]

English popular fiction is thus reflecting its era in a completely different way. It is 'eucatastrophic', a term coined by Tolkien in his *On Fairy Stories* (1947), where it is defined as '[the] Consolation of the Happy Ending. Almost I would venture to assert that all complete fairy-stories must have it'. But eucatastrophe is also essential to thrillers, however gritty the journey to the final resolution. This may in turn suggest that thrillers, like fairy stories, are exploring fears and tensions within a narrative context where the reader can trust in ultimate resolution.[52]

The same eucatastrophic quality characterizes Christie's principal métier, the detective story, which became massively popular at all levels in interwar England. The semi-literate devoured Sexton Blake, highbrows read Dorothy L. Sayers and Cecil Day Lewis, and just about everybody read Christie, who according to the *Guinness Book of Records* is one of the bestselling authors of all time. Sayers, Day Lewis, and many others, took up detective fiction as potboiling. After leaving Oxford, Sayers wrote her first Lord Peter Wimsey story (*Whose Body*, written 1921, published 1923) when she was barely able to maintain her independence with a series of temporary teaching jobs. She was rescued from penury by Benson's advertising agency, and from Benson's by the success of her books.[53] Similarly, it was the stories written as Nicholas Blake, and not his poetry, which allowed Day Lewis to give up schoolteaching and make a living as an author. Rather ironically, it was Christie who initially took up writing for fun.[54]

The point of the detective story is that, like the thriller, it resolves anxiety. Murder can plausibly occur in socio-economic groups otherwise unlikely to be criminal or to experience much crime, but until the murderer is correctly identified, all the potential suspects face social ostracism, and one or more may be in danger of judicial execution. Wherever suspicion may rest in the course of the narrative, the

[50] Arthur Machen, *The Three Imposters* (first published 1897; London: Everyman, 1995), p. 15.

[51] Machen, whose purposes are not those of a thriller writer, in fact allows his evil gang to bamboozle the detectives completely—but nonetheless, the detectives are led to the house where the crime takes place.

[52] Queenie Leavis considered addiction to popular fiction pure escapism, a sort of dope habit (Cunningham, *British Writers of the Thirties*, p. 284). However, if detective stories are urban fairy tales, then they may also be serving some of the purposes of folk literature as described by Bruno Bettelheim in *The Uses of Enchantment* (London: Penguin, 1991, first published 1976).

[53] David Coomes, *Dorothy L. Sayers: a Careless Rage for Life* (Oxford: Lion Publishing, 1992), pp. 76–8.

[54] Agatha Christie, *An Autobiography* (London: Fontana, 1978), pp. 261–6.

reader of a detective story is ultimately left certain that the murderer has been successfully identified, a degree of certainty which did not attend real-life murder trials. The consolatory quality of detective stories, however sanguinary, depends on this certainty: even if the murderer turns out to be the detective, a trick Gladys Mitchell pulls in *A Speedy Death* (1929), or the narrator, they never end with the innocent still under suspicion. The most morally serious detective stories, such as Dorothy Sayers' *The Nine Tailors* (1934), give full weight to the corrosive social effects of inadequately assigned guilt; the stories Cecil Day Lewis wrote under the name of Nicholas Blake, particularly *The Beast Must Die* (1938), while they obey the basic rule of plot construction, express a complex moral sense though the novel as a whole. But popular literary culture in England is thus another aspect of the English preference for self-delusion and fantasy, which may have a bearing on the limited success of modernism in this country and its preference for modern baroque.

While the surrealist reception of *Fantômas* is a salient instance of the influence of mass culture on the French avant-garde, there were other currents flowing between the two. One of the first people to be seriously interested in the democratization of high culture was Jean Cocteau. Throughout the First World War, though parts of northern France and Belgium resembled the wetter circles of hell, the intellectual and social life of Paris continued. Cocteau, unfit for army duty, volunteered for the Red Cross in 1914: he was among those who drove down towards the Battle of the Marne, where half a million men were killed or wounded in less than a week, to care for wounded soldiers with French and German shells screeching overhead.[55] When he was back in Paris, he worked on a journal, *Le Mot*, with Paul Iribe. Much later, he said, 'There were two fronts: there was the war front, and then in Paris there was what now might be called the Montparnasse front.... There was continual coming and going between the war front and the art-war front in Montparnasse.'[56] Cocteau's schizophrenic experience of the war was not unusual for a French non-combatant.

As Kenneth Silver observed, the First World War had a powerful effect on French culture, and favoured the classic over the baroque,[57] since it brought about a new suspicion of 'Munichismus', a catch-all condemnation which covered cubism, Wagner, and the Ballets Russes, among other manifestations, all in the context of a struggle to protect French culture from foreign contaminants, and of a concomitant renewed interest in classicism, which, being Mediterranean in origin, was therefore at the opposite pole from 'Munich'.[58] Jacques-Émile Blanche observed,

[55] Francis Steegmuller, *Cocteau: a Biography* (London: Constable, 1982), p. 125.

[56] Steegmuller, *Cocteau*, p. 149.

[57] Kenneth Silver, *Esprit de Corps: the Art of the Parisian Avant Garde and the First World War, 1910–1925* (Princeton: Princeton University Press, 1989), p. 12.

[58] Jennifer Mundy, *On Classic Ground: Picasso, Léger, de Chirico and the New Classicism, 1910–1930* (London: Tate Gallery, 1990).

'Everyone was running down pre-war *boche* taste.'[59] There seems to have been some uncertainty among French critics as to whether the Germans were too avant-garde or too classical, but what is quite clear is that they had a sound grasp of the principle that the export of taste was economically essential, and they were determined to maintain France's pre-war position as the arbiters of European style. Paul Iribe was to devote a book, *La Choix* (1930), to this issue—a call to arms aimed at French designers.[60]

Despite the 'rappel à l'ordre', the baroque impulses in interwar Paris were not easily quashed, partly because of the importance of music and dance, both of which were highly susceptible to influence from popular art forms. The twenties and thirties were a period in which dancing was an essential form of social interaction for fashionable people. The *Dancing Times* published pages of 'Where to dance in London' each month, listing venues in clubs, hotels, and dance halls. 'You danced whenever and wherever you could'; 'If one wasn't dancing one watched people dancing.'[61]

The popularity of dance-related arts, music hall, revue and ballet, which absorbed more than their fair share of talent, must owe something to the social centrality of dancing, but in France is also connected with the fact that the French ended the war in a state of economic slump. Paris started to fill up with Americans because they had found that dollars went an amazingly long way there: during the financial crisis of 1924–6 there were fifty francs to the dollar, but even in 1920 a dollar was worth over twenty francs.[62] The Americans and English preferentially patronized entertainment which was not dependent on a good understanding of French, or of the intricacies of French culture, for obvious reasons.

Diaghilev found himself in a tricky position towards the end of the war. He needed to modernize the Ballets Russes so it would retain its importance, but his pre-war, orientalist style was identified with 'Munichismus'.[63] Picasso also had problems. As a foreigner in a nation at war he was a conspicuous alien in a sea of khaki, and as a leading cubist he was tarred with the brush of 'Munichismus'. Jean Cocteau, who was determined to emerge at the end of the war as a major artist and arbiter of French culture, proposed a new ballet which would solve everyone's problems. This was *Parade* (1917), choreographed by the Russian Léonide Massine to French music by Erik Satie.[64] Cocteau meant to pique, to surprise, and to charm, or to create the right sort of scandal, in the sense that the *Sacré du Printemps* of 1913

[59] Richard Buckle, *Diaghilev* (London: Hamish Hamilton, 1984), p. 298.

[60] Paul Iribe, *Choix* (Montrouge (Seine): Éditions Iribe, 1930).

[61] Ethel Mannin, *Young in the Twenties* (London: Hutchinson & Co., 1971), p. 31; Lisa Cohen, *All We Know: Three Lives* (New York: Farrar, Straus & Giroux, 2012), p. 257.

[62] William Wiser, *The Crazy Years* (London: Thames & Hudson, 1983), p. 29.

[63] Silver, *Esprit de Corps*, pp. 38–9.

[64] Susan Calkins, 'Modernism in Music and Erik Satie's *Parade*', *International Review of the Aesthetics and Sociology of Music*, 41.1 (June 2010), pp. 3–19.

had been the right sort of scandal: a first-night riot followed by massive publicity and critical success. He miscalculated badly.[65]

The ballet reflected Cocteau's own fascination with variety, circus, jazz, and cinema. 'Parade' is the French for what American showmen called 'ballyhoo', a spiel to draw a crowd, typically illustrated with brief appearances by the performers featured in the show. In the ballet, the managers of a travelling show advertise it to the passing crowd by presenting excerpts on the platform outside, but not a single ticket is sold.[66] The performers include a 'Little American Girl' enacting roles from silent films to a ragtime tune lifted from Irving Berlin,[67] and a Chinese Conjuror, based on the American magician who painted himself up as an oriental and worked under the name Chung Ling Soo. Massine's 'flickering, jerky' choreography was partly inspired by Charlie Chaplin.[68]

Unfortunately, the cubist sets and Managers and the pop-culture elements in the choreography were received as intolerably glib avant-gardism, and therefore 'German', despite the commedia dell'arte references in Picasso's backdrop: a booing audience yelled 'Boche!'[69] Ironically, Picasso's designs for the Managers were evolved from a nineteenth-century woodcut alphabet of the 'Cris de Paris', and were intended to be recognizably French.[70] An appreciation of indigenous popular culture, such as the naïve woodblock *images d'Épinal*, the French equivalent of the English theatre prints loved by the Sitwells, was another feature of the developing wartime aesthetic. Picasso's cubism erased the truth of where the images originated, and the link with popular visual tradition was lost.

Diaghilev took *Parade* off, and scored the success he needed with *Pulcinella*, which had a score by Stravinsky, based on work by the eighteenth-century Italian composer Giovanni Battista Pergolesi, with decor by Picasso, albeit at his most neoclassical. Despite its un-Frenchness, the ballet was much more evidently in a continuum with the commedia dell'arte and traditional forms of representation than *Parade* had been.[71]

Though he personally distrusted mass culture, Diaghilev had to move with the times.[72] After *Parade*, critics detected a palpable change in the structure of his ballets,

[65] Steegmuller, *Cocteau*, p. 188, observes that the avant-garde were not slow to praise it, but it did not achieve the popular success which was needed.

[66] David Drew, 'The Savage Parade – From Satie, Cocteau, and Picasso to the Britten of "Les Illuminations" and beyond', *Tempo*, New Series, 217 (July 2001), pp. 7–21.

[67] 'Ragtime du Paquebot', based on Berlin's 'That Mysterious Rag'; Joseph Machlis, *Introduction to Contemporary Music* (Scranton: W. W. Norton & Co., 1979), p. 215.

[68] Buckle, *Nijinsky*, p. 465. [69] Silver, *Esprit de Corps*, p. 114.

[70] Silver, *Esprit de Corps*, pp. 122–3.

[71] Lynn Garafola, *Diaghilev's Ballets Russes* (Oxford: Oxford University Press, 1990), pp. 90–3; Weaver, *The Crazy Years*, p. 44.

[72] Lynn Garafola, 'Dance, Film, and the Ballets Russes', *Dance Research*, 16.1 (summer 1998), pp. 3–25: 'Just as in his early days as an impresario he insisted on identifying his company exclusively with "high art" venues and audiences and dissociating it from the "popular" ballet tradition linked to music hall and

a shift away from dramatic narrative to short sketches, and a tendency to divide the dancing into 'turns'—characteristic of music hall and revue.[73] André Levinson, perhaps the most influential ballet critic in France, complained: 'In his acrid search for modernity of subject and form, M. Diaghilev becomes more and more the tributary of the circus and the music hall.'[74]

Diaghilev was not the only person in Paris trying to build bridges between popular art and music and high culture. Rolf de Maré's short-lived Ballets Suédois (1920–5) was another dance-based enterprise in Paris which drew heavily on the circus and other popular art forms, with de Maré's lover, Jean Borlin, as sole choreographer and principal dancer. De Maré and Borlin had nothing like the Ballets Russes's range of dance talent at their disposal, but on the other hand, unlike Diaghilev, they had a great deal of money. Cocteau promptly involved himself with the rival enterprise and brought his friends and associates on board as well. Ballets Suédois performances, such as Cocteau's *Les Mariés de la Tour Eiffel*, were 'a mixture of acrobatics, cabaret, circus, comedy, dance, drama, magic, music-hall and pantomime'.[75]

Other interesting Ballets Suédois projects explored contemporary strains in Parisian culture which were anything but orderly and classical. *La Création du Monde* (1923) was a response to contemporary fascination with Négritude, based on African origin myths and danced in costumes evoking African art.[76] The score was by Darius Milhaud, and influenced by American jazz; Lambert comments, 'The whole work and in particular the final section, with its brilliant blending of themes, is a most remarkable example of the compromise possible between popular idiom and sophisticated construction.'[77] *Relâche* in some ways answered or extended *Parade*; the composer was, again, Satie, and the designs were by the Dadaist Picabia. 'Relâche' is the conventional billboard notice indicating that the theatre in question is closed. Since the Managers of *Parade* failed to sell any tickets, 'relâche' presumably followed.[78]

spectacle shows, so he took pains throughout his career to restrict the use of film and cinematic borrowings' (p. 4).

[73] Garafola, *Diaghilev's Ballets Russes*, p. 136.

[74] *André Levinson on Dance*, ed. Joan Acocella and Lynn Garafola (Hanover and London: Wesleyan University Press, 1991), p. 66.

[75] Nancy van Norman Baer, *Paris Modern: the Swedish Ballet, 1920–1925* (San Francisco: Fine Arts Museum of San Francisco, 1995), p. 13.

[76] Judi Freeman, 'Fernand Léger and the Ballets Suédois: the Convergence of Avant-Garde Ambitions and Collaborative Ideals', *Paris Modern*, ed. Baer, pp. 86–107, and Richard Brender, 'Reinventing Africa in their Own Image: the Ballets Suédois "Ballet nègre", "La Création du monde"', *Dance Chronicle*, 9.1 (1986), pp. 119–47. On the context of avant-garde interest in African music, art, and myth, see Petrine Archer-Shaw, *Negrophilia: Avant-Garde Paris and Black Culture in the 1920s* (London: Thames & Hudson, 2000), pp. 60–2.

[77] Lambert, *Music, Ho!*, pp. 218–19.

[78] William Camfield, 'Dada Experiment: Francis Picabia and the Creation of Relâche', *Paris Modern*, ed. Baer, pp. 128–39. David Drew, 'The Savage Parade – From Satie, Cocteau, and Picasso to the Britten of "Les Illuminations" and beyond', *Tempo*, New Series, 217 (July, 2001), pp. 7–21.

The knowingness and self-consciousness of Ballets Suédois events are also suggested by their version of an opening-night scandal: a riot at the premiere of the American George Antheil's *Airplane Sonata*, *Sonata Sauvage*, and *Mechanisms*. It was filmed, and the arrival of the cameras was far from adventitious: Margaret Anderson, editor of *The Little Review*, engineered the dust-up because her intimate friend, the actress Georgette Leblanc, needed a riot scene for the movie she was shooting, *L'Inhumaine*, and couldn't afford to stage one.[79]

In 1925 another indication of the way the post-war world was changing is that Rolf de Maré bought an iconic building strongly associated with the Ballets Russes, the Théâtre des Champs-Élysées, and turned it into a music hall. 'High culture would not be excluded, merely democratised,' he announced.[80] *Relâche* was staged there, after which the Ballets Suédois was disbanded. Seven months later, de Maré staged the sensational *Revue Nègre*, which brought Josephine Baker to Paris, and inaugurated the French 'Tumulte Noir'.

Baker, like Chaplin, used her body with a unique expressiveness, in her case in semi-improvised jazz dance, very different from the dancing which resulted from classical training (see Figure 8). However, George Balanchine, Diaghilev's principal choreographer at the time, was quite prepared to learn from her, and she from him: thus even the Ballets Russes did not hold itself aloof from what was patently a major new development.[81] Mathilde Butkas observes that 'there is evidence that Balanchine not only choreographed for, danced with and admired Baker, but most importantly that the two traded material, with Baker learning to dance *en pointe* and Balanchine absorbing her jazz style.'[82] There is a very great difference between the improvised dance of Josephine Baker and the work of a ballerina, based on a highly precise physical training, but both could learn from one another. While Balanchine was teaching Baker the basic elements of classical dance, conversely the black American Buddy Bradley taught Alicia Markova to do the 'snake-hips' for the Camargo Society's *High Yellow* (1932) and worked with Frederick Ashton on several other occasions.[83]

The circus also contributed to the eclecticism which I am defining as an aspect of modern baroque. Jean Cocteau is, again, a pivotal figure in this. His mother complained in 1920 that 'Jean is exhausted by the show he is organizing at the

[79] Adrienne Monnier, *The Very Rich Hours of Adrienne Monnier*, ed. Richard Macdougal (New York: Charles Scribner's Sons, 1976), pp. 247–8.

[80] Phyllis Rose, *Jazz Cleopatra: Josephine Baker in her Time* (London: Vintage, 1991), p. 17.

[81] Juliet Bellow, 'Balanchine and the Deconstruction of Classicism', *Cambridge Companion to the Ballet* (Cambridge: Cambridge University Press, 2007), p. 237, notes: 'Audiences of the 1920s saw in Balanchine's work an aggressive, even violent anti-classicism: an eagerness to "abuse" ballet by splicing it with modern and popular dance, vaudeville and gymnastic routines.'

[82] 'George Balanchine', *Cambridge Companion to the Ballet*, p. 227.

[83] Julie Kavanagh, *Secret Muses: the Life of Frederick Ashton* (London: Faber & Faber, 1996), pp. 150, 153, 157.

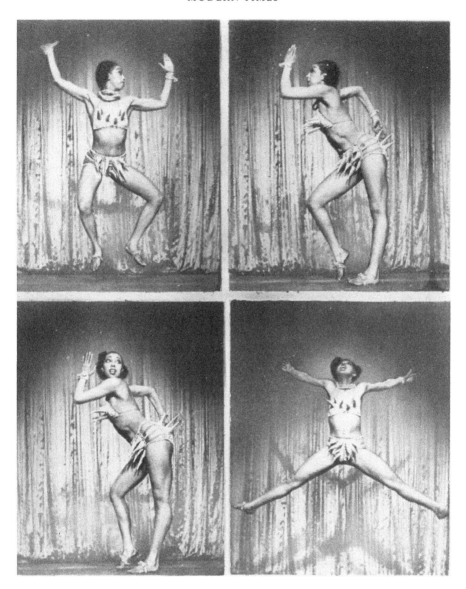

Figure 8 Josephine Baker, fetishistically costumed for the 'Island in the West Indies' number in the *Ziegfeld Follies* (1938) by Vincente Minnelli; her dances were choreographed by George Balanchine. Photographer: unknown. © Billy Rose Theatre Division, The New York Public Library for the Performing Arts, Astor, Lenix, and Tilden Foundations.

Théâtre des Champs-Élysées with the Médrano clowns, les fils Footit, Darius Milhaud, Poulenc and Auric,' a line-up eclectically assembled from the high and low culture of contemporary Paris: three of the modernist composers known collectively as 'Les Six', and Paul, François, and Albert Fratellini, famous French clowns who worked for the Cirque Medrano and got involved in avant-garde projects. George Footit, an Englishman, was a very famous Cirque Medrano clown of the previous generation, and Mme Cocteau has confused the names.[84] Cocteau's show was *Le Boeuf sur le Toit*, a surrealist ballet with a score by Milhaud, strongly influenced by Brazilian popular music. By 1923 the Fratellini brothers were the toast of Paris, admired by the general public and by Raymond Radiguet and Jean Cocteau, both of whom created characters based on the Fratellinis. Edith Sitwell adored the Fratellinis, and said, 'Music halls delight me, and circuses still more.'[85]

The death of Diaghilev and the Wall Street Crash, both of which occurred in 1929, marked the end of an era. Ballet, having lost its wily presiding genius, lost ground as an art form, and Americans were no longer rich. For these and other reasons, English culture in the thirties was more independent of developments in Paris. In this new climate, a superficially unlikely saviour for a synthesis of high and low culture appeared in London: Charles B. Cochran (1872–1951). The baton which Cochran took up from Diaghilev was the mainstreaming of modernism. A Cochran revue was an arena where high culture could find a mixed and fashion-conscious audience. While 'Mr Cochran's Young Ladies' were very different from Diaghilev's *corps de ballet*, as was Cochran himself from the aristocratic Diaghilev, he was, like the Russian, an idealist, completely serious about putting major plays, and stars, in front of an audience and about employing the best available talent. His record speaks for itself. The first play he ever staged was Ibsen's *John Gabriel Borkman*. He put on Sean O'Casey's *The Silver Tassie*, an attack on imperial war-making, in 1929, when the Abbey Theatre refused to touch it. He had, like Diaghilev, great faith in his own judgement and an extraordinary ability to raise money: he is probably the only man to have left an English bankruptcy court to a chorus of 'For he's a jolly good fellow' from his creditors.[86]

Cochran also resembled Diaghilev in being alert to new artists as well as new musicians and writers, though he was even less scrupulous than the Russian: he got onto Cecil Beaton as early as 1926, looked at his sketches, and pirated some designs; this was a valuable learning experience for Beaton, who never again showed his work without a contract in place.[87]

Cochran's career shows a canny balancing of money-spinners and shows mounted from more exalted motives. In 1921 he put on a revue called *League of*

[84] Steegmuller, *Cocteau*, p. 240.
[85] Richard Greene, *Edith Sitwell, Avant-Garde Poet, English Genius* (London: Virago, 2011), p. 170.
[86] Harding, *Cochran*, p. 106. [87] Vickers, *Cecil Beaton*, p. 66.

Notions, a one-woman show from the legendary Sarah Bernhardt, and ten weeks of the Ballets Russes (on which he lost £5,000 and was, he said, proud to do so).[88] In 1923 he offered Londoners another elderly theatrical legend, the Italian actress Eleanora Duse, and also *Dover Street to Dixie*, the first show to put an all-black cast in front of a London audience. It was his star Florence Mills, not Josephine Baker, who awakened English aesthetes to black American music and dance.[89] She was potentially a star of the first magnitude, but tragically died of appendicitis in 1927. In 1929 *The Silver Tassie* was supported by Cole Porter's *Wake Up and Dream*. Cochran was a showman to the core, but if there is an opposite of dumbing down, he was its embodiment.

Cochran established the London Pavilion at Piccadilly Circus as London's home of revue, which, in his hands, was highly sophisticated entertainment. Gilbert Seldes, editor of the seminal modernist magazine, *The Dial*, but a doughty defender of popular culture, declared, 'A revue is a modern baroque phenomenon...the good revue pleases the eye, the ear, and the pulse; the very good revue does this so well that it pleases the mind.'[90] Cochran's revues were of this kind. Throughout the 1920s and 1930s the first night of a new Cochran revue was an annual theatrical highlight and a major social occasion. The shows included ballet: though Noël Coward was the principal author of the 1925 revue *On with the Dance*, it also featured three pieces by Leonide Massine, one of which was *The Rake*, based on Hogarth types, to a score by Roger Quilter, with scene and costumes by William Nicholson—not names one would readily associate with revue. It followed one of Coward's best-known songs, 'Poor Little Rich Girl', sung by Alice Delysia, Hermione Baddeley, et al.[91]

While, as *On with the Dance* suggests, Ballets-Russes-trained dancers were prepared to work in revue while Diaghilev was still alive, after his death Cochran's patronage of classical dance was essential to dancers' survival. Before ballet companies could offer year-round employment, many dancers appeared in revue between their ballet engagements, or even after them. Cochran staged a late-night 'Song and Dance Show' in the Grill Room of the Trocadero, half a dozen musical numbers interspersed with dancing; dancers could therefore perform in a legitimate ballet and rush over to Shaftesbury Avenue to give another performance

[88] Gareth Thomas, 'Modernism, Diaghilev and the Ballets Russes in London', 1911–1929', *British Music and Modernism, 1895–1960*, ed. Matthew Riley and Paul Rodmell (Aldershot: Ashgate, 2010), pp. 67–91, p. 75.

[89] Shead, *Constant Lambert*, p. 40: the pianist Angus Morrison said, 'Florence Mills brought tears to one's eyes purely by the quality of her voice and the sincerity of her acting'. Gilbert Seldes similarly observed that 'Florence Mills, who died very young, is, after all these years, a great person in the memory of all who ever saw her....When she sang, the whole of her person was engaged, so that even if I cannot remember her voice, I am still under the spell of her singing.'

[90] Gilbert Seldes, *The Seven Lively Arts* (New York: Harper & Bros., 1924), pp. 132–3.

[91] Valerie Langfield, *Roger Quilter: His Life and Music* (Ipswich: Boydell & Brewer, 2002), p. 74; Leslie Norton, *Leonide Massine and the 20th Century Ballet* (Jefferson, NC: McFarland & Co. Inc., 2004), pp. 101–2.

at midnight. Richard Shead, biographer of Constant Lambert, commented that the Camargo Society 'bridged the gap between the collapse of the Ballets Russes and the establishment of the Vic-Wells Ballet', and that is true in one sense, but it was working for Cochran that actually made it possible for dancers to survive financially.[92]

The ballets in Cochran's revues were sometimes surprisingly avant-garde. In 1930, the post-Diaghilev doldrums, his revue included a short ballet called *Luna Park, or The Freaks*, with a book by Diaghilev's erstwhile secretary, Boris Kochno, music by Lord Berners, and designs by the English painter Christopher Wood. Ex-Diaghilev dancers Alice Nikitina and Serge Lifar danced The One-Legged Woman and The Six-Armed Man respectively. Self-evidently, six years before the first London Surrealist Exhibition, this ballet introduced English audiences to a surrealist aesthetic.[93] Other new short ballets which were staged in Cochran revues were to new music by Cocteau's friend Henri Sauguet and by William Walton, with designs by Christian Bérard and Cecil Beaton respectively. George Balanchine also worked for Cochran on a number of occasions.

Osbert and Sacheverell Sitwell were happy to work for Cochran, but otherwise Cochran's English connections were with music and the visual arts, which have tended to obscure his real importance for critics and cultural commentators. The absence of a connection between Cochran and higher literary culture in England was not the fault of the impresario, whose openness to staging serious drama is beyond doubt. James Laver, the costume historian, who was on the fringe of the Bloomsbury set, published a frivolous novel called *Nymph Errant* in 1932, which formed the basis for a successful show with music by Cole Porter in the following year, but the serious writers of the day were not interested in experimenting with commercial theatre. One of the few people with a foot in both camps was Ashley Dukes, a playwright and friend and collaborator of both T. S. Eliot and W. H. Auden; he was married to Marie Rambert, and subsidized her work.

Of Eliot's theatre work of the interwar period, *Sweeny Agonistes* was privately produced, and was performed as a double bill with Auden's *The Dance of Death* by the Group Theatre at the Westminster Theatre on 1 October 1935,[94] *The Rock* and *Murder in the Cathedral* were the result of persuasion from the Bishop of Chichester and consequently staged in an uncommercial context. Ironically, the first London performance of *Murder in the Cathedral* was at the tiny Mercury Theatre, built by Rambert and Dukes and paid for by Dukes's successful play *The Man with the Load of Mischief*,

[92] Richard Shead, *Constant Lambert* (London: Simon Publications, 1973), p. 49.

[93] Harding, *Cochran*, p. 133.

[94] See Michael Sidnell, *Dances of Death: the Group Theatre of London in the Thirties* (London: Faber & Faber, 1984).

which had been staged at the Haymarket.[95] Equally, Auden's plays, *Paid on Both Sides* and *The Ascent of F6*, were aimed at a coterie audience.

All of this suggests that the English writers of the thirties who wanted to communicate with a wider audience did not include West End theatregoers in their definition of 'people'. Their purposes were therefore better served by collaborations with documentary film-makers such as Humphrey Jennings, and perhaps their most enduring monument is the famous *Night Mail* (1936), with words by W. H. Auden and music by Benjamin Britten.

[95] Kavanagh, *Secret Muses*, p. 62.

Streams of Consciousness

I ris Murdoch once took issue with modernist literature on the grounds that it sought to escape from history and to cancel the idea of progress through time in favour of 'the timeless non-discursive whole which contains its meaning in itself'—that is to say, she objected to the typical modernist preoccupation with interrogating the medium.[1] However, high modernism in literature was more receptive to the interplay of a classical tradition with the present than other modernist art forms. The Futurists and Dadaists did indeed attempt to start from the present, and there are major modernist prose writers—among them Kafka, Beckett, Lawrence, Woolf, and Dorothy Richardson—whose writing focuses on the present moment or on alienated conditions experienced in the present. But first-wave modernists, the 'men of 1914' (Ezra Pound, Wyndham Lewis, T. S. Eliot, and James Joyce) were far from wishing to declare a Year One.

The gigantic oeuvre of James Joyce is undoubtedly a response to modernity, but its complex and playful relation with the language and literature of the past, such as the recapitulation of the *Odyssey* in *Ulysses*, and its fascination with popular culture, suggest that literary modernism is qualitatively different from modernism in the visual arts.[2] Eliot argued that the overt intertextuality of *Ulysses* with its classical model was an essential key to writing non-realist fiction, because it suggested a way of creating a classical art out of the materials of the modern world. 'The mythic method' was not 'an amusing dodge, or scaffolding erected by the author for the purpose of disposing his realistic tale', but 'a way of controlling, of ordering, of giving a shape and a significance to the immense panorama of futility and anarchy which is contemporary history.... It is, I seriously believe, a step toward making the modern world possible for art.'[3]

[1] Astradur Eysteinsson, *The Concept of Modernism* (Ithaca and London: Cornell University Press, 1990), p. 13, and Iris Murdoch, 'The Sublime and the Beautiful Revisited', *Yale Review* 49 (Dec. 1959), pp. 247–71, p. 260.

[2] Christopher Butler, 'Joyce the Modernist', in *The Cambridge Companion to James Joyce*, ed. Derek Attridge (Cambridge: Cambridge University Press, 1990), pp. 67–86, esp. p. 74.

[3] T. S. Eliot, '*Ulysses*, Order, and Myth', *The Dial*' (Nov. 1923), in *Selected Prose of T. S. Eliot*, ed. Frank Kermode (New York: Harcourt, 1975), p. 178.

Eliot's own poetic praxis, like that of Ezra Pound, similarly uses mythological archetypes, for example in 'Sweeney Agonistes', to give form, but he also draws upon contemporary popular culture, though his borrowings are deployed to express the chaos of values in culture, not its energy. The notorious bricolage of *The Waste Land*, for example, not only includes snippets of material culled from revenge tragedy, Shakespeare, Wagner, the Bible, Baudelaire, Virgil, and Dante, but also material from children's songs, ragtime, and ephemera such as the 'Mrs Porter' song, a parody of a sentimental 'Indian ditty' sung by Australian soldiers fighting at Gallipoli. Jazz, vaudeville, and music hall were all among Eliot's personal enthusiasms. His interest in jazz comes through more strongly in the verbal rhythms of 'Sweeney Agonistes', especially in its account of a murder, partly narrated through a comic song.

The problem with modernist fiction is that, unlike the situation in other arts, where cubism *could* become a style and ballet could cross-fertilize with jazz dance or clowning, there was no natural connection between the writing of the avant-garde and the mass market, yielding the paradox which Clement Greenberg seems to take for granted—that anything popular wasn't culture, and anything which was culture wasn't popular.[4] Joyce and Wyndham Lewis did not, and could not, affect the development of popular fiction. The literary modernism of the 'men of 1914' lies above all in its elusiveness, which was a point of principle. Eliot declared that modern poets 'must be *difficult*', acknowledging, or even insisting upon, the gap between literary modernism and the common reader.[5] While the work may have elements of the eclectic, referential, and accreted, and to that extent partake of a baroque spirit, like most forms of modernism, and classicism, it controls and limits its audience: in this case, by positioning them on the wrong side of a glass wall of linguistic difficulty. As Strychacz observes, 'esoteric knowledge keeps the mass public at arms' length', and that includes esoteric style.[6] High modernist writing is addressed exclusively to a small, highly educated coterie. Subscriptions to Eliot's journal *Criterion*, where many of Pound's *Cantos* were first printed, never reached more than 500. By contrast, Auden, though he is often hard to comprehend fully due to the presence of coded subtexts, offers little difficulty with the basic act of attaching meanings to words, as the poems of Pound and Eliot so often do.

The most fruitful aspect of high modernism for writers who were more interested in storytelling than formal experiment was the mythic parallelism which Eliot suggested was the key to Joyce. Its usefulness, however, may have derived from the fact that an interest in mythic archetypes was also championed by two

[4] Clement Greenberg, 'Avant-Garde and Kitsch', *Partisan Review*, 6.5 (1939).
[5] Valentine Cunningham, *British Writers of the Thirties* (Oxford: Oxford University Press, 1989), p. 298.
[6] Thomas Strychacz, *Modernism, Mass Culture and Professionalism* (New York: Cambridge University Press, 1993), pp. 25–6.

individuals whose ideas were much more accessible, Freud and Frazer. Sigmund Freud used mythological figures such as Oedipus and Electra to explain personal identity formation, and James G. Frazer's almost equally influential anthropological study, *The Golden Bough*, used classical myths and legends to explain social structures. The work of both men was more susceptible to popular redaction than that of Joyce, even if the latter's work had been readily available, which, as a banned book, it was not.

The influence of Freud and Frazer is to be found both on literary fiction and on more popular writing. The poet and novelist H.D., for example, looked to ancient Greece for archetypes.[7] She was, on the one hand, a member of Ezra Pound's circle, and, on the other, a personal friend of Freud and deeply convinced by him. When she turned to the legends and culture of ancient Greece to give external form to her prose writing in works such as *Palimpsest* and *Hedylus*, and also translated from, and responded to, ancient Greek drama, the impulse might equally well be considered Poundian or Freudian. More probably, it was both, with an additional helping of Jane Ellen Harrison's *Prolegomena to the Study of Greek Religion* and *Themis*.[8] Mary Butts, similarly, was a passionate Hellenist, deeply interested in Greek religion, and Harrison's books were central to her work.[9] Naomi Mitchison's *The Corn King and the Spring Queen* (1931) is also fundamentally Frazerian/Harrisonian.[10] In Mitchison's invented Black Sea kingdom of Marob, the king and queen embody the fertility of the land, and engage in an annual cycle of sacred drama. Their story becomes entangled with that of Sparta, where King Kleomenes III has taken the land into state ownership and distributed it to citizens in equal shares, while also opening up citizenship to Sparta's subject race, the helots. Unlike the Marob strand of narrative, that of Sparta bears some relationship to historical fact, though presented in a way which stresses parallels with the Russian Revolution. Kleomenes and his revolution are agonizingly defeated by a combination of vested interests within Sparta and external pressure from more powerful kingdoms. Since Mitchison was a committed socialist, who visited the Soviet Union in 1932, she is evidently using a moment in ancient history to examine communism in her own time and to explore the odds against the creation of a genuinely egalitarian society. Examining the present through the past is a central baroque rhetorical device. Other modernist women also turned to the distant past for parallels with the present. In a considerably less

[7] Deborah Kelly Kloepfer, 'Fishing the Murex Up: Sense and Resonance in H.D.'s *Palimpsest*', *Contemporary Literature*, 27.4 (winter 1986), pp. 553–73, p. 557.

[8] Mary Beard, *The Invention of Jane Ellen Harrison* (Cambridge, MA: Harvard University Press, 2000), p. 8.

[9] Natalie Blondel, *Mary Butts: Scenes from the Life* (Kingston, NY: MacPherson & Co., 1998), p. 22.

[10] Butts admired it enormously: Blondel, *Mary Butts*, p. 268. Reviewers perceived affinities with her own historical fiction (p. 380). On Butts and Mitchison, and also Laura Riding, Phyllis Bently, Bryher, and Mary Renault, see Ruth Hoberman, *Gendering Classicism: the Ancient World in Twentieth Century Women's Historical Fictions* (New York: SUNY Press, 1997).

thought-through fashion, Mina Loy's poem *Lunar Baedeker* layers cocaine, Broadway shows, and pharaonic Egypt in a manner suggesting the influence of T. S Eliot. Her visual referents are variously described as white, silver, black, crystal, and glassy, all key terms in interwar aesthetics.

The 'men of 1914' show distinct symptoms of a neoclassical spirit. They called for a hard, emotionless, and impersonal masculinist literature, and decried writing which indulged in expressions of unconscious and subjective experience.[11] Their work was profoundly influential. Pound, as Lawrence Rainey points out, was successful in establishing himself as the ultimate authority on contemporary verse, and it was due to their trust in Pound's judgement that *The Waste Land* was defined as *the* great modern poem and fought over by would-be editors, none of whom had actually read it.[12] The 1923 Boni and Liveright edition sold 5,000 copies, and Eliot made something like $800 from his poem,[13] making it the first work of modernist literature to be financially as well as critically successful.

The literature of the twenties gives repeated testimony to the importance of *The Waste Land*. Since *Ulysses* could only be obtained by smuggling a copy out of Paris, its influence was inevitably indirect.[14] Both Waugh in *Brideshead Revisited* and Osbert Lancaster in his Oxford memoir stress that avant-gardists seized on Eliot's poem as the manifesto of their kind. Peter Quennell recalled the undergraduate Harold Acton reciting the entire poem at a Conservative Party garden fête in 1923, with manifestly provocative intention.[15] The aesthetes of the twenties, such as Waugh and his circle, were followed by the 'Auden generation', who were more politically minded, but also powerfully influenced by Eliot.

Coming to be recognized as one of the 'writers of the day' presented a different problem to that of becoming a well-known painter or photographer. Writers were less directly dependent on patronage than visual artists, because their art could be practised in the leisure hours of schoolmastering, journalism, or office work, though Joyce and Lawrence were dependent on patrons, and Lytton Strachey lived on his friends and relations till he was 38.[16] Where patronage loomed largest for most writers was not so much in the context of paying the rent as in that of getting published, reviewed, and recognized. Connections through family and, above all, through public schools and universities sorted the insiders from the outsiders quite efficiently.

[11] Monika Faltejskova, *Djuna Barnes, T. S. Eliot and the Gender Dynamics of Modernism* (New York and Abingdon: Routledge, 2010), p. 1.

[12] Lawrence S. Rainey, *Revisiting The Waste Land* (New Haven and London: Yale University Press, 2005), pp. 71–101, p. 82.

[13] Rainey, *Revisiting*, pp. 86, 100. Eliot also received the $2,000 Dial Award.

[14] Osbert Lancaster, *With an Eye to the Future* (London: John Murray, 1968), p. 86.

[15] Samuel Hynes, *The Auden Generation* (Princeton: Princeton University Press, 1972), p. 26.

[16] Virginia Nicholson, *Among the Bohemians: Experiments in Living, 1900–1939* (London: Penguin, 2003), gives many other examples.

Hope Mirrlees's *Paris* illustrates this. In 1919, as a multilingual Newnham graduate and the star pupil of Jane Ellen Harrison, with connections in both Cambridge and Bloomsbury, she published a long poem—which she described as an 'aural kaleido-scope'—expressive of walking through Paris on 1 May 1919, when both a general strike and the Paris Peace Conference were in progress. It is a cascade of sensory impressions, snatches of speech, machine noises, memories, music, items for sale (from chestnuts to antiques), advertising, street signs, people in cafés, smells such as sewage, face powder, tobacco, and car tyres.[17] Written with the detached enjoyment of the flâneuse, and influenced by Guillaume Apollinaire and other French writers, it is less sophisticated than *The Waste Land*, which appeared four years later, and, though it is haunted by the French war dead, much less nihilistic, but there are obvious connections of approach between her poem and Eliot's.

Furthermore, *Paris* shares both the recreation of a specific day, and a marked indebtedness to the literature of ancient Greece, with *Ulysses*, which had begun to appear serialized in *The Little Review* when Mirrlees was writing. The first section appeared there in March 1918 and the last in December 1920, though the book was not published in full until 1922. Like *Ulysses*, Mirrlees's poem does not lack for solid intellectual underpinning, since it is shaped by the very widely received research of Jane Ellen Harrison on the *Anthesteria*, the ancient Greek spring festival of Dionysus, celebrated by the 'spring songs' from which tragedy as a genre ultimately sprang. Mirrlees was thus employing the 'mythic method' four years before it was advocated by Eliot.[18] John T. Connor suggests that Mirrlees's poem explores the shortcomings of the modernist poet's individual voice as against the collective and cathartic context of dithyrambic poetry in ancient Greece, of which she had a profound knowledge.[19]

Mirrlees's *Paris* was, like *The Waste Land*, published by the Woolfs' Hogarth Press. However, when they met, Virginia Woolf found the younger woman attractive, confident, fashionable, dismayingly erudite, and rather intimidating. She wrote to her friend Margaret Llewelyn Davies, 'She knows Greek and Russian better than I do French; is Jane Harrison's favourite pupil, and has written a very obscure, indecent and brilliant poem, which we are going to print. It's a shame that all this should be possible to the younger generation; still I feel that *something* must be lacking.'[20] The edition was of 175 copies and sold reasonably well, though the reviews were poor.

[17] Julia Briggs, 'Hope Mirrlees and Continental Modernism', *Gender in Modernism: New Geographies, Complex Intersections*, ed. Bonnie Kime Scott (Urbana and Chicago: University of Illinois Press, 2007), pp. 261–303; Bruce Bailey, 'A Note on *The Waste Land* and Hope Mirrlees' *Paris*', *T. S. Eliot Newsletter*, 1 (spring 1974), p.4. See also Hope Mirrlees. *Collected Poems*, ed. Sandeep Parmar (Manchester: Carcanet Press, 2011).

[18] Eliot, '*Ulysses*, Order and Myth', p. 178.

[19] John T. Connor, 'Hope Mirrlees and the Archive of Modernism', *Journal of Modern Literature*, 37.2 (winter 2014), pp. 177–82, p. 179.

[20] *The Question of Things Happening: the Letters of Virginia Woolf*, II: 1912–1922, ed. Nigel Nicolson (London: Hogarth Press, 1976), pp. 384–5.

An anonymous review in *The Athenaeum* called the poem 'immensely literary and immensely accomplished' and suggested, quite shrewdly, that its context was somewhere 'between Dada and the *Nouvelle Revue Française*'. But it gave Mirrlees no encouragement to experiment further. A reference to 'clear, witty vision' is balanced against one to 'quite superfluous pedantry', and it neither says nor implies that she was a writer of promise.[21] The *Times Literary Supplement* said flatly, 'It is certainly not a "Poem".'[22]

Eliot was intellectually persuaded by the work of Jane Ellen Harrison. He wrote a Harvard graduate paper on her second book on Greek religion, *Themis*.[23] He also regarded the household of Hope Mirrlees's mother as a home from home, and knew Mirrlees well. Nonetheless, she did not discuss her poem with him and never discovered if he had read it—though, since it was published by the Hogarth Press, it would have been very strange if he had not.[24] Yet he did not choose to review her poem (unless he did so anonymously), or even to acknowledge that it had been published. The gatekeepers of literary modernity followed his example in ignoring her.

Women, historically, have been highly sensitive to this sort of discouragement unless they have had alternative support. Bloomsbury, as Woolf's reaction to Mirrlees suggests, did not perceive her as 'one of us', and she seems to have been unimpressed by Natalie Barney, which was rash of her, since Barney's coterie in Paris was by far the most powerful alternative group of opinion-formers for an ambitious woman.[25] Unfortunately for her, Mirrlees naïvely failed to realize that a position on the inside needed to be negotiated by the poet, not by the poem. She was not the only woman to find herself on the wrong side of the gate: Mary Butts, who was disliked by the Bloomsbury set on several counts, wrote a novel—*Armed with Madness*—which shares *The Waste Land*'s Grail theme, stylistic adventurousness, and use of embedded quotations, but challenges its nihilism and misogyny. It received mixed, largely perplexed reviews, and disappeared from sight, as did she.[26] She lacked what Thomas Strychacz called the 'capacity to *stay news*', because there was no one, after her early death, to promote her, and there were several people who positively preferred her to be forgotten, for personal reasons.[27]

[21] *The Athenaeum* (21 May 1920), p. 686. [22] *Collected Poems*, ed. Parmar, p. xxxix.

[23] Beard, *The Invention of Jane Ellen Harrison*, p. 8.

[24] Michael Swanwick, *Hope-In-The-Mist: the Extraordinary Career and Mysterious Life of Hope Mirrlees* (Upper Montclair, NJ: Temporary Culture/Henry Wessells, 2009), p. 49; Bailey, 'A Note on *The Waste Land*', p. 5.

[25] Julia Briggs, 'Hope Mirrlees', *Oxford Dictionary of National Biography*.

[26] Jennifer Kroll, 'Mary Butts' "Unrest Cure" for *The Waste Land*', *Twentieth Century Literature*, 45.2 (summer 1999), pp. 159–73, p. 170.

[27] Thomas Strychacz, *Modernism, Mass Culture and Professionalism* (New York: Cambridge University Press, 1993), p. 165. As he points out (p. 138), women were significantly more likely to drop out of the canon than men. With respect to Butts's posthumous reputation, see Kroll, 'Mary Butts' "Unrest Cure"', p. 160.

This retrospectively obvious division between insiders and outsiders explains why the trajectory of critically well-received writers from 1914 to the 1930s is, to a very great extent, an apostolic session from one generation to another of Oxbridge and Harvard men. The 'men of 1914' gave way to Men of the Twenties, then to Men of the Thirties, each generation of men in turn pronouncing on what literature should and should not be, and frequently pronouncing that one thing it should be is 'masculine'. Pound, Eliot, and Lewis were among those who declared war on the perceived 'feminization' of literature.[28] It is only since the 1980s that the fact that, through the twenties and thirties, literature and criticism were controlled by Oxford- and Cambridge-educated male intellectuals, much given to manifestos, magazines, and the compulsive construction of canons, has been taken up for question and examination in itself.[29]

One aspect of all the scoring and ranking which went on, much clearer now than it was at the time, is the extent to which it replicated public school and university behaviour patterns, not least in being profoundly homosocial. The vertiginous hierarchies of public-school life were so genuinely formative that it was hard for those thus formed to understand other ways of coming to maturity. And out of that experience came the unexamined assumption that only men were originators, and that women's writing was inevitably derivative or uninteresting.

Women writers were well aware of this. Stevie Smith reacts pithily to the guardians of modern English poetry in a poem called 'The Choosers':

> It is because it is like the school they never forget,
> So-and-so must be the driven out one, this the pet.[30]

In the third of her novels, she writes: 'I felt a contempt for this...hysteria of a masculine *agape* that runs through our English literature and through our life too.'[31] Queenie Leavis similarly observed the closeness of England's literary circles: 'The odious spoilt little boys...move up in a body to the universities to become inane pretentious young men, and, still essentially unchanged, from there move into the literary quarters vacated by the last batch of their kind.'[32]

[28] Wayne Kostenbaum, 'The Waste Land: T. S. Eliot's and Ezra Pound's Collaboration on Hysteria', *Twentieth Century Literature*, 34.2 (summer 1988), pp. 113–39, p. 120. See also Monika Faltejskova, *Djuna Barnes, T.S. Eliot and the Gender Dynamics of Modernism* (New York and Abingdon: Ashgate, 2010), p. 16: 'We are yet to be convinced that any woman ever invented anything in the arts.'

[29] The competitive side of literary modernism is explored by Lawrence Rainey, *Institutions of Modernism: Literary Elites and Public Culture* (New Haven: Yale University Press, 1998), and canon construction by Aaron Jaffe, *Modernism and the Culture of Celebrity* (Cambridge: Cambridge University Press, 2005).

[30] *Collected Poems*, p. 376. Reproduced by permission, Estate of James MacGibbon.

[31] *The Holiday*, p. 67.

[32] Cunningham, *British Writers of the Thirties*, p. 149, quoting 'The Background of Twentieth Century Letters', *Scrutiny*, 8 (June, 1939).

Where one might look for a modern baroque in interwar writing is not so much by contrasting an engagement with a classical tradition with a focus on the present moment, since both are part of mainstream modernism, as by looking at writing which is extra-canonical, alternative, subjective, parodic, camp, artificial, fantastical in subject matter, or copious in invention. Given the effectiveness with which literary orthodoxy was policed and the unexamined assumptions on which it was based, it is hardly surprising to find that the baroque strain in interwar fiction, in the sense defined above, is often an expression of alterity; and, in particular, an expression of sex- or gender-based heterodoxy.

Other alterities, of race and class, were less important to the development of interwar baroque fiction, at least in Europe. The modernist fascination with African art and with great black performers such as Josephine Baker and Paul Robeson was based on assumptions about primitivism and black people's innate qualities as children of nature, which for some, such as Nancy Cunard and Carl van Vechten, made black people probably superior to whites, but always inevitably different.[33] The Americanness of black Americans was not readily understood by the avant-garde. When the 'Blackbirds' came to London, they were welcomed, but were irritated to find that their English hosts persisted in responding to them as 'Africans'.[34]

Consequently, while Paris and London may have extended open arms to black singers, dancers, and actors, they were not interested in 'New Negroes', i.e. educated Westerners who were black. The American writer Langston Hughes and the Jamaican Claude McKay both tried their luck in Europe and got nowhere. Hughes worked for a while in Paris as a doorman and washer-up; and McKay was a nude model for a girls' art class, among other odd jobs. A black friend in Paris said to Hughes, 'Less you can play jazz or tap dance, you'd just as well go back home,'[35] which was sadly true. Claude McKay travelled widely in Europe but ended up deciding that, despite his communist sympathies and the profound racism of American society, he could only find an audience for his writing by moving to Harlem, and he did.[36] It is true that André Breton came to admire and champion the Martinique poet Aimé Césaire, but Césaire did not publish his first work until 1939 and the two poets did not meet until 1940, so they do not form part of this study. Similarly, black fine-art painters struggled with the racist tendency to attribute childishness and artless spontaneity to their work, regardless of its quality or intentions. They thus tended towards

[33] Sally Price, *Primitive Art in Civilised Places* (New Haven: Yale University Press, 1989).

[34] James Knox, *Robert Byron* (London: John Murray, 2003), p. 129. Similarly, Harold Acton once overheard Nancy Cunard exhorting her black American lover Henry Crowder to 'be more *African*': Anne Chisholm, *Nancy Cunard* (London: Sidgwick & Jackson, 1979), p. 170.

[35] Archer-Shaw, *Negrophilia*, p. 162.

[36] Wayne Cooper, 'Claude McKay and the New Negro of the 1920s', *Phylon*, 25.3 (Sept. 1964), pp. 297–306.

conventional academicism, eschewed engagement with African art, and consequently formed no part of the avant-garde.[37]

Working-class writers, like black poets and novelists, similarly suffered from patronizing assumptions about what their work ought to be like. Most of the interest in their work came from the far left. The communists championed realism, and so the more politically engaged eschewed stylistic experimentation in favour of simple language and realist narrative. Cyril Connolly assumes that unvarnished realism is the only way to communicate which isn't, as he puts it, 'mandarin'.[38] Accordingly, such working-class autodidacts who had time to write anything at all duly wrote witness narratives documenting the appalling conditions of work and home.[39]

However, politically inspired proletarian fiction exists at a considerable angle to the creative life of the proletariat when viewed other than through red-tinted spectacles. Mass culture, at its most successful, drew on tale types and situations with deep roots, notably the 'little men' who, even when apparently defeated by circumstances, always bounce back. Chaplin, Mickey Mouse, and the Jerry of Tom and Jerry are all examples of the indestructible underdog: earlier variations on the theme include Robin Hood, Harlequin, and Brer Rabbit, an American naturalization of Africa's Anansi the spider.

Working-class oral culture was linguistically playful: jokes, shaggy-dog stories, and other forms of recreational communication were, and still are, frequently fantastical and even surrealist, which is also characteristic of twenties cartoons and comic strips, from Felix and Betty Boop to Krazy Kat. In an urban context, peasant aphorisms and proverbs gave way to catchphrases, taken up from sources such as popular comedians, appropriated and, often, ironized. Ross McKibbin observes a working-class taste for parody, and also for grandiloquence, and the social rewards which accrued to wit and repartee.[40] Working-class story and song often handled themes non-naturalistically and were replete with imagery, metaphor, and metonymy in particular. Criminals, travelling showmen, and theatre people had their own metalanguages, such as Polari and thieves' cant.[41] Sexual, as well as

[37] Archer-Shaw, Negrophilia, p. 162: 'Lois Mailou Jones, Palmer C. Hayden and Henry O. Tanner were more inclined towards a conventional academicism, despite Paris's reputation for modernity.' See also Richard J. Powell, Rhapsodies in Black: the Art of the Harlem Renaissance (Berkeley and London: University of California Press, 1997), p. 104.

[38] Connolly, Enemies of Promise, 'Predicament'.

[39] Ethel Mannin, Young in the Twenties (London: Hutchinson, 1971), pp. 142–3, gives an overview of proletarian writers admired by contemporaries.

[40] Ross McKibbin, Classes and Cultures: England 1918–1951 (Oxford: Oxford University Press, 1998), pp. 131, 514.

[41] These are overlapping linguistic communities: there is a brief guide to fairground slang in Philip Allingham, Cheapjack (London: William Heinemann, 1934), pp. 303–7, and for Polari see Paul Baker, Fantabulosa (London: Continuum, 2002).

criminal, activity might be discussed very frankly by such means, particularly among the gay community, who also often needed to communicate in code.[42] Thus a gay New Yorker might chat about 'liking seafood' (i.e. sailors), or the lesbian blues singer Bessie Smith begin a song, 'Now, did you ever hear the story 'bout that boy in the boat, don't wear no shoes or no overcoat,' the subject of which is women's external genitalia. All of this verbal activity was hard for left-wing, university-educated intellectuals to grasp, if they noticed it at all. They were more interested in speaking to, or even for, the working class than in listening to it.[43]

Alterity is a phenomenon dependent on perceiving oneself as part of a subgroup which has something, but not everything, in common with the power élite. Therefore, while cross-class and cross-race communication was difficult between the wars, one clearly identifiable thread of alternative writing in interwar prose is the development of a queer sensibility independent of the lush aestheticism of Oscar Wilde and his circle; it was sharper, wilder, more satirical, and more humorous, and therefore more baroque.

The presiding geniuses of this strain within modern baroque literature were two homosexual Edwardians, Ronald Firbank and Saki (H. H. Munro). Saki will be discussed below. Firbank, one of the most overtly queer writers to publish in English before the legalization of homosexuality, was much read. His first book was published (self-financed) in 1905, but he continued to publish into the 1920s, and his last complete novel, *Concerning the Eccentricities of Cardinal Pirelli*, came out in the year of his death, 1926. He was personally much courted by Osbert and Sacheverell Sitwell and other habitués of the Eiffel Tower and Café Royal, though pathological shyness made him reluctant to accept such overtures. He was a regular at both establishments when he was in England, but for reasons of poor health and personal inclination he was chronically itinerant, and spent much of his life in Spain, Italy, the Middle East, and North Africa. The Sitwells' enthusiasm for his company was not reciprocated, and the one person who seems genuinely to have got quite close to him was that passionate maverick, Nancy Cunard.[44]

Firbank was a master of dialogue and, above all, of expressive punctuation. He summed up his own work as 'aggressive, witty, & unrelenting', a fair description.[45] His first biographer, Ifan Kyrle Fletcher, describes Firbank's writing as 'baroque', but also insists that it was highly disciplined: 'Never did he pose; never was he deliberately eccentric.'[46] His stylistic influence on later writers was considerable; not least, his courage to omit. 'I think nothing of fileing fifty pages down to make a brief, crisp

[42] George Chauncey, *Gay New York: Gender, Urban Culture, and the Making of the Gay Male World, 1890–1940* (New York: Basic Books, 1994), pp. 286–91.

[43] Cunningham, *British Writers of the Thirties*, pp. 212–13.

[44] Miriam Benkovitz, *Ronald Firbank: a Biography* (London: Weidenfeld & Nicolson, 1969), p. 286.

[45] Benkovitz, *Ronald Firbank*, p. 191.

[46] Brigid Brophy, *Prancing Novelist* (London: Macmillan, 1973), p. 97.

paragraph, or even a row of dots!' he wrote in a letter.[47] Often, the essential physical events within a story occur between dots, or between chapters. Sylvia Townsend Warner shows her indebtedness to Firbank when she structures a crucial episode in her *Summer Will Show*, the beginning of a love affair between the heroine Sophia and her husband's ex-mistress, by putting the entire episode into a hiatus between one sentence which ends with 'triumphant cry' and another which includes the words 'a few hours later'.

Firbank was very much more than a camp cult among writers of the next generation. Auden writes in *Letter to Lord Byron*:

> You must ask me who
> Have written just as I'd have liked to do.
> I stop to listen and the names I hear
> Are those of Firbank, Potter, Carroll, Lear.[48]

Which is to say, he most respects the works of a gay man, a woman, and two unhappy, sexually ambiguous celibates; three of them primarily thought of as writers for children, all of them uncanonical. In their different ways, Ivy Compton-Burnett and Evelyn Waugh are both obvious debtors to Firbank, and Waugh himself, in 1929, argued for Firbank's influence on Osbert Sitwell, Carl Van Vechten, Harold Acton, William Gerhardie, and Ernest Hemingway.[49] Compton-Burnett is stylistically indebted to Firbank in her reliance on moving the story forward through dialogue, but Waugh illuminates Firbank's work in more interesting ways. He said of *Vile Bodies*, 'I cribbed much of the scene at the customs from Firbank,'[50] and in the same book the eventual death of the child Lord Tangent, following a minor injury at a school sports day, is a homage to the 'fleas at the Ritz' narrative thread in Firbank's *Flower Beneath the Foot*, which Waugh had singled out for praise in his essay.[51] More importantly, both men were writing satire, with an underlying moral seriousness of a specifically Catholic kind.[52] Waugh's slapstick is in no danger of being mistaken for sympathy with his subjects; but it is an error careless readers of Firbank have made.

[47] Brophy, *Prancing Novelist*, p. 69.

[48] *The English Auden: Poems, Essays and Dramatic Writings, 1927–39*, ed. Edward Mendelson (London: Faber & Faber, 1977), pp. 169–99, p. 190. Copyright © 1977 by W. H. Auden, renewed. Reprinted by permission of Curtis Brown, Ltd.

[49] Waugh, 'Ronald Firbank', in *Life and Letters*, Mar. 1929; reprinted in Waugh, *A Little Order: Selected Journalism*, ed. Donat Gallagher (London: Penguin Classics, 2010), pp. 77–80.

[50] Julian Jebb (interviewer), 'Evelyn Waugh, the Art of Fiction', *The Paris Review*, 30 (summer–fall 1963).

[51] 'Ronald Firbank', p. 80.

[52] Discussed by Martin Stannard in *Evelyn Waugh: the Early Years* (London: J. M. Dent, 1986), pp. 207–9.

Firbank's last book, *Concerning the Eccentricities of Cardinal Pirelli*, illustrates what he and Waugh have in common. It begins with a grotesque incident: the christening of a puppy in the cathedral of Clemenza, modelled on Seville.[53] Insofar as there is a plot, it is that the cardinal is subsequently called to Rome to account for himself, retreats to a disued medieval convent to prepare his defence, and dies there of a heart attack sustained while pursuing a choirboy. Firbank spent about three weeks in Seville in August–September 1926, and observed it well. The life of Clemenza turns around the rituals and festivals of the church, with the city's cardinal at its apex, yet the novel is about queerness and alienation. The occasionally transvestite Pirelli is a profoundly lonely figure. The book is also a meditation upon Spanish baroque, in an almost Sitwellian fashion, though Firbank engages far more fully with the religious aspect of southern baroque than Sacheverell Sitwell had done.

Firbank's religious position was equivocal. Lord Berners, who had known him for years and was with him when he died, was quite unaware that he was a Catholic, and inadvertently caused a good deal of trouble by having him buried in the Protestant cemetery in Rome. Firbank had told him, 'The Church of Rome wouldn't have me and so I laugh at her.' But a satirist's laughter does not necessarily connote lack of engagement. *Pirelli* is anti-clerical rather than anti-Catholic; the people of Clemenza are superstitious ritualists, and its church is venal and corrupt. The Pope, Tertius II, is a sinister figure, physically and morally unappealing. It may be relevant to Firbank's presentation of churchmen that he was, for a time, in love with Evan Morgan, Viscount Tredegar, who was both one of the 'Papal Gentlemen' serving as a Vatican chamberlain for one month out of each year, and a practising black magician.[54] Firbank's relationship with him ended in 1920, so Firbank's Pope Tertius II is based on Benedict XV, who died in 1922. While it lasted, it must have given Firbank access to privileged gossip, and a sense that the church was not well guided. It may also be relevant that Monsignor Hugh Benson, who converted Firbank and received him into the church in 1907, was deeply interested in the occult.

Morgan observed that Catholicism 'puzzled [Firbank] more than it helped him'.[55] This is perhaps due to Morgan himself, who seems to have been blithely unruffled by the contradictions in his own spiritual life. If Firbank felt, like Marguerite Yourcenar, that Christian faith offered the only possible hope in a disordered world,[56] but also saw that it was, itself, morally disordered and failing to uphold its own transcendent value, this would account for the sharpness of his satire, which, like that of Waugh,

[53] The name presumably chosen from a very English associational link between Seville, marmalade oranges, and the St Clement's bells chiming 'oranges and lemons'.

[54] He is the model for Ivor Lombard in Aldous Huxley's *Crome Yellow*, and Lord Intriguer's son Eddy Monteith in *The Flower Beneath the Foot*.

[55] Benkovitz, *Ronald Firbank*, p. 106.

[56] Erin G. Cawston, *Thinking Fascism: Sapphic Modernism and Fascist Modernity* (Stanford: Stanford University Press, 1998), p. 121.

appears to spring from a profound sense of moral order. His saying 'the Church of Rome wouldn't have me' can be interpreted in various ways, but may well relate to his homosexuality—the church's rejection of his essential self, its failure, in fact, to be genuinely catholic, provoked in him an answering anger and contempt towards its shortcomings.

Auden and Isherwood occupy a curious place among interwar writers. They *were* the orthodoxy, Auden above all—'Wystan, lone flyer, birdman, my bully boy!' as Cecil Day Lewis rhapsodizes. The naïvety within the dominant culture which had come to believe that homosexuality could be identified by an addiction to 'aesthetic' signifiers—whether Wildean grey velvet and white lilies or Brian Howardesque Oxford bags and mascara—and had therefore accepted Siegfried Sassoon and T. E. Lawrence as what popular culture called 'he-men', continued to work in favour of a new generation of gay men who wore aertex shirts and corduroy trousers and wrote about sport and adventure. But in the hands of these homosexual writers, the cult of masculinity develops hysterical and obsessive aspects which are, viewed from a gay perspective, camp. Often, members of the Auden circle play with acceptable homosociality, such as Buchanesque adventuring in the wilder corners of the British Isles, spy stories, 'Biggles' and the romance of the air, and queer it. Auden's narratives are full of spies (notably in *The Orators*), undercover agents; these figures cypher the camouflaged homosexual.

The whole nature of gay male life in the thirties necessarily required the skills of a double agent, particularly the ability to carry on intricate conversations whose coded meaning was unintelligible to potentially hostile bystanders. As Harold Beaver observed, 'The homosexual... is a prodigious consumer of signs—of hidden meanings, hidden systems, hidden potentiality.'[57] So are poets, and gay poets may well be operating codes within codes. To be sure, the public school/Oxbridge context from which these writers were launched meant that their sexual proclivities were a pretty open secret, but open only among insiders, and secret they had to stay, at the risk of prosecution and imprisonment. Auden wrote, in a stanza of *Letter to Lord Byron* deleted from the final version:

> I've lately had a confidential warning
> That Isherwood is publishing next season
> A book about us all. I call that treason
> I must be quick if I'm to get my oar in
> Before his revelations bring the law in.

[57] Harold Beaver, 'Homosexual Signs (in memory of Roland Barthes)', *Critical Enquiry*, 8 (1981), pp. 99–109, p. 104.

Much of *Letter to Lord Byron* is seriousness in masquerade, a camp strategy. Thus the Auden of the thirties was simultaneously the poster boy of a new poetics and a man writing from the margins. Interestingly, in December 1933 he directed a sixth-form production of Cocteau's *Orphée* at the Downs School, probably in the English translation by Carl Wildman which had been published earlier that year, thus suggesting some interest in Continental queer modernism.[58]

Auden and MacNeice's *Letters from Iceland* (1937), which include the first outing of *Letter to Lord Byron*, form a sort of palinode to the grimly earnest heroics of their earlier writing.[59] The twelfth chapter, 'Hetty to Nancy', is by MacNeice, and as in Lord Berners' 1932 *The Girls of Radcliff Hall*, an entire male milieu is written about in terms of a girls' school story. Auden appears as Maisie. The terms 'hetty' and 'nancy' were contemporary gay slang: 'hete'-rosexual MacNeice was writing to his 'nancy' friend Anthony Blunt, with whom he had shared a study at Marlborough. They had enough tastes in common for lifelong friendship, though sexual preference was not among them. What is interesting, and revealing, is that the 'irredeemably hetero-sexual' MacNeice was evidently perfectly comfortable writing as a member of a queer coterie. He returned to the 'Hetty' voice in his subsequent Hebridean volume, *I Crossed the Minch* (1938), writing to Maisie/Auden.[60]

Another obvious strand of alterity in interwar fiction is that of the writing by women which achieved considerable success but received a distinctly backhanded critical reception. Eliot, in essays such as 'Tradition and the Individual Talent', deprecated the use of autobiographical material: 'Poetry,' he declared, 'is not a turning loose of emotion, but an escape from emotion; it is not the expression of personality, but an escape from personality.'[61] This judgement put many interwar women artists, both literary and visual, outside the canon. Quite a few of them wrote and painted in a way which Eliot and his epigones found distasteful. Among the painters who persistently centred their art around their own bodies and faces were Frida Kahlo, Leonor Fini, Remedios Varo, and Leonora Carrington, all of whom were involved with surrealism without ever being regarded as members of the club.[62] Equally, a variety of women modernist writers—Dorothy Richardson, Jean Rhys, and Djuna Barnes among them—drew directly on personal experience in

[58] W. H. Auden and Christopher Isherwood, *Plays and Other Dramatic Writings 1928–1938*, ed. Edward Mendelson (London: Faber & Faber, 1989), p. 503.

[59] Christopher Isherwood, *Lions and Shadows* (London: Four Square, 1963), p. 193; Hynes, *The Auden Generation*, pp. 49–53.

[60] *I Crossed the Minch* (Edinburgh: Polygon, 2007), pp. 231–47: Isherwood and Spender appear as Christine and Stephanie, Cyril Connolly as Sibyl Donnelly, Evelyn Waugh as Evelyn Priest (etc.).

[61] T. S. Eliot, 'Tradition and the Individual Talent', *Selected Essays, 1917–1932* (New York: Harcourt, Brace, 1932), p. 10.

[62] Whitney Chadwick, *Women Artists and the Surrealist Movement* (London: Thames & Hudson, 1991), p. 66.

their fictional work, and writing the self is a major strand in alternative literary modernism.

Isherwood, of course, also made himself the protagonist of most of his fiction, but gender made a considerable difference to the reception of these various works. Critics and readers seem to have had no problem with separating 'Herr Issyvoo' from Isherwood-the-writer, but when women wrote apparently confessional fiction, it tended to be received as confirming an established prejudice that women's writing was naïvely self-revelatory. Experimental writing seems to have been perceived as fundamentally masculine. When Djuna Barnes first tried to publish *Nightwood*, a series of editors asked her to rewrite it as a realistic novel in a traditional form.[63] The non-reception of Mirrlees's *Paris* is a further indication that women were expected to know their place.

Another writer in English, besides Djuna Barnes, who suffered from this unexamined assumption about women's writing is Stevie Smith. When she first tried to publish her poems, she was told to go away and write a novel. *Novel on Yellow Paper*, the result, was a poet's book, impatient of the formal characteristics of prose, including punctuation. Uninterested in the technicalities of fiction, she tells us what she was thinking about in 1936 through the mouth of Pompey Casmilus. Smith's contemporaries were reluctant to recognize Pompey's fictionality, and read the book as a roman-à-clef.[64] Smith clearly realized that this was likely to happen, for in the first paragraph she bids goodbye to her friends, many of whom were understandably furious when it appeared.

However, Smith is not revealing herself naïvely. She is examining the social and cultural formation of an English intellectual. She writes with brutal frankness in her third novel, 'I thought, I am a middle-class girl, conditioned by middle-class thoughts, when I think of England, my dear country, I think with pride, aggression, and complacency.' Thus she is deliberately revealing some of the more septic aspects of the educated English mentality of her 'low, dishonest decade' through the medium of the person she knew best, herself.[65]

Pompey tells us about aspects of herself which form the typical subjects of women's fiction—her sexual and emotional life, the nuances of her sensibility; an

[63] Monika Faltejskova, *Djuna Barnes, T. S. Eliot and the Gender Dynamics of Modernism: Tracing Nightwood* (New York and Abingdon: Routledge, 2010), p. 2. Bob Perelman, *The Trouble with Genius: Reading Pound, Joyce, Stein and Zukofsky* (Berkeley: University of California Press, 1994), p. 119, notes that in Joyce's 'Oxen of the Sun' no women writers are imitated: 'Women are banished from the process of literary gestation.'

[64] Both Romana Huk, *Stevie Smith: Between the Lines* (London and New York: Palgrave Macmillan, 2005), and William May, *Stevie Smith and Authorship* (Oxford: Oxford University Press, 2010), discuss the sophistication of Smith's self-presentation.

[65] Alison Light, *Forever England: Femininity, Literature and Conservatism between the Wars* (London: Routledge, 1991), p. xii, suggests that 'literary work might do well to look for ways of anthropologizing the middle classes, making their assumptions seem a strange and unfamiliar culture rather than the unexamined norm'. She does not mention Smith, who seems to be doing just that.

incontinent flood of opinion spiced with quotation. But other thoughts blurt up from time to time, such as anti-Semitism, felt secretly, with embarrassment. More unusually, she is aware of the economic basis of her life in an England not yet post-imperial, and perceives that her party-going and her comfortable suburban life are underwritten by the exploitation of subject peoples. Smith stresses that Pompey genuinely knows a great deal about this, since she is a financier's secretary and encodes his confidential correspondence. Smith is saying that a beneficiary of the spoils of empire can't absolve herself of responsibility on the grounds of gender.

In 1938 she published a sequel, *Over the Frontier*, a title which warns that she intends to engage with hysterical heroics: Auden and Isherwood published *On the Frontier*, and Edward Upward *Journey to the Border* in the same year. It confused and alienated those who believed Pompey was a self-portrait, and further emphasizes the extent to which Pompey stands for English intellectuals. On one level, she remains bien pensant, a lover of nature and literature, anti-fascist, left-leaning. However, her talent for codes receives a new prominence, and not only does she aid her employer in shady deals, she takes personal advantage of insider knowledge to buy stock in nitrates, used for making explosives. We are reminded that the cannon she sees in the Baltic town of 'Ool' were made in England. Thus Pompey is doing on a small scale what her country is doing on a large one. Auden, similarly, wrote:

> Nor ask what dubious acts are done –
> To buy our freedom in this English house.[66]

Candid as she appears to be in emotional matters, Pompey merely hints smugly that she is doing pretty well financially. And she proceeds to sleepwalk into taking an active part in making war. Britain was doing the same.

Smith's Pompey, buttoned into her beautiful uniform in the last quarter of the novel, is an interesting counter-instance to Virginia Woolf's assertion in *Three Guineas*, also published in 1938, that militarism is a problem created by a male quest for power and dominance.[67] 'Obviously there is for you some glory, some necessity, some satisfaction in fighting which we have never felt or enjoyed,' writes Woolf, taking the high moral ground on behalf of womankind. By contrast, Smith is dismayingly clear that pride, anger, and ambition are not traits peculiar to the male. To be sure, Pompey doesn't acquire a sudden taste for physical combat, and when she shoots someone, she takes no pleasure in it, but there is nothing in her highly feminine sensibility which prevents her from being caught up in the intellectual exhilaration of code-breaking and the satisfaction of winning. Once she is over the frontier, she is only too prepared to jettison the sort of moral scruples

[66] 'A Summer Night'.

[67] Laura Severin, *Stevie Smith's Resistant Antics* (Madison: University of Wisconsin Press, 1997).

which exercise Woolf: 'I laugh and laugh with delight... and thank the God of War to be rid of the tea-cups and tattle and the boring old do-all-nothings of a finished existence.'[68]

Daniela Caselli argues with respect to Djuna Barnes that '[her] work is both a resource and a problem for feminism; it offers an uncompromisingly ruthless analysis of sexual politics but it also refuses to produce a model for redressing past wrongs'.[69] The same is true of Smith. In these novels she describes what she sees around her in London literary circles: women who make successful careers from peddling misleading twaddle to other women in the twopenny weeklies; women who talk feminism and perhaps left-wing politics but have a healthy respect for their own finances and their personal power. All she can do is advocate non-compliance with patriarchal agendas, avoiding the love and marriage which so very readily become a 'bright little tight little hell-box', and trying to understand and come to terms with the extent of one's personal complicity in England as it is— Smith herself worked for the Newnes Publishing Company, but as Laura Severin noticed, the reviews she wrote for *Modern Woman* are notably subversive of the magazine's overall message.[70]

Another woman modernist whose work has a highly problematic relationship with autobiography is Djuna Barnes, who also has a particular claim to be considered a modern baroque prose writer, in that her work is copious, queer, obscure, and full of dark humour. Peter Quennell and T. S. Eliot both related her writing to Webster and Tourneur as the 'darkest', most baroque of the Elizabethans.[71] In Eliot's case, this was partly because he deprecated the autobiographical element in *Nightwood*.[72] An earlier book, *Ladies Almanack*, is written in a consciously archaizing prose loosely based on seventeenth-century popular writing, as are its illustrations, also created by Barnes,[73] a linguistic and visual smokescreen which allows Barnes to construct a narrative explicit about the pleasures and mechanics of lesbian sexuality (see Figure 9). It was written to amuse Natalie Barney, whose principal interest was sex. She enjoyed a number of grand passions in the course of a long life, a fifty-year relationship with Romaine Brooks, and casual flings. The *Almanack* has divided critics, some of whom find it self-hating and homophobic, others celebratory.

[68] *Over the Frontier*, p. 229.

[69] Daniela Caselli, *Improper Modernism: Djuna Barnes's Bewildering Corpus* (Burlington: Ashgate, 2009), p. 247.

[70] Severin, *Stevie Smith's Resistant Antics*.

[71] Faltejskova, *Djuna Barnes, T. S. Eliot*, p. 5.

[72] Miriam Fuchs, 'Djuna Barnes and T. S. Eliot: Authority, Resistance, and Acquiescence', *Tulsa Studies in Women's Literature*, 12.2 (autumn 1993), pp. 288–313.

[73] Robert Medley, a close friend of Barnes, rather surprisingly asserts in his *Drawn from the Life: a Memoir* (London: Faber & Faber, 1983), p. 107, that the illustrations were by Demetrios Galanis. They moved in contiguous social circles, and possibly he offered some technical assistance.

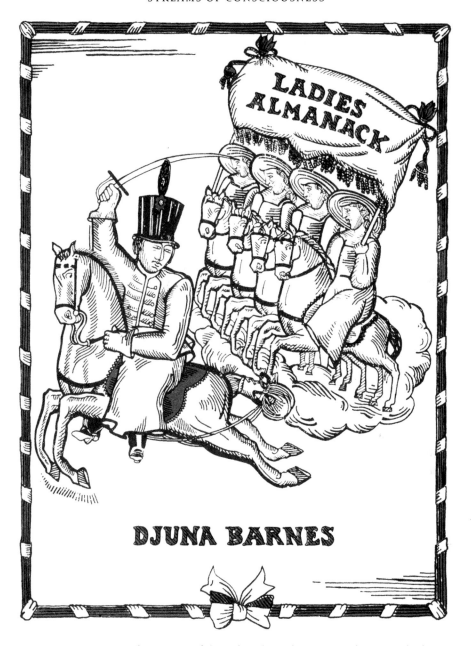

Figure 9 Djuna Barnes, front cover of the *Ladies Almanack* (1928): Natalie Barney leading an Amazon army, treated in a style which closely resembles an Épinal print.

Consider this passage, in which one woman seeks to establish what point another has reached in her menstrual cycle before making further advances:

> But hear how a Maid goes at a Maid: 'And are you well my own? but tell me hastily, are you well? for I am well, oh most newly well...but if you be about to be nowise probable, but tell me, and I will burst my Gussets with hereditary Weeping, that we be not dated to a Moon.'[74]

How you respond to a passage such as this depends on your estimation of how disgusted Barnes was by menstruation, and how you feel about it yourself. 'For [Karla] Jay, *Ladies Almanack* comprises a vicious satire aimed at Natalie Barney and the lesbians who frequented her literary salon....[Susan] Lanser finds in Barnes's text a "refusal of phallocentrism" and a reclamation of "the positivity of the female body and the lesbian experience".'[75] But Barnes's own experience of being lesbian was by no means entirely positive. She valued sexual fidelity and found it inexpressibly painful that her lover, Thelma Wood, did not. This may account for the text's ambivalence towards Evangeline Musset, the Barney figure. On the other hand, Barnes had absolutely no time for the notion that lesbianism was intrinsically pathological.[76]

Nightwood, Barnes's masterpiece, was created out of her love for Thelma Wood, who appears as 'Robin Vote', perhaps by association with the archetypical outlaw Robin Hood. Her backstory bears no resemblance to Wood's early experience, however, her alcoholism, drunken couplings with fellow barflies, and eventual seduction by another woman, are based on Barnes's memories. Lesbianism is not the subject, as it is in *The Well of Loneliness*, and consequently some readers failed even to notice that same-sex love was an aspect of the story.[77] Nora's love for Robin is lesbian because Barnes loved Thelma Wood, and it is pathological and disastrous not because it is homosexual, but because Nora wants and needs to bind Robin into

[74] Djuna Barnes, *Ladies Almanack* (Manchester: Carcanet, 2006), p. 43.

[75] Karla Jay, 'The Outsider Among the Expatriates: Djuna Barnes's Satire on the Ladies of the Almanack', in *Lesbian Texts and Contexts: Radical Revisions*, ed. Karla Jay and Joanne Glasgow (New York: New York University Press, 1990), pp. 204–16, p. 210; Susan Sniader Lanser, 'Speaking in Tongues: Ladies Almanack and the Discourse of Desire', *Frontiers: A Journal of Women's Studies*, 4.3 (1979): pp. 39–46.

[76] Christine Berni, '"A Nose-Length into the Matter": Sexology and Lesbian Desire in Djuna Barnes's *Ladies Almanack*', *Frontiers: A Journal of Women Studies*, 20.3 (1999), pp. 83–107, p. 84: 'The lesbian bodies that populate *Ladies Almanack* resist sexological and socially hegemonic categories and successfully complicate theorizations of lesbianism as an inversion, that is, as an innate "masculinity complex". Likewise, in Freudian terms, portraits of same-sex desire in Barnes's text escape inscription within psychoanalytic developmental narratives that cast lesbianism as regression to infantile relations.'

[77] Leigh Gilmour, 'Obscenity, Modernity, Identity: Legalizing *The Well of Loneliness* and *Nightwood*', *Journal of the History of Sexuality*, 4 (Apr. 1994): pp. 603–24.

half of a couple, and finds no answering need in Robin. Robin's nature is to be untameable.

Nightwood articulates an idea expressed more literally by fantastical writers of the period: 'Sometimes one meets a woman who is a beast turning human' (p. 37). Her beauty is like a young beast with horns (p. 134), a notion which reminds one that Marie Laurencin was another member of Natalie Barney's coterie. The notorious ending, in which Robin oscillates between the performance of Catholic ritual and unsuccessful attempts to commune with animals until, having been disturbed at prayer, she makes advances to Nora's dog, seems to underscore her liminal state. She is just sufficiently human that her dog-to-dog gesture bewilders and terrifies the animal, but insufficiently human to be domesticated and possessed.

While there is much that is non-realist in both the matter and manner of *Nightwood*, it is not fantasy. But a whole variety of interwar writers explored fantastic themes. The central figure in a modernist novel may be dead, as in Wyndham Lewis's *The Childermass*, turn into a cockroach like Gregor Samsa, or, like Orlando, change sex, and many of the popular novels of the twenties and thirties similarly desert realism for the fantastic. The established Victorian and Edwardian taste for fantasy remained very much alive, as did some of the leading proponents. G. K. Chesterton continued to write unstoppably until his death in 1936, M. R. James's last collection of ghost stories appeared in 1925 and influenced Mary Butts,[78] while Arthur Machen's last fiction was published in 1936. Older writers of fantastic fiction were still read: Auden was not the only writer to value Lear and Carroll. Nancy Cunard declared *The Hunting of the Snark* to be a surrealist text, persuaded Louis Aragon to translate it into French, and printed the result at her Hours Press.[79] Herbert Read and Julien Levy both claimed *Alice* for surrealism,[80] and it informs Waugh's *Decline and Fall*. Paul Nash cited the fantastical tradition in English fiction as an aspect of his argument that surrealism was characteristically English.[81]

The English appetite for fantasy at all levels from children's fiction to the avant-garde is a complex phenomenon. It might be simply suggested that, like the popularity of detective stories, the liking for fantasy fiction reveals the English taste for eucatastrophe among both educated and uneducated readers, but much fantastical writing, notably that of Carroll and Lear, is filled with anguish and terror. Some popular fantasies were merely consolatory, but others address major themes

[78] The title story in *With Or Without Buttons* (London: Carcanet, 1991) is deeply Jamesian: what she responded to in his work is the revelation of supernatural forces irrupting into everyday reality.

[79] *La chasse au snark, agonie en huit crises*, trans. Louis Aragon (Chapelle Réauville: Hours Press, 1929), and Aragon, 'Lewis Carroll—En 1931', *Le Surréalisme au service de la revolution*, 3 (Dec. 1931), pp. 25–6.

[80] Herbert Read, ed., *Surrealism* (London: Faber & Faber, 1936), pp. 55–6; Julien Levy, *Surrealism* (New York: Black Sun Press, 1936), p. 4.

[81] 'Surrealism and the Illustrated Book' (1937), *Paul Nash, Writings on Art*, ed. Andrew Causey, pp. 131–4.

by this means—analogous, perhaps, to the deployment of the term 'amusing', disguising seriousness as play.

One individual who contributed to this tendency towards fantasy among alternative modernists was Saki. He was killed by a sniper in the Great War, but his slight, memorable stories continued to appeal to the dandy strain in interwar aesthetics. They were valued for their epigrammatic wit and neatly twisted plots, but also for their subtext: Saki sides with the young against the old, is in favour of sex and wildness, is against strangling conformity and inhibition, and, in particular, discreetly champions homosexuals' right to flourish in the shadows. He also elides the boundary between human and animal in several stories. Similarly, a surprising number of widely read interwar novels were concerned with the frontiers of the human.

One such is David Garnett's first novel, *Lady into Fox* (1922). In this short, strange book, the heroine metamorphoses into a fox, and her devoted husband attempts as best he may to live with her in her new form. This is directly indebted to Saki, whose stories include 'The She-Wolf', in which a house party is successfully convinced that their hostess has turned into a wolf; and another, 'Laura', about a gentlewoman who reincarnates as an otter, with, apparently, memories of her human life. Another interwar writer who tackled a non-human heroine, and even interspecies sex, was John Collier. In *His Monkey Wife* (1930), a novel of distinctly misogynist tone, Alfred Fatigay, engaged to a thoroughly modern girl called Amy Flint, has brought back from Africa a chimpanzee called Emily. Once in London, Emily proceeds to become civilized and successfully detaches Fatigay from her human rival.

Apart from semi-human animals, unreal, or semi-real, characters also turn up in a surprising variety of well-received novels of the twenties. Edith Olivier's *The Love Child* (1927), a tale of an achingly lonely woman with an imaginary companion child, was a success in its day. In one of De la Mare's later works—*Memoirs of a Midget* (1921)—he created another disturbingly lonely misfit of a heroine; like *Lady into Fox*, it won the James Tait Black Memorial Prize. Miss M is literally a misfit, because she is monstrously small. The novel also introduces the theme of sexual inversion: Miss M cannot even fit the role of a very small woman, because she suffers from an obsessive and unrequited love for another woman, of normal size.

One trope of pre-war literature which continued to be surprisingly attractive to interwar writers is the idea of an epiphany of Pan.[82] *The Wind in the Willows* presents the most benign version, as befits a book for children, but more dangerous manifestations of the god appear in stories by Saki and E. M. Forster, among others.[83] The implication that repression and hyper-civilization are dangerous, and that natural

[82] Patricia Merivale, *Pan the Goat-God: His Myth in Modern Times*, Harvard Studies in Comparative Literature 30 (Cambridge, MA: Harvard University Press, 1969).
[83] 'The Story of a Panic' and 'The Music on the Hill'.

urges deserve respect, was very much in accord with interwar thought. D. H. Lawrence, predictably, was interested in the figure of Pan: 'Pan in America' is his most specific treatment.[84] A version of Pan deeply informed by ancient Greek sources was also important to Mary Butts, while Glyn Philpot's 1933 painting *The Great God Pan* shows that the ancient god was still available as a metaphor for inspiration and sexual desire.[85] The devil who appears in order to solace another isolated and neglected heroine in Sylvia Townsend Warner's first novel, *Lolly Willowes* (1926), is far more like Pan than Beelzebub—amoral, rural, and not discernably evil.

An alternative means of escape from 'the neotechnic phase' was, literally, to go somewhere else.[86] Fiction set in some kind of other world is surprisingly well represented between the wars. Christopher Isherwood and Edward Upward, who made friends at school, created the village of Mortmere. Isherwood recalled, 'One evening, as we were strolling along Silver Street (in Cambridge), we happened to turn off into an unfamiliar alley, where there was a strange-looking, rusty-hinged little old door in a high blank wall. [Upward] said: "It's the doorway into the Other Town". This idea of "The Other Town" appealed to us greatly; for it offered a way of escape from Cambridge altogether.'[87] They saw Cambridge as a dark, spectral citadel of the enemy which they had infiltrated—the queer-as-spy motif again. In theory, Mortmere was to serve as the basis for a series of fictions; in practice, the fantasy world was a creation in its own right.

Arthur Machen's similar perceptions of openings between worlds has more in common with the surrealists' sense of the city as a place of infinite possibility and strangeness. Machen, whose supernatural fictions impressed Jorge Luis Borges,[88] perceived London as unknowable: if one walked randomly, without plan or direction, it might yield anything, just as Walter Benjamin had found Paris the site of profane illuminations. Machen summed up this entire aspect of his fiction in an incidental simile in *The Green Round* (1933), writing of 'the man who, passing along some street that he has trodden a hundred times, sees a door before unnoticed, and opening it enters a world of marvel and strange experience that has been unsuspected but close at hand all his days'.[89]

The Oxford circle known as the Inklings also reacted to modernity by going somewhere else. The first of Charles Williams's fictions of spiritual adventure was published in 1930, and though Lewis's Narnia books are post-World War II, the first

[84] 'Pan in America' (1924), in *Phoenix*. See also *St Mawr*, p. 65.

[85] Mary Butts, *The Crystal Cabinet* (Manchester: Carcanet, 1988), pp. 22–6; J. P. G. Delaney, *Glyn Philpot: His Life and Art* (Aldershot: Ashgate, 1999), pp. 125–7.

[86] The phrase is Lewis Mumford's, from his influential *Technics and Civilisation* (1934).

[87] Isherwood, *Lions and Shadows*, p. 68.

[88] Jorge Luis Borges, 'Arthur Machen: *Los Tres Impostores*', in *Biblioteca Personal. Prólogos, Obras Completas* IV (Buenos Aires: Emece Editores, 2009), p. 474.

[89] Arthur Machen, *The Green Round* (London: Ernest Benn, 1933), p. 68.

of his metaphysical fictions, *Out of the Silent Planet,* appeared in 1938. Tolkien began writing about Middle-earth in the twenties, and his first published story, *The Hobbit,* reached print in 1936. He retreated from the twentieth century entirely into Middle-earth, a creative response to the literature of the early Middle Ages, notably the *Kalevala* and *Beowulf,* though the hobbits mysteriously contrive to inhabit a bubble of the early nineteenth century in an otherwise first-millennium landscape. As a response to modernity, Tolkien's work can only be perceived as a complete rejection of everything it implies; it is interesting, therefore, that it was massively successful from the first.

Williams and Lewis both wrote with more reference to the present day than Tolkien, but in Williams's novels heaven, hell, Platonic and other archetypes surround and press upon day-to-day life, and may suddenly invade it. Small courtesies or omissions open up Calvary or the Pit. Both Williams and his work, incidentally, were much admired by Auden, who was also impressed by Tolkien.[90] Lewis, with some perfunctory concessions to the conventions of science fiction, extends the Christian drama of the fall of man across the entire solar system. Outside that particular circle, T. F. Powys also offered theologically informed, bleakly gnostic allegorical fantasy to interwar readers, notably in *Mockery Gap* (1925), *Mr Weston's Good Wine* (1927), and *Unclay* (1931). These feature avatars of God, the Archangel Michael, Christ, and Death, but none of these figures, with the exception of Death, is remotely consoling.

In most of these stories, the supernatural erupts into everyday experience. But there were also others in which ordinary people found themselves transported to extraordinary places. One work which influenced many writers of the twenties and thirties was by an outsider in every sense, David Lindsay. He was an insurance clerk of Scottish extraction who, after serving in the First World War, decided to become a writer. The bizarrely original *A Voyage to Arcturus* was his first book, published in 1920, and was a failure, as were all his subsequent publications, because he was, in any ordinary sense, a poor writer.[91] Lewis describes him, quite fairly, as 'unaided by any special skill or even any sound taste in language',[92] but he also admitted, 'It's a remarkable thing, because scientifically it's nonsense, the style is appalling, and yet this ghastly vision comes through.'[93]

Lindsay's alien world was an arena for exploring spiritual and religious issues, expressed through the creation of intensely visualized landscapes and individuals of

[90] Auden wrote 'Charles Williams: a Review Article' for the *Christian Century,* 73.18 (2 May 1956), pp. 552–4, and reviewed *The Return of the King* for the *New York Times,* 'At the End of the Quest, Victory', 22 Jan. 1956.
[91] Bernard Sellin, *The Life and Works of David Lindsay,* trans. Kenneth Gunnell (Cambridge: Cambridge University Press, 1981).
[92] C. S. Lewis, 'On Stories', *Of Other Worlds: Essays and Stories* (Orlando: Harcourt, Inc., 1975).
[93] 'Unreal Estates', in *Of Other Worlds,* p. 88.

spectacular strangeness; this was its importance. Structurally, his work is picaresque quest: as the anti-hero Maskull wanders across the planet Tormance (torment/ romance), he meets one being after another who seems to promise him self-knowledge. Each apparent truth is exploded by the next encounter, until the only realities left are illusion and pain.[94] Lindsay's book was profoundly admired by both Lewis and Tolkien, though neither had any sympathy for the gnostic thrust of Lindsay's argument.

Other stories which took people to alien worlds were written for children. Although the Pevensies first fell through a wardrobe into Narnia in 1950, there were interwar children's books by other writers which opened magic casements of one kind or another. John Masefield's *The Midnight Folk* (1927) and *The Box of Delights* (1935) both feature travel through time and space, for example, and so do P. L. Travers's Mary Poppins stories (from 1934). Mary Poppins's absolute, magically reinforced authority makes her more like Lewis's representations of God than any lesser being. Her charges are made to realize that if they allow her to order their lives, enchantment, adventure, and the enlargement of experience will result. The same could be said of Aslan. The books also disturbingly remind one of what working-class women had to put up with as employees, even domestic goddesses: Mary Poppins shares a room with the five children she cares for, and has no private space.

Works such as *A Voyage to Arcturus* and Lewis's *Perelandra* are not science fiction. The mechanism of the voyage to another planet is frankly magical, and the overall intention akin to parable. They have more in common with the neo-Latin philosophical other-worldly fictions of the seventeenth and eighteenth centuries, such as Ludvig Holberg's *Niels Klim's Underground Travels* (1741), Cyrano de Bergerac's *Comical History of the States and Empires of the Moon*, or Athanasius Kircher's *Celestial Journey* (both published in 1656), than they do with H. G. Wells or Olaf Stapledon. *A Voyage to Arcturus*, influential despite its obvious deficiencies, suggests that the familiar dialectic of literary fiction, focused on language, and popular fiction, focused on narrative—'the plotless art novel and the styleless bestseller', as Fredric Jameson[95] neatly puts it—requires a third term.

It is perhaps no accident that Tolkien, Lewis, and Williams were serious readers of pre-modern and, perhaps especially, medieval literature. Thus all three were profoundly familiar with texts which were simultaneously formulaic, accessible (to contemporaries), and vehicles for complex thought. Their own creative work expressed an underlying assumption that this approach was still viable: in their

[94] Patricia Merivale, 'Learning the Hard Way: Gothic Pedagogy in the Modern Romantic Quest', *Comparative Literature*, 36.2 (spring 1984), pp. 146–61, pp. 156–7.
[95] Fredric Jameson, *Fables of Aggression: Wyndham Lewis, the Modernist as Fascist* (Berkeley: University of California Press, 1979), p. 7. See also Eysteinsson, *The Concept of Modernism*, pp. 79–80.

different ways, they use the conventions of formulaic fiction to articulate strongly held and consciously thought-through intellectual positions, an approach so different from the agendas of the modern novel that John Wain came to think that they were attempting to create a counter-movement.[96] Perhaps, rather than envisaging a linear continuum with James Joyce near one end and Agatha Christie near the other, it might be better to imagine a triangle, with Lindsay and Charles Williams near its third angle. This third angle represents those writers who are not interested in language *or* plot, or, in the usual sense of the word, in character, but who are using prose fiction for early modern purposes, to express a set of philosophic, scientific, or theological perceptions.

[96] Humphrey Carpenter, *The Inklings: C. S. Lewis, J. R. R. Tolkien, Charles Williams and their Friends* (London: George Allen & Unwin, 1978), p. 159.

Machines to Live In

At a distance of seventy years, it is easy to perceive that there is a good deal of fantasy in modernist architecture. Perhaps the most truly fantastical aspect is its attitude towards time. It is one thing to start from Year One, and quite another to think, with Theodor Adorno, that 'it seems paradoxical for something modern, already under the spell of the sameness of mass production, to have any history at all'.[1] This stupefyingly silly remark implies that, since the future has arrived, time has come to a stop. But a building starts to acquire history from the moment it is laid out, and refusal to progress through time is peculiarly unhelpful as an approach to the built environment. There might have been a certain logic in creating avowedly temporary structures to cope with the ever-changing now, but modernist architects cannot have built for the moment alone, for the prosaic reason that their houses were very expensive. Thurso House in Cambridge, built for a venturesome don at King's in 1932, cost £2,550—about five times the price of a conventional building of equivalent size.

Modernist buildings were never meant to *look* as if they had any history. Raymond McGrath observes, 'When we speak of the "good weathering" properties of a synthetic material such as glass…any surface change is to be guarded against. Retention of the original surface brilliance is part of the aesthetic of the new architecture as well as of other contemporary forms.' Whereas materials such as stone and brick may mellow, acquire patina, or otherwise show signs of age interpreted as benign, buildings which represent the present cannot age gracefully.[2]

The idea of change as it might apply to buildings intended to embody the 'now' was evidently very hard to internalize, but this is radically at odds with the way buildings are, and always have been, used. As Stewart Brand has pointed out, every time a house changes hands there is some remodelling—a kitchen is extended, a window removed, or added, or turned into a door, a bedroom becomes a bathroom;

[1] Theodor Adorno, 'Looking Back on Surrealism', *Modernism: an Anthology*, ed. Laurence Rainey (Oxford: Wiley-Blackwell, 2007), pp. 1113–16, p. 1113.
[2] Nikolaus Pevsner, 'Time and Le Corbusier', *Architectural Review*, 125.7 (Mar. 1959), pp. 159–61, p. 160.

this is perhaps an aspect of home ownership we take entirely for granted.[3] The inhabitants of homes they do not own cannot always exercise this degree of control over their environment, but those who can, do.

The key intellectual problem which modernist architecture failed to address was that modernity might be superseded. The need for shelter, warmth, and safe storage of possessions is a constant, but other aspects of what houses are for have changed out of all recognition in the last hundred years. For example, the almost religious devotion to flooding domestic interiors with natural light which is so characteristic of Le Corbusier and his followers has turned out to be totally incompatible with a world in which much of the population spends a lot of its time sitting in front of screens. In 1949 the architectural historian John Summerson made the remarkably prescient comment that 'when television has reached the technical perfection which it presumably will, it seems to us inevitable that radio entertainment will dominate the cultural life of our time'.[4] In the world of the twenties and thirties, houses were still mostly what they had been in the nineteenth century, a private sphere where one shut out the world, but there was already a significant change: widespread ownership of radios meant that the world came to one's hearth.[5] Now, as Summerson was among the first to recognize, people's homes are where their cultural life is centred, where they listen to music and watch films, and even the place where they shop.

The functionality of 'International Style' houses has turned out to be somewhat problematic. Their large windows, designed to let the sun into rooms which are often open-plan and/or double height, were single-glazed, so the houses were extremely hard to heat. Walter Gropius's famous Bauhaus cost 11 per cent more to heat than the Dessau Town Hall, a conventional building.[6] Beyond that, some at least of the 'needs' met by the International Style were fantastical. Sometimes it seems as if the mantra that form must follow function reversed itself, and the qualities of a building were imagined not only to dictate the life lived in it in practical terms, but also to mould the character of the occupants, in much the same way that Virginia Woolf thought that clothes moulded the consciousness of their wearers.[7] The architectural mystic Paul Scheerbart made this claim directly,

[3] Stewart Brand, *How Buildings Learn* (London: Viking, 1994).

[4] John Summerson, *Heavenly Mansions* (Cresset Press, 1949), p. 206.

[5] The nineteenth-century home was analysed in a famous work by Jürgen Habermas, *The Structural Transformation of the Public Sphere: an Inquiry into a Category of Bourgeois Society* [1962], trans. Thomas Burger (Brighton: Polity Press, 1989). On radios, see Juliet Gardiner, *The Thirties: an Intimate History* (London: Harper Press, 2010), p. 315.

[6] Raymond McGrath and A. C. Frost, *Glass in Architecture and Decoration* (London: Architectural Press, 1937), p. 165.

[7] Virginia Woolf's 'frock consciousness' is discussed in chapter 13. The idea of the house which moulds the minds of its occupants is also explored in contemporary horror stories. Kipling's short story 'A habitation enforced' and John Buchan's 'Fullcircle' take up this theme.

arguing that culture is created by architecture, and since there is a direct connection between an individual's external and internal world, consequently, altering the formal structure of one's surroundings can effect a change in thinking.[8]

Functionalism can have a Scheerbartian element. The ubiquitous balconies and rooftop spaces offered by modernist designers were designed not only to accommodate sunbathing, because a tan was in itself a signifier of attachment to modernity between the wars, but also to allow sleeping out of doors. Thurso House (now Willow House), in Cambridge, not untypically has a master bedroom giving onto a roof terrace intended for this purpose. This particular shibboleth emerges out of the pre-World War I culture of kursaals and alpine clinics for treating tuberculosis in dry, pure mountain air, creating a strong association between sleeping outdoors and physical and mental health. As an aspect of domestic economy in damp, low-lying Cambridge, it is more like ritual magic. There was also an unstated reason for these roof terraces: the architect's need to make some kind of visual sense of the house's cold-water tank. Gravity requires this to be located above the upstairs taps, so with a flat-roofed building, it becomes an intractable lump, which designers of conventional houses with pitched roofs could simply tuck into the attic.[9] But, for whatever reason it was arrived at, the idea of a sun terrace opening from a bedroom evidently made sense, both to architects and to their clients.

Glass vies with concrete as the ultimate modern building material.[10] Even before the First World War, the expressionist Bruno Taut designed a Glass House (1914), and Paul Scheerbart imagined a brave new world of all-glass architecture.[11] His projects, had they been built, would have produced a rich, shimmering world of reflections. The enterprise of filling buildings with light tilts over into the baroque world of marvel if the structures are designed for reflection rather than translucence.

The use of glass where a solid material is expected also effects astonishment: for example, the celebrity hairdresser Antoine's glass house in the rue Saint-Didier in Paris, built in 1927, in which the exterior walls were replaced by plate glass, the staircases ripped out and replaced by glass, and, as far as possible, the furniture was glass. Or Paris's other 'Maison de Verre', built in 1928–32.[12] In the case of Antoine, a married man, it was not the 'hiding in plain sight' agendas of queerness

[8] Rosemary Haag Bletter, 'Paul Scheerbart's Architectural Fantasies', *Journal of the Society of Architectural Historians*, 34.2 (May 1975), pp. 83–97, p. 87, and (focusing on the modernist theorist Walter Benjamin's attraction to Scheerbart's idea) Detlef Martins, 'The Enticing and Threatening Face of Prehistory: Walter Benjamin and the Utopia of Glass', *Assemblage*, 29 (Apr. 1996), pp. 6–23, p. 10.

[9] I owe this observation to Alan Powers.

[10] G. S. Reynolds and G. P. Hughes, *ABC Guide to Glass in Architecture, Building and Decoration* (London: Stone & Cox, 1939).

[11] Bletter, 'Paul Scheerbart's Architectural Fantasies', pp. 83–97, p. 87.

[12] Martin Battersby, *The Decorative Twenties* (New York: Walker, 1969), p. 79.

which motivated the creation of this extraordinary building, but theatricality: the need for self-advertisement which he shared with actors and the demi-monde. The 'Maison de Verre', commissioned by a married couple, seems to be the product of intellectual curiosity.[13]

International Style houses tend to be white almost as an article of faith. Where the walls are not glass, they are most typically of concrete or cement render. Mark Wigley has explored the many connotations white walls bore for polemicists of the avant-garde.[14] Colour was sexual; white intellectual. Colours changed with the light or in relation to one another, pulled masses forward or pushed them back. White focused the eye on the 'true' composition of a building, its volumes, rather than seducing the eye into lingering on the surface, an internalization of the ancient argument for the primacy of sculpture over painting, but perhaps with additional overtones of paint as feminine deception. Above all, white seemed both hygienic and virtuous. However, an additional, unstated reason for favouring concrete and white render is that the shape of a white building reads more expressively in a small-scale black-and-white photograph in a magazine than that of a building in traditional materials such as brick, and magazines were increasingly the means by which any building became known beyond its immediate environment.

Unfortunately, between Britain's plunge into war in 1939 and the late 1950s, it was seldom possible to keep up a programme of repainting windows and repairing cracked render, due both to labour shortages and to a shortage of materials. This was particularly problematic for modern-movement structures since, as the restoring architect John Winter comments crisply, 'The buildings weathered appallingly and leaked from day one. Leave a brick house for ten years and it won't look much different. Leave a concrete house for the same time and it looks a little sad.'[15] By 1946, after only ten years of life in wet, dirty, pre-Clean-Air-Act London, Lubetkin's Highpoint looked increasingly dilapidated.[16]

Since they were using new materials in new ways, modern-movement architects may be forgiven for not anticipating 'concrete cancer', to which many of their houses have fallen victim. This occurs because the reinforcing rods which give reinforced concrete its name were of mild steel, which rusts. If, as was sometimes the case, they were only half an inch beneath the surface, they were vulnerable to water seepage if any break developed; and concrete can crack if the building settles, or as the result of frost damage, or for any number of other reasons. But beyond that, as Anthony Jackson observes, 'While the hazards of pioneering and lack of

[13] Dominique Vellay, *La Maison de Verre* (London: Thames & Hudson, 2007).

[14] Mark Wigley, *White Walls, Designer Dresses: the Fashioning of Modern Architecture* (Cambridge, MA: MIT Press, 1995).

[15] Ross Clark, 'They saw the future—but has it worked?', *Daily Telegraph*, 30 Nov. 2011.

[16] Anthony Jackson, *The Politics of Architecture: a History of Modern Architecture in Britain* (Toronto: University of Toronto Press, 1970), p. 36.

money were the reasons often used in excuse, the contrasting durability between the traditional and modern shows that logic was often abandoned when it conflicted with dogma.'[17]

Some structural errors are less forgivable, because they were perpetrated for purely aesthetic reasons. Like reinforcing rods, window frames were made of mild steel because stainless steel was yet to be developed, and were protected only by paint, but some architects embedded them in the concrete, in the interests of visual smoothness. If they subsequently rusted beyond repair, they have had to be chipped out. Checkley's Thurso House was one such: John Winter, who worked on it, observed, 'It didn't occur to the modernists that their houses would ever wear out.'[18] Sassoon House in London, designed by Maxwell Fry and Elizabeth Denby, was hailed when it was built as a major advance in inexpensive rented housing, but it was unable to resist the climate. The windows failed, and it rapidly became unusable.[19] In many International Style houses, the experimental designs of the architects met with the technical inexperience of the builders, to disastrous effect. Judith Donahue observes, of one of America's iconic modernist buildings—Frank Lloyd Wright's Fallingwater (1935)—that the waters did not merely fall around the house, as intended, but through it.[20]

The modernist impulse to streamline is often aesthetic rather than functional, especially when it comes to tidying away gutters and drainpipes. Few buildings other than the Pompidou Centre have made a visual statement out of rainwater goods, but in northern Europe it is self-deceiving to think that they can ever be unnecessary. However, the fashionable interwar boldness about acknowledging bodily functions in human beings was balanced by a mysterious new prudery when it came to buildings. Consequently, as Alan Powers comments, there was '[a] difference between what actually was efficient, and that which merely looked as if it might be'.[21]

Truth to materials is an article of modernist faith—that construction should dictate design. But although modernist houses in England are often designed to look as if they were built from poured concrete, few were actually constructed that way, because the small number of building contractors who were masters of the technology were unwilling to undertake small domestic projects. Ove Arup, doyen of concrete engineers, observed, 'There is a streak of dishonesty running through the

[17] Jackson, The Politics of Architecture, p. 56. [18] Clark, 'They saw the future'.

[19] Jackson, The Politics of Architecture, p. 100.

[20] Judith Donahue, 'Fixing Fallingwater's Flaws', Architecture (Nov. 1989); Paul R. Bertram, Jr, 'Technical Insights on the Restoration of Frank Lloyd Wright's Fallingwater', Building Envelope Technology Symposium (2006).

[21] Alan Powers, Britain: Modern Architectures in History (London: Reaktion, 2007), p. 40.

architectural profession. They do not face facts, they fake facts.'[22] More commonly, houses of egregiously modernist appearance were constructed with a reinforced-concrete frame enclosing blocks, and cement-rendered, a method which was also used by some of the most famous International Style architects. Andre Lurçat constructed the Villa Guggenbuhl in Paris, completed in 1927, in this fashion, and Le Corbusier's Villa Savoye at Poissy (1928–9) is another frame-and-block building. In England, Amyas Connell's 1929 'High and Over' was designed as a poured-concrete structure, but actually built, faute de mieux, as frame-and-block by Messrs Watson of Ascot because they had limited experience in reinforced-concrete con-struction. Its white cement-render skin is like the icing on a Christmas cake.

Sarah Williams Goldhagen has argued that equating modernist architecture with the International Style has led to other kinds of interwar building which did not fit this model being written out of architectural history, and she suggests there were other important currents in early twentieth-century architecture besides buildings which looked as if they were about to head out to sea.[23] Some of them are baroque. Geoffrey Scott's *The Architecture of Humanism* (1914) was a study in the history of taste which argued the case for Renaissance and baroque architecture. He was one of several architectural scholars who found Rome a shock to their preconceptions and came away with a perhaps reluctant admiration for baroque architects.[24]

Scott was very familiar with Italy: having gone there initially with John Maynard Keynes, he was introduced to the Berensons, became a protégé of Mary Berenson's, and decided to stay. He and the architect–designer Cecil Pinsent went into partner-ship and developed a practice renovating villas and their gardens, as well as creating new villas in a Renaissance style, notably the Villa le Balze near Fiesole. Having married Lady Sybil Cutting in 1918, he lived with her at the Villa Medici, where he and Pinsent proceeded to install a red lacquer library. Though Scott moved away from the practice of architecture after le Balze, he remained influential, because his book was very widely read.

Gavin Stamp has argued that the reason why modernist houses, as distinct from other types of building such as factories and Underground stations, did not catch on in England is that the problem of a new urban architecture had effectively been solved before the First World War by less drastic means.[25] A German architect,

[22] Peter Jones, *Ove Arup, Master Builder of the Twentieth Century* (New Haven and London: Yale University Press, 2007), p. 128.

[23] Sarah Williams Goldhagen, 'Something to Talk About: Modernism, Discourse, Style,' *Journal of the Society of Architectural Historians* 64.2 (June 2005), p. 145.

[24] Louise Campbell, 'A Curious Heritage: Humanism, Modernism, and Rome Scholars in Architecture during the 1920s and 30s', *Lutyens Abroad*, ed. Andrew Hopkins and Gavin Stamp (London: For British School at Rome, 2002), pp. 87–100.

[25] Gavin Stamp and André Golancourt, *The English House, 1860–1914* (Chicago: University of Chicago Press, 1986), p. 28.

Hermann Muthesius, came to England before the war and applied his considerable analytic powers to what the English were getting right in the realm of design. One result was *Das Englische Haus* (Berlin, 1904–5). He wrote of 'a sure feeling for suitability...a practical, indigenous and pre-eminently friendly house...instead of a sham modernity expressing itself extravagantly.' The much despised Victorian Gothic revival had given rise to excellent craftsmen, who passed their skills on to the builders who put up the houses of the Arts and Crafts movement.[26] The First World War devastated the ranks of these skilled individuals who had built so well. In the immediate post-war world there was a shortage of both conventional building materials and skills.[27] By 1930 Madge Garland takes for granted 'a scarcity of able craftsmen'.[28]

The eclectic urban style evolved by Edwardian speculative builders and jobbing architects was based on the study of unpretentious houses of the seventeenth and even eighteenth centuries, both English and Flemish.[29] The architects Richard Norman Shaw and Ernest George are particularly associated with the style, and Kew Palace was a favourite model: its flat, seven-bay brick front can be straightforwardly recast into the façade of a block of flats and extended by as many bays as might be needful, while its four storeys could become five or six.[30]

Such buildings have proved eminently useful and adaptable, and so England's pre-modern modernization helps to explain why the International Style was so tepidly received. John Summerson suggests that the key date was as late as 1927: 'The year in which scattered and indiscriminate observation of events on the continent coalesced into an opinion—that such a thing as a "modern movement" existed and was in the nature of a "cause".'[31] It probably helped that it was in 1927 that an English translation of Le Corbusier's *Vers une architecture* appeared.[32] High and Over was completed in 1929.

Quite apart from building in styles which represent an unselfconscious continuum with seventeenth- and eighteenth-century ideas about urban housing, there were other strands in English building which might be seen as modern baroque. One strand of interwar architecture which definitely does not fit with the tenets of International Style is the expression of a camp or fantastical sensibility through building. Clough Williams-Ellis was, to Alan Powers, 'the supreme master of Curzon Street Baroque'.[33] His Portmeirion, a life work which he began in 1925

[26] Stamp and Golancourt, *The English House*, p. 36. [27] Powers, *Britain*, p. 29.

[28] Madge Garland, *The Indecisive Decade* (London: Macdonald, 1968), pp. 18–19.

[29] Osbert Lancaster, *Here, of All Places* (London: John Murray, 1959), p. 104.

[30] Stamp and Golancourt, *The English House*, p. 18.

[31] John Summerson, writing an introduction to Trevor Dannatt, *Modern Architecture in Britain* (London: Batsford, 1959).

[32] Jackson, *The Politics of Architecture*, p. 18.

[33] Alan Powers, *The Twentieth Century House in Britain* (London: Aurum Press, 2004) p. 28.

and continued to add to until 1939, is a curious mixture of architectural salvage and frankly theatrical new building painted in brilliant colours, with a good deal of disguise, illusion, and trompe l'oeil. Less a village than a pleasure park, it was built to express Williams-Ellis's own aesthetic principles on land he personally owned.[34] He conceived it as 'propaganda for good manners', a demonstration of the way that planned development could enhance its environment, not destroy it. Its peculiarly bogus quality stems from the fact that it is only a place to visit or, at best, to take a holiday; popular as it has always been, it has the artificial quality of a show home, which cannot undergo the organic development natural to a place where people actually live.

The issues which meant that architecture for and by women, and, in particular, architecture for or by lesbians, often failed to embrace a modernist aesthetic of whiteness and open-plan living have been considered in chapter 2, with reference to Le Corbusier and Eileen Gray. Gay Englishmen also had reasons for wanting their homes to convey ambiguous messages, and a number of them were also strongly interested in using architecture for self-expression.

England did not feature any surrealist building per se, in the sense of entirely new structures such as the Beistegui penthouse in Paris, but a number of houses underwent a fantastical makeover between the wars. One of the most thorough-going was Monkton House, built by Edwin Lutyens in 1902 for the father of Edward James. Having started as an orthodox neo-Georgian brick building, it was rendered, painted purple and pale green, equipped with downpipes made to look like giant bamboo, and decorated with aprons of fictive cloth hung from the first-floor windows—a development of a baroque motif, as Gavin Stamp observes. Giant palm trees were erected on either side of the door. Additions to the chimney stacks included a clock to tell the days of the week, while the balcony balustrades were hugely overscaled naturalistic fern shoots, reminiscent of Emilio Terry consoles.

This remodelling was done by Kit Nicholson, architect brother of the painter Ben, with the help of Hugh Casson. The interiors were even stranger, and were the work of Norris Wakefield, an assistant to Mrs 'Dolly' Mann.[35] James's bed was modelled on the funeral carriage which took the body of Nelson to St Paul's, with palm-tree columns. Palms were both a baroque and rococo motif; the Palm Room at Spencer House, built 1756–66—fantastical architecture with carved and gilded palm trees—was based on John Webb's seventeenth-century design for the King's bedchamber at Greenwich Palace, then thought to be by Inigo Jones.

Among its furnishings Monkton held two of Dalí's Mae West Lips sofas, in a dining room which Wakefield had had padded, buttoned, and quilted in blue serge,

[34] Alwyn Turner, Jan Morris, Mark Eastment, Stephen Lacey, and Robin Llywelyn, *Portmeirion* (London: Antique Collectors' Club, 2006).
[35] Gavin Stamp, 'Surreal Recall', *Anti-Ugly* (London: Aurum, 2013), pp. 25–6.

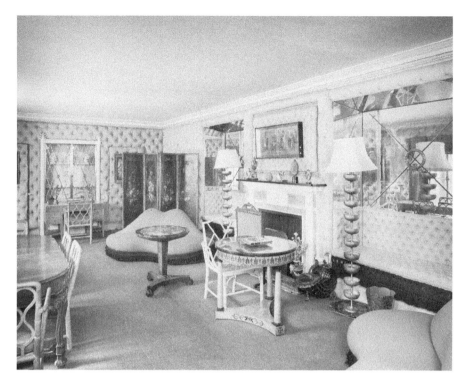

Figure 10 Monkton House, dining room with Dalí 'Mae West' sofas, champagne glass standard lamps, and upholstered walls. Photographer: unknown. English Heritage © Crown copyright. Historic England.

the same colour as James's suits. Dalí's lobster telephones and 'Arm' chair also featured, along with some of the surrealer offerings from Chanaux, acquired via Syrie Maugham: plaster-hand lamps, and pieces by the Giacomettis and Serge Roche (see Figure 10).[36] Monkton also housed James's extensive collection of surrealist paintings. Gavin Stamp described it as 'one of the most eccentric, revealing, enchanting, and—yes—subtly representative architectural creations of its time'.

What it was representative of is the alternative thread in interwar culture. Monkton is an outstanding example of a queer taste expressed in architecture, but it is in a continuum with contemporary homes of other wealthy and aesthetic bachelors. Though Lord Berners did not remodel his eighteenth-century Faringdon House architecturally, he similarly used it to express surreal taste: he kept a flock of pigeons dyed in brilliant colours, and filled it with incongruities—paintings by Derain, Sisley, Matisse, and moustachioed family portraits on the walls, and, among other curious

[36] Ghislaine Wood, *Surreal Things* (London: V&A Publications, 2007), p. 53.

furnishings, stuffed birds, mechanical toys, a pink, squeaking Disney pig that for some reason reminded him of Violet Trefusis, and a chest of drawers designed by Salvador Dalí that leant sharply to one side.[37] He built a folly—a tower nearly 100 feet high—in 1935, saying 'the great point of the tower is that it will be entirely useless'.[38] The commission went to Gerald Wellesley, 7th Duke of Wellington, known to contemporaries as 'the Iron Duchess',[39] and it was inaugurated with a tremendous firework display, with guests permitted up to six effigies of enemies to be burned on the accompanying bonfire.

Other queer bachelors with exotic tendencies included Edward Bootle-Wilbraham, 3rd Earl of Lathom and patron of Noël Coward, who remodelled Blyth Hall with a neo-Greek swimming pool, steps with crystal banisters, and cut-glass pillars, and Sir Philip Sassoon, whose party house, Port Lympne, was subverted from Herbert Baker's fairly conventional 'Dutch Colonial' original with interventions from the gay architect Philip Tilden.[40] Another wealthy bachelor, Geoffrey Bushby, similarly commissioned a holiday home and party venue, Portland House (1935), on a dramatic, steeply sloping site overlooking Portland Harbour near Weymouth, from Gerald Wellesley and Trenwith Wills. Like Port Lympne, it was a theatrical house, in a 'Hollywood Spanish' style.[41] Wellesley, or Wellesley/Wills, also produced other fantasy buildings and rooms for gay clients, including a Vogue Regency library for 'Chips' Channon, at 5 Belgrave Square, and Wellesley's personal style was baroque: '[His] bedroom in his London townhouse displayed the "Magnasco society taste", and a neo-baroque form was evident in his bizarre and spectacular bed, the paintings that hung on the walls, and other baroque-inspired schemes in the room's decoration.'[42]

One of the most dramatic, and best evidenced, example of interwar fantasy architecture is Raymond McGrath's Finella, in West Road, Cambridge (1928–9), created for an English lecturer, the 'small, androgynous and homosexual' Mansfield Forbes. It is a Victorian detached villa, the interior of which has been converted into an imaginary palace. Alan Powers asks of it, 'Could architecture deal with ambivalence about modernity through a Modernism equivalent to that of Eliot and Joyce?...The doctrine of efficiency had no time for inner contradiction.'[43] But modern baroque embraced contradiction and ambiguity.

[37] Mark Amory, *Lord Berners: the Last Eccentric* (London: Chatto & Windus, 1998), p. 136.

[38] Amory, *Lord Berners*, pp. 149–50.

[39] Alan Pryce-Jones, *The Bonus of Laughter* (London: Faber & Faber, 2012).

[40] Peter Stansky, *Sassoon*, p. 45.

[41] Twentieth Century Society: Casework, December 2001: http://www.c20society.org.uk/casework/portland-house-weymouth.

[42] Stephen Calloway, *Baroque Baroque: the Culture of Excess* (London: Phaidon, 1994), p. 48.

[43] Powers, *Britain*, p. 35.

Finella appears to be the product of personal obsession. Forbes was not hugely wealthy. Apart from his salary, he reckoned on an investment income of £400 a year, based on a capital of £4,800. The bursar of Gonville and Caius, which owned the house, sensibly required him to clarify his financial position before entering into a contract; and these facts come from his correspondence with the college, which has been unearthed by Elizabeth Darling. Forbes was nonetheless prepared to spend money like water, though initially he held only a seven-year lease on the house, later extended to fourteen years.[44] Interestingly, Cecil Beaton's beloved Ashcombe, on which, like Forbes, he lavished money and ingenuity, was leased, not owned, though he did eventually try to buy it: the element of fugacity, of living for and in the moment, may also be an aspect of queer aesthetics.[45] In the case of Finella, Gonville and Caius agreed to put in £1,100 for repairs; but by 1931 Forbes had a £7,000 overdraft, which suggests that he spent considerably more on the house than he possessed, even if his investments were affected by the crash of 1929. Ironically, the building was intended to demonstrate the relative *cheapness* of new materials.[46]

One reason for his reckless extravagance may be his feelings towards Raymond McGrath, a young, gifted, and handsome Australian who was only 25 when Forbes picked him up and adopted him as a protégé. Personal affection perhaps led him to countenance unsustainable spending in order to allow McGrath to make his name with a masterpiece.[47] Their relations were not sexual, but in a 1928 letter to a friend McGrath refers to his employer by his nickname, 'Manny', and their closeness is also witnessed by McGrath's diary, which attests to their visiting art exhibitions and interesting new buildings together.[48]

Another reason for the project, Darling suggests, is self-expression. Finella is the architectural realization of a personal mythology. Mansfield Forbes was related to the noble family of Forbes-Sempill of north-eastern Scotland, and it is an Angus legend which informs his building. According to Forbes, Finella was a Pictish queen who died in the tenth century, the inventor of glass, who had a glass palace built for herself with a roof thatched with copper, and died gloriously, escaping

[44] Elizabeth Darling, 'Finella, Mansfield Forbes, Raymond McGrath, and Modernist Architecture in Britain', *Journal of British Studies*, 50.1 (Jan. 2011), pp. 125–55, p. 130.

[45] John Potvin, *Bachelors of a Different Sort: Queer Aesthetics, Material Culture and the Modern Interior in Britain* (Manchester: Manchester University Press, 2014), pp. 267–79. Cecil Beaton describes it in *Ashcombe: the Story of a Fifteen-Year Lease* (London: B. T. Batsford, 1949).

[46] Hugh Carey, *Mansfield Forbes and his Cambridge* (Cambridge: Cambridge University Press, 1984), p. 14.

[47] Darling, 'Finella', p. 136.

[48] When Mary Crozier came into McGrath's life in 1928, Forbes gave the relationship his blessing: 'Forbes and I are in the middle of a Texan romance! Malfroy... turned up the other day with a charming American girl, whom Manny singled out for his immediate blessings. So he invited them to lunch with us on the river-bank in the Fellows' Garden.' Tim Beaglehole, *A Life of J. C. Beaglehole, New Zealand Scholar* (Wellington: Victoria University Press, 2006), p. 139. McGrath and Mary Crozier married in 1930.

capture by her enemies by plunging headlong into a waterfall at Den Finella, near Montrose in Angus.[49]

This story bears no relationship to the Finella of medieval Scottish history, where she figures as inventress of a weapon of assassination, a statue cunningly linked to drawn crossbows which were triggered at a touch, with which she successfully murdered Kenneth III.[50] The glass palace, waterfall, et cetera, are not historical, and I have found no traces of Forbes's version of her story before 1853,[51] but it is essential to his building, since the house references glass, copper, and water. Finella's extraordinary interior surfaces were in varying degrees reflective, starting with its 40-foot entrance hall, which has silver-leaf walls and a vaulted, silver-green glass ceiling (see Figure 11). Its double salon, 'the Pinks', had ceiling and walls of rosy pink, which were separated by folding doors of a copper-faced plywood called Plymax. Steel-framed folding doors opened on to the garden. A niche on the east wall evoked Finella's waterfall: it was faced in silvered fluted glass and held a 6-foot-high white glass trumpet vase, with jets for a fountain placed around it. When it was switched on, the fountain was illuminated by blue and orange light enhanced by an X-ray reflector.

Forbes thus appears to have sponsored a personally symbolic building, in which he figured as a Pictish queen in a palace of glass and copper. His highly selective treatment of the Finella legend suggests he preferred to think of himself as a victim rather than an aggressor. Other elements of his decor reference Pictish art directly: the floor, made from a new material called induroleum, a relative of the more familiar linoleum, was decorated with Pictish symbols, of which he owned many photographs.[52] Additionally, oriental statues alluded to his upbringing in Sri Lanka, where his father had run tea and coffee plantations. Externally, the brick house was rendered and painted pink, with green woodwork and trellis, giving it a Regency look, rather as Edward James was to do a few years later at Monkton. The furnishings were an eclectic combination of antique and modern, with oriental china.[53]

The purpose of the house was evangelistic. It was to be an 'exhibition-piece-cum-arts-centre', an advertisement for modernist architecture and the use of new materials,

[49] Anonymous [pseud. Mansfield Forbes], 'An Imaginary Conversation with Mansfield D. Forbes, Esq.: an Experiment in Modernism,' *Varsity Weekly*, 4 June 1932, p. 1.

[50] John of Fordoun, *Chronicle* IV.32–3, ed. W. F. Skene (Edinburgh: Edmonston and Douglas, 1871), pp. 174–5.

[51] He drew on *The Kaim of Mathers: a Legendary Tale and Verses on Den-Finella* (Brechin: Alexander Black, 1853). The Picts made 'glass castles', deliberately burning forts so they turned into slag-glass. As Forbes well knew, a vitrified site, Cairnton of Balbegno, was alternatively known as Green Cairn or Finella's Castle and associated with her.

[52] Carey, *Mansfield Forbes*, pp. 100–1. Sir Geoffrey Keynes, who knew Forbes personally, discussed him with Peter Davidson in the early 1980s. He mentioned both the collection of photographs, the basis for a book which Forbes planned but did not write, and that Forbes associated Finella's legendary 'glass castle' with Pictish vitrified forts (pers. comm.).

[53] N. L. Gall, 'Furnishing and Decoration at "Finella"', *Good Housekeeping* (Nov. 1929).

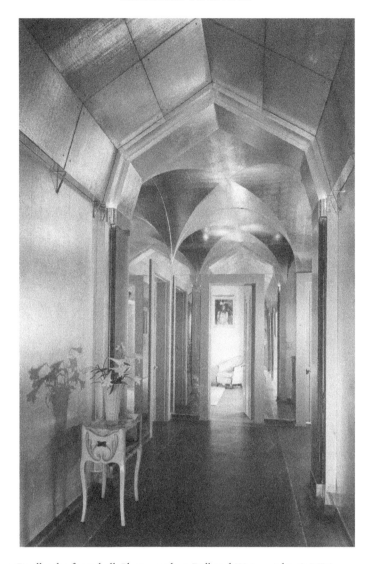

Figure 11 Finella: the front hall. Photographer: Dell and Wainwright. © RIBA.

where Forbes intended to entertain lavishly in order to convince doubters, to which end it boasted a 50-foot double salon, a dining room, and a morning room. He brought together a 'Twentieth Century Group' in 1930, with the aim of holding modernist exhibitions.[54] Additionally, it was an advertisement for Raymond McGrath,

[54] Darling, 'Finella', p. 154.

who was developing a particular interest in the architectural and decorative use of glass; in 1937 he would publish the highly influential *Glass in Architecture and Decoration*.[55] Finella did indeed get McGrath's career off to a glorious start, and however anxious he may have been about his enormous overdraft, Forbes did entertain there. His guests included a roll call of leading modernists, including Eric Gill, Paul and John Nash, Jacob Epstein, Maynard Keynes and Lydia Lopokova, Philip Sargant Florence, and Ottoline Morrell. He also showed the house, and estimated that by 1932 30,000 people had seen it, some of whom were architects and opinion-formers.[56] It was very extensively written up, notably in British *Vogue*, *The Studio*, and an Italian magazine, *Domus*.[57]

A British architect whose work showed a marked streak of the fantastical was Oliver Hill, who fell in love with baroque style as a schoolboy. Alan Powers writes: 'The seventeenth century remained at the centre of his inspiration down to the writing of *English Country Houses: Caroline 1625–1685* with John Cornforth in 1966. The richness of baroque furniture, covered in silver or gold leaf, and the curves and counter-curves of Daniel Marot's style as seen in the Long Gallery at Penshurst or the King's Bedroom at Knole, were lasting influences.'[58] He educated his eye as a pupil architect in London by browsing antique shops and making friends with dealers.

Architects needed to have the social skills which could turn a chance meeting at a party into a lucrative commission. Hill, like Philip Tilden, had a great knack of charming clients, several of whom came back to him more than once, but he was much more original than Tilden. David Dean said of him, 'Romantic, enthusiastic to the point of extravagance and sometimes beyond, he moved easily from style to style: Tudor, Georgian, Lutyensesque, Pseudism, even Provençal and not least a Moderne-inflected modernism. But he was more than literally style-ish, there was an aplomb, a dashing elegance running through all his work.'[59]

In the twenties he built a number of houses using conventional materials, stone, wood, and thatch, including one—Cock Rock at Croyde—for Brenda Girvin and Monica Cosens, playwrights who also wrote stories for girls.[60] He subsequently designed a town house, Venice Yard House in Gayfere Street, Westminster, for the same couple. His clientele included other theatre people: another of his twenties

[55] Darling, 'Finella', p. 141. [56] Darling, 'Finella', p. 152.

[57] 'A Modern House in Cambridge', *Vogue* (11 Dec. 1929), pp. 60–1; 'Aladdin at Cambridge', *The Studio*, 99 (July 1930): pp. 183–5; *Decorative Art, 1930: The Studio Yearbook*, ed. C. Geoffrey Holme and S. B. Wainwright (London, 1930), p. 27; 'Ambienti D'Eccezione', *Domus* (Nov. 1930), pp. 50–2.

[58] Alan Powers, *Oliver Hill: Architect and Lover of Life* (London: Mouton, 1989), p. 5.

[59] John Cornforth, *The Search for a Style: Country Life and Architecture, 1897–1935* (London: HarperCollins, 1988), p. 34, quoting David Dean in *The Thirties: Recalling the English Architectural Scene* (London: RIBA and Trefoil, 1983).

[60] Powers, *Oliver Hill*, pp. 11, 17–18.

houses, Woodhouse Copse, for the actress Amy Brandon Thomas and her husband, had decided modern baroque tendencies—the bath was of blue mosaic, filled from a wall mask by the ceramic sculptor Phoebe Stabler.[61] Hill became increasingly popular as a highly successful creator of 'Vogue Regency' town houses for extremely smart and moneyed clients.

Hill shared Syrie Maugham's taste for very pale rooms: the drawing room in the town house he designed for Lord Vernon in 1930, Vernon House in Carlyle Square, had silvery-grey Australian walnut panelling, niches filled with blanc de Chine china, and the only painting was a Gluck study of lilies in one of her stepped frames. The furniture was covered in ivory satin.[62] His modernist house, Joldwynds, also had an all-white dining room, with furniture veneered with ivory shagreen and upholstered in white calf.[63] His own weekend cottage, Valewood, was baroque-eclectic, with solid Arts and Craftsy furniture combined with ship models, interestingly shaped ironwork, zebra skins, and black-and-white textiles.[64]

Other major clients of Hill's included Colonel and Mrs Wilfrid Ashley, later Lord and Lady Mount Temple: the second of two houses called Gayfere House which he built for them in 1931 was externally conservative, red brick and Portland stone, but internally remarkable, the result of a combination of his own ideas with Lady Mount Temple's. Curiously, Lady Mount Temple had Forbes-Sempill connections, since, like Finella, Gayfere House speaks of a fascination with glass: the hall had a mirror-glass ceiling and mirrored doors; and the bathroom was completely mirrored, with a black marble floor. The drawing room walls were of green-silvered mirror glass and silver-grey oak, with a chimney piece and overmantel of eighteenth-century inspiration carried out in engraved looking glass (see Figure 12).

At the beginning of the thirties Hill converted for a time to the International Style and built Joldwynds for a barrister client, Wilfred Greene, in 1932. It was structurally traditional, brick-built, but for aesthetic reasons he used the same rendering he had employed for Vernon House, made of white cement and carborundum, which could be polished to look like marble.[65] Unfortunately, it illustrated the hazards entailed in using innovative materials: Joldwynds leaked like a sieve, and Greene sued him. Hill's major project in this vein, the Midland Hotel at Morecambe, also had major damp problems, which, sadly, destroyed the Eric Ravilious mural in the café only two years after its completion.

Greene gave up on Joldwynds and built another house, The Wilderness; his god-daughter Margaret was married to its designer, Berthold Lubetkin of Tecton. It is brick-built with a slate roof, suggesting that Greene had got a little tired of experiments. However, there are elements of playfulness and whimsy in other Tecton

[61] Powers, *Oliver Hill*, p. 11. [62] Powers, *Oliver Hill*, p. 23.
[63] Cornforth, *The Search for a Style*, p. 250. [64] Cornforth, *The Search for a Style*, p. 260.
[65] Cornforth, *The Search for a Style*, p. 250.

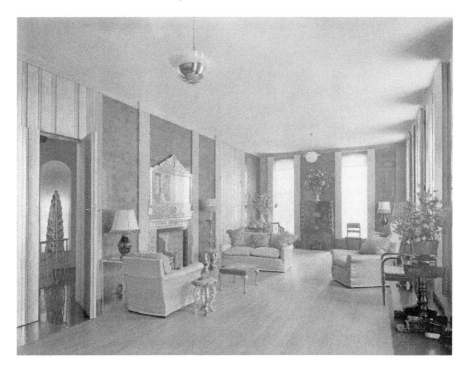

Figure 12 The drawing room at Gayfere House. The house was designed in 1932 by Oliver Hill and the interiors were also his, in collaboration with the client, Lady Mount Temple. Photographer: A. E. Henson. © *Country Life*.

work which link it with the baroque: Lubetkin's six-storey block, Highpoint Two, in North Road, Highgate (1936–8), plays with architectural history and conventions, though in quite a different way from Finella or Monkton. It features a cantilevered concrete canopy sweeping out in a great curve to shelter the entrance, with two chiton-clad Greek caryatids standing beneath it. They are completely unnecessary for structural support, and thus both evoke and refute classicism.[66]

Interestingly, Lubetkin decided to add a penthouse for himself to Highpoint Two. It is a dacha evoking the buildings of his native Georgia, with blue-painted ceilings, chairs upholstered in cowhide, a vaulted roof, and pine panelling. Its construction may have been influenced by Le Corbusier's own Porte Molitor apartment in Paris, 24 rue Nungesser-et-Coli, which had been completed five years earlier; this was in the same area of Paris as an apartment Lubetkin had built in avenue de Versailles, so he would certainly have seen it—a whitewashed, rubble-walled rustic villa with a vaulted ceiling on top of an otherwise steel/glass/concrete building overlooking a park.

[66] Jackson, *The Politics of Architecture*, p. 48.

The reasons for commissioning a modernist private house were many. Dr and Mme Dalsace built the Maison de Verre, Wilfred Greene found water dripping through the ceiling of Joldwynds, and Professor Ashmole spent about £3,000 to shiver in the unheatable High and Over, all willing guinea pigs, brave souls who for various reasons permitted able young visionaries to experiment at their expense. But since it demanded a certain amount of courage and independence of mind to commission a very unusual house, it is not surprising to find that conspicuous display, camp humour, and individual fantasy were also expressed architecturally, most notably by individuals who were either gay or had professional reasons for wanting a highly individual milieu as part of their overall self-presentation: socialite politicians, or people prominent in the world of entertainment and fashion (there is, of course, overlap between these categories).

It is striking that the campest, most fantastical houses of the interwar period are adaptations of pre-existing structures. There was nothing to stop Mansfield Forbes from building something completely new. In the late twenties there were building plots aplenty available along Cambridge's arterial roads, and even if he was determined to live in Queens Road for some reason, he could still have got land there with a little diplomacy. Similarly, James revised the house he inherited from his father rather than pulling it down, and Sassoon remodelled the plainish building he had originally constructed as somewhere to stay when he was in his constituency, once he had decided to turn it into a house for August parties. This may not be accidental. These highly individual houses do not ignore the past; they subvert it. Their authors have, in their various ways, embraced difference, but remained in dialogue with what went before.

III

Rooms

Outdoor Rooms

For modernists, the question of how modern buildings were to be integrated with their site, when that site was not a streetscape, was not easily resolved. As Christopher Tunnard, himself one of the more successful modern-movement landscape designers, put it, 'The great white bird of modern architecture has not yet found a secure and decorative perch.'[1] One underlying problem for modernist gardening was ideological. Since a garden is a decorative pleasure ground, it is hard to integrate with an aesthetic of functionality.[2] None of the sorts of technical revolution that inspired modern-movement houses could be applied to gardens, unless the area were to be treated architecturally using materials such as glass and concrete, at which point it would cease to offer the traditional pleasures of a garden.[3]

Another problem for garden designers arose from modernism's reluctance to countenance organic growth and change over time. A garden cannot escape dialogue with the past and the future, because plants grow. Where gardens in a modern idiom were attempted, they were professionally designed and, as Alexandra Harris shrewdly observed, 'intended to stay looking much the same'—that is, with growth and change set, as far as possible, to one side, and visual interest supplied by hard elements such as water, mirrors, mobiles, and electric light.[4] The 'Jardin de l'eau et de lumière' of 1925 for the Paris Exposition des Arts Décoratifs, designed by Gabriel Guevrekian, and the garden made for Jacques Rouché in 1930, were influential examples.[5]

Another purely practical problem for garden designers was modernity's enthusiasm for open-air exercise, which on the one hand gave the grounds some kind of

[1] David Jacques and Jan Woudstra, *Landscape Modernism Renewed: the Career of Christopher Tunnard, 1910–1979* (London and New York: Routledge, 2009), p. 23.

[2] David Jacques, 'Modern Needs, Art and Instincts: Modernist Landscape Theory', *Garden History*, 28.1, *Reviewing the Twentieth-Century Landscape* (summer 2000), pp. 88–101.

[3] Peter Shepheard, *Modern Gardens* (London: Architectural Press, 1953), p. 13.

[4] Alexandra Harris, *The Romantic Moderns: English Writers, Artists and the Imagination from Virginia Woolf to John Piper* (London: Thames & Hudson, 2010), p. 233.

[5] Dorothée Imbert, *The Modernist Garden in France* (New Haven: Yale University Press, 1993), pp. 94, 126–30.

functionalist excuse, but on the other called for visually obtrusive structures: a tennis court for vigorous play is a rectangular wire box, and swimming pools also tended to be rectangular, and to require a changing room. One answer was to use these rectangles as a visual cue, and to create rectangular flower boxes of brick or concrete, formally planted.[6] This highly disciplined treatment of decorative plants was also used where there was no such constraint. The Vicomte de Noailles' cubist garden at Hyères, also designed by Guevrekian, is an example of this: the planted areas are set among rectilinear hard landscaping, and the plant element is reduced to tulips in season, ground cover, and a couple of orange trees.[7] The cubist impulse to simplify, to see the 'cylinder, sphere, and cone' underlying the diverse and unruly shapes of nature, made it difficult to deploy actual plant material which could not be clipped or manipulated into some kind of geometric regularity. The only flower which was much admired by purists was the tulip, the abstract and regular form of which lends itself to regimented display.

Flat chequerboards were another solution, favoured by the English designer Russell Page. The idea actually originated in one of the most notably baroque gardens of the era, a small chequered area which Norah Lindsay introduced into Sir Philip Sassoon's garden at Port Lympne. This was laid out as a series of terraces stepping down a steep slope, so the chequerboard was to be viewed from above. Lindsay's brainwave was to recess the flower squares 9 inches below the squares of turf, so that the flowers bloomed flush with the grass. Page took note of the idea, and sank beds of box into paving, or devised other kinds of patterns, zigzags, and abstract shapes, keeping the box clipped flat and flush with the level of the terrace like living carpet.[8] Similar effects, in which the form of living plants was, as far as possible, annulled, were employed by other modernist gardeners.[9]

The designers of modern gardens in France started with the advantage of an indigenous taste for highly formal treatments of the area round a house, and a tendency to see the garden as a composed picture to be viewed from the windows, rather than as a place to stroll and relax in, in the English manner.[10] Modernist designers in England had to make headway against a quite different tradition of picturesque planting and a tremendous enthusiasm for plants in and of themselves. The Guevrekian-style garden of concrete plant boxes was imitated in England, but not often or very successfully: A. E. Powell actually copied the triangular Noailles

[6] Christopher Tunnard cites Crowsteps, Tydehams, Newbury, 'with flowerbeds decoratively incorporated into the design' (waist-high concrete boxes).

[7] Imbert, *The Modernist Garden*, illustrated on p. xiv.

[8] Russell Page, *The Education of A Gardener* (London: Harvill, 1994), p. 131.

[9] Imbert, *The Modernist Garden*, illustrates a flat composition of floral colour blocks, with a zigzag, which was a garden for the Duc Decazes at Archachon, made in 1926 (p. 62). The Duc was the brother of Daisy Fellowes, perhaps the most fashionable woman in Europe.

[10] Page, *Education*, pp. 257–64.

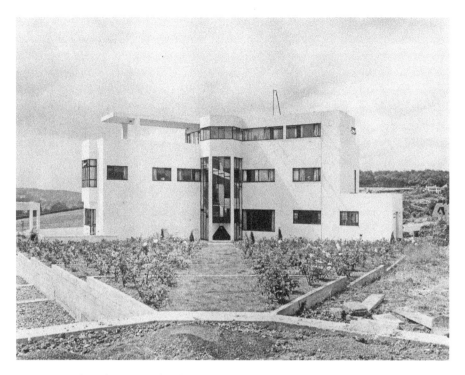

Figure 13 High and Over garden from the south-east. The terraced rose garden is in the foreground. The house was designed by Amyas Connell for Bernard Ashmole in 1929. Photographer: Newbery. © *Country Life*.

garden for a house near Bristol around 1935, but replaced the high concrete walls which boxed in the original version with a conventional low hedge, which was doubtless cheaper but spoiled the effect.[11] More importantly, in 1931 Amyas Connell landscaped the area round his influential and much-photographed house, 'High and Over', which has been called the first modernist house in Britain, in the Guevrekian style, with concrete terracing (see Figure 13).[12] Alternatively, some of Oliver Hill's modernist buildings made intelligent use of on-site mature Scots pines.[13]

Christopher Tunnard was perhaps the most conspicuous modernist gardener in England. One of his most successful plantings was for Serge Chermayeff's Bentley Wood at Halland in Sussex, designed in 1928, a project which was showcased both

[11] Christopher Tunnard, 'The Functional Aspects of Garden Planning', *Architectural Review*, 83 (1937), p. 195.

[12] Michael Findlay, 'So High You Can't Get Over It', *Interstices* 09; http://www.interstices.ac.nz/published-journals/interstices-09/. Illustrated in Jane Brown, *The Art and Architecture of English Gardens* (London: Weidenfeld & Nicolson, 1983), p. 183.

[13] Alan Powers, *Oliver Hill: Architect and Lover of Life* (London: Mouton, 1989), pp. 28–9.

in the *Architectural Review* and in Tunnard's own book, *Gardens in the Modern Landscape*. Essentially, the grounds were light woodland, with a paved patio by the house. Nearest to the house, the trees thinned to shaded lawn. The trees were planted in relation to the house, in groups or by themselves, and the only flowers were spring bulbs. The underlying concept is described by Tunnard as 'letting space flow by breaking down division between usable areas and incidentally increasing their usability'. Though this sort of garden seemed at the time highly abstract, the design reference is the eighteenth-century English park as planted by Capability Brown and Humphrey Repton, shrunk to a more domestic scale: to Tunnard, 'the eighteenth century "natural" style with its irregular "atmospheric" planting was proving peculiarly appropriate as an adjunct to [modernist] architecture.'[14]

There were thus two tendencies in modernist gardening—towards concrete, or towards grass. By contrast, a baroque spirit in gardening can manifest in a variety of ways, most of which are reflected in the interwar era. Actual baroque survivals include a number of great royal or ducal gardens of the seventeenth century composed of avenues, water features, parterres, and statuary, developed out of the principles of garden design established in Renaissance Italy: gardens such as Versailles and Herrenhausen. A garden in this tradition was created in the 1930s in England, that of Ditchley Park, designed for Nancy Lancaster and Ronald Tree by Geoffrey Jellicoe and inspired by the gardens of the Villa Gamberaia, near Florence.[15]

There is also a baroque tradition of gardens embodying an idea, notably the dark and sinister Bomarzo, near Viterbo, built to embody the grief of Prince Pier-Francesco Orsini on the death of his wife in 1560. This was only too apposite to the interwar period, since by far the commonest type of themed garden after the carnage of the First World War was, inevitably, the garden of remembrance. One of the best of many is the Irish National War Memorial Gardens in Dublin, designed by Sir Edwin Lutyens, with a clearly articulated symbolic scheme expressive of consolation.

The key baroque principles of eclecticism and excess are also expressed in English gardens. Russell Page, one of the greatest of English garden designers, looking back at the acknowledged masterpieces of interwar gardening, mostly now owned by the National Trust and among their best-loved and most popular attractions, sees them as baroque in their eclecticism and extravagance, though the word he uses is 'involved':

> If you analyse a group of important English gardens constructed at any time between 1900 and 1930 you will see that they are based on designs borrowed from every period of European garden design. Terraces, stair-cases, fountains and architecture derive

[14] Jacques and Woudstra, *Landscape Modernism*, p. 23.
[15] Allyson Hayward, *Norah Lindsay: the Life and Art of a Garden Designer* (London: Frances Lincoln, 2007), p. 161.

largely from the late Italian Renaissance; courtyards, green plots and topiary work come mainly from late seventeenth-century Dutch models. For parterres and the layout and design of flower beds, garden-makers went to Gothic manuscripts, to du Cerceaux or to Kip's engravings of country seats or to the embroideries of Le Nôtre.... They used all these elements to frame the widest range of plant material ever cultivated in any one country at any one time. The spirit of this luxurious horticultural 'never-never land' has continued, and has coloured most British and some continental thinking about garden design until today.[16]

A key pre-war figure in English garden design is the enormously influential Gertrude Jekyll, who collaborated with the architect Edwin Lutyens. The cottagey image associated with her is deeply misleading, since her style is actually one of reckless extravagance. A Jekyll garden is as high-maintenance as a Second Empire courtesan: for her own 15 acres at Munstead Wood, 10 of which were woodland, she is said to have employed 17 gardeners.[17] The Lutyens/Jekyll style was perceived as profoundly English. Jekyll used a high proportion of the indigenous plants appreciated by Elizabethan herbalists such as John Parkinson, and liked old varieties of rose. She also carried on the work of the 'florists' of the sixteenth and seventeenth century, developing improved strains of old-fashioned flowers, notably polyanthus primulas, aquilegia, lupins, and lavender.[18] Her gardens, with their painterly drifts of colour, combined minute attention to each separate plant with large-scale effects produced by using plants in their hundreds, and even labour-intensive tricks such as taking out early flowerers mid-season and replacing them with something else which would bloom in the autumn. Gardeners such as Major Lawrence Johnston and Norah Lindsay combined the English plants favoured by Gertrude Jekyll with the spoils of empire, the new plants brought back by nineteenth-century plant hunters, thus achieving the ultimate end of Renaissance botany and bringing five continents together in an earthly paradise.[19]

One element of baroque gardening which is particularly relevant to the way interwar English people liked to experience their gardens is the use of high architectural hedges.[20] André Le Nôtre created 'green rooms' (*cabinets de verdure*) at Versailles. These are smallish areas defined by hedges of more than head height, alongside the grand parterre which was designed to be seen all at once from a raised vantage point. These *cabinets* were intimate areas walled by clipped shrubs or trees,

[16] Page, *Education*, p. 53.

[17] Jane Brown, *Gardens of a Golden Afternoon* (Harmondsworth: Penguin, 1982), p. 38.

[18] Gertrude Jekyll, *Colour in the Flower Garden* [1908] (London: Mitchell Beazley, 1995), p. 48. Sacheverell Sitwell wrote about the florists in *Old-Fashioned Flowers* (London: Country Life, 1939).

[19] Represented, for example, in Carolus Clusius's 1603 botanical garden at Leiden, laid out in four quadrants for the four continents then known.

[20] Anne Scott-James, *Sissinghurst: the Making of a Garden* (London: Michael Joseph, 1975), p. 17.

where it was possible to walk in the shade in the summer heat, or hold a private conversation.[21] The division of a garden into 'rooms' is thus a principle articulated in great baroque gardens, from whence, like all good gardening ideas, they were promptly copied by other designers. It was well developed in gardens in England.

Hermann Muthesius saw much to admire in English domestic architecture, not least the way in which the English managed the transition between indoors and outdoors. The garden is seen as a continuation of the rooms of the house, almost as a series of separate outdoor rooms, each of which is self contained and performs a separate function. Thus the garden extends the house into the midst of nature,' he wrote.[22] He was reacting to the division into yew walks, shrubberies, roseries, arbours, and so forth which characterized large Edwardian gardens used by the family at different times and seasons; but the principle of compartmentalization was, if anything, elaborated in some of the best known gardens of the twenties and thirties.

Major Lawrence Johnston's Hidcote Manor garden is perhaps the ultimate expression of English garden style, though, as it happens, Major Johnston was an anglophile American.[23] Both Hidcote and Harold and Vita Nicolson's Sissinghurst could be described as enfilades of 'green rooms'. Johnson was the acknowledged master of this: the sequence of twenty-eight garden areas at Hidcote is created by using yew hedges and trellis to compartmentalize the space.[24] The central feature is an enfilade lined mostly with walls of clipped yew, but partly with pleached hornbeam, the rows of trunks giving the feel of a living colonnade—nature imitating architecture. The scale is such that the spaces form a series of stages, in which two or three people can interact without feeling dwarfed by a colossal vista in the Le Nôtre manner. Tintinhull, gardened by Phyllis Reiss, who was a friend of Major Johnston's and influenced by him, is similarly organized into 'garden rooms', six of them in an acre and a half of ground, divided with formal yew hedges.

Sissinghurst, for all that the intention was to create a wholly English garden, compartmentalizes the site into rooms separated by high architectural hedges.

[21] Scott-James, *Sissinghurst*, p. 17.

[22] Gavin Stamp and André Golancourt, *The English House, 1860–1914* (Chicago: University of Chicago Press, 1986), p. 41.

[23] Some of the more notable gardeners of the era were Americans in Europe. The Villa Gamberaia was bought in 1895 by Princess Jeanne Ghyka, sister of Queen Natalia of Serbia, who lived there with her American companion, Miss Blood, and restored both the villa and its garden (Marcello Fantoni, Heidi Flores, John Pfordresher, eds., *Cecil Pinsent and his Garden in Tuscany* (Florence: Edifis, 1996), p. 21). After the First World War, Edith Wharton and her compatriot Louis Bromfield both created grand gardens in the south of France (Hermione Lee, *Edith Wharton* (London: Chatto & Windus, 2007), pp. 529–35). Back in America, Amy Lowell had a passion for gardening, and was a keen student of Gertrude Jekyll's work (Amanda Vaill, *Everybody was so Young* (London: Warner Books, 1999), p. 89).

[24] Graham S. Pearson and Anna Pavord, *Hidcote: the Garden and Lawrence Johnston* (London: National Trust, 2009); Ethne Clarke, *Hidcote: the Making of a Garden*, 2nd edn (New York: W. W. Norton & Co., 2009).

Formal sculpture is also used to close and define vistas, notably eight bronze urns originally from the chateau of Bagatelle, built for Marie Antoinette in 1777, which were presents from Lady Sackville to Vita (her daughter), part of the extraordinary collection of loot left to her by her friend Sir John Murray Scott.[25] At Sissinghurst, 'most of the statues', Anne Scott-James says, 'were picked up in junkshops'—so the Nicolsons were using the classic decorator's trick of using a few large, grand and real objects as eye-catchers, while less exalted pieces contribute to the general effect.

Where excess really comes in with these gardens is in the borders. Johnston needed twelve full-time gardeners to tend grounds only ten acres in extent, because his borders required such attention to detail. When baroque gardeners such as Le Nôtre had used flowering plants at all, they used few varieties, very sparingly. The seventeenth-century florists' treasures were cosseted as individual specimens. Inter-war great gardens combined both passions. Johnston was himself a plant-hunter who collected specimens from all over the world and paid for expeditions made by others; within his 'rooms', hundreds of different species burgeoned, tended with a botanist's loving care. Sissinghurst, similarly, used an enormous range of plants in romantic profusion, and Vita Sackville-West was herself a plant hunter, who collected in Persia when Harold Nicolson was posted to Teheran. When he was in London, Nicolson made a point of browsing the Royal Horticultural Society flower shows, looking for new varieties.[26] Less wealthy than Johnston, the couple did a good deal of the actual work themselves, but they also employed two gardeners, and since they bought Sissinghurst in 1930, the year after the Great Depression, when men were hungry for work, there was never a problem with finding casual labour for major projects. Hidcote and Sissinghurst are now perceived as canonical, inspiring, and classically English gardens, but they were actually highly experimental amalgamations of what had been separate strands.

Since this style of garden-making demanded immense resources, it was entirely suitable for the expression of magnificence. Hidcote and Sissinghurst were gardened for their own sake and were genuinely private (Sissinghurst did not even have a guest room), but Waldorf and Nancy Astor used their house and estate at Cliveden for house parties of politically minded intellectuals, the so-called 'Cliveden Set'. As a contribution to the overall demonstration of the Astors' wealth, taste, and import-ance, the estate was gardened in the new grand manner, with formal structuring of box and topiary informally and lavishly planted. This was designed by Norah Lindsay, and maintained by sixty-odd gardeners.[27] Sir Philip Sassoon, who was another friend of Major Johnston's, also used palace gardens to support his career as politician and host, and he similarly called upon Norah Lindsay to design the planting at both of his country houses, Trent Park and Port Lympne.[28] Port Lympne

[25] Scott-James, *Sissinghurst*, p. 49.
[26] Scott-James, *Sissinghurst*, pp. 30, 32.
[27] Haywood, *Norah Lindsay*, p. 126.
[28] Haywood, *Norah Lindsay*, pp. 133–45.

had fourteen gardeners, with another six drafted in for August, when he entertained there. The borders were designed to be at their best then: Laurence Whistler said rather sourly, 'For a social month in the year Flora trooped the colour,'[29] and Sassoon himself allegedly told a lady friend, 'At twelve noon on the first of August each year, I give a nod to the head gardener who rings his bell and all the flowers pop up.'[30]

The cultural prestige of Italy remained strong between the wars. There was still a notable colony of expatriate Italophiles living around Florence, with strong connections to English literary and intellectual circles, such as the Actons and Vernon Lee (née Violet Paget), and so there were also gardens in both Italy and England which reinterpreted Italian Renaissance principles, and were primarily green. This Italian influence on English gardening is found before, as well as after, World War I. It owes a good deal to Sir George Sitwell. His book on Italian gardens, *On the Making of Gardens*, was published in 1909 after nearly a decade of travels in Italy, followed by practical experiment at Renishaw, where he created a largely green garden, given shape by massive hedges and blocks of clipped yew, and planted on several terraces going down from the house itself. His contemporary, Harold Peto, garden designer and architect, was another practical enthusiast for Italian gardens.[31]

Lady Ottoline Morrell moved to Garsingon in May 1915, and immediately plunged into gardening in the Italian manner:

> We have made one terrace and a walk round the pond, and in the autumn we are arranging to plant yew hedges that will grow like a tall dark wall around the water. It is more Italian than any other place in England that I have ever known – partly I suppose through being high on a hill and having a few dark cypresses already in the garden.[32]

A woman of acute sensitivity to colour, with a strong visual memory, her particular reference point was the Villa Capponi, which she had visited in youth with her aunt Louise, when it was owned by an Englishwoman: 'I drank then of the elixir of Italy— I drank so deeply of it that it has never left me.'[33]

Garsington Manor was a social centre and, during the First World War, a haven for conscientious objectors in Bloomsbury circles, such as Clive Bell and Mark Gertler. Its garden was thus less of a private space than a theatre for human interaction. Miranda Seymour observes that in the garden at Garsington Manor,

[29] Lawrence Whistler, *The Laughter and the Urn: the Life of Rex Whistler* (London: Weidenfeld & Nicolson, 1985), p. 201.

[30] Peter Stansky, *Sassoon: the Worlds of Peter and Sibyl* (New Haven and London: Yale University Press, 2003), p. 154.

[31] Fantoni et al., *Cecil Pinsent and his Garden in Tuscany*, p. 8.

[32] Miranda Seymour, *Ottoline Morrell: Life on the Grand Scale* (London: Hodder & Stoughton, 1992), p. 304.

[33] Seymour, *Ottoline Morrell*, pp. 304–5.

scene of many complex sexual dramas, 'High hedges and terraces seemed designed for scenes of Shakespearean intrigue in which every exchange was in danger of being overheard or observed.'[34] Guests who wished their secrets to remain secret eschewed the garden entirely, tiptoed past the servants' rooms on the top floor, and went and sat on the roof leads to talk.

After the war a number of theorists and designers insisted on the continued relevance of Italian baroque to garden design. Geoffrey Jellicoe was one. In 1926, after intensive work surveying and measuring classic Italian garden sites, he and John Shepherd published *Italian Gardens of the Renaissance*; as he himself said, looking back, the work began with the two of them determined to focus on the Renaissance, but the educational effect of analysing garden after garden gradually instilled in them a new sympathy for the baroque.[35]

Jellicoe's ideas about design were considerably indebted to Cecil Ross Pinsent, an English designer who did most of his work in Italy itself.[36] The English settlers in Italy, particularly in Tuscany, included a number of garden enthusiasts with an interest in historically sensitive recreations and adaptations.[37] Pinsent and Jellicoe met in 1923 on the site of Villa Papiniano in Fiesole, where Pinsent had been commissioned to design a superb formal garden and pool surrounded by an informal 'bosco' (woodland pleasure ground) on a steep slope beneath the house. Jellicoe said, 'He became my first maestro in the art of placing buildings in the landscape.'[38]

Pinsent was responsible for the design and construction of new villas and gardens such as La Foce and Villa le Balze, and also for the renovation of historically sensitive garden sites including the Villa I Tatti, where he worked for the Berensons, and Michelozzi's fifteenth-century Villa Medici, owned by Lady Sybil Cutting.[39] Vita Sackville-West and Harold Nicolson were among the notable English gardeners who were influenced by Pinsent, and he is the dedicatee of Geoffrey Scott's *The Architecture of Humanism*, probably the first English book to assert continuity from Renaissance to baroque.

Probably the most Italianate of garden architects working in England was Philip Tilden, who was charming, discreetly homosexual, and an expert networker. Most

[34] Seymour, *Ottoline Morrell*, p. 360.

[35] Geoffrey Jellicoe, *The Studies of a Landscape Gardener*, vol. I (Woodbridge: Garden Art Press, 1993), p. 16.

[36] Ethne Clark, *An Infinity of Graces: Cecil Ross Pinsent, an English Architect in the Italian Landscape* (New York and London: W. W Norton & Co., 2013).

[37] G. Galletti, 'Il ritorno al modello classico: giardini anglofiorentini d'inizio secolo', in *Il giardino storico all'italiana* (Milan: Electa, 1992), pp. 75–85.

[38] Ethne Clark, Author's interviews with Sir Geoffrey Jellicoe, 1989, in Clark, 'A Biography of Cecil Ross Pinsent, 1884–1963', *Garden History*, 26.2 (winter 1998), pp. 176–91.

[39] Clara Bargellini and Pierre de la Ruffiniére du Prey, 'Sources for a Reconstruction of the Villa Medici, Fiesole', *Burlington Magazine*, 111.799 (Oct. 1969), pp. 597–605.

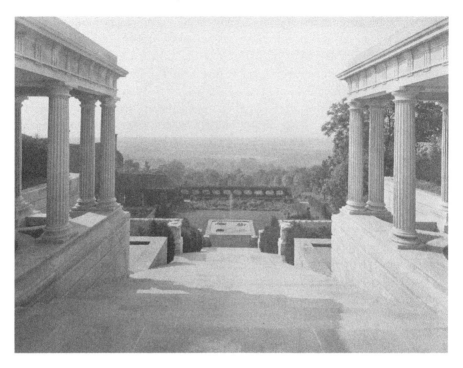

Figure 14 Port Lympne gardens, view looking towards the sea. Photographer: Will Pryce. © *Country Life*.

of his work was done for politicians—both Lloyd George and Churchill were among his clients—but he also worked on Garsington Manor for Lady Ottoline Morrell. It was also he who laid out the flamboyant garden at Port Lympne for Philip Sassoon, taking advantage of the dramatically steep site to create a series of terraces, marching down a hillside, virtually a cliff, overlooking a spectacular, distant view of Romney Marsh and the Channel (see Figure 14).

> Framed in great hedges of *Cupressus macrocarpa* . . . were formal parterres, a swimming pool, blazing herbaceous borders and Gothic-walled enclosed gardens bursting with rare lilies as thickly planted as lobelias. . . . Here a harmony seemed to be established in terms of incongruity, the whole swimming in the golden summer light.[40]

Many of the great Italian gardens were built on steep hillsides, but this choice of site was highly unusual in England. Jane Brown comments, 'This hillside garden has never been taken quite seriously in English gardening terms, yet it is worth

[40] Page, *Education*, p. 92.

suggesting that Sassoon and the Medici princes had much in common in terms of desires and resources, as well as immensely high standards and a taste for the best of their own time. Port Lympne ... is the nearest England can come to the Italian villa gardens in aesthetic terms.'[41]

This garden expressed its owner's lush personality. Russell Page, whose description is quoted above, seems to have found himself liking the result rather against his will. Herbert Baker, who designed the actual house at Port Lympne, clearly felt that the garden was over the top, un-English, not to say queer, and was anxious to disassociate himself from the final result: 'I was at the time away in India for many months in the year, and Sassoon, eager and impulsive, with a keen artistic imagination, which lacked a sense of proportion, employed artists to decorate the rooms of the house, and overweigh the garden with heavy stone fountains, terraces and temples in a manner which he had admired in Paris or in Spain.'[42]

Though Sassoon had borders orthodoxly stuffed with exotic flowers, the sheer drama of the site meant that the overall focus of the garden was the architecture: the great piers and ramparts of stone that called attention to themselves in a flaunting, histrionic manner, an unabashed statement of wealth. Sassoon's version of magnificence was suspect because it stirred up both racism and homophobia. The Sassoon family were Jews originating in Baghdad who made a great mercantile fortune in Bombay, and were therefore 'lesser breeds' on all these counts from an establishment English perspective. Sir Philip was widely believed to be homosexual, though on no specific evidence since his name was never linked with any individual, and this also rendered his taste suspect. Port Lympne was not, in fact, any more excessive than a garden such as Cliveden or the Duke of Westminster's Eaton Hall, where there were pleasure greenhouses with 30-foot camellias, lilies, azaleas, and scented rhododendrons, and an orchid house under the management of its own expert;[43] but it embodied a slightly alien aesthetic, in somewhat the same way the Catholic fervency of Fr D'Arcy's Campion Hall disconcerted those who picked up their idea of the baroque from the Sitwells. Reactions to Port Lympne make it clear that the dominant garden style for the expression of wealth was that of the Astors, which also exploited a thread of baroque sensibility, but a different one, following in the footsteps of Renaissance plantsmen such as Carolus Clusius and Matthias de L'Obel.

[41] Jane Brown, *The English Garden in Our Time* (London: Antique Collectors Club, 1986).

[42] Stansky, *Sassoon*, p. 45.

[43] Loelia, Duchess of Westminster, *Grace and Favour: the Memoirs of Loelia, Duchess of Westminster* (London: Weidenfeld & Nicolson, 1961), p. 203.

8

Chinese Wallpaper

This chapter is about the social context in which interwar art was created, sold, and bought, and the rooms in which it was hung. Modernity rejected decoration in principle, but in practice interwar artists could not afford to do so. Le Corbusier attacked the whole concept of design and ornament in a series of essays and statements throughout his career, but Nancy Troy reminds us that he 'gained access to the Parisian art world during the teens not as a painter or architect but as an interior decorator with professional links to such Art Deco designers as André Groult and Paul Poiret'—which suggests that the relationship between decoration and modernity is worth examining.[1]

Twentieth-century abstract art developed as a series of movements, each with its philosophy, manifestos, and subsequent denunciations from the popular press, while its practitioners rejected any association between painting and simple visual appeal, let alone decoration. Integrity to one's personal vision meant taking a considerable risk, since few potential patrons had the heroic quality of the intrepid Sergei Ivanovich Shchukin, buyer of Gauguin, Matisse, and Picasso, among others, who was prepared to shut himself up with a picture till he understood it, even though he made it known that entering the room where he had hung his cubist purchases made him feel as if he had put his foot in a bucket of broken glass.[2]

However, as the art dealer René Gimpel pointed out in 1930, after the public had got its eye in, 'Cubism is a decorative art, though the cubists didn't suspect this at the outset.... Once Cubism passes from a canvas to textiles, wallpapers or bindings, everyone understands it.'[3] A difficult concept which is visually expressed, such as cubism, abstraction, or surrealism, can be and, if it is genuinely expressive of the moment, *will* be, reinterpreted as fashion.[4] As early as 1914, in the aftermath of

[1] Nancy J. Troy, *Modernism and the Decorative Arts in France: Art Nouveau to Le Corbusier* (New Haven and London: Yale University Press, 1991), p. 5.

[2] Hilary Spurling, *Matisse* (London: Penguin, 2009), pp. 226, 255. The 'broken glass' comment dates to 1913, when cubism was very new indeed.

[3] Dan Klein and Nancy McClelland, *In the Deco Style* (London: Thames & Hudson, 1987), p. 110.

[4] Thomas Crow, *Modern Art in the Common Culture* (New Haven and London: Yale University Press, 1996), p. 35.

the 1913 International Exhibition of Modern Art in New York (better known as the Armory Show), an advertisement for a Chicago department store, Mandel Brothers, claimed to illustrate the 'influence of cubist art on the new gowns, wraps, hats, silks, etc.'[5] In 1937, the New York *Harper's Bazaar* invited artists to paint hat boxes for a spring issue. Those who accepted included Giorgio de Chirico, Miguel Covarrubias, Leonor Fini, and Alexander Calder. It is surely also relevant that almost all had links with the surrealist movement.[6] Surrealism tended to see the monstrous and the beautiful in the everyday—in found objects, bric-a-brac, and popular culture. Fashion similarly has links with popular culture, and with playfulness and grotesquerie.

Art has never been able to defend itself against fashion, because artists were and are powerless to prevent their concepts from being interpreted as style. As Marshall Berman observed: 'Creative processes and products will be used and transformed in ways that will dumbfound or horrify their creators. But the creators will be powerless to resist, because they must sell their labour power in order to live.'[7] Camille Mauclair, as early as 1909, wrote: 'One hears talk only of "making a tabula rasa" and "starting over". The work of one's predecessors is now perceived as an intolerable weight.'[8] But breaking with tradition propels one into the present moment, and therefore into the company of others for whom the now is their central concern: decorators.

There is a clear relationship between Chanel selling extremely expensive *luxe pauvre* items in the Place Vendôme and women buying straight, simple frocks and jerseys all over Europe and America in the following season. There is also a relationship between Picasso's paintings, the saleability of geometrically designed fabrics and rugs produced by Enid Marx and Marian Dorn, 'cubist' or 'bizarre' designs for domestic pottery by Clarice Cliff and Susie Cooper, and the 'jazz' patterns produced for Woolworth's and the like by unnamed imitators in all these fields. If artists are going to make a living, their work must sell; so dealers had to create an interface between what their chosen artists were doing and the development of public taste. This is the province of fashion.

The interface between couture and the avant-garde was quite extensive. Elsa Schiaparelli got into couture via making friends with Gabrielle Picabia, wife of the

[5] Elizabeth Carlson, 'Cubist Fashion: Mainstreaming Modernism after the Armory', *Winterthur Portfolio*, 48.1 (spring 2014), pp. 1–28, p. 16. Another store, Wanamaker's of Philadelphia, had a history of using art to sell merchandise, and presented 'cubist' fashion in its New York store immediately after the Armory Show (p. 7).

[6] Martin, *Fashion and Surrealism*, p. 223.

[7] Marshall Berman, *All that is Solid Melts Into Air* (Harmondsworth: Penguin, 1982), p. 117. See also Andreas Huyssen, 'Mass Culture as Woman: Modernism's Other', in *After the Great Divide: Modernism, Mass Culture, Postmodernism* (Indiana: Indiana University Press, 1986), p. 51.

[8] Jeffrey Weiss, *The Popular Culture of Modern Art: Picasso, Duchamp and Avant-Gardism* (New Haven and London: Yale University Press, 1994), p. 53.

painter Francis Picabia. Once established in Paris, Schiaparelli bought designs from Alberto Giacometti, who made brooches and buttons for her, and from Meret Oppenheim. The inspiration for Le déjeuner en fourrure, the fur teacup which is one of the most iconic of surrealist objects, was a deer-fur-covered brass bracelet which Oppenheim had designed for Schiaparelli as costume jewellery.[9] The bottle for Schiaparelli's signature perfume, 'Shocking', was designed by another woman surrealist, Leonor Fini, based on Mae West's torso and, incidentally, subsequently imitated by Jean Paul Gaultier. Schiaparelli also bought designs for fabrics and decorations from Salvador Dalí and Jean Cocteau, while Elsa Triolet (Russian novelist and mistress of the surrealist Louis Aragon), and Jean Schlumberger were among those who made startling jewellery sold under her name.

Sonia Delaunay is interesting in this context, since she began as a painter and crossed over to become a successful designer. From 1913 she expressed her 'Simultaneous' style—originally developed in the context of painting—in furniture, clothes, cushions, lampshades, and curtains. La robe simultanée was treated as an art event by the futurists, even though it was only the colours, not the cut, of Delaunay's clothes that were particularly innovative (see Figure 15).[10] She opened a shop in Paris, the Boutique Simultanée, and numbered Nancy Cunard and Gloria Swanson among her clients. In 1927 she was invited to lecture at the Sorbonne on 'The Influence of Painting on Fashion'.[11]

Germaine Bongard, sister of Paul Poiret and Nicole Groult, was another woman with a foot in both worlds, since she managed both a couture house and an avant-garde gallery; counted Léger, Derain, and Ozenfant among her friends; and made the costumes for the Ballets Russes's Cuadro Flamenco to Picasso's designs. She herself conceived a ballet, which was to have music by Poulenc and costumes by Marie Laurencin, though it never got off the drawing board.[12] The couturière Madeleine Vionnet also had strong modernist connections. Famous for her exquisitely simple bias-cut, Greek-influenced dresses, she designed clothes for Natalie Barney and from 1919 to 1925 worked in collaboration with an Italian futurist known as Thayaht (Ernesto Michahelles), who was interested in clothing reform.[13] Like Jeanne Lanvin, another fashion designer, she furnished her salon from art deco craftsmen such as Jean Dunand.[14]

[9] Andrew Webber, The European Avant-Garde, 1900–1940 (Cambridge: Polity Press, 2004), p. 34.

[10] Tate Gallery, Sonia Delaunay (London: Tate Publishing, 1915).

[11] Radu Stern, Against Fashion: Clothing as Art, 1850–1930 (Cambridge, MA: MIT Press, 2004), pp. 65, 68. Her lecture is given pp. 183–6.

[12] Guillaume Garnier, Paul Poiret et Nicole Groult: maîtres de la mode art deco (Paris: Musee de la Mode et du Costume, 1986), p. 120.

[13] Stern, Against Fashion, gives the 'Manifesto for the Transformation of Male Clothing' which Thayaht published with Ruggero Michahelles in 1932 (pp. 167–9).

[14] Betty Kirke, Madeleine Vionnet (New York: 1998, pp. 58, 137); Schenkar, Truly Wilde, p. 155.

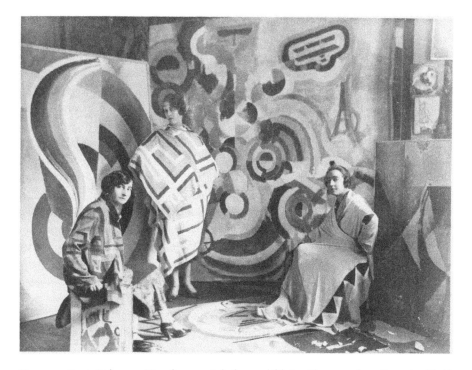

Figure 15 Sonia Delaunay: 'Simultaneous' clothes and fabrics. Photographer: Germaine Krull.
© Estate Germaine Krull, Museum Folkwang, Essen.

The soaring value of works by major modernist artists during the second half of their first century of existence has tended to disguise from us the fact that, initially, high modernist art did not sell itself. Originality is, among other things, a commercial problem, and patronage was often crucial to artists' survival: Matisse, for example, was initially able to commit himself to painting because Sarah Stein (sister-in-law of Gertrude) bought nearly everything he painted for eighteen months; it was her belief in him, as well as the financial backing, that mattered.[15]

But alongside the individual relations of the wealthy with artists they were prepared to back, a new kind of patronage was developing, which changed the terms on which artists could live, or even how they were defined. Before the First World War, Daniel-Henry Kahnweiler contracted with Braque, Picasso, Juan Gris, and Fernand Léger to be their sole dealer, and he promoted them as the 'real' cubists.[16] His gallery was unusual in its time, uncompromisingly modern, with plain walls covered in sackcloth and without ornate furniture—the precursor of

[15] Hilary Spurling, *Matisse*, pp. 139–40.
[16] Nancy Troy, *Couture Culture: a Study in Modern Art and Fashion* (Cambridge, MA: MIT Press, 2003), pp. 58–66.

the 'white cube' which subsequently became the dominant model for gallery design. Kahnweiler fought to maintain his clients' élite status as creators of unique objects, while at the same time to reach a larger audience, generate recognition, and increase public comprehension of the work. His strategy was to discourage his artists from exhibiting in the salons but to make a point of providing foreign journalists with photographs, a high-risk approach which was very successful. It meant that his clients could hold themselves aloof from the business of selling, thus promoting a view of the artist as autonomous, purely concerned with the creative, and indifferent to the marketplace. Kahnweiler claimed that, of their own accord, his painters aspired to 'une certaine attitude discrète et aristocratique': 'aristocratic' meaning, in this context, unconcerned with commercial transactions.[17] Kahnweiler put himself in the service of maintaining this mystique and of building relations with potential patrons which would convince them that he knew *which* of the many repulsive paintings for sale in Paris were genuinely worth the effort of re-educating one's eye and taste.

Other experimental painters of the time, such as Jean Metzinger and Robert Delaunay, who exhibited in the salons, sold directly and were not marketed as an exclusive line. Their reputations, and prices, have not recovered to this day.[18] The extent to which dealers act as gatekeepers, not merely as agents, is not always well understood. The cubists did not manage to achieve resale values equalling or exceeding original purchase price until 1926, even with their dealers quite straight-forwardly rigging the market.[19] Léonce Rosenberg liked to remind his clients that without a dealer backing them who was prepared to 'buy in' work that surfaced at auction, their work might lose its value entirely.[20] A basic fact about the art market is that most original painters' work has to be protected for years, if not decades, before its value suddenly increases exponentially, if it ever does.

Art history has often been reluctant to engage with the role of dealers in establishing the reputations of artists, and it has been equally reluctant to acknow-ledge the absence of a clear distinction between the creators of fine and applied art, particularly in the interwar period. Dealers such as Kahnweiler sold on the basis of the radical uniqueness of their clients' work. But between the wars the art market was a luxury one, and buyers were few. Most European economies were severely damaged by the First World War; and the Wall Street Crash of 1929 brought down the Americans as well. Simon Lissim, a young Ukrainian painter, said, 'If you wanted in the mid-twenties to make a living in Paris as an artist, you had to work in all areas, and mostly in those of the decorative arts.'[21] Caught between the devil and the deep

[17] *Cahiers d'Art* 1927, *Feuilles Volantes* no. 2, quoted in Malcolm Gee, *Dealers, Critics and Collectors of Modern Painting* (New York and London: Garland, 1981), p. 21.

[18] Gee, *Dealers, Critics, and Collectors*, p. 214. [19] Gee, *Dealers, Critics and Collectors*, p. 29.

[20] Gee, *Dealers, Critics and Collectors*, p. 36. [21] Klein and McClelland. *In the Deco Style*, p. 45.

blue sea, interwar artists were forced into design work of one kind or another after 1929—photography, advertising, design, interior decoration, and industry—and this is as true of London as it is of Paris.[22]

Many artists moved flexibly between easel painting and design, whether for theatre productions, fashion houses, or commercial textile and ceramic companies. Designing for ballet will be considered in chapter 17, but fashion and furniture design is also important, not least because it has been airbrushed out of the story of art. Jean-Michel Frank, who was, like Chanel, a purveyor of *luxe pauvre*, became artistic director of a Parisian interior design business, Chanaux & Co., around 1930, and recruited Alberto Giacometti to produce light fittings in bronze and plaster. Giacometti also designed buttons and other small items for Schiaparelli. Another sculptor, Emilio Terry, also worked in plaster for Chanaux, creating distinctive palm-frond console tables and mirror frames. These were taken up by Syrie Maugham in England, and became very much part of her signature style. Dalí did so much decorative work of various kinds, not only for Schiaparelli but also for private patrons such as Edward James, that it is quite surprising he is still thought of as primarily a painter.

One group particularly interesting in this context are the 'neo-romantics'—Eugene Berman, Pavel Tchelitchew, and Christian Bérard—because they have been retrospectively defined as 'mere decorators'. All three designed sets and costumes for major ballet and opera productions; their works were frequently used as backdrops for fashion shoots, and Bérard also did fashion drawings for Chanel, Schiaparelli, and others.[23] Their work was figural, highly finished, and clearly related to personal mythologies; but the same could of course be said of surrealists. They were taken seriously as painters by contemporaries, championed in England by Arthur Jeffress, and in the United States by gallery owner Julien Levy and curators James Thrall Soby and 'Chick' Austin.[24]

It is worth enquiring why they fell out of the grand narrative of twentieth-century art to the extent they did. It cannot have been their involvement with decoration as such which rendered the neo-romantics' work 'inauthentic', since it is hard to find an interwar artist who wasn't prepared to do design work on occasion. Being European

[22] Andrew Stephenson, 'From Conscription to the Depression: the Market for Modern British Art in London, c. 1914–1930', *Marketing Art in the British Isles, 1700 to the Present*, ed. Charlotte Gould and Sophie Mesplède (Aldershot: Ashgate, 2012), pp. 57–68, p. 63.

[23] Michael Duncan, *High Drama: Eugene Berman and the Legacy of the Melancholic Sublime* (New York and Manchester: Hudson Hills Press, 2005). For Tchelitchew as a designer, see Donald Windham, 'The Stage and Ballet Designs of Pavel Tchelitchew', *Dance Index*, ed. Donald Windham (New York, 1944), p. 6, and anon., *Pavel Tchelitchew 1898–1957: a Collection of Fifty-Four Theatre Designs c.1919–1923 arranged by Richard Nathanson*, 13–22 Dec. 1976 (London: for the Alpine Club, 1976).

[24] Julien Levy, *Memoirs of an Art Gallery* (New York: Putnam, 1977), p, 136; James Thrall Soby, *After Picasso* (New York: Dodd, Mean & Co., 1935).

had something to do with it, on account of America's successful post-war bid to appropriate cultural leadership from France and to break the association between modernism and left-wing politics.[25] But beyond that, neo-romanticism was a queer style. Tchelitchew and Bérard were openly homosexual; and though Berman was not, his ruined landscapes and dead divas appealed to a gay sensibility. The influential critic Clement Greenberg described their work as 'decadent' and 'spurious', contrasting it with the 'rigor, strength and masculine physicality' of the new American painters such as Jackson Pollock—yet another expression of a profound prejudice in favour of masculinity as a style.[26]

Christopher Reed has noticed what an embarrassment painters' design work was for Greenberg, who attempted to prove '[h]ow little a decorator Matisse is by instinct ... he is an easel painter from first to last'.[27] The problem, Greenberg argued, was the influence of 'all-over' abstract art, which, because 'it comes very close to decoration—to the kind seen in wallpaper patterns that can be repeated indefinitely', now 'infects' painting as a whole.[28] Greenberg's language of 'infection' implies that the repeating patterns of wallpaper, also characteristic of textiles, are not, and cannot be, art, and that a painter risks the sacred individuality of his perceptions by stooping to design. But Matisse came from a family, and city, deeply involved with textile production.[29] Hilary Spurling, Matisse's biographer, considers, by contrast, that Matisse's aesthetic as a painter was profoundly influenced by his love of textiles and their patterns. Interestingly, his loyal patron Shchukin had made his money in textiles; Spurling suggests that this allowed him to '[understand] instinctively the syntax of the new pictorial language Matisse was evolving'.[30] She also considers that the textiles Matisse himself designed for Poiret's spin-off decoration business, Atelier Martine, and for other clients were an important part of the painter's oeuvre.

Textiles have a very uneasy relationship with fine art, and carpets and tapestries are particularly problematic. Tapestries were high-status productions in the Middle Ages and the Renaissance. Major Renaissance and baroque artists designed them, including Peter Paul Rubens and Raphael, and in the Middle East in the same period

[25] Crow, *Modern Art*, p. 44, and Serge Guilbrant, *How New York Stole the Idea of Modern Art: Abstract Impressionism, Freedom and the Cold War*, trans. Arthur Goldhammer (Chicago and London: University of Chicago Press, 1983).

[26] *Clement Greenberg: the Collected Essays and Criticism, vol. I. Perceptions and Judgments, 1939–1944* (Chicago: University of Chicago Press, 1986), p. 164.

[27] Christopher Reed, 'Introduction', *Not at Home: the Suppression of Domesticity in Modern Art and Architecture*, ed. Christopher Reed (London: Thames & Hudson, 1996), pp. 14–15.

[28] Crow, *Modern Art*, p. 41, comments on large-scale abstract paintings with an all-over composition: 'Posing in front of it was the activity for which it had been conceived.'

[29] Hilary Spurling and Jack Flam, *Matisse, His Art and His Textiles: the Fabric of Dreams* (London: Royal Academy of Art, 2004).

[30] Spurling, *Matisse*, p. 173.

good carpets were prized as highly important possessions. In interwar Paris and London both antique tapestries and oriental rugs were extremely expensive. Gerald Reitlinger has commented that 'there could be no better barometer of the state of high finance in those days than the sales of tapestries', so clearly they were being bought by very rich people, and supported their self-presentation in a way that modern art did not. In 1920, thirty-two antique tapestries were put on the market, making £1,000–7,000 apiece; after 1929, only three or four a year exceeded £1,000.[31] This is still a very great deal more than the price of a Picasso at the time.

Other textile survivals from the seventeenth and eighteenth centuries were much sought after. Their sumptuous textures were keenly valued by professional decorators: in England, Mrs Guy Bethell of Elden Ltd was particularly knowledgeable about eighteenth-century furniture and also knew a great deal about antique fabrics. She could combine old brocades and damasks with new materials, which became crucial to the 'Vogue Regency' style.[32] For clients who could not afford monstrously expensive whole tapestries, usable bits of damaged ones were made into cushions, or modern upholstery fabric was trimmed with gold lace. Precious damasks and velvets were reclaimed from ecclesiastical vestments and recycled. These textiles were part of the stock-in-trade of the international antique market: Napoleon's secularization of his empire appears to have put quantities of priceless textiles, once the property of the church, into private hands in the nineteenth century, from whence they came down to junk shops. In Djuna Barnes's *Nightwood*, Robin and Nora's flat is decorated with ecclesiastical embroideries and cherubim along with merry-go-round horses.[33] Syrie Maugham was another decorator who would buy any old tapestry and embroidery which came her way, and she employed pickers to rummage the flea market in Paris on her behalf.[34]

A number of interwar artists took an interest in tapestry, including Le Corbusier and Jean Lurçat,[35] but as a modern art form it never acquired anything like the status of easel painting.[36] This may help to explain why women were involved with many varieties of decorative textile production, both as patrons and as creators. Alternatively, the causality may be reversed—the age-long association of women with textile production may have sufficed to depress its status to that of craft. The low

[31] Gerald Reitlinger, *The Economics of Taste: the Rise and Fall of the Picture Market, 1760–1960* (New York, Chicago and San Francisco: Holt, Rinehart & Winston, 1961), p. 210.

[32] Ethel Bethell, c. 1865–1932. See Pauline Metcalf, *Syrie Maugham* (New York: Acanthus Press, 2010), p. 25. Maugham learned a lot from her. Elden was taken over by Hermann Schrijver in 1932.

[33] Djuna Barnes, *Nightwood* (London: Faber & Faber, 2007), p. 50.

[34] Metcalf, *Syrie Maugham*, p. 55.

[35] Le Corbusier's pre-war designs were realized by the Pinton workshops in Felletin, near Aubusson. Wendy Moonan, 'Le Corbusier Saw Tapestry As Part of Art', *Antiques*, 28 Sept. 2001.

[36] Dirk Holger, *Tapestries: the Great 20th-Century Modernists* (Washington: Trust for Museum Exhibitions, 2006).

status of tapestry is sometimes linked with the fact that the design is not usually realized by the designer, but if that is so, it is hard to explain the high status of sculpture, an art form associated principally with men, since the perceived authenticity of sculptors' work was not affected by the fact that for centuries most of them have handed over a maquette to expert craftsmen to be realized, whether bronze founders or stonemasons, and only some sculptural purists have regarded this as bad practice.[37]

One arena in which leading modernists, even the 'real' cubists, were persuaded to cooperate with the commercial production of luxury textiles was Myrbor, the creation of Marie Cuttoli, née Myriam Bordes, who was also a patron and collector of modern art. Brought up in Algeria, she set up a workshop before the First World War to teach tapestry-making to local women, drawing on indigenous craft traditions.[38] Interestingly, this idea of carpet-making as women's craft also attracted Eileen Grey and Evelyn Wyld, while in the same generation textile designers Phyllis Barron and Dorothy Larcher were equally anxious to learn from other aspects of traditional women's weaving and dyeing skills.[39]

In 1912 Marie/Myriam married a French politician, Pierre Cuttoli, but continued to pursue her career as a decorator. She exhibited at the International Exposition of Modern Industrial and Decorative Arts in 1925, and in the same year opened a gallery and design atelier called Maison Myrbor designed by Jean Lurçat, himself an artist in tapestry as well as an architect. This was in rue Vignon, home to a number of art dealers, including Daniel-Henry Kahnweiler. In 1927 she commissioned designs from Georges Braque, Fernand Léger, Joan Miró, and Pablo Picasso, and later persuaded Raoul Dufy, Le Corbusier, Jean Lurçat, Henri Matisse, and Georges Rouault to allow paintings to be reinterpreted as hangings. Myrbor products were highly exclusive. Each design was limited to six copies at first, though as the enterprise became more successful, this was changed to a hundred, with the exception of designs by Picasso, which remained limited to seven.

Myrbor produced different kinds of textiles: there were woven tapestries, for which she called on the Aubusson tapestry works as well as her Algerian workwomen, and there were also embroideries. An exhibition of textiles at the Lefevre gallery in London in 1937, with designs by Braque, Dufy, Léger, Matisse, and Picasso,

[37] There was an early twentieth-century movement in favour of direct carving rather than modelling: Eric Gill, Jacob Epstein, Barbara Hepworth, and Henry Moore were among its champions.

[38] Dominique Paulvé, *Marie Cuttoli: Myrbor et l'invention de la tapisserie moderne* (Paris: Editions Norma, 2010); Elizabeth Ann Coleman, 'Myrbor and other Mysteries: Questions of Art, Authorship and Emigrés', *Costume*, 34 (2000) pp. 100–4.

[39] Bridget Elliott, 'Art Deco Hybridity, Interior Design and Sexuality between the Wars: Two Double Acts: Phyllis Barron and Dorothy Archer/Eyre de Lanux and Evelyn Wyld', in Laura Doan and Jane Garrity, eds., *Sapphic Modernities: Sexuality, Women and National Culture* (New York: Palgrave Macmillan, 2006), pp. 109–32.

was actually of large embroideries, mostly made in 'point de Beauvais', a traditional French embroidery with eighty-one stitches to the square inch, and some in point d'Aubusson, with forty-nine stitches to the square centimetre. The imitation of paint texture is very sophisticated in these pieces. This was not a selling exhibition, but was organized under the aegis of the French Minister for Foreign Affairs, so these textiles were clearly being deployed as part of the drive to keep France the world leader in luxurious taste.

A book written to show American women how to get the most out of a shopping trip to Paris, which unfortunately came out in the year of the Wall Street Crash, suggests another reason why Myrbor was important. Cuttoli worked to familiarize her customers with modern art, thus helping to extend the range of buyers. She 'uses her walls for a constantly changing exhibit of modernists', and also used the shop to demonstrate how modern pieces could be integrated with antiques. 'You may see a Moroccan chest or old chairs in an interior dominated by a Leger rug. She commenced this experimenting in her own home, first developing single rooms in modern and leaving others with their rare antiques. Then she dared to combine in the same room on the theory that beauty of one age is rarely incompatible with beauty of another ... If you are interested in this problem of "marriages", her salons will help you.'[40]

The modern-art market was as depressed in London as it was in Paris after 1929, and so, similarly, artists had to produce work which would sell.[41] Francis Bacon first made his name as a designer, producing rugs, furniture, and interior schemes. His earliest surviving painting (1929), an abstract, seems to have evolved from his carpet designs,[42] and Madge Garland, in her book on the thirties, describes a constructivist room of his which featured curtains of white surgical rubber sheeting, low glass circular tables, and white walls.[43]

Other easel painters had a sideline in design work for large-scale industrial production. As was the case in Paris, who was—and who was not—deemed 'contaminated' by this kind of design work seems in retrospect somewhat arbitrary. Fry's Omega Workshop employed painters, notably Vanessa Bell and Duncan Grant, whose reputations survived the experience, but designing for large-scale commercial production was more damaging. Eric Ravilious's design work for clients such as Wedgwood long overshadowed his achievement as a painter, but Barbara Hepworth and Ben Nicolson also designed textiles, curtains, and ceramics for retailers.[44] John Armstrong designed fabrics and china, and Paul

[40] Thérèse and Louise Bonney, A Shopping Guide to Paris (New York: Robert McBride & Co., 1929), pp. 33, 196–7.

[41] Madge Garland, The Indecisive Decade (London: Macdonald, 1968), p. 201.

[42] Tate Britain exhibition, Francis Bacon: Early Work, 2009.

[43] Garland, The Indecisive Decade, p. 14.

[44] Penelope Curtis, Barbara Hepworth (London: Tate Publishing, 1998), p. 14.

Nash produced fabric patterns for Cresta Silks, china and earthenware for Foley and for Clarice Cliff's 'Bizarre' wares, glass for Stuart Crystal, and posters and rugs for Edinburgh Weavers.[45]

In England, where there were few modernist houses or even flats, sympathy with the modern movement had to be expressed through interior decoration. The availability of modern rugs, textiles, glassware, and so forth was thus of some importance. Dorothy Todd and Raymond Mortimer concede that 'in ninety-nine cases out of a hundred, a decorator has to make something of an old room'. What they suggest is compromise: 'If living in an old house, the first step is to eliminate every touch of existing ornament,' and strip out mouldings and cornices.[46] Designer/decorators such as John Duncan Miller, Arundell Clarke, and Denham Maclaren could be called in; and they 'began by eliminating moulding and cornices and using as much built-in furniture as possible'.[47] Randall Phillips, in *The House Improved* (1931), a response to the economic downturn after 1929 in that it assumed people would stay where they were and make do, gives directions for making a panelled door flush by nailing plywood over it, boxing in turned balusters on the staircase, and encasing old-fashioned carved marble chimney pieces in smooth wood.

Building-in the furnishings allowed architects to direct how the room would be used. In Gerrit Rietveld's iconic Schröder House of 1924, the interior, exterior, and furnishings were all integrated.[48] The underlying principle, as the substitute designer John Gloag enunciated in his 1923 *The House we Ought to Live In*, was to avoid trapping dust and dirt,[49] but for Le Corbusier, at least, there was more than practicality and hygiene involved: he argued that the architect should supervise the equipping of a house in such a way that no subsequent rearrangement would be necessary, or possible.[50] The interior decorator Herman Schrijver, equally reasonably but from the opposite corner, complained: 'These modern designers have a mania for built in furniture.... It is much more practical to have furniture you can move about.'[51]

One problem for Londoners who wanted to achieve high modernist rooms was that the majority of smart and fashionable people leased, rather than owned, their homes. This militated against investing in furnishing that could not be taken away. All the same, modernism's difficulty in making headway with the smart set who were in the habit of changing their decor every few years is interesting. Aldous

[45] James King, *Interior Landscapes: a Life of Paul Nash* (London: Weidenfeld & Nicolson, 1987), pp. 111–12. On Nash's ceramics, see *Design for Today* (Dec. 1934), p. 461.

[46] Dorothy Todd and Raymond Mortimer, *The New Interior Decoration* (London: Batsford, 1929), p. 33.

[47] Garland, *The Indecisive Decade*, p. 22.

[48] *Modernism: Designing a New World, 1914–1939*, ed. Christopher Wilk (London: V&A Publications, 2006), p. 55.

[49] (London: Duckworth & Co., 1923), p. 55.

[50] Penny Sparke, *As Long as It's Pink: the Sexual Politics of Taste* (London: Pandora Press, 1995), p. 74.

[51] Herman Schrijver, *Decoration for the Home* (Leigh on Sea: F. Lewis, 1939), p. 10.

Huxley, a 'modern' novelist and liberal intellectual, was for all that not attracted to modernist furnishings: 'To dine off an operating table, to loll in a dentist's chair—this is not my ideal of domestic bliss.'[52] But if the avant-garde found that almost nobody was bringing up the rear, it was not necessarily due to absence of comfort or style. Maison Jansen put an 'operating table'-style glass dining table in Chateau Solveig (in Switzerland) for the millionaire Francis Francis and his wife Sunny Jarman in the early thirties,[53] and the Salon des Artistes-Décorateurs offered 'metal-supported dining tables with tops of black glass'; these firms were responsible for some of the most luxurious decor in Europe.[54] As for 'dentist's chairs': Eileen Gray's low 'Transat' chair was designed for the palace of the Maharajah of Indore, made of leather and black-lacquered chrome, and could hardly be faulted for lack of luxury; Charlotte Perriand's tubular steel 'dentist's chair', 'Basculant', was also very expensive.[55] At a more democratic level, the Bauhaus steel-and-leather 'Wassily' chair, designed by Marcel Breuer (1925–6), was so comfortable that versions are still being made.

However, it is also relevant to popular lack of enthusiasm that the excellence of these designs was seldom reflected in downmarket versions. Robert Graves sums up the situation: 'Unless one was rich enough to go to one of the very few shops that still employed their own craftsmen and catered for cultivated taste, the unappetizing choice was between the mass-produced mock-antique, the modernist "gorblimey" or "godawful" in veneered walnut or bleached oak, tubular steel, light-coloured plywood. The only solution was to "shop in the past" at country sales, street markets, or antique shops.'[56]

The mass market preferred mock-antique and was highly selective in its uptake of modernist design. To the fury of John Betjeman, Clough Williams-Ellis, and other contemporary critics of the built environment, the buyers of the small semi-detached houses put up by speculative builders all over England were eclectic in their tastes.[57] They liked certain modernist elements in their homes, such as sunburst gates, but the great majority preferred buildings which referenced the English past. Paul Nash spoke for possessors of educated taste in his onslaught on 'modernistic' design and its naïve consumers in Room and Book, but typically never asked why suburbanites liked what

[52] Aldous Huxley, 'Notes on Decoration', The Studio, 100 (1930), p. 242.

[53] James Archer Abbott, Jansen (New York: Acanthus Press, 2006).

[54] Martin Battersby, The Decorative Twenties (Walker: New York, 1969), p. 82.

[55] Charlotte Perriand: an Art of Living, ed. Mary McLeod (New York: Harry N. Abrams, Inc., 2003), p. 14.

[56] Robert Graves and Alan Hodge, The Long Week-End: a Social History of Great Britain 1918–1939 (London: Reader's Union, 1941), p. 350.

[57] Juliet Gardiner, The Thirties: an Intimate History (London: Harper Press, 2010), pp. 295–324. See also Mark Pinney, Little Palaces: the Suburban House in North London 1919–1939 (Enfield: Middlesex Polytechnic, 1987), and Helena Barrett and John Phillips, Suburban Style: the British Home, 1840–1960 (London: Macdonald Orbis, 1987).

they liked, or what they liked about it.[58] Osbert Lancaster similarly has nothing positive to say about their houses—buildings which, he claimed, 'will inevitably become the slums of the future', which is nonsense.[59] Some were 'jerry-built', but nearly a hundred years later many are standing the test of time extremely well.[60]

The design of the three-bedroom semi is in a continuum with more prestigious structures, as Osbert Lancaster, in his well-informed guide to architectural trends, observed: scaled-down versions of his 'Wimbledon Transitional', pre-First World War houses which randomly applied half-timbering, tile-hanging, weatherboarding, and fancy brickwork; and 'Stockbroker's Tudor', slightly later buildings of a more thoroughgoingly Elizabethan appearance. He stresses that both were styles evolved for wealthy clients.[61] The speculative builders of £400–500 semi-detached dwellings were therefore drawing on pre-existing building types conceived by, and for, more educated folk.[62]

Suburbia was at odds with modernist aesthetics in being profoundly individualistic: minor variations of decorative treatment on an essentially similar plan allowed each owner to perceive his 'Osokosi' or 'Mon Repos' as unique. The principal virtues perceived within Metroland were status, privacy, comfort, and safety; and status was defined by features such as bay windows and immaculately kept lawns, not by superior design. As J. M. Richards, editor of the *Architectural Review*, pointed out in his iconoclastic *Castles on the Ground*, 'There is no popular demand for what superior people call "good taste".'[63]

The great popularity of mock Tudor, or 'Jacobethan' as Betjeman called it,[64] may be to do with its ornamentation which, by its sheer superfluity, underlined that the buildings were not council housing.[65] But a more or less seventeenth-century style was preferred for some furniture, particularly dining sets, which may suggest that one of the few discernible aesthetic principles in suburban taste was nationalism. Unlike modernism, Jacobethan is distinctively English. However, as even Nash admitted, decorative items, above all textiles, ceramics, rugs, and mirrors—the less permanent aspects of the overall decor—were often chosen for their 'modernity'. A trio of flying plaster ducks were popular enough as decoration to become a cliché, but so were other types of wall plaque, such as vases and masks, which were more modernist in spirit.

[58] Paul Nash, *Room and Book* (London: Soncino Press, 1932), pp. 37–40.
[59] Osbert Lancaster, *Here, of All Places* (London: John Murray, 1959), p. 152.
[60] Gardiner, *The Thirties*, pp. 306–7.
[61] Osbert Lancaster, *Here, of All Places* (London: John Murray, 1959), pp. 138–45.
[62] John Burnett, *A Social History of Housing, 1815–1985* (London: Methuen, 1990), p. 255.
[63] J. M. Richards, *Castles on the Ground* (London: Architectural Press, 1946), p. 60.
[64] John Betjeman, *Ghastly Good Taste* (London: Chapman & Hall, 1933), p. 41.
[65] Barrett and Phillips, *Suburban Style*, p. 125.

Since suburbanites had no taste, as defined by the tastemongers who are my concern, their choices are to one side of this book's central theme, but the principle of individuality which they embraced is equally relevant to the more aesthetically informed. John Burnett has observed that the tastes and aspirations of suburbia had more in common with those of *Vogue* readers than the latter might have liked to think:

> The vast majority of English people of all social classes obstinately refused to accept functionalism. The functionalists' case rested on the false assumption that people were basically logical about their houses, and a false reading of social trends which they thought reduced the importance of home in favour of travel, outdoor recreation and collective activity. People did not want a machine for living so much as a vehicle for living out a fantasy.[66]

Suburban taste, like suburban housing, shares common ground with more self-conscious design choices. One reason why educated English patrons such as Raymond Mortimer kept modernism at arm's length was that the severely modern room expressed the architect/designer's personality more than that of the owner. The assertiveness of modernist design seems in itself to have been a source of discomfort. John Fowler, an enormously successful decorator, enunciated the following principles: 'I like the decoration of a room to be well behaved but free from too many rules; to have a sense of graciousness; to be mannered, yet casual and unselfconscious; to be comfortable, stimulating, even provocative, and finally, to be nameless of period—"fantaisie" expressing the personality of the owner.'[67] Of these design tenets, the last is the most practically important, as much so in the living quarters of urban sophisticates as in suburbia.

Despite their championing of the principle of smoothness, both Todd and Mortimer considered that modernist rooms had an intrinsic formality which was alien to English tradition:

> We need fantasy, imagination, wit, in our houses.... The Corbusier style of decoration is as formal as the old French salon which had hardbacked chairs at regular intervals all round it. We require our houses to be quieter, more informal, more personal.[68]

It may be relevant to note that Todd, Mortimer, Fowler, and Schrijver were all homosexual, whereas the leading spokesmen for the modern movement, such as Le Corbusier, Benjamin, and Gropius, were not. It is clear from *The New Interior Decoration* that Mortimer's own preference is for interiors which combine modern

[66] Burnett, *A Social History of Housing*, pp. 266–7.
[67] Martin Wood, *John Fowler, Prince of Decorators* (London: Frances Lincoln, 2007), p. 33.
[68] Todd and Mortimer, *The New Interior Decoration*, p. 28.

French pictures, eighteenth-century French furniture, a Georgian mantelpiece, and decorations by contemporary English painters (he was connected with the Bloomsbury group). Equally, Schrijver is a classic exponent of post-Sitwell modern baroque taste: in his own *Decoration for the Home* (1939) he advocated mixing modern and traditional styles, and one of his maxims was that 'the eye cannot be deceived too often or too much in a house'. His personal decor included a Monet, a large Lurçat tapestry, an African primitive statue, obelisks, seashells, trompe l'oeil, and mirrors.[69]

It is interesting that even the most sophisticated decorators and clients were so doubtful about contemporaneity. The problem is not that modernism was left-leaning. After the Paris Arts Décoratifs exhibition of 1925 a luxuriant and elegant modern style was established, that of designers such as Émile-Jacques Ruhlmann and Jean Dunand, known as art deco. But in England the wealthy were curiously reluctant to banish their old furniture. This may be because a taste for antiques was established in the nineteenth century, encouraged by the vogue for Gothic in both church and home furnishings, fostered by architect-designers such as Augustus Pugin and Eugène Viollet-le-Duc.[70] Benjamin Disraeli commented that 'palaces are daily broken up like old ships', and a number of London dealers began importing continental panelling, fireplaces, and mouldings, both secular and ecclesiastical, from the 1820s onwards.[71]

This established interest in the antique continued and even intensified after the First World War. Herman Schrijver was puzzled by the continued importance of the trade: 'What is surprising to me is the terrific effort which the advocates of modernism have to make to remain in existence. Never since the struggle to be modern has there been such an interest in the public at large in the antique.'[72] The eclecticism of Sitwell style evidently touched a chord with contemporaries, suggesting that it was genuinely expressive of the time, and rapidly diffused into popular taste. The middle-market *House and Garden*, in 1925, suggested that 'a more interesting and pleasing effect can be achieved by the association of pieces which, although dating from varying periods and having many contradictions in point of style, yet possess a certain harmonious relationship.'[73]

Clearly, despite a widespread rejection of Victorianism as such and Victorian Gothic in particular, the taste for a harmony of old and new which was established in the nineteenth century was not easy to budge. It is unwise to exclude issues of

[69] Charles Burkhart, *Herman and Nancy and Ivy, Three Lives in Art* (London: Victor Gollancz, 1977), pp. 23, 36.

[70] See Mark Girouard, *The Return to Camelot: Chivalry and the English Gentleman* (New Haven: Yale University Press, 1981).

[71] John Harris, *Moving Rooms: the Trade in Architectural Salvage* (New York and London: Yale University Press, 2007), p. 54.

[72] Herman Schrijver, *Decoration for the Home* (Leigh on Sea: F. Lewis, 1939), pp. 11–12.

[73] Potvin, *Batchelors*, p. 16. See also 'Ancient and Modern Settle Down Together' (*Vogue*, 30 Mar. 1932), pp. 56–7.

class and social status from any aspect of interwar life in England, and it may well be a factor in this context also. There was a solid presupposition, going back at least as far as the early Georgian world depicted by Frances Burney, that a room in which everything was new looked somewhat vulgar, because *arriviste*. The implication of including some carefully chosen antique, or at least non-contemporary, items in the overall display was that the household's wealth and status went back more than one generation.

Whatever their reasons, it certainly seems to be the case that many of the notable patrons of modern art and architecture preferred to live in modern baroque rooms (see Figure 16). Jean-Michel Frank designed Nancy Cunard's apartment in a seventeenth-century building on the Île Saint-Louis in 1924. There were two very large public rooms, a hall and a sitting room. The walls were plain plaster, the floor covered only with a glossy cement, the fireplace completely plain. Some of the furniture was Frank's own elegantly simple sofas and armchairs, but other chairs and tables were elaborate French and Italian pieces from the eighteenth and nineteenth centuries, some of them gilded. There was also a huge rock-crystal chandelier

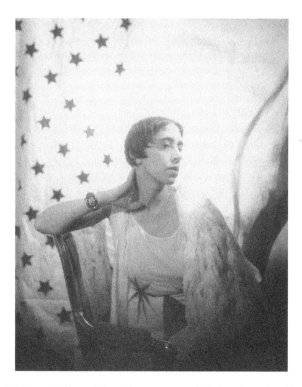

Figure 16 Elsa Schiaparelli, her coiffure, dress, pose, and chair referencing Empire style. The stars in the background evoke her astronomer namesake. Photographer: Cecil Beaton. © The Cecil Beaton Studio Archive at Sotheby's.

in the hall, roughly of age with the building and giving the impression that it had been abandoned there by the original owners. In this austerely eclectic space, pictures by de Chirico, Yves Tanguy, Francis Picabia, and Oskar Kokoschka gradually accumulated.[74]

Coco Chanel, high priestess of modernism in her own sphere of fashion, decorated her shop austerely in white and beige but turned to baroque for her own highly theatrical living space in 1923, for which she took advice from her close friend Misia Sert, married to the neo-baroque muralist, Josep Maria Sert. Chanel owned gilded Louis Quatorze chairs covered in white velvet, Coromandel screens by the dozen, gilt-framed mirrors, and Venetian blackamoors, and she placed enormous bouquets of white flowers in every room.[75]

Marie-Laure de Noailles, who made a notable collection of contemporary art,[76] had a severely luxurious smoking room in the Hôtel Bischoffsheim in Paris, decorated by Jean-Michel Frank with his signature vellum walls, which contained an eclectic mixture of African sculpture, Rubens tapestries, and enormous pictures by Dalí.[77] Other rooms were more traditional, gilded, and mirrored. The de Noailles also commissioned a starkly angular modernist country house at Hyères by Robert Mallet-Stevens, where they experimented with a more modernist decor: Edith Wharton wrote bitchily to Bernard Berenson, 'They have just inaugurated a new salon where the furniture is painted with the new rain resistant motor paint, and the armchairs are covered with the thin rubber sheeting put under leaking patients in hospital wards.' This is 'textuel', she added, meaning 'not literally true', though both Ripolin and rubber sheeting were certainly used in doctrinaire modernist circles. Frank gave his friend Elsa Schiaparelli white rubber upholstery for her sitting room.[78]

In Paris, it was Frank, for Chanaux, who was the master of *luxe pauvre*—stripped-down, austerely simplified classicism—but simultaneously Stéphane Boudin, for Jansen, was creating baroque magnificence as if the *ancien régime* had never come to an end.[79] No London decorator of the twenties was offering this level of sophisticated decor, but the influence of French design was also exercised through the decorators who ensured that Paris came to London. One of the first people to import French furnishings was Marcel Boulestin, who opened Decoration Moderne, an interior-design shop at 15 Elizabeth Street, Belgravia, in 1911. 'My stock was small,' he wrote, 'but modern and first-rate. I had made no concessions. The silks, the

[74] Martin-Vivier, *Jean-Michel Frank*, pp. 88–9.

[75] Linda Simon, *Coco Chanel* (London: Reaktion, 2011), p. 61.

[76] James Stourton, *Great Collectors of Our Time: Art Collecting since 1945* (London: Scala, 2007), pp. 25–6.

[77] Philip Core, *The Original Eye: Arbiters of Twentieth Century Taste* (London: Quartet Books, 1984), p. 120, illustrates her studio, 'the stark modernism of which contrasts eloquently with her Louis XV chair and Schiaparelli tailleur'.

[78] Hermione Lee, *Edith Wharton* (London: Chatto & Windus, 2007), p. 538.

[79] See Abbott, *Jansen*.

velvets, the linens, the knick-knacks and the wallpapers came from Martine, André Groult, and Iribe. I had bought stuffs at Darmstadt, Munich and Vienna; Berlin and Florence supplied me with certain papers, Paris with new and amusing vases, pottery, porcelain, glass, and a few fine pieces of Negro art.'[80] After the war his venture was overtaken by some of his erstwhile clients who had become competitors, such as Syrie Maugham, and he retreated into restaurant-keeping.

Syrie Maugham learned a great deal from Boulestin about decorating surfaces— faux finishes, pickling, and gilding—and also about recreating original upholstery and drapery.[81] She also learned by apprenticeship: after her marriage to Maugham ended, she leased a house in Regent's Park, and asked the director of the firm who decorated it for her, Ernest Thornton-Smith, if she could work unpaid in his showroom to learn about antique furniture and its restoration.[82] One problem which English decorators struggled with was that London craftsmen were not working to the highest French standards.[83] Maugham had some of the most competent—John Fowler thought her upholstery the best in London—but she also followed Boulestin's example as an importer, and became representative and special agent for Jean-Michel Frank, Serge Roche, and Diego Giacometti.[84]

As the twenties wore on, several London shops opened which, between them, made quality design available to the better-off. Heal's was one, where Ambrose Heal's mistress Prudence Maufe ran a show flat in the Mansard Gallery from 1919. Good modern furnishing fabrics could also be found in Elspeth Ann Little's shop, Modern Textiles, which opened in Beauchamp Place, London, in 1926 and featured work by Phyllis Barron and Dorothy Larcher, Enid Marx, Marion Dorn, Paul Nash, Eric Kennington, and Norman Wilkinson.[85] Allan Walton was another textile designer, associated with Bloomsbury, who founded Allan Walton Textiles in 1931 with his brother Roger, and promoted designs by his London Group colleagues, notably Duncan Grant and Vanessa Bell. Madge Garland thought his work very important. She said, '[He] had this flair, this eye...I always wanted everything that Allan had. In fact if I have any taste at all, you could say it was formed by Allan.'[86] The photographer Curtis Moffat exhibited modern rugs at his Fitzroy Square Galleries and held the English agency for the French Décorations Interieures Modernes (DIM). He also sold primitive African art.[87] The Zwemmer Gallery sometimes showed furnishing items.[88]

[80] Marcel Boulestin, *Ease and Endurance* (London: Horne & van Thal), p. 58.
[81] Metcalf, *Syrie Maugham*, p. 18. [82] Metcalf, *Syrie Maugham*, p. 18.
[83] Garland, *The Indecisive Decade*, pp. 18–19. [84] Metcalf, *Syrie Maugham*, p. 54.
[85] Valerie Mendes, 'Marion Dorn, Textile Designer', *Journal of the Decorative Arts Society 1890–1940*, 2 (1978), pp. 24–35.
[86] Lisa Cohen, *All We Know*, p. 322.
[87] Isabelle Anscombe, *A Woman's Touch* (London: Viking, 1994), p. 85.
[88] Paul Nash, *Writings on Art* (Oxford: Oxford University Press, 2000).

Maugham's arch-rival in London decorating was the team of Colefax and Fowler. John Fowler was a practical craftsman, while Sibyl Colefax was a socialite and society hostess who needed the money. They were a team, each supplying what the other lacked. The style they developed was notably eighteenth century in inspiration, mixing eighteenth-century furniture, Adam colours, and plaster consoles and fittings which, like Syrie Maugham, Colefax imported from Chanaux.[89] The Marchioness of Anglesey's bedroom at Plas Newydd, designed by Colefax, is one of the few monuments to her style to survive intact. Twin Venetian blackamoors stand on either side of the dressing table. The bed is a four-poster with painted chinoiserie decoration; the lamps are crystal with heavy fringes of prisms, and there is a rococo mirror and two rococo mirrored consoles with narrow gilt frames.

Raymond Mortimer claimed that 'intelligent persons today feel enormously in sympathy with the eighteenth century. The Victorian age seems a curious intervening backwater.'[90] A design manual, British Interior Architects, describes a room in which the aim is to strike a balance between modernity and the eighteenth century:

> The sitting-room, while attractively 'different', shows how near Modern may approach Period decoration. The furniture is eighteenth century in character, and the walls, though individual in colouring and detail, are appropriate in feeling. Modern touches are also supplied by the accessories.

This English fascination with the eighteenth century may relate to its being Augustan and imperial. In Holland the seventeenth century is the 'Golden Age', so Dutch decorators tend to reference it, and to French decorators it is the 'grand siècle', the era of the Sun King, and so, similarly, it is where they tend to hark back to. Practically, because the Great Fire of London meant that the city had to be rebuilt after 1666, most of the great houses of London were late seventeenth and eighteenth century. But the reason why the eighteenth century is the reference point for English decorators' dialogue with the past is certainly not simply because there was eighteenth-century furniture to be had: supply can be brought in line with demand, and much of the antique furniture which was changing hands was not as old as it looked.[91]

Another factor is that interwar baroque is a camp and aristocratic style. Its eighteenth-century reference points are the toys and treasures of an educated aristocracy, before the French Revolution brought the party to an end. The spirit

[89] Anscombe, A Woman's Touch, p. 81.

[90] Christopher Reed, 'A Vogue that Does Not Speak its Name: Sexual Subculture during the Editorship of Dorothy Todd, 1922–26', Fashion Theory, 10.1/2, pp. 39–72, p. 53–4.

[91] Martin Wood, John Fowler, Prince of Decorators (London: Frances Lincoln, 2007), p. 18. 'Michael Raymond, a great friend of John's, recalled buying an eighteenth-century faux-bamboo table, beautifully painted beneath two centuries of grime. He set to work restoring it.... When John arrived, he exclaimed, "what are you doing, Childie? I spent hours painting on all that grime!"'

of elegant irony with which some French aristocrats who escaped the guillotine subsequently sported a choker of narrow red ribbon suited the thirties: it was not an optimistic decade, and all but the stupidest of its *jeunesse dorée* were aware that Europe was once more moving towards war.[92]

One salient example of rococo taste between the wars was the popularity of Chinese wallpaper, at the opposite end of the spectrum from modernist aesthetics. Fantastic wall treatments in an eighteenth-century mode were part of the aesthetic of modernized rococo, not so much *trompe l'oeil* as *attire l'oeil*: a playful enticement, meeting an answering willingness to pretend. The delicate climbing plants and tropical birds of Chinese wallpaper are an exuberant imitation of nature intended not to deceive but to give delight, and to suggest a through-the-looking-glass world. It fitted with the taste for the eighteenth century, since it came to Europe as an aspect of eighteenth-century chinoiserie, and it brought with it a flavour of old money and aristocratic taste: Elsie de Wolfe, for example, installed a set in Condé Nast's penthouse at 1040 Park Avenue, New York, which had come out of Lord Anglesey's Staffordshire house, Beaudesert (dismantled in 1921), though she perhaps did not mention that it had been hung there only recently.[93] Both of Edith Wharton's French houses had Chinese wallpaper.[94] Lady Sackville's sitting room at Knole had Chinese wallpaper: since it was she who did Knole up, and she was one of the first society ladies to start a decorating shop, the chinoiserie taste of her private room is of interest.[95] Chinese wallpaper also figured in the eighteenth-century town house which Sir Samuel Courtauld bought in 1932, 12 North Audley Street, where decorator style was forced to coexist with major paintings. A new bedroom was given Chinese wallpaper, but Rex Whistler was hired to paint a matching panel over the fireplace, designed to frame Picasso's *L'Enfant au Pigeon*.[96]

John Fowler made the first step towards his decorating career when he was taken on by Ernest Thornton-Smith, who ran the antiques end of Fortnum's Contemporary Decoration Department, a large decorating and antique business in Soho Square, under the auspices of Syrie Maugham.[97] There he began in its paint studio, 'restoring'— i.e. faking—Chinese wallpapers. These papers, suitably distressed, were sold as

[92] Ronald Schechter, 'Gothic Thermidor: the *Bals des Victimes*, the Fantastic, and the Production of Historical Knowledge in Post-Terror France', *Representations*, 61 (1998).

[93] Cornforth, *The Search for a Style*, p. 181. Harry Lindsay, a family connection (Lady Paget's brother was married to his sister), had found it at Welbeck Abbey, unused. A younger son of the Earl of Crawford, Lindsay learned about old furniture working in the family castle of Balcarres, but after the end of the First World War he took up antique dealing and restoration as a profession (Allyson Hayward, *Norah Lindsay: the Life and Art of a Garden Designer* (London: Frances Lincoln, 2007), p. 68).

[94] Lee, *Edith Wharton*, pp. 526, 542. [95] Cornforth, *The Search for a Style*, p. 151.

[96] This is now in the Victoria and Albert Museum (no. P. 13–1977). White, Allom, the firm responsible for this decor, were used to providing backgrounds for great paintings: Sir Charles Allom furnished houses for Henry Clay Frick and William Randolph Hearst, among others.

[97] *Surreal Things*, p. 48; Martin Wood, *John Fowler, Prince of Decorators*, p. 17.

genuinely of the eighteenth century, and they were one of Syrie Maugham's standbys circa 1930.[98]

Chinoiserie other than Chinese wallpaper also played a considerable part in modern baroque aesthetics. Coromandel screens, sumptuous in black and gold lacquer, became fashionable in Europe in the late seventeenth century[99] and were greatly valued by interwar decorators. Stephane Boudin used them to panel the smoking room at the no-expense-spared modern baroque Chateau Solveig (1935), built for a musical comedy actress as the last word in contemporary smartness;[100] and the actor Lucien Guitry panelled his dining room with alternating Coromandel panels and Louis Seize mirrors.[101] Coco Chanel, who owned more than thirty, decorated her rue Cambon apartment with them. Other chinoiserie items could also be incorporated into a modern baroque room. The Marquess of Anglesey's bedroom at Plas Newydd is naturally more masculine in style than his wife's pink-and-white boudoir, but it embodies the baroque principle of overscale, dominated by a magnificent, ceiling-high, eighteenth-century chinoiserie bed with hand-painted gold hangings, an item so splendid that the rest of the decor merely showcases it. The bed had come from Beaudesert.[102]

Another important eighteenth-century marker of interwar baroque style is the Venetian blackamoor. Usually male, made of porcelain or wood, and often in pairs, blackamoors stand anywhere between 3 and 7 feet high. Any exposed skin is shining black, and their clothing is rococo, usually including a turban and featuring a great deal of gilt. Some have candelabra or jardinières on their heads; others proffer trays. The fashion for these figures has persisted from the eighteenth century to the present day. Chanel, Helena Rubinstein, Elsie de Wolfe, Syrie Maugham, and Stephen Tennant were among the tastemakers who owned one or more (see Figure 17).

Silvered grotto furniture has already been discussed in the context of the Sitwells. Though some was genuinely antique, the Venetians continued to manufacture it in response to demand. Eighteenth-century Venice, which Sacheverell Sitwell wrote about so often, was a strong influence on interwar decoration; its shimmering, silvery light, reflected up from the omnipresent water, was an obvious reference point for an aesthetic so concerned with reflections. Venice, of course, was much visited, but as well as blackamoors and grotto furniture, Venetian glass mirrors, chandeliers, Murano glassware in all its varieties, and a suspiciously large supply of

[98] Metcalf, *Syrie Maugham*: three of her rich American clients were given Chinese wallpaper *c.* 1930, Grace and Harry Payne Bingham, New York, Mona and Harrison Williams, Palm Beach, and Celia Tobin Clark, Hillsborough, California.

[99] Hugh Honour, *Chinoiserie* (London: John Murray, 1961) p. 72. [100] Abbott, *Jensen*, p. 87.

[101] Edward Knoblock, *Round the Room: an Autobiography* (London: Chapman & Hall, 1939), p. 165.

[102] Cornforth, *The Search for a Style*, p. 181.

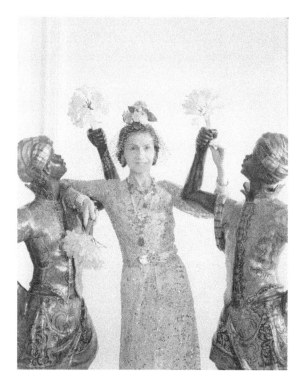

Figure 17 Coco Chanel with two Venetian blackamoors. Photographer: Cecil Beaton. © The Cecil Beaton Studio Archive at Sotheby's.

nearly real Canalettos, made the trip back to England in vast quantities to become mainstays of the designers' trade. Other eighteenth-century furniture, especially if it was gilded, was a highly acceptable alternative. Beaton's house at Ashcombe was 'quite magic. The drawing room full of amusing Rococo chairs, tables and couches. A riot of carved gilt with bunches of wax flowers like wedding cakes ... the sittin-groom delights the eye, with its pink walls and the dull old gilt ornaments and furniture softly winking in candlelight.'[103]

Some rooms were more amenable to modern design than others. Bathrooms were very much part of a functional aesthetic between the wars, partly because much of the impetus behind urban planning was hygienic. The eighteenth century could be of no help with bathroom design, and so when these rooms were anything more than utilitarian, they were often fantastical in a modernist mode. Randall

[103] *Edith Olivier from her Journals*, ed. Penelope Middelboe (London: Weidenfeld & Nicolson, 1989), pp. 115, 118.

Phillips states as a principle: 'Of all the rooms in the house the bathroom is the place where, if desired, one can indulge in extravagant decorative fancies.'[104]

Some of the more remarkable bathrooms of the twenties were glass or mirrored. Paul Nash designed a completely mirrored bathroom in 1932 for the beautiful dancer Tilly Losch, then married to the exceedingly wealthy Edward James. Nash did it because he badly needed the money, but he was in any case a child of his times in being fascinated by glass: 'No other material contains so many elements of magic,' and there were other mirrored bathrooms, some of them with trompe l'oeil painting on the glass (see Figure 18).[105] Bedrooms, or at least bedroom furniture, were also glass-prone: Lady Mount Temple, who had a mirrored bathroom, also had a bedroom 'the cool green of deep water, a bed set in a crystal alcove and resting on crystal feet, standing on a milk-white floor. The walls and ceiling are glazed green.'[106] When Linda, the heroine of Nancy Mitford's *The Pursuit of Love*, is set up in a Paris *cocotterie* by a wealthy lover around 1939, her furnishings are a somewhat clichéd version of this art deco trend, as Lord Merlin (based on Lord Berners) hints: '"I bet you've got a glass bed, Linda?" "Yes—but—" "And a glass dressing-table and bathroom, and I wouldn't be surprised if your bath was made of glass." "You've looked", said Linda sulkily. "Very clever".'

Mirrors were often deployed in halls. Several reasons suggest themselves: halls tend to be small, and mirrors make them look bigger; also, in a place where outer garments are removed or put on, mirrors are practical. On a less utilitarian level, the hall's liminal status as space between the outer world and the home lent itself to fantasy: Elsie de Wolfe made the very sensible point that since one doesn't loiter in a hall, it can receive the kind of elaborate decor, such as a landscape paper or a trompe l'oeil wall treatment, which would be overwhelming in a living room or drawing room (see Figure 19).[107]

Glass as a transparent, impervious, light-transmitting material serves modernist agendas, but as a *reflective* surface it becomes baroque, lending itself to trompe l'oeil effects, false perspectives, and playful ambiguities. In Oliver Hill's Devonshire House (1927), a flat designed for Albert Levy featured a hall lined with grey and black looking glass, with a false perspective carried out in glass rather than the traditional treillage.[108] Madge Garland mentions a room where the exact shape of the two arched openings was repeated in mirrors of the same dimensions, producing the effect of an enfilade.[109] Using panels of glass or mirror to produce modern versions of traditional design elements, such as pilasters, in order to create a room with a

[104] R. Randal Phillips, *The Modern English Interior* (London: Country Life, 1939), p. xxix.

[105] James King, *Interior Landscapes: a Life of Paul Nash* (London: Weidenfeld & Nicolson, 1987), p. 153, and see *Vogue* (30 Jan. 1932), pp. 36–7.

[106] John Cornforth, *London Interiors from the Archives of Country Life* (London, Aurum Press, 2009), p. 29.

[107] Elsie de Wolfe, *The House in Good Taste* (New York: Century Publishing Co., 1914), p. 68.

[108] Cornforth, *London Interiors*, p. 66. [109] Garland, *The Indecisive Decade*, p. 37.

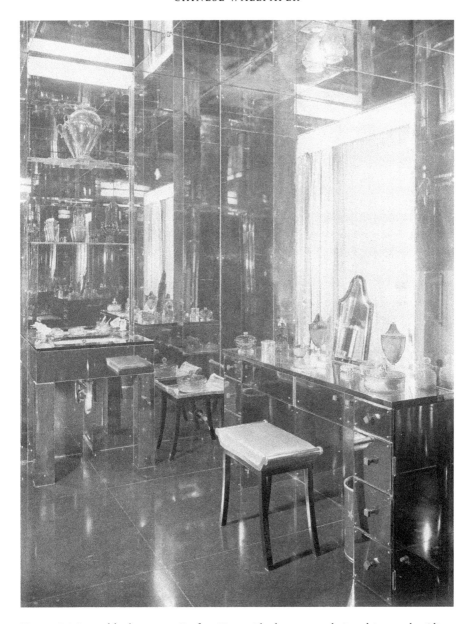

Figure 18 Mirrored bathroom at Gayfere House. The house was designed in 1932 by Oliver Hill and the interiors designed by him in collaboration with the client, Lady Mount Temple. Photographer: A. E. Henson. © *Country Life.*

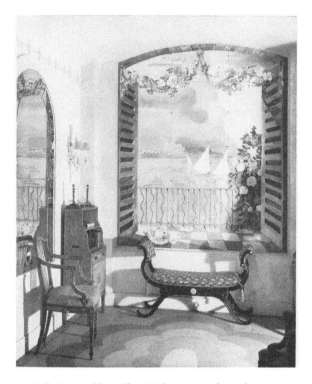

Figure 19 Entrance hall designed by Allan Walton, carried out by Fortnum & Mason. The walls are lightly marbled, there is a trompe l'oeil panel painted on glass depicting a marine landscape, and a false window in mirror glass. The floor is rubber, and 'a few pieces of Empire furniture complete the scheme'. Photographer: unknown.

baroque or rococo feel which was at the same time definably modern was a trick also used by other decorators, including Jansen's Stéphane Boudin: the dining room of Chateau Solveig, for example, has mirror pilasters, and Armand-Albert Rateau used them in the music room of Cole Porter's Paris mansion (1928), a room of multiple reflections with its sheet-silver ceiling and black marble floor.[110]

On a smaller scale, furniture veneered with mirror glass became enormously fashionable in the thirties.[111] A number of furniture makers offered mirrored tables, consoles, dressing tables and so forth, notably Serge Roche. Ivor Novello's profoundly theatrical flat over the Strand Theatre had a mirrored bedroom, with a dressing table and other furniture which were rococo in shape but veneered in

[110] Pierre-Emmanuel Martin-Vivier, *Jean-Michel Frank: the Strange and Subtle Luxury of the Parisian Haute-Monde in the Art Deco Period* (New York: Rizzoli, 2008), p. 107.

[111] Serge Roche, *Mirrors*, trans. Colin Duckworth (London: Duckworth, 1956).

mirror.[112] Downmarket versions of these sophisticated designs were particularly horrible: G. S. Reynolds and G. P. Hughes, in ABC Guide to Glass in Architecture (1939), give examples.[113]

Apart from glass, other transparent materials were used for furnishing. Helena Rubinstein's New York apartment had its windows and most of the walls covered with curtains of heavy-grade pleated cellophane, a luminous background designed by Jean Lurçat, better known as a creator of tapestries.[114] It made, of course, a superb background for black-and-white photographs. Another devotee of transparent surfaces was the poet Mina Loy; far from wealthy, she achieved her effects by sheer invention. In her Paris apartment, 'rooms were divided by wirework or wickerwork cages in which birds flew or hopped about. Doors were always glass, the panes covered in transparent material so there was privacy but also light. Whatever patching of crumbling walls or decorative colouring there might be was mostly done with scraps of metallic paper pasted together in floral collages, and coloured cellophane everywhere.'[115]

One modern baroque development was to make furnishing items in eighteenth-century shapes out of unexpected materials: mirrored furnishings have been mentioned, but another approach is suggested by a set of eight dining chairs of eighteenth-century shape commissioned for Helena Rubinstein by the Hungarian artist Ladislas Medgyes, and made by Roman Haas out of lucite (polymethyl methacrylate, now known as perspex, or acrylic). Lucite was a thoroughly modern material, strong, light, castable and cuttable. A would-be Cinderella could have glass slippers if she so chose: lucite is shatterproof. As a furnishing material, it is most readily associable with a severely modern aesthetic of strictly functional bottom-supports mounted on bent chrome, but it is also serviceable for baroque purposes, as a sort of visual joke. Helena Rubinstein particularly liked lucite: when in New York, she slept, and was photographed, in a Regency-style sleigh bed made of lucite, which was also used for her other bedroom furniture.[116] Another bedroom suite which she had in her Paris house also played with reflection, but trailed other kinds of association: dating from around 1830, the pieces were veneered in mother-of-pearl, upholstered in silver and white silk damask, and bought from a great collector of the previous generation, Diaghilev's friend and patron Misia Sert.[117]

One problem with assessing what fashionable rooms actually looked like between the wars is that photographs may not be as informative as they seem. Architects liked to seize a window of opportunity between the completion of a

[112] Adrian Woodhouse, Angus MacBean: Face Maker (London: Alona Books, 2006), p. 85.
[113] ABC Guide to Glass in Architecture (London: Stone & Cox, 1939), p. 49.
[114] Susanne Slesin, Over the Top (New York: Pointed Leaf Press, 2003), p. 78.
[115] Julien Levy, Memoirs of an Art Gallery (New York: Putnam, 1977), p. 120.
[116] Slesin, Over the Top, p. 170. [117] Slesin, Over the Top, p. 117.

project and the clients' actual moving in, and they used it to photograph their concept in all its purity. Alice Friedman notes of Le Corbusier: 'When he published his work, he preferred to show the rooms completely empty, or as settings for evocative, dreamlike tableaux.'[118] *Country Life*'s superb photographs of interiors by architects such as Oliver Hill may or may not represent how the rooms looked once they were lived in.[119] The rugs and furniture may be the property of the clients, or they may be props. Les Terrasses, the house Le Corbusier built at Garches for Michael Stein (Gertrude's brother), his wife, and their friend Mme de Monzie, was actually furnished with old pieces of Florentine furniture as well as paintings by artists such as Matisse, which is not reflected in the photographs.[120] The Steins' eclecticism was principled: 'Sarah felt that juxtaposing traditional objects with avant-garde paintings helped the viewer to see the paintings, which she knew could be disorienting.'[121] Once Edith Farnsworth actually began living in the glass and steel box house Mies van der Rohe built for her, she decorated it with antiques and family heirlooms, including Chinese Fu dogs on either side of the door.[122]

Similarly, in England even clients who chose to commission a striking modernist house did not necessarily choose modern furniture for it. A modern house, Portland House near Weymouth, which was designed for a wealthy bachelor, Geoffrey Bushby, as a holiday home and party venue in 1935 by Gerald Wellesley and Trenwith Wills, was actually filled with eighteenth-century pieces from Bushby's family home in Hertfordshire, including an antique wig stand in the bedroom. The National Trust, which now owns the house, has told a much simpler tale by furnishing it with art deco pieces. It is another example of the way that the continued importance of the eighteenth century in English aesthetics was only minimally affected by modernism.

One reason why the material covered in this chapter is of some importance is because of who was doing it. Graves and Hodge wrote, 'By 1939 it was calculated that there were at least 200,000 self-styled artists in England, of whom the great majority were women, but fewer than 200, mostly men, lived wholly by their art.'[123] Graves and Hodge's figures may have been plucked from the air, but the distinction they are making between artists and the merely 'arty' conceals assumptions about what it

[118] Alice T. Friedman, *Women and the Making of the Modern House: a Social and Architectural History* (New Haven: Yale University Press, 2006), p. 119.

[119] Penny Sparke and Susie McKellar have drawn attention to the underdocumentation of rooms as they were actually lived in, in *Interior Design and Identity* (Manchester: Manchester University Press, 2004), p. 2.

[120] Friedman, *Women and the Making of the Modern House*, p. 119.

[121] *The Steins Collect: Matisse, Picasso and the Avant Garde*, ed. Janet Bishop et al. (San Francisco: Museum of Modern Art/New Haven and London: Yale University Press, 2011), p. 173.

[122] Friedman, *Women and the Making of the Modern House*, p, 24.

[123] Robert Graves and Alan Hodge, *The Long Week-End: a Social History of Great Britain 1918–1939* (London: Reader's Union, 1941), p. 45.

meant to be an artist. This chapter began by making the point that interwar painters depended on critical reception and being taken up by a dealer if they were going to make a living; and very few did. And of those who did, very few were women, the notable exceptions in France being Marie Laurencin, who was represented by Wilhelm Uhde and subsequently by Paul Rosenberg, and the future Sonia Delaunay, who had the nous to take Uhde, a homosexual, as her first husband.[124] There is no obvious English equivalent to Laurencin in terms of status or earning power. Incidentally, while women dealers might have been more sympathetic to women artists, there were very few. Malcolm Gee lists Paul Poiret's sister Germaine Bongard, Jeanne Boucher, and Katrin Granoff in Paris. In London, Dorothy Warren, who was also an antique dealer, ran the Warren Galleries, where she gave a show to Dorothy Hepworth, the partner of Stanley Spencer's femme fatale Patricia Preece, among other young artists; and Lucy Wertheim opened her Burlington Gardens gallery in 1930.[125]

Another barrier which women were faced with was that artists formed cliques: the cubists stuck together, on the whole, and so did the surrealists. With the important exception of Laurencin, the cubists did not rate women as fellow artists: they were models, muses, and/or sleeping partners, and, similarly, André Breton and his fellow surrealists had no time for the idea of women as equals. As Whitney Chadwick put it, 'Surrealism's idealised vision of women was like an albatross round the neck of the woman artist.'[126] In London, though a number of women were members of groups such as the Seven and Five, and relations between the sexes in bohemian circles seem to have been friendlier, there was a definite sense that women were perceived as muscling in on what was already a frantically competitive market: Frances Hodgkins, Dod Procter, Laura Knight, Winifred Nicholson, and even Barbara Hepworth were collectively described as 'artistic flappers', implying that their work was frivolous and relatively unimportant.[127]

If by 'living wholly by one's art', Graves and Hodge mean, essentially, 'painting', they may be right. One wonders, though, if women such as Marion Dorn, Enid Marx, Syrie Maugham, Helen MacGregor, Clarice Cliff, or Phyllis Barron were being counted in, or indeed, any of the decorative artists whose work was a middle term between the galleries of Bond Street and the mass market.[128] There were also all the assistants who block-printed fabric, pickled furniture, made cushions, retouched photographs, and stippled walls—many of them women. A wide variety

[124] Gee, *Dealers, Artists and Collectors*, pp. 33, 68. [125] Gee, *Dealers, Artists and Collectors*, p. 68.

[126] Whitney Chadwick, *Women Artists and the Surrealist Movement* (London: Thames & Hudson, 1991), p. 66. Incidentally, Leonora Carrington's response to André Breton's view of women was 'bullshit' (p. 161).

[127] Andrew Stephenson, 'From Conscription to the Depression: the Market for Modern British Art in London, c. 1914–1930', *Marketing Art in the British Isles, 1700 to the Present*, ed. Charlotte Gould and Sophie Mesplède (Aldershot: Ashgate, 2012), pp. 61–2.

[128] Nancy J. Troy, *Modernism and the Decorative Arts in France: Art Nouveau to Le Corbusier* (New Haven and London, Yale University Press, 1991), p. 1.

of gay men, who patently brought a highly developed camp sensibility to the art of design, such as John Fowler, Marcel Boulestin, Herman Schrijver, and Oliver Messel, worked in the field of design; with the exception of the well-connected and well-off Messel, they were outsiders and mostly self-taught. The alternative style which they evolved—playful, sceptical, ambiguous, and irreverent—has as much claim to be a genuine expression of the times as modernism.

9

Whiteness

The aesthetic of whiteness in the twenties and thirties is rather complicated. Plain white Ripolin was the doctrinaire modernist's prescription for interior decoration,[1] but a highly complicated version of whiteness was also enlisted on the side of modern baroque. 'With the strength of a typhoon she blew all colour before her,' wrote Cecil Beaton of Syrie Maugham. 'For the next decade [she] bleached, pickled or scraped every piece of furniture in sight.'[2] As Beaton implies, Maugham had no reverence for antiques as such, or for original finishes. James Amster, an American decorator, confirms: 'She took pieces that nobody wanted, and painted the hell out of them and made them look wonderful.'[3] According to Viva King, the all-white look was actually invented by an American, Winkie Philipson (Enscombe, her house in Kent, is certainly a monument to the principle), but it was Maugham who claimed and promoted it.[4] White became her signature: 'I am off to India to paint the Black Hole of Calcutta *white*,' she once declared.[5] Her house in the King's Road, Chelsea, and the Villa Eliza in Le Touquet became society showrooms for her wares, where almost everything was for sale. In effect, Maugham interiors picked up the eclecticism originally championed by the Sitwells, and unified their effect by taking out the colour—a simple principle, graspable by even the thickest of potential clients (see Figure 20).

Loelia, Duchess of Westminster, observed the trickle-down of Mrs Maugham's ideas in action: 'Dowdy old bits of furniture were brought out of attics and painted white and at once looked ultra smart.'[6] By 1930, as Robert Graves pointed out, the

[1] Nigel Whiteley, 'Whitewash, Ripolin, Shop-Girls and Matière: Modernist Design and Gender', in *Modernism, Gender and Culture: a Cultural Studies Approach*, ed. Lisa Rado (London and New York: Garland, 1997), pp. 199–228; Mark Wigley, *White Walls: Designer Dresses* (Cambridge, MA: MIT Press, 1995).

[2] *The Glass of Fashion* (London: Weidenfeld & Nicolson, 1954), p. 208.

[3] Pauline Metcalf, *Syrie Maugham* (New York: Acanthus Press, 2010), p. 11.

[4] Viva King, *The Weeping and the Laughter* (London: Macdonald & Jones, 1976), p. 135; Metcalfe, *Syrie Maugham*, p. 35.

[5] Sarah Woodcock, 'Messel on Stage', *Oliver Messel in the Theatre of Design*, ed. Thomas Messel, pp. 54–84, p. 64.

[6] *Grace and Favour: the Memoirs of Loelia Duchess of Westnminster* (London: Weidenfeld & Nicolson), p. 100.

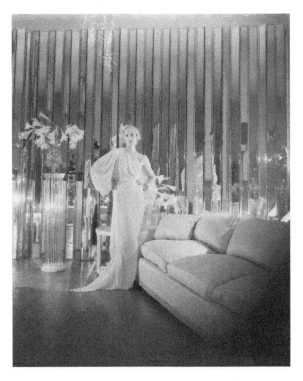

Figure 20 Baba Beaton posing in Syrie Maugham's famous white sitting room, with mirror-glass screen, and beige satin settee. The room also contained a rug by Marion Dorn in two shades of cream, and a low white lacquer screen concealing a piano. Note the arrangement of white lilies on the crystal pillar. Photographer: Cecil Beaton. © The Cecil Beaton Studio Archive at Sotheby's.

style was rampant: 'Numbers of interior decorators made large incomes by collecting odd and useless junk from antique shops and giving it a new life in modernistic sitting-rooms in combination with stainless steel, white paint, and plaster imitations of serpentine or malachite.'[7] By 'plaster imitations' Graves perhaps means the 'escargot' plaster shell uplights which Diego Giacometti designed for her, or the palm-leaf plaster consoles and standard lamps made by Emilio Terry for Jean-Michel Frank, both of which Maugham frequently used in her interiors.[8] The key to the 'junk' was that it had interesting shapes, for which she had an excellent eye: she hunted out items with striking profiles or an unusual form.[9] They could then be

[7] Robert Graves and Alan Hodge, *The Long Week-End: a Social History of Great Britain 1918–1939* (London: Reader's Union, 1941), p. 180.
[8] Metcalf, *Syrie Maugham*, p. 64. [9] Metcalf, *Syrie Maugham*, p. 30.

unified or harmonized by a coat of white paint, or a pickle bath: as modernist architects had observed with respect to buildings' exteriors, knocking out colour drew attention to shape.

A white room was not that easy, as Madge Garland noticed: 'Walls distempered white, curtains of white wool or shiny satin, off-white rugs combined with metal and glass furniture could be arid in the extreme, and a clever play of texture and light, with an occasional touch of contrast was needed to give life to such a restricted palette.'[10] Nonetheless, Garland's own flat at the time was all-white, with white curtains and built-in white furniture, except for the rug, which was pale blue and designed by Edward McKnight Kauffer. The photographer Dorothy Wilding's New York studio was a good example of Maugham's modern baroque style: it contained 'fawn coloured modern couches, perfectly supplemented by a fine old Italian table, credenza and chest, which had been pickled ... adding to the beauty of the whole was the interesting window treatment. Over the curtains hung a most unusual glazed chintz, with silver patterns on a white ground.'[11] Maugham's interiors of 1927 and 1930 respectively for Coward's country and town houses resembled sets from his plays, with their Syrie sofas, zebra-print cushions, pickled Louis Quinze chairs, and carefully chosen, somewhat startling antiques.[12] At Port Lympne, Philip Sassoon's August house, Chips Channon recorded that 'the drawing room is a mixture of fashionable whites, distressed white, off white, cream, and even the famous frescoes [by Josep Maria Sert] have been whitewashed'.[13]

Nancy Mitford gives a couple of fashionable young aesthetes a white room in her 1931 novel, Highland Fling; she also observes that in a London still heated by coal fires it was a very high-maintenance style, something which decorators did not emphasize. Describing a decor which has been in place for two years, she writes, 'The walls were covered in silver tissue a little tarnished; the curtains and chair covers were of white satin, which the grime of London was rapidly turning a lovely pearl colour; the floor and ceiling were painted a dull pink. Two huge vases of white wax flowers stood one each side of the fireplace; over the mantelpiece hung a Victorian mirror, framed in large white shells and red plush.' The incomer who is surveying the room, an established surrealist artist who has returned to London after two years in Paris, feels 'blissfully happy' there. No wonder, since it was a very crisply observed evocation of the elegance of that specific moment.

The fashion for white spread far and wide in aesthetic circles. The White Party, given by Sandy Baird, a 'Bright Young Person', and held in a barn in Kent in 1931, was decorated by John Banting with objects painted white, including branches and a

[10] Garland, The Indecisive Decade, p. 15.

[11] Val Williams, Women Photographers (London: Virago, 1986), p. 154.

[12] Philip Hoare, Noël Coward (London: Sinclair-Stevenson, 1995), p. 237.

[13] Stansky, Sassoon, p. 152.

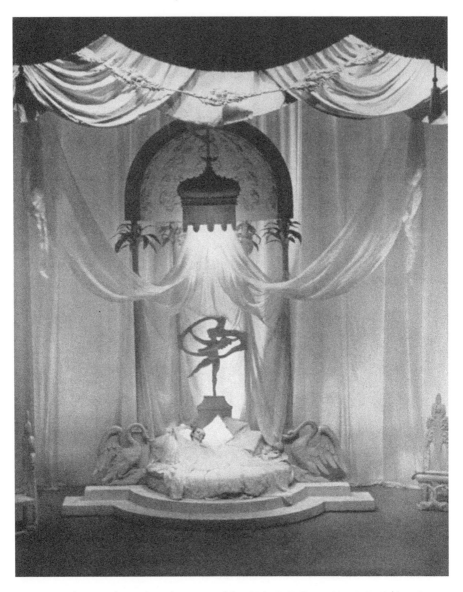

Figure 21 White set design by Oliver Messel for 'Helen's Bedroom' in C. B. Cochran's production of Offenbach's *Helen!*, Adelphi Theatre, 1932. Evelyn Laye, as Helen, is on the bed. Photographer: Alex Edward Sasha.

bicycle, and, naturally, the guests all wore white.[14] The Sissinghurst White Garden was conceived in 1939, though not constructed until after the war.[15] White was traditionally taboo on the stage, but such was Maugham's success that Cochran yielded to the pressure of fashion: in his 1930 Revue, he got Oliver Messel to design a white number called 'Heaven'. Like Maugham, Messel realized that pure white was not actually the answer, because it was desperately unflattering; he used charlady's swabs, loofahs, and bath scrubbers to break down the stark white of the costumes, and devised an apricot-tinted make-up to keep the actors from looking like corpses. In 1932 Cochran entrusted him with *Helen!*, an updating of Offenbach's *La Belle Hélène*.[16] For *Helen!*, which was directed by Max Reinhardt, he contrived a beautiful and imaginative decor, draping the bedroom and bathroom scenes almost wholly in white and clothing Helen herself entirely in white for the final scene (see Figure 21).

The design aesthetics of modern baroque thus reveal an underlying consistency: a focus on shape, not colour; on glass in the form of mirrors rather than glass in the form of transparent windows; on illusionism, camp parody, witty invention, and an un-historicist evocation of the past, which forms an interesting contrast to modernism as such.[17] It also amounts to an identifiable alternative style, not merely a set of muddled expressions of aversion to contemporaneity.

[14] Marie-Jacqueline Lancaster, *Brian Howard: Portrait of a Failure* (London: Timewell Press, 2005), p. 169. The party became notorious because it ended with a drunken car-chase.

[15] Anne Scott-James, *Sissinghurst: the Making of A Garden* (London: Michael Joseph, 1983), p. 102.

[16] Sarah Woodcock, 'Messel on Stage', *Oliver Messel in the Theatre of Design*, ed. Thomas Messel, pp. 54–84, p. 58.

[17] Alexandra Harris, *The Romantic Moderns: English Writers, Artists and the Imagination from Virginia Woolf to John Piper* (London: Thames & Hudson, 2010), makes a cognate point with respect to Beaton's oeuvre and treatment of Ashcombe: 'History could be invented rather than inherited, and it was less troublesome that way' (p. 79).

White and Gold

One area in which a conflict between modern baroque and modern classicism was fought quite consciously was in the furnishing of churches. The internal furnishings of a church are designed to express and communicate religious feeling; and a church which, to one worshipper, is a truthful and supportive expression of the impulse to praise God may very well seem repellent, desolate, or even blasphemous to the product of a different tradition. The presence or absence of altar candles, incense, a reredos, or a communion rail represent differences over which much actual, not metaphoric, blood has been shed. Every nuance of church decor can be, and often has been, read symbolically, and it usually has some reference to a venerable iconographic tradition.[1]

To Sacheverell Sitwell, a lifelong atheist, baroque was a style to be approached in a mode of camp irony, or conscious, unserious surrender. In all his writings the fact that the most extreme manifestations of baroque were created to the greater glory of God was barely mentioned, and certainly not related to a modern aesthetic response. But many of the artists he most admired were committed Christians, for whom the practice of art was a form of devotion, and the results of their labours were intended to be religiously effective. Between the wars there were still English intellectuals to whom this was relevant.

Many of England's intelligentsia, particularly the Bloomsbury Group, were actively hostile to Christianity. S. J. D. Green notes that 'a strident irreligion' gathered renewed pace among the intellectually sophisticated in the 1920s,[2] and in 1929 G. K. Chesterton, perhaps England's most widely read explicitly Catholic writer, commented on this hostility: 'It is obvious [that these writers feel] if a man begins to think he can only think more or less in the direction of Modernism.'[3] However, the interwar world was not post-religious. In addition to the battle between fascism and

[1] M. D. Anderson, *History and Imagery in British Churches* (London: John Murray, 1995), p. 83.

[2] S. J. D. Green, *The Passing of Protestant England* (Cambridge: Cambridge University Press, 2010), p. 156. See also Michael Levenson, *The Cambridge Companion to Modernism* (Cambridge: Cambridge University Press), pp. 191–4.

[3] Alzina Stone Dale, *The Outline of Sanity: a Biography of G. K. Chesterton* (Grand Rapids: Eerdmans, 1983), p. 273, quoting *The Thing: Why I am a Catholic*, published 1929.

communism, war was also being waged on another front: between religion, rooted in the past, and science, the underpinning of modernity. A question which was posing itself to a variety of Chesterton's contemporaries was whether there were modern ways of being religious, or religious ways of being modern.

In the context of society more generally, Britain was notably less secular between the wars than it has since become.[4] It was still considered impossible for Edward VIII to marry a divorcee, due to his position as head of the Church of England, an issue which is not being treated as relevant to the throneworthiness of the current Prince of Wales. The shape of the Christian year was far more visible in the ordinary life of the citizen. Many who did not consider themselves religious ate fish on a Friday as a matter of habit, went to church at Christmas and Easter, and in some form observed Lent. One of Osbert Lancaster's pocket cartoons shows Maudie and Willie Little-hampton, not anybody's idea of obsessively religious people, standing over the drinks tray, glass in one hand, watch in the other, with the caption, '5 – 4 – 3 – 2 – 1 – Lent!' At which point, Lancaster implies, the corks went back into the bottles and stayed there for forty days. Many upper-class English people gave up spirits for Lent, not because they were nagged by their doctors but out of a vague sense that 'one does', or even as a matter of personal conviction. *Vogue* magazine for late March 1927, in its regular feature 'For the Hostess', suggests 'Simple Delicacies for the Lenten Season'.

W. H. Auden drifted away from, then back to, High Anglican Christianity, but even when he was furthest from religious commitment, going to Spain during the Civil War revealed to him that on some fundamental level his thinking was Christian:

> On arriving in Barcelona, I found as I walked through the city that all the churches were closed and there was not a priest to be seen. To my astonishment, this discovery left me profoundly shocked and disturbed. The feeling was far too intense to be the result of a mere liberal dislike of intolerance, the notion that it is wrong to stop people from doing what they like, even if it is something silly like going to church. I could not escape acknowledging that, however I had consciously ignored and rejected the Church for sixteen years, the existence of churches and what went on in them had all the time been very important to me.[5]

However, in addition to this general sense that Britain was a Christian country and people who felt the sort of unconscious allegiance which Auden expresses here, there were also significant voices raising the question of whether it was possible to be modern and Christian and, if so, how. Among the interwar novelists, Evelyn

[4] Ross McKibbin, *Classes and Cultures: England 1918–1951* (Oxford: Oxford University Press, 1998), pp. 272–92, observes that all churches save the Catholics were losing ground (p. 274), while at the same time 'most believed themselves (one way or another) to be Christian'.

[5] W. H. Auden, in The Dean of New York (ed.), *Modern Canterbury Pilgrims* (London: Mowbray, 1956), p. 41.

Waugh and Graham Greene both expressed different, overtly Catholic perspectives. *Brideshead Revisited*, which for many is the archetypical novel of interwar English society, explicitly judges its characters in terms of their spiritual development.

There were also popular writers interested in religious issues. Dorothy Sayers had much to say about Christian perspectives even in her detective stories, as of course did Chesterton in his 'Father Brown' tales. Charles Williams's spiritual thrillers were admired by major contemporary writers, including T. S. Eliot, Auden, and Mary Butts.[6] Helen Waddell's historical romance on the tempestuous life of a twelfth-century theologian, *Peter Abelard* (1933), which presents Abelard and Héloïse's relationship as a triangle, with God as the third party, was reprinted fifteen times within its first year of publication. A middlebrow romance, Robert Keable's *Simon Called Peter* (1921), which was also about ending a love affair in favour of God, sold some 600,000 copies in England and America. *Simon Called Peter* and A. S. M. Hutchinson's *If Winter Comes* (1921) were two of the three bestselling novels of the twenties: both suggest that the answer to the problems of modernity was Christianity.

Among English poets, John Betjeman was an Anglican, as was Stevie Smith (both in rather complicated ways); T. S. Eliot became one, Auden returned to Anglo-Catholicism, and David Jones wrote from a Catholic perspective, as did Kathleen Raine. The thirties also saw a revival of interest in seventeenth-century Christian poets—John Donne and his fellow 'metaphysicals'—led by the critic Herbert Grierson and T. S. Eliot,[7] and the reassessment of a long-dead Jesuit, Gerard Manley Hopkins, as a major poet. A Hopkins collection was edited and published by Robert Bridges in 1918, and a larger one by Charles Williams in 1930.

In the visual arts, David Jones, as well as being a poet, was a painter who frequently treated Christian themes, while alongside the Welsh Jones, Stanley Spencer was probably the most prominent English painter of the period to focus most of his work on Christian subjects.[8] Jones's delicate watercolours, with their palimpsestic textures and references to Christian tradition and early Welsh literature, are perhaps classifiable as modern baroque. Spencer was more clearly a modernist; and other Christian modernists include the sculptor Eric Gill, and, in France, Georges Rouault. Additionally, there were Christian painters working in more traditional styles, notably Frank Brangwyn and the portraitist Glyn Philpot, who was the first president of the Guild of Catholic Artists, founded in 1928.

Thus there were still major writers and artists happy to identify themselves as Christians, along with a considerable number who entertained some kind of

[6] Considered by Thomas Howard, *The Novels of Charles Williams* (New York: Oxford University Press, 1983; San Francisco: Ignatius Press, 1991). His Christian non-fiction and poetry are discussed by Glen Cavaliero in *Charles Williams: Poet of Theology* (London: Macmillan, 1983).

[7] *Metaphysical Lyrics and Poems of the Seventeenth Century* (London: Oxford University Press, 1921).

[8] Kenneth Pople, *Stanley Spencer: a Biography* (London: Collins, 1991).

spiritual belief of a less formalized kind.[9] The American poet May Sinclair wrote, teasingly: 'The Imagists are Catholic. For them the bread and wine are the body and blood.'[10] In 1918 Edith Sitwell told Robert Nichols, 'One day I shall become a Roman Catholic. (It is the only creed for someone like myself. I do feel that more and more).' She did, and so did the music critic and patron Edward Sackville-West, with whom she discussed the matter.[11]

Sackville-West was homosexual, and a surprising number of the gay artists and writers of the interwar years were, or became, Catholics.[12] Marguerite Yourcenar, who was one of them, considered that Catholicism was half of an underlying European dialectic, the other half being Greek philosophy and all that derives from it. She wrote, 'Along with hellenism, for which it provides all at once the complement and the corrective in my thought, Catholicism represents in my eyes one of the rare values that our epoch has not managed to shatter completely. More and more in the world's current (and purposeful) disorder, I have come to see the Catholic tradition as one of the most precious parts of our complex heritage ... and the disappearance or the disintegration of these traditions in favour of a crude idealism of force, of race or of the crowd, strikes me as one of the future's worst dangers.'[13]

Auden, an Anglo-Catholic, came to a similar view: to him, it was the fascist denial of any value in the individual as such, so that entire groups—whether Jews, homosexuals, Gypsies, or the mentally handicapped—could be arbitrarily stripped of human status, as they were in Nazi Germany, that sent him back to Christianity in search of moral absolutes transcending expediency. He dealt with the Church's attitude to homosexuality by ignoring it, writing to the Jesuit Martin D'Arcy, 'Eros must be transformed,' (he is summing up orthodox Christian views on sexuality) 'but without Eros, there would not be anything to transform.'[14] For himself, he was certain that imperfect love is infinitely better than none. 'You shall love your crooked neighbor / With your crooked heart,' he wrote, and himself practised the Christian virtues with the exception of sexual continence.[15]

[9] Believers in the occult included Mary Butts and D. H. Lawrence, as well as less well remembered writers such as Evelyn Underhill and Hugh Benson.

[10] Erin G. Cawston, *Thinking Fascism: Sapphic Modernism and Fascist Modernity* (Stanford: Stanford University Press, 1998), p. 65.

[11] Richard Greene, *Edith Sitwell: Avant-Garde Poet, English Genius* (London: Virago, 2011), p. 395.

[12] Lowell Gallagher, Frederick S. Roden, and Patricia Juliana Smith (eds.), *Catholic Figures, Queer Narratives* (Basingstoke: Palgrave Macmillan, 2007).

[13] Cawston, *Thinking Fascism*, p. 121.

[14] London, Farm Street Jesuit Archives, D'Arcy correspondence. On this issue, the Catholic catechism simply states, 'Homosexual persons are called to chastity.'

[15] Edward Mendelson, *Moral Agents: Eight Twentieth-Century American Writers* (New York: New York Review Books, 2015), pp. 171–5, records instances of Auden's practical charity: 'I learned about it mostly by chance, so it may have been far more extensive than I or anyone ever knew.'

A major Jesuit thinker, George Tyrrell, agreed with Auden, arguing that the Church should be developing its theology of sex in response to twentieth-century insights about people and identity. He also believed in the value of sexuality: 'From me it has departed for many years, and I hope for its return with all the costs and inconveniences, for the easier way is the poorer and thinner.' Discussing homosexuality with André Raffalovich in a series of letters, he wrote: 'It cannot be denied that such unnatural propensities are to some degree latent in most of us.'[16] He was expelled from the Order, and died excommunicate.

The conversion of homosexuals such as Oscar Wilde, Aubrey Beardsley, Glyn Philpot, and Ronald Firbank is often associated in a rather simple-minded way with the ritualistic and aesthetic elements of the Catholic tradition—incense and brocade, altar boys and music. It might, however, also be to do with Catholicism's inclusivity—after all, the first Pope, St Peter, was the apostle who denied Christ after the crucifixion. There is also sacerdotalism to take into account: the Catholic tradition offers sacraments of penitence and absolution by which sin can be forgiven. As Wilde said wryly, 'The Catholic Church is for saints and sinners alone. For respectable people, the Anglican Church will do.'[17]

The particular trajectory of gay English people who decided to become Catholics may also be linked with the status of Catholicism itself—within the British Isles, that is, since this would obviously not hold good in France or Italy—as a religion of dissidence and alterity. Radclyffe Hall, for one, was converted to Catholicism by her lover, Mabel Batten, in 1912.[18] Her subsequent partner, Lady Troubridge, was also a Catholic convert (independently). Radclyffe Hall was sufficiently serious about her religion to develop hysterical stigmata while writing *The Master of the House*. Like Auden, she practised Christian virtues: in 1929, she sold her Sargent portrait of Mabel Batten, a most treasured possession, on behalf of striking miners.[19] Also like Auden, Hall and Troubridge were untroubled by the Church's condemnation of homosexual practices: Una Troubridge simply said, 'There was nothing to confess.'[20]

[16] Lowell Gallagher, Frederick S. Roden, and Patricia Juliana Smith, *Catholic Figures: Queer Narratives* (Basingstoke and New York: Palgrave Macmillan, 2007), p. 5. See also Darell Jodock (ed.), *Catholicism Contending with Modernity: Roman Catholic Moderns and Anti-Moderns in Historical Context* (Cambridge: Cambridge University Press, 2000), pp. 22–4.

[17] Richard Ellmann, *Oscar Wilde* (London: Hamish Hamilton, 1987), p. 548.

[18] Michael Baker, *Our Three Selves: a Life of Radclyffe Hall* (London: Hamish Hamilton, 1985), pp. 43–5; Joanna Glasgow, 'What's a Nice Lesbian Like You Doing in the Church of Torquemada? Radclyffe Hall and Other Catholic Converts', *Lesbian Texts and Contexts: Radical Revisions*, ed. Karla Jay and Joanna Glasgow (New York: New York University Press, 1990), pp. 241–54.

[19] Baker, *Our Three Selves*, pp. 251, 273.

[20] Baker, *Our Three Selves*, p. 357. In a sense she was quite right, since the canon-law definition of sexual intercourse focused on penile erection, intromission, and ejaculation, though a sophisticated confessor would have regarded this as casuistry.

The Anglo-Catholic movement within the Church of England also attracted more than its share of homosexuals.[21] Colin Stephenson, an affectionate memoirist of their foibles, recalled that at the beginning of the war the Anglo-Catholic monks of Nashdom were evacuated to a girls' school at Laleham: 'Here all the rooms had been called after flowers, and at night there was some activity as members of the Community crept around transferring the card reading "Pansy" to someone else's door.'[22] A marked degree of campness did not prevent the Nashdom monks from being perfectly serious about their religion, and the same is true of the monks of Caldey, who began as Anglo-Catholics but subsequently joined the Church of Rome. Architecturally, the Caldey Island monastery became a sort of religious Portmeirion, with turrets and pergolas, crazy pavements, goldfish, and peacocks, in what has been called a 'Hollywood Cinema' style; but as Peter Anson emphasizes, Dom Aelred and his monks were caught in a cleft stick—owing over £3,000 for their new church, they had to attract as much publicity as possible. They could hardly turn down contributions of any kind, and they became a magnet for the fantasies of others.[23]

In one sense, there are as many ways of being Christian as there are Christians. In another, there are a number of identifiable styles, which is where the topic becomes relevant to this book. One response to the widespread scepticism towards revealed religion expressed by public intellectuals was articulated by Dean Inge, an important voice within interwar Anglicanism, who argued for a more rational, less sacerdotal or ritualistic, version of Christianity.[24] Though public intellectuals were the clamorous voices of modernism, this begs the question of whether they spoke for the feelings and desires of English people more generally.

Another response to the modernist/secularist challenge to traditional faith was to make a virtue of its improbable, surprising, decorative, and irrational aspects. As Dean Inge reluctantly acknowledged, the mass of the population had not, and still has not, responded to the secularization of education by becoming rational.[25] While people in Britain today are even more sceptical about revealed religion than they were in the 1920s, they are no less given to superstition and more or less pagan belief. The Chestertonian aphorism—'when a man stops believing in God, he doesn't believe in nothing, he believes in anything'—still continues to hold

[21] David Hilliard, 'UnEnglish and Unmanly: Anglo-Catholicism and Homosexuality', *Victorian Studies*, 25.2 (1982), p. 206.

[22] Colin Stephenson, *Merrily on High* (London: Darton, Longman & Todd, 1972), p. 91.

[23] Peter F. Anson, *The Benedictines of Caldey* (London: Burns Oates & Washbourne, 1940), pp. 111, 116.

[24] Green, *Passing of Protestant England*, p. 126: Dean Inge distrusted Anglo-Catholic pretensions, because their effect was to 'magnify the sacerdotal theory of priestly office' at precisely the moment when the masses (at last in receipt of a 'sound secular education') had definitively 'ceased to believe in it'.

[25] Green, *Passing of Protestant England*, p. 131.

good: according to British Religion in Numbers, at the time of writing 41 per cent of British people believe in angels, 53 per cent in an afterlife, and 70 per cent in a soul.

While church leaders and the majority of practising Christians consider that doctrinal differences are what separates one confession from another, there is also a distinction of another kind to be drawn between churches and church services which are aesthetically minimalist (often, but not inevitably, narrowly focused on the biblical text) and others which draw on a rich, affective repertory of music, sometimes bells and incense, visual magnificence, fine art, processions, and incantatory or participatory experience. It is an oversimplification to regard the former as Protestant, the latter as Catholic. There is such a thing as Catholic modernism: Le Corbusier was invited to design a monastery, the Dominican house at La Tourette,[26] and in England, F. X. Velarde produced a number of art deco Catholic churches.[27] There were also individuals and movements in the Anglican and Scottish Episcopalian tradition that acknowledged and embraced baroque visions of how to express and articulate Christian faith.

While there were other strains within Anglicanism which embraced modernism in church architecture and patronized modern art,[28] the Anglo-Catholics were instrumental in a baroque revival in the furnishing of English churches. In 1911 the Society of Saints Peter and Paul launched an assault on Anglican visual sensibilities, which were for the most part Victorian Gothic, arguing that since the Church of England was part of Western Christendom, though not under the jurisdiction of the Pope, it should be brought into line with Continental Christianity. The ideal at which they aimed was Counter-Reformation Catholic taste.[29] For Maurice Child, a leading member of the Society, 'Only the baroque at its most luxuriant could express the assertion that the Church of England was not a survival of the second year of Edward VI but a living part of the Catholic church of Italy, Spain, and Latin America.'[30] One of the most extraordinary interiors to result from this movement is the Anglican shrine of Our Lady at Walsingham, the creation of the Rev. A. Hope Patten, who was appointed to the living in 1921. The church was expanded to its present size in 1938, with fifteen altars in honour of the mysteries of the rosary surrounding the shrine itself. The result reflects the accretive character of a baroque

[26] H. Allen Brooks (ed.), *Le Corbusier* (Princeton: Princeton University Press, 1987), p. 115. Robert Proctor, *Building the Modern Church: Roman Catholic Church Architecture in Britain, 1955–1975* (Farnham: Ashgate, 2014) also singles out Auguste Perret's 1922 Notre-Dame du Raincy.

[27] Michael Day, *Modern Art in English Churches* (London and Oxford: Mowbray, 1984), pp. 22, 59; Fiona Ward, 'Merseyside Churches in a Modern Idiom: Francis Xavier Velarde and Bernard Miller', *Twentieth Century Architecture*, 3 (1998), pp. 95–102.

[28] Discussed by Day, *Modern Art in English Churches*.

[29] Peter F. Anson, *Fashions in Church Furnishings, 1840–1940* (London: Faith Press, 1960), p. 320.

[30] Evelyn Waugh, *Ronald Knox* (London: Cassell, 1959), p. 114.

church on the Continent, a crowded congeries of murals, painted statuary, baroque candlesticks, pictures, banners, and lamps, with gleams of gold and candlelight glittering from a dimly lit and crowded interior.

One of the architects and designers who did most to realize Maurice Child's baroque vision for the Anglican church is Martin Travers (1886–1948). He had personal links with the bohemian end of London life, since his wife was the tempestuous Christine Willmore, sister of the actor Micheál MacLiammóir.[31] Travers was trained by Ninian Comper, whose personal taste was more aligned with the Gothic revival, but his connection to the world of decorators is shown by the fact that he also worked for George Elton Sedding from 1911 to 1914, designing ecclesiastical furnishings, glass, and enamelled jewellery. As a church fitter he specialized in baroque decorations of gilded and painted wood, inspired by Austrian and Bavarian church interiors. Much of his work had a theatrical quality, because he was aiming for maximum effect on a minimal budget, using cheap decorative techniques such as tinted varnishes, trompe l'oeil, and moulded plaster to mimic high-relief carving and gilding. At St Saviour's, Hoxton, he created gigantic, two-dimensional high altar candlesticks, propped behind by iron rods, inspired by similar candlesticks in an Austrian church.[32] The reredos he built for St Augustine's, Queen's Gate in London, also had a fictive quality: made of wood covered in silver foil and varnished with gold, it was painted up with a deliberate trompe l'oeil effect to make it appear much more three-dimensional.[33] Travers decorated the London church of St Magnus the Martyr, built by Christopher Wren, the interior of which T. S. Eliot described in The Waste Land as an 'inexplicable splendour of Ionian white and gold'. The Ionian columns were contributed by Wren, and the white and gold were refurbished by Travers a couple of years after this was written; the line encapsulates the intended effect of Anglican baroque— surprise and glory—an utter contrast to the grey, drab, crowded streets of the city (see Figure 22).

The Society of Saints Peter and Paul had a side effect in the development of secular decoration, since, as Peter Anson noted, this enthusiasm for baroque among a small but determined group of Anglicans had the result of encouraging antique dealers to source the material they wanted. The French Revolution had brought a giant wave of church and monastery loot on to the European market. The majority of imported

[31] Rodney Warrener and Michael Yelton, Martin Travers, 1886–1948: an Appreciation (London: Union Press, 2003), p. 13. MacLiammóir, founder of Dublin's Gate Theatre, was born Alfred Lee Willmore in London, where he was a child actor in the company of Herbert Beerbohm Tree. He moved to Ireland in 1917, but his Irishness was complete self-invention.

[32] Anson, Fashions, p. 91. [33] Anson, Fashions, p. 107.

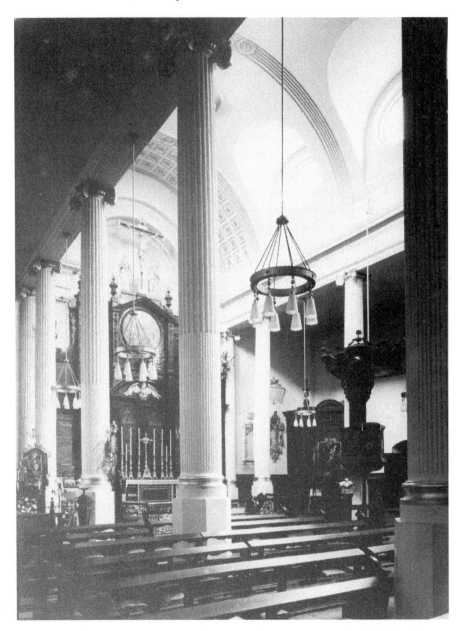

Figure 22 Church of St Magnus the Martyr: the Wren interior as restored by Martin Travers in 1924. Photographer: Edwin Smith (1912–71). © RIBA.

architectural salvage had long been ecclesiastical;[34] and the new interest generated by the Anglo-Catholics, and by the aficionados of 'Curzon Street baroque' supplemented this existing trade in panelling and so forth with textiles, candlesticks, church furniture, even manuscripts, which began coming into the country in some quantity. Notable London dealers in antique textiles included E. B. Souhami, who had premises at 6c Prince's Arcade, Jermyn Street, for a good many years, John Cohen (trading as C. John), and Sidney Franses. Both the latter firms continue to flourish.

Some of these imported textiles ended up in churches. For example, Stephen Dykes Bower designed a frontal for the altar of St Bede in Durham Cathedral, which combined antique Italian textiles, reshaped and rearranged, with modern embroidery by a specialist, Mary Symonds.[35] Some of it, on the other hand, was snapped up by decorators such as Syrie Maugham and Dolly Mann.[36] Bits of copes and altar frontals were made into cushions; giant altar candlesticks became fantastically shaped standard lamps; leather-bound books were hollowed out to become cigarette boxes; and the enormous manuscripts of church music, 2 to 3 feet high, which were created in the fourteenth and fifteenth century for the use of choirs, were taken to bits to make splendid lampshades.

While the Anglo-Catholic revival thus had an indirect effect on English interior decoration, particularly with respect to antique textiles, there is one interesting case of direct influence of church decor on a secular tastemaker. In the early twenties John Fowler was at school at Feltham, not far from the parish of Conrad Noel, the so-called 'Red Vicar' of Thaxted, where Noel had become incumbent in 1910. He was a man of enormous energy and talent, a founding member of the British Socialist Party and no Anglo-Catholic, but he had a clear perception of the importance of splendour in Christian worship. Music at Thaxted was at a very high level, since the composer Gustav Holst was among Noel's friends and frequently played for the church.[37] Noel refurbished his church on individual principles, completely alien to the historicist efforts of Martin Travers. He banished much conventional church furniture—pews, choir stalls, and mediocre stained-glass windows—on grounds of ugliness, and instead made extensive use of textiles, tapestries, bright hangings of deep red and pink silk, and sea-green shimmering net between chapel and chancel. The paint colours were subtly chosen, as were those of the ecclesiastical vestments. The altar was decorated in the mode first advocated by Gertrude Jekyll and subsequently made fashionable by Constance Spry, with flowers of field and hedgerow.

[34] John Harris, *Moving Rooms: the Trade in Architectural Salvage* (New York and London: Yale University Press, 2007), p. 35.

[35] Anthony Symondson, *Stephen Dykes Bower* (London: RIBA, 2011), p. 8.

[36] Metcalf, *Syrie Maugham*, p. 55.

[37] R. Groves, *Conrad Noel and the Thaxted Movement* (Balbriggan: Merlin Press, 1967); R. Woodfield, *Catholicism, Humanist and Democratic* (Greenwich, CT: Seabury, 1954).

Fowler, who encountered the Thaxted church at 15 or so, was impressed by Noel, and formatively influenced by his decorative approach and bold use of colour.[38]

English Catholic tradition in the last century has not been strongly aesthetic. Unlike Anglicans, who have a considerable latitude in the externals of worship and can therefore make choices expressive of a particular stance or approach, for Catholics the layout and furniture of both church and altar are laid down by the Sacred Congregation of Rites. For England, the directives of Cardinal Vaughan standardized church ornament as eighteenth-century interpretations of Renaissance models.[39] Perhaps consequently, many Catholic priests took a completely utilitarian approach to their surroundings, in or out of church; Evelyn Waugh said of the Jesuit house in Mayfair that it was 'superbly ill furnished. Anglicans can never achieve this ruthless absence of "good taste".'[40] One exception to the rule is Canon John Grey, fin-de-siècle poet, aesthete, priest, and creator of St Peter's, Morningside, Edinburgh, which he built together with another veteran of the world of Oscar Wilde, André Raffalovich.[41] Sir Robert Lorimer designed the furnishings, putting in a genuine baroque marble high altar and an assemblage of contemporary art alongside a copy of a Guido Reni. Among the painters who worked on it were Sir Frank Brangwyn and Glyn Philpot. It embodied a distinctly queer sensibility: Janet Grierson said of André Raffalovitch, who paid for it all, 'Beauty only appealed to André if it was in some way curious or exotic, or at least odd.'[42] Typically, the ensemble was not valued by his successors, and has since been dismantled.[43] Apart from a few lay patrons who were adorning private chapels, such as the new Catholic church dedicated to St Joan of Arc at Farnham, Surrey (1930), which was by the architect John Edward Dixon-Spain and decorated with a seventeenth-century giltwood reredos and other architectural salvage, Catholics played very little part in the importation of antique church furniture from the Continent.[44]

There were important exceptions to this general Catholic obtuseness towards ecclesiastical art. On the Continent, Fr Marie-Alain Couturier was a practising artist and Dominican priest, editor of L'Art Sacré, and a man who spent his life trying to find a place for modern art in the contemporary Catholic church—with some success. In the German-speaking world, the Austrian Fr Otto Mauer was, similarly,

[38] Martin Wood, John Fowler, Prince of Decorators (London: Frances Lincoln, 2007), p. 12.

[39] Day, Modern Art in English Churches, p. 15.

[40] H. J. A. Sire, Father Martin D'Arcy: Philosopher of Christian Love (Leominster: Gracewing, 1997), p. 59.

[41] Brocard Sewell, Footnote to the Nineties: a Memoir of John Gray and André Raffalovitch (London: Cecil and Amelia Woolf, 1968).

[42] Sewell, Footnote to the Nineties, p. 59.

[43] [John Gray,] St Peter's, Edinburgh: a Brief Description of the Church and its Contents (Oxford: Basil Blackwell, 1925).

[44] See RIBA Journal (1954–5), p. 62; Charles Tracy, Continental Church Furniture in England: a Traffic in Piety (London: Antique Collectors' Club, 2001), p. 84; Anson, Fashions, p. 342; English Heritage Review of Diocesan Churches (2005).

a priest committed to dialogue with the interwar avant-garde. In England, the crucial figure for modern baroque is Fr Martin Cyril D'Arcy SJ (1888–1976), who has been described as 'perhaps England's foremost Catholic public intellectual from the 1930s until his death'.[45]

The secular version of baroque art championed by the Sitwells, which became an aspect of modernity, had an interesting minor consequence. Though as a result of their efforts, Magnasco and other seicento painters enjoyed a small vogue in the thirties, the baroque art which was not only seriously religious, but effectively so, retained baroque's power to shock and embarrass. One person who benefited from this was Fr D'Arcy. Embarrassment has never been characteristic of the Jesuit tradition, and D'Arcy was educated at Stonyhurst, where there is a genuine continuity with baroque Catholicism. Stonyhurst is a relocation of the community of St Omer's, the English Catholic seminary founded in 1593 which was displaced from Pas-de-Calais by the French revolution in 1794, and the principal buildings it still inhabits are sixteenth- and seventeenth-century. Its alumni include three saints, twelve *beati*, and twenty-two martyrs. Relics and paintings of the English martyrs are preserved there, together with witnesses of all kinds to the Jesuits' engagement with a wider world—literally, from China to Peru. True to his own formation, D'Arcy was not only at ease with excess, and with work which secular patrons did not appreciate, he positively sought out painting and sculpture which provoked religious, rather than merely aesthetic, reactions.

D'Arcy entered the Society of Jesus in 1907, and was ordained priest in 1921. From 1927 to 1945, when he became provincial of the English province of the Society, he was in Oxford, at the English Jesuit college, Campion Hall. He was a man of notorious personal charm, and very skilled at using social networking to achieve his ends.[46] He corresponded with an enormous number of the rich, well-born, and/or talented, and made several high-profile conversions, including those of Evelyn Waugh and Edith Sitwell. One of his goals was to set Campion Hall on more of a social and intellectual footing with other Oxford colleges, and another was to fill it with art. The Hall was first founded in 1896, in a small way, but in the early thirties D'Arcy persuaded Sir Edwin Lutyens, whom he knew socially, to design the buildings it now inhabits and more or less to waive his fee. Work began in 1934. The result is a subtle exercise in imagining what England might have been like had it remained Catholic. In the chapel there are Stations of the Cross by Frank Brangwyn, and altar furniture is by Lutyens himself. He put Arts and Craftsy acorns on the newel posts, but also set a splendid 'Wrenaissance' baldachin over the altar. The

[45] Richard Harp, 'A Conjuror at the Xmas Party', *Times Literary Supplement*, 11 Dec. 2009.
[46] The guests at his eightieth birthday party, held in New York, included the Duke and Duchess of Windsor, Diana Vreeland, Edmund Wilson, and Ved Mehta (the menu is among the collection of his papers at Farm Street).

murals in the Lady Chapel express a similar spirit, setting the birth and marriage of the Virgin in humble English homes and gardens of the 1930s.

D'Arcy's art collecting was part of his overall project. The typescript of a brief talk which he gave late in life, 'Treasure Hunting', is quite clear about the purpose of his collecting, which is twofold. On the one hand, it was political: a demonstration that Jesuits were, within an Oxonian sense of the term, civilized. 'The Jesuits have been so often denigrated—at times quite unfairly—for their lack of taste, more barbari even than Barberini,' he observes. Typically, this is a Roman joke, about the seventeenth-century Pope Urban VIII, Maffeo Barberini, who melted and reused Roman bronze from the roof of the Pantheon which had survived the barbarian invasions. On the other hand, D'Arcy wanted to display and reveal the glory of God through art, a principle which the Society of Jesus embraced from very early in its history. 'Beyond these considerations,' he wrote, 'is that of the vast importance beauty does and should play in the Catholic faith.'

D'Arcy's idea of beauty was a somewhat different thing from Sacheverell Sitwell's. He acquired, with the help of his friend the calligrapher Nicolete Gray, drawings by Henry Moore, Ben Nicholson, Rouault, and Picasso (sadly, some of these were ignorantly disposed of by a less visually aware successor), and medieval and baroque art. He hung a seventeenth-century painting of Christ before the High Priest alongside two stark Rouault drawings, and put a life-sized Spanish high-relief sculpture of St Ignatius and companions in the entrance hall. The Jesuit missions in China, Japan, India, and South America are all reflected in the Campion Hall art collection, which includes an Ethiopian Madonna (a gift from Evelyn Waugh), angels from Mexico and Peru, and Chinese Catholic ceramics.

D'Arcy's budget for creating this collection was extremely limited. He achieved so much with it that he may have been in receipt of supernatural assistance. He certainly received friendly advice from Kenneth Clark,[47] who once wrote to him (with reference to a sixteenth-century painting dubiously attributed to Michelangelo), 'We [i.e. the National Gallery] would much rather it went to you, for its purpose is to inspire devotion.'[48] As this suggests, the sincerity of D'Arcy's purpose evoked an answering sympathy in a surprising variety of people, not all of them Christians, let alone Catholics, such as John Hunt and his wife Gertrude, who ran an antique shop in Bury Street and sold him a travelling altar once owned by Mary, Queen of Scots.[49] Others of the 'objets D'Arcy' were donated, or asked for (a drawing by Eric Gill, for instance, was given to Campion Hall by his widow because Gill had scribbled on the bottom, 'Father D'Arcy wants this'). But, interestingly, much of this collection is of items which failed to sell at one of the great auction

[47] Mount Street, Jesuit archives 40/4/15.
[48] Antonio Forcellino, *The Lost Michelangelos* (Cambridge: Polity Press, 2011).
[49] Mount Street, Jesuit archives 40/3/2.

houses and were offered to him by sympathetic dealers after being 'bought in'. There are all kinds of reasons why a picture does not sell at auction, but the unifying factor in D'Arcy's acquisitions is that the image, whatever its style, is attempting to evoke religious feeling with some success, in some way which might have made it an uncomfortable purchase for someone who did not share its creator's religious viewpoint.

Campion Hall thus exposes various aspects of twentieth-century baroque. It embodies the neo-baroque of Lutyens: historically informed, eclectic, and playing sensitively with the idea of the English Catholic past but also including camp visual jokes such as the chapel lamps in the shape of cardinals' hats. But at the same time, through the art collection, it offers the shock and embarrassment of baroque sincerity; the obstinately surviving, blood-and-tears baroque of recusant Lancashire, where a man as certain of his vocation as D'Arcy was consciously walking in the path of Jesuit martyrs such as Robert Southwell and Edmund Campion.

11

Rococo Arcadia

Chapter 8 considered the social context of art, and the extensive connections between fine art, craft, and design, particularly fashion-design. This chapter pursues a related theme—that of mural painting, and the borderline between fine art and decoration. Murals relate art and architecture: they have been a solution to the decoration of buildings since the ancient Egyptians, and they were frequently undertaken in the twenties and thirties, when they were used in private houses as well as in public spaces of various kinds.[1] Since mural decoration in private houses raises in rather an acute form the issue of the personal relationship between artists and patrons, this chapter also considers the position of another group poised between fine art and decoration: 'society painters'.

Quite a few murals from before the First World War are in buildings where a didactic purpose was particularly relevant, such as schools and libraries, and these tended to be conservative in treatment. An example of work in this tradition made in the late twenties is the series of eight murals for St Stephen's Hall (part of the Houses of Parliament) depicting episodes in 'the Building of Britain', from King Alfred in 877 to the Union of Parliaments in 1707. The subjects were chosen by a committee headed by Sir Henry Newbolt, and the results were much as might be expected.[2] However, the Arts and Crafts Movement was strongly in favour of murals as part of its commitment to breaking down distinctions between fine art and decoration.[3] One of the few public murals from before the First World War to point in a more avant-garde direction was 'The Amusements of London', created by a group of artists assembled by Roger Fry in 1911 for the Borough Polytechnic

[1] For an overview, see Clare A. P. Willsdon, *Mural Painting in Britain 1840–1940: Image and Meaning* (Oxford: Oxford University Press, 2001).

[2] Willsdon, *Mural Painting in Britain*, pp. 130–42; Alan Powers, 'History in Paint: the Twentieth-Century Murals', *Apollo* 135.363 (May 1992), pp. 317–21; J. P. G. Delaney, *Glyn Philpot: His Life and Art* (Aldershot: Ashgate, 1999), p. 104.

[3] Alan Powers, *British Murals and Decorative Paintings, 1920–1960* (London: Sansom & Co., 2013), p. 29.

in South London, one of the first manifestations of the new Bloomsbury art in a public space.[4]

Though the association of murals was strongly with the civic,[5] in 1927 the muralist Mary Adshead extended their role by arguing that they might also have a place in corporate life. She suggested that hotels and restaurants, shipping companies, and 'the smaller and more individual shop owners' ought to commission mural work, and many in fact did. In London, Marcel Boulestin had been a trend-leader in this: his second London restaurant, the eponymous Restaurant Boulestin in Southampton Street, Covent Garden, featured circus-themed murals by Jean-Emile Laboureur and Marie Laurencin.[6] Adshead's own clients included Selfridges in London, and Lewis's in Bristol and Leicester. Such stores, Selfridges in particular, were an entirely new kind of public space, particularly relevant to women: while it was not the aspect of their provision that the stores themselves most wanted to stress, their ladies' lavatories and respectable restaurants gave middle-class women the freedom of the city.[7]

Ocean liners were also a new kind of public space, and the argument for murals in hotels, restaurants, and liners was essentially similar. Decoration was required to be entertaining and distinctive, and there was practicality in its being integral. When most people who crossed the Atlantic did it by sea and took four days or more over the trip, luxury ships were used to showcase national arts and crafts to a captive audience, particularly first-class passengers. The Île de France (1927) was the first to be brought into the service of national prestige, and was a floating art deco palace decorated by Jean Dupas, but other shipowners were quick to follow. Doris Zinkeisen and her sister Anna, painters and theatrical designers, painted murals for the Verandah Grill of the Queen Mary (1936). Edward Wadsworth also worked on this ship, though a scheme devised by Duncan Grant was rejected.

It is worth noting that many of the mural specialists between the wars were women. Mary Adshead, Evelyn Dunbar, Eve Garnett, Winifred Knights, Daphne Pollen, Nan West, and the Zinkeisen sisters were distinguished practitioners in England, while Phoebe Traquair in Scotland and, in America, Hildreth Meière were among the more successful professional woman artists of their generation.[8]

[4] Christopher Reed, Bloomsbury Rooms: Modernism, Subculture and Domesticity (New Haven and London: Yale University Press, 2004), p. 71. It was well received by an anonymous critic in the Spectator (11 Nov. 1911, p. 19).

[5] Peter Wollen, Raiding the Icebox: Reflections on Twentieth Century Culture (London: Verso, 2008), p. 81.

[6] Some of this artwork survives: see A Salute to Marcel Boulestin & Jean Emile Laboureur: an Exhibition of Artists associated with the Restaurant Boulestin (London: Michael Parkin Fine Art, 1981).

[7] Erika Diane Rappaport, Shopping for Pleasure: Women in the Making of London's West End (Princeton: Princeton University Press, 2000).

[8] See Powers, British Murals & Decorative Painting, 1920–1960; Philip Kelleway, Highly Desirable: the Zinkeisen Sisters and their Legacy (Leiston: Leiston Press, 2008); Elizabeth Cumming, Phoebe Anna Traquair

Because mural work is very large scale, it could have been perceived as 'heroic' and appropriated by men, but in fact it appears to be another instance of an area not conceptualized as fine art and consequently low-status. With some spectacular exceptions, such as Raphael's and Michelangelo's work in the Vatican, murals tend to be perceived as ancillary. This is perhaps a testimony to the dealers' and galleries' roles in establishing worth in rather more than a merely financial sense. Some murals were painted on panels and mounted on the walls they were meant for, and can thus be considered large paintings and enter the marketplace as such—the murals Mary Adshead made for Lord Beaverbrook in 1928 were of this kind.[9] But murals painted in situ on the wall rarely have a market value.[10] Though interwar easel paintings of even moderate quality are highly valuable commodities, mural decoration has frequently been destroyed due to surface deterioration or changes in fashion, even when the building it was created for is still in use and still serving its original purpose.

In a domestic context it was the permanence, not the impermanence, of murals which was problematic. Todd and Mortimer comment practically: 'Town life has become so nomadic that one often hesitates to have beautiful decorations done which cannot be taken away in a pantechnicon when one moves. Who knows if next year a nicer house may not be possible or a smaller one inevitable.'[11] Mural decoration was therefore a symptom of confidence, wealth, or occasionally the high bohemian bravado which led Madge Garland, penniless in Antibes in a flat which contained no furniture other than a bed, to ask her friend John Banting to paint images of tables and chairs on the walls (see Figure 23).[12]

Despite the problem of adding permanent decoration to a temporary home, domestic murals provided a possible resolution of the modernist difficulty with decoration per se, which was condemned by theorists all across Europe. Walter Benjamin praises the modernist glass houses proposed by Le Corbusier and the Bauhaus on the grounds that they 'will completely transform people', because 'this hard and flat material' resists the imprint of the individual: 'They have made rooms in which it is difficult to leave a trace.'[13] Le Corbusier declared, 'Modern decorative

(Edinburgh: National Galleries of Scotland, 2005); Catherine Coleman Brawer, *Walls Speak: the Narrative Art of Hildreth Meiere*, ed. Elaine Banks Stainton (New York: St Bonaventure University, 2009).

[9] When he decided against them, they were left with the artist. Six panels surfaced at an auction in 2006. Ann Compton, 'Mary Adshead: an English Holiday, 1928', in Powers, *British Murals & Decorative Painting, 1920–1960*, pp. 177–89.

[10] Hans Feibusch, *Mural Painting* (London: Adam & Charles Black, 1947), pp. 66–77, describes the technical aspects and reasons for preferring direct painting on site.

[11] Quoted in Martin Battersby, *The Decorative Twenties* (New York: Walker, 1969), p. 199.

[12] Lisa Cohen, *All We Know* (New York: Farrar, Straus & Giroux, 2012), p. 273.

[13] *Bloomsbury Rooms*, p. 12; Detlef Martins, 'The Enticing and Threatening Face of Prehistory: Walter Benjamin and the Utopia of Glass', *Assemblage*, 29 (Apr. 1996), pp. 6–23.

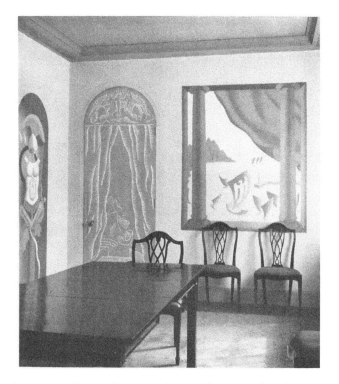

Figure 23 A dining room for Geoffrey Fry with mural decoration by John Armstrong, before 1933. He was a member of 'Unit One', the most avant-garde English group of English artists of the early thirties. Photographer: unknown.

art has no *décor*. Architecture, furnishings, and the accessories of life should be unadorned,'[14] and, similarly, the Italian *Futurist Manifesto of Architecture* (1914) laid down that 'the house of concrete, glass and iron, without painting and without sculpture, [should be] enriched solely by the innate beauty of its lines and proportions'.[15] Piet Mondrian's radical purification of painting into coloured lines and squares was, he was honest enough to argue, merely a step towards an ultimate total abolition of decoration which would render even his own work otiose.[16]

Collecting together contemporary comment of this kind, one seems to see a sort of covert war in progress. Though the human instinct for decoration turned out to be irrepressible, architects and decorators, whatever their mutual disagreements, united in the attempt to keep painting in its place, or even to keep it out entirely. Modern art was thus being rejected for its modern qualities by one section of

[14] *In the Deco Style*, p. 109.
[15] Elizabeth Wilson, *The Sphinx in the City* (London: Virago, 1991), p. 91.
[16] Hans L. C. Jaffé, *De Stijl* (London: Thames & Hudson, 1970), p. 24.

potential buyers, and for its subjectivity and individualism by another. Architects were increasingly interested in taking control of interiors and creating a unified aesthetic effect. Oliver Hill, though his instinct for the baroque meant that modernists never quite saw him as one of themselves, preferred rooms to have painted decoration rather than to see pictures hung in them, which he thought spoiled the line of the walls.[17]

Decorators who were not architects were equally resistant to paintings. In Dorothy Todd and Raymond Mortimer's 1929 The New Interior Decoration, any kind of surface elaboration is treated as highly suspicious. If you must go in for personal touches, 'pictures should be chosen with great care to fall in with the scheme of decoration'.[18] But a picture of the first quality disrupts the harmony of a room by demanding attention: as T. J. Clark puts it, 'A Picasso or a Mondrian always exists as a problem for the space around it.'[19] Elsie de Wolfe 'preferred furniture to pictures, and second-rate decorative pictures to great ones',[20] and John Cornforth suggests that this is a discernible strand in English collecting: 'More ambitious collectors of English furniture... also seem to have been relatively uninterested in pictures. It was as if they were deliberately elevating fine pieces of English furniture to being works of art in their own right and part of the national achievement rather than being just part of the unity of a room. This remained a strong strand in English collecting until after the Second World War.'[21] It was in the context of this tendency on the part of both decorators and collectors that conversation pieces, landscapes, and undemanding family portraits acquired an undistinguished collective identity as 'furnishing pictures', a term which emphasizes their subordinate role.

Martin Battersby noticed that in French exhibitions of decorative arts through the twenties easel paintings are almost absent: 'An exception to this was Marie Laurencin,' whose work, as we have seen, is featured in the 'Cubist House' of 1911.[22] In thirties London perhaps the nearest equivalent to Marie Laurencin as an individual respected simultaneously as artist and decorator was Gluck, née Hannah Gluckstein, the lesbian heiress of a sizeable chunk of the Lyons teashops fortune.[23] Her flower studies, generally pale-toned and always meticulously executed, are sufficiently in a continuum with recognized modernist surrealists such as Edward Wadsworth and Tristram Hillier to appear contemporary, yet they are decorative. Her first flower painting, Chromatic, was a painstaking oil of an all-white arrangement which took her several months to complete in the course of 1932: the flowers had, naturally, to

[17] Alan Powers, Oliver Hill: Architect and Lover of Life (London: Mouton Publications, 1989), p. 19.

[18] The New Interior Decoration (London: Batsford, 1929), p. 36.

[19] T. J. Clark, 'False Moderacy', London Review of Books, 22 Mar. 2012.

[20] Philip Core, The Original Eye: Arbiters of Twentieth Century Taste (London: Quartet Books, 1984), p. 53.

[21] John Cornforth, London Interiors from the Archives of Country Life (London: Aurum Press, 2009), p. 32.

[22] Battersby, Decorative Twenties, p. 69.

[23] Diana Souhami, Gluck: Her Biography, rev. ed. (London: Phoenix Press, 2001).

be renewed again and again, and by the time it was finished she had fallen in love with the arranger, Constance Spry. This relationship brought Gluck into the world of designers, since Spry introduced her to Syrie Maugham, Norman Wilkinson, and Oliver Hill.[24] Maugham saw at once that Gluck's fastidious work would admirably complement her own all-white and off-white interiors. In 1935 an article in *Better Homes and Gardens* about Gluck's own home enthuses about 'how suited they are to a room furnished in the modern manner',[25] and the decorators agreed. When Oliver Hill designed Vernon House, Chelsea Square, for Lord Vernon, a Gluck painting of white lilies was selected as the overmantel.[26] Another painter prepared to cooperate directly with Maugham was Glyn Philpot, who painted decorative panels and pale flower pictures in sage green, grey, and white at her behest.[27]

Another aspect of modern thinking about design—the aesthetic of flatness which swept away plaster mouldings and cornices—also militated against pictures, because it turned frames into a problem, particularly modelled, stuccoed, and gilded frames in traditional style.[28] Gluck invented and patented a new style of frame which rose from the wall in three cushion-moulded tiers. Painted or papered to match the wall on which it hung, it integrated the artist's work with the architecture of the room, which solved 'how to hang pictures in the typically "modern" interior, with its severe lines and plane surfaces'.[29] Oscar Wilde, as often ahead of his time, had come up with a version of this in the 1890s, which was to build out the wall, painted ivory white, round the pictures, so that they appeared recessed rather than advanced.[30] Gluck frames were used by other interwar painters apart from Gluck herself: Cedric Morris was one and, according to the *Leeds Mercury*, this 'queer new kind of art' had become quite fashionable.[31]

Returning now to murals, being treatments of the walls themselves they did not contravene the aesthetic of flatness, and also they subordinated the work of the artist to the overall control of an architect or designer and discouraged clients from subsequently importing pictures. For example, Oliver Hill's drawing-room decor for Albert Levy at Devonshire House (1929) featured screen-like panels of landscapes

[24] Susan Shepherd, *The Surprising Life of Constance Spry* (London: Macmillan, 2010), p. 152.

[25] Bridget Elliott, '"Honoring the Work": Women Artists, Modernism and the Maison d'artiste', *Women Artists and the Decorative Arts, 1880–1835*, ed. Bridget Elliott and Janice Holland (Aldershot: Ashgate, 2002), pp. 176–96, p. 186.

[26] Alan Powers, *Oliver Hill: Architect and Lover of Life* (London: Mouton Publications, 1989), p. 23; Shepherd, *Constance Spry*, p. 152.

[27] Though some work she had asked him for remained on his hands. Robin Gibson, *Glyn Philpot: 1884–1937, Edwardian Aesthete to Thirties Modernist* (London: National Portrait Gallery, 1984), p. 32.

[28] Garland, *The Indecisive Decade*, p. 22.

[29] Shepherd, *Constance Spry*, p. 156.

[30] Alice T. Friedman, *Women and the Making of the Modern House: a Social and Architectural History* (New Haven and London: Yale University Press, 2006), pp. 47–8.

[31] *The Leeds Mercury*, 9 Feb. 1926.

by George Sheringham, a versatile and highly professional designer. Another much-photographed modern drawing room was that of Mulberry House, Westminster, commissioned in 1930 by Henry Mond (later the 2nd Lord Melchett) and his wife Gwen. This was designed by Darcy Braddell, and decorated with angular murals depicting the loves of Jupiter against a background of New York, painted in transparent shades of grey, black, pale blue, and pink on silver foil by Glyn Philpot,[32] with an overmantel bas-relief sculpture by Charles Sargeant Jagger (see Figure 24).

The survival of a handful of eighteenth-century domestic murals in grand London town houses may have helped to encourage the interwar fashion for mural decoration in the home, given the era's enthusiasm for eighteenth-century furniture and some aspects of rococo decoration, particularly in England. Staircases were thought particularly appropriate for this treatment. The staircase at Burlington House was

Figure 24 The drawing room at Mulberry House, designed by Thomas Arthur Darcy Braddell and decorated by Charles Sargeant Jagger and Glyn Philpot. Photographer: A. E. Henson. © *Country Life*.

[32] Cornforth, *London Interiors*, p. 29.

decorated by Sebastiano Ricci, and, on a less grand scale, 8 Clifford Street (1719–21) was probably painted to the design of Sir James Thornhill.[33] This type of decoration went massively out of fashion in the nineteenth century: Dickens, for example, associates a baroque ceiling painting with the desiccated, predatory lawyer, Mr Tulkinghorn, where it forms part of the suffocatingly dreary atmosphere which is built up around him.[34] The dining room of Drakelowe Hall in Derbyshire, which was painted with a continuous landscape by Paul Sandby, was described by *Country Life* in 1902 and 1907, and in both articles was dismissed as 'not in accord with the taste of these days'.[35]

The revival of domestic mural decoration in the twentieth century thus seems to be linked both with modernism and with a revived interest in the eighteenth century. One notable scheme was commissioned in 1912 by the playwright Edward Knoblock, who, together with Arnold Bennett, is credited with the revival of Regency style in England.[36] In his autobiography, *Round the Room*, Knoblock, who had been made wealthy by the phenomenal success of his 'oriental' play *Kismet*, records his passion for Empire and Directoire furniture and explains how he asked William Nicholson to ornament his Paris dining room.[37] The pictures which ensued were painted on glass and strongly resembled late baroque capriccios—with crumbling architecture and picturesquely costumed figures in landscape. They also owe something to the baroque imaginings of Nicholson's business partner and brother-in-law, James Pryde. Another indication of a turning tide is that *Country Life*, having disparaged Paul Sandby's landscape murals in 1907, campaigned against the destruction of 75 Dean Street in 1914, *because* of its eighteenth-century painted staircase.[38]

The early twentieth century produced a muralist recognizably working in the somewhat overwhelming tradition of the seventeenth-century Jesuit masters of fictive architecture and imaginary space: the Catalan Josep Maria Sert (1874–1975). The architect Philip Tilden wrote, 'What I admired in all Sert's work was its extreme modernity of expression wedded to baroque tradition.'[39] Sert, a highly international figure based in Paris, perhaps came to English notice via the Ballets Russes, since he designed scenery for *La Légende de Joseph*, which premiered in Paris in 1914 and was staged in London in the same year. When in England, he painted a bathroom niche for Lady Juliet Duff, a socialite and one of Diaghilev's most

[33] Other survivals were at 11 Bedford Row, 75 Dean Street, and 39 Grosvenor Square. Cornforth, *London Interiors*, pp. 77–8.

[34] *Bleak House*, ch. 10. [35] Cornforth, *The Search for a Style*, p. 99.

[36] Viva King, *The Weeping and the Laughter* (London: Macdonald & Jane's, 1976), p. 199.

[37] Stephen Calloway, '"A Special Decoration": William Nicholson and Edward Knoblock', *Journal of the Decorative Arts Society 1850–the Present*, 10 (1986), pp. 18–21.

[38] Cornforth, *Search for a Style*, p. 83.

[39] *True Remembrance: the Memories of an Architect* (London: Country Life, 1954), p. 42.

faithful supporters, which probably increased his visibility,[40] and he went on to create two murals for one of Tilden's chief clients, Philip Sassoon. One was in the drawing room of Sassoon's party house, Port Lympne in Kent. Executed in 1914–15, it was of sweeping sepia and brown figures against gold, representing France defended by the Allies in the form of children and being attacked by German eagles, with elephants over the fireplace.[41] The effect must have been stupefyingly tasteless, and Sassoon tired of it,[42] but he commissioned a ballroom mural for his Park Lane house in 1920—'Caravans of the East', in blue and silver. This consisted of fantastic scenes of Greek temples, camels, elephants, and exotic figures, while mirrors where the ceiling met the wall created an illusion of unlimited space. James Knox wrote of it: 'Sert's coup de théâtre was a masterpiece of modern Baroque.'[43] His vertiginous inventions were more suited to a room intended for the expression of magnificence on special occasions than to a smallish room at Port Lympne.

Roger Fry's trajectory from Arts and Crafts to Bloomsbury was the catalyst of another strand in pre-First-World-War domestic mural painting. He painted a mural for the drawing room of C. R Ashbee's house, 37 Cheyne Walk, around 1894.[44] From photographs, it has a certain eighteenth-century flavour, since it depicts a formal garden with central fountain, but the house was widely publicized for innovative decorations in wood, metal, and leather, so in context the work looks forward rather than back. The Studio observed approvingly that '[the mural] grows out of the walls as part of them and does not detach itself as a painting is apt to do'.[45] Fry executed other murals for friends, and the house he designed for himself, Durbins, was decorated with murals by himself, Duncan Grant, and Vanessa Bell.[46] Grant also produced murals for John Maynard Keynes's rooms at King's College, Cambridge, in 1910,[47] and decorated many walls in 38 Brunswick Square, which he and Bell shared with Maynard Keynes, one in collaboration with Frederick Etchells.[48] Apart from the famous wall decorations of their own house, Charleston,[49] Grant and Bell painted murals in other people's houses, notably Penns-in-the-Rocks, where the poet Lady Dorothy Wellesley lived with her partner Hilda Matheson.[50]

[40] Powers, British Murals, p. 96. [41] Stansky, Sassoon, pp. 45–6.

[42] Stansky, Sassoon, p. 152 (the comment is from Chips Channon's diary).

[43] Stansky, Sassoon, p. 147. This has survived, and is in the Museum of Modern Art in Barcelona.

[44] Reed, Bloomsbury Rooms, p. 37. [45] Reed, Bloomsbury Rooms, p. 37.

[46] Reed, Bloomsbury Rooms, pp. 48–9. [47] Reed, Bloomsbury Rooms, pp. 51–3.

[48] Reed, Bloomsbury Rooms, pp. 95–9.

[49] Quentin Bell and Virginia Nicholson, Charleston: a Bloomsbury House and Gardens (London: Frances Lincoln, 2004).

[50] The Studio of August 1930 carried an article illustrating the dining room in which Madge Garland wrote: 'A transformation has taken place. This room in the house of Lady Gerald Wellesley, Penns-in-the-Rocks, Withyham, Sussex was once devoid of any character, with no particular ornament or happy proportion to recommend it. From this uncompromising material Duncan Grant and Vanessa Bell have evolved a room of outstanding beauty, rich in colour, harmonious in design.... The colouring is extraordinarily limpid and

Roger Fry, Vanessa Bell, and Duncan Grant all took the view that a mural should have the coarse, bold qualities of a stage set, which may be a useful guideline for public murals but is a less relevant principle for those carried out in relatively small spaces. Domestic murals may be seen from a distance of less than a foot. Outside Bloomsbury, there were practitioners of domestic murals who thought they presented a specific technical challenge. They must charm and interest, to justify their existence; they must be well painted enough to read well at very close quarters; and at the same time they must be legible from the other side of the room. They have to stand up to changing light at different times of year, or day. Afternoon light works best—time for tea, England's Arcadian hour. Laurence Whistler comments: 'In the murals, though the scenery must change along the route, the light must be constant to give unity. It should be always afternoon, so as to achieve a general "Chinese wallpaper effect", which, however, would be dull on so large a scale unless modified by realism.'[51]

It was Laurence Whistler's brother Rex who was the great master of this type of interwar decorative painting. His first mural was a collaboration with Mary Adshead in 1924, when he was 19, at Highways Club, Shadwell, London (now removed).[52] The commission was from Henry Tonks, their tutor at the Slade, who was personally committed to the revival of mural painting, and who had inherited a small fund of perhaps £200 to promote the art.[53] In 1926 Sir Joseph Duveen offered a new refreshment room to the Tate Gallery, and again Whistler's tutor Henry Tonks recommended him. Whistler continued to be in demand as a muralist for private clients until his untimely death on active service in 1944. His work starts from a very different place from Bell's and Grant's crudely detailed decorations. His technique seems to have been precociously formed, as if, like a partridge, he was hatched out of the egg all ready to run, and he was virtually unteachable. The fictive landscape of his Tate mural shows that most of his ideas about mural painting were already in place by the time he was 20, except the cityscapes which often feature in later work. These may have emerged from his visit to Italy in 1928, where he was deeply impressed by the villa at Caniparola, every room of which had been elaborately painted with fictive architecture in the eighteenth century, and which still had its original furniture and hangings to carry out the intended effect.[54]

In 1925 Whistler visited Rome, Pisa, and Florence, and was overwhelmed by baroque Rome—an unusual response for a English aesthete of his generation. In

clear. Although almost every colour is called into play, the tones are so subtle, the blending so ingenious that the general effect is one of iridescence, rather then of any particular colour scheme.'

[51] Laurence Whistler, *The Laughter and the Urn: the Life of Rex Whistler* (London: Weidenfeld & Nicolson, 1985), p. 94.

[52] Hugh and Mirabel Cecil, *In Search of Rex Whistler: His Life and His Work* (London: Frances Lincoln, 2012), pp. 30–3. They were removed for safekeeping during World War Two, and are mostly now too fragile to be viewed, but one is on display in University College, London.

[53] Whistler, *The Laughter and the Urn*, p. 69. [54] Whistler, *The Laughter and the Urn*, p. 122.

Rome he studied Andrea Pozzo's two great Jesuit churches, the Gesù and (his masterpiece) San Ignazio, and back in England he perhaps also looked at the greatest English mural created with reference to Pozzo, James Thornhill's work in the Royal Naval Hospital, Greenwich (1708–27).

The mural which Whistler painted for Sir Philip Sassoon in the billiard room at Port Lympne in 1931 illustrates the unique qualities of his mature work. The room is not enormous, and the decorative scheme, unlike Sert's overwhelming symbolic elephants who had been in the room immediately across from it, has a certain restraint. No human figure is more than a few inches high, and perhaps the subtlest aspect of the whole composition is that it moves through time (see Figure 25). To the immediate left of the door, a parade of eighteenth-century houses is lived in by eighteenth-century people: an old gentleman on a balcony is interrupted by the rat-a-tat-tat of a black footman knocking on the door below. Moving along, a school-boy playing with a hoop is in the clothes of Charles Dickens's childhood, and an elderly Victorian couple is toddling down an avenue. By the midpoint of the room, a lady in a landau is fashionably dressed (she is Sassoon's sister Sybil), and boys watching a Punch and Judy are in contemporary shorts and socks. At the far end, a contemporary restaurant loved by the richer artists and bohemians, the Eiffel Tower, stands, with a modern crowd strolling outside.

While the recession is handled with extraordinary skill, and the detail survives very close inspection, the fictive reality overall is lent its particular nostalgic quality by two factors: the scale, and the overall tonality, which is a sort of dusty dark turquoise. The effect is not so much trompe l'oeil as ghostly: like looking through a window of old, greenish glass at a scene, remote and far away, which is enacting itself independently of you as the observer, an effect enhanced by the subtle setting back in time of much of what is depicted.

Another aspect of mural painting for private clients which is evidenced by Rex Whistler's career is social. The social contract of mural painting aligns it with portraiture: there has to be a significant degree of social interaction with the patron, especially when the work is painted in situ.[55] Whistler was unusually successful: leaving murals by members of the Bloomsbury Group to one side, because they were produced for people recognizably of their own sort, not many interwar murals were added to domestic settings, as opposed to being created as part of the initial construction. Glyn Philpot, also a portrait painter, did some work as a muralist,[56] as did Eric Ravilious.[57] Both men were, like Whistler, notoriously charming.

[55] Alan Powers, 'The Fresco Revival in the Early Twentieth Century', *Journal of the Decorative Arts Society 1850–the Present*, 12 (1988), pp. 38–46.

[56] J. G. P. Delaney, *Glyn Philpot: His Life and Art* (Aldershot: Ashgate, 1999), pp. 113–14.

[57] John Armstrong decorated rooms in modern flat conversions by Wells Coates in the 1920s, and a dining room for Sir Geoffrey Fry (Figure 23) in a flat that also included panels of tennis players by Eric Ravilious.

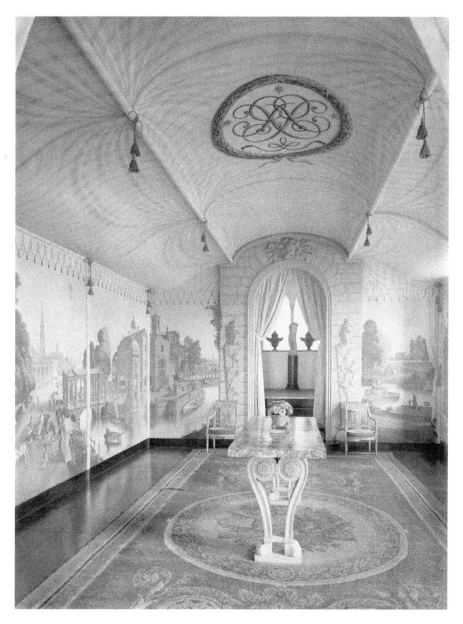

Figure 25 The view into the Painted Room with murals by Rex Whistler at Port Lympne. Photographer: Arthur Gill. © *Country Life.*

Some muralists were hired as craftsmen. John Banting was straightforwardly an employee of Fortnum & Mason, who got by socially on good looks combined with louche cockney sex appeal, which also netted him several upper-class boyfriends. However, others—notably Whistler, Philpot, and Ravilious—were in the trickier position of trying to maintain a position of social equality with their clients. Ravilious was aided by extraordinary good looks, which seem to have enabled him to walk through the glass walls of the English class system as if they were not there, but Whistler put great effort into passing for a gentleman. Having made friends with Stephen Tennant at art school, he attached himself to the aristocratic circles of the Herberts under the guidance of Edith Olivier, was taken round Italy by Lord Berners, and fell in love with a series of society beauties—notably Pempie, daughter of the Prince of Wales's mistress Freda Dudley Ward, and Caroline Paget, daughter of Lord Anglesey. He must have been mortified by George Bernard Shaw's speech at the opening of the Tate mural, in which Shaw, perhaps obtusely but more probably maliciously, made a point of the social position of the mural painter, contrasting the two Whistlers, Rex and James:

> Since Hogarth, artists had mistakenly been gentlemen, but Rex Whistler had worked for so much a week. He was entirely unlike the other Whistler — above everything a gentleman painter. Rex should be regarded as a house painter, and be called in like the plumber. He would name a moderate sum, behave like a workman in the house, touch his cap to you, and never be confused with the dukes and duchesses who came to luncheon, though he and his bag of tools might sometimes be in the way.[58]

Shaw thus put his finger on what Rex Whistler most feared about his peculiar talent: that he would be lumped together with the likes of John Banting. In the years that followed, he made very sure that he was always presentable, always amusing, and always among those invited to luncheon. He was so successful at this that his charm seems to have left an indelible impression on everyone who knew him. He appears to be the principal model for Waugh's Charles Ryder in *Brideshead Revisited*, in which the relationship of Ryder with the Marchmains seems suggested by an amalgamation of Whistler's relationships with the Paget family and with Stephen Tennant.[59] He is also probably the model for the surnameless 'Arthur' who is painting a rococo capriccio on Julia Stitch's bedroom ceiling in the first chapter of *Scoop*: there is an obvious associational chain linking Arthur and Rex, via 'king'.

[58] Whistler, *The Laughter and the Urn*, p. 111.

[59] This is disputed; but though Waugh and Whistler were not personally close, Waugh was very much aware of him, and his comments on Whistler's last illustrations (Whistler was killed in the year in which *Brideshead* is set) suggest that he was, for the novelist, something of a touchstone. 'Dream World', Time and Tide, 6 Dec 1952, pp. 1456–7.

One of the interesting things about Rex Whistler is that his talents were essentially eighteenth-century. His great virtues as a craftsman were speed, a sure grasp of perspective, economy, and a good memory, combined with a solid enough knowledge of architecture to produce a capriccio. His interest in painting was a craftsman's, the paint surface suave to the point of invisibility, and until the last year of his life, when the experience of military life seems to have prompted a different kind of seriousness, his human figures were pretty marionettes—girls with the neatly rounded, high-bosomed figures of Boucher's nymphs, or even those of Jean Dupas—and epicene boys. His practice as a painter was at the opposite pole from the tormented interrogation of problems created by the medium itself which is typical of modernism. It is possible to deal with Whistler simply by saying that he is not a painter, merely a decorator, or that he merely carried out the wishes of clients, but that hardly seems an adequate response to his great ability, or to the impression he made on his contemporaries.

What Whistler's work tells us is that, alongside the painters who might now be defined as artists by art historians, there was a different strand of productive, sometimes extremely skilled, individuals who were producing a quite different kind of picture in a different social context. Someone with pre-modern skills in representational painting who accepted direct commissions could earn enough to live like a gentleman. While modernist painters such as Paul Nash and Ben Nicholson scraped by, selling little of their 'real' work and designing tea sets and printed fabrics to pay the rent, Glyn Philpot (1884–1937)—who, like Whistler, was charming, gentlemanly in his manner, and beautifully dressed—could charge £500 for a portrait, even as a young man, and by 1930 was asking £1,500.[60] Other interwar artists of the same kind active in London were the Scottish Zinkeisen sisters, Doris and Anna, who were muralists, portraitists, and designers for the theatre, but also beauties and socialites. Whistler agonized over settling a fee, and charged less than he could have for murals because he found it so embarrassing, but for the Port Lympne room he was paid £800. In 1933–4 his taxable income, with allowances for studio, car, and so forth already deducted, was £1,130. This was not wealth sufficient to keep Lord Anglesey's daughter in the style to which she was accustomed, but in most other contexts it was a very respectable sum.[61]

Another, Paris-based individual whose work and career illustrate the difference between society painters and artists is one of the most financially successful of interwar women painters—Tamara de Lempicka (1898–1980). Her paintings remain extremely recognizable, though as Philip Core crisply observes, her work is 'glacially pseudo-modernist art adopted by conservative people who felt the need to fuse the avant-garde and tradition'.[62] By the 1950s she was critically perceived as irrelevant to the history of painting, but between the wars she was

[60] Delaney, *Glyn Philpot*, pp. 46–7, 112. [61] Whistler, *The Laughter and the Urn*, pp. 175–6.

[62] Philip Core, *The Original Eye: Arbiters of Twentieth Century Taste* (London: Quartet Books, 1984), p. 89.

not only famous, but successful. Furthermore, the sort of people who used to like her work still do, and her interwar pieces now fetch six-figure sums at auction. Madonna is among those who collect her. De Lempicka began painting because she needed the money, having ended up penniless in Paris after the Russian Revolution. Her husband was stunned into inertia by the abrupt overturning of their life, but she was energized. The style she arrived at, after a brief but intense period of training at the Académie de la Grande Chaumière with the post-symbolist French Nabi painter, Maurice Denis, was a commercial version of cubism, strongly influenced by the work of André Lhote. She was successful in establishing her work as an instantly recognizable brand: highly finished paintings of mannerist female nudes with the smooth, simplified surfaces of the machines painted by Fernand Léger. As well as referencing Lhote, they have a strong resemblance to the work of the commercial artist Jean Dupas, notably his *Les Perruches*, a wall panel of mannequin-like naked girls and parakeets which he showed at the Exposition Internationale des Arts Décoratifs et Industriels Modernes in Paris, where de Lempicka will undoubtedly have seen it. She exhibited at the Salon d'Automne and the Salon des Indépendants, and, since she was sexually interested in women, she was welcomed into the circle of Natalie Barney, where she found sufficient patrons and clients to get her career off the ground.[63] Her slick nudes look packaged for consumption, but primarily for consumption by other women, for which, in twenties Paris, there was a considerable market.

Essentially, De Lempicka succeeded in positioning herself as a 'society painter' and, once she was selling her works for an average of 50,000 francs, as a salonnière in her own right.[64] Like Philpot, Whistler, and the Zinkeisens, she was personally attractive and beautifully dressed, and she made an encounter with her into an experience. Her method was not quite that of the English artists discussed in this chapter since, like Diaghilev, she made capital out of her sexual unorthodoxy. Her thrillingly decadent soirées featured cocaine, hashish, and nude waitresses, and her portraits were both 'modernes' and flattering. Having divorced the first husband, she made a sizeable fortune by her own efforts before cannily marrying one of her patrons in 1934.

De Lempicka and Whistler were wholly different in personal style: one tempestuously Slavic, sexually adventurous, and international; the other wholly English, charming, and diffident. Their work is also very different: Da Lempicka's influenced by mannerism, and Whistler's by rococo. But both built up their careers out of personal and social interaction with patrons, just as much as Cecil Beaton or Noël Coward did, and both exemplify the fact that between the wars the line between fine art and decoration is not easy to draw.

[63] Judith Mackrell, *Flappers* (London: Macmillan, 2013), pp. 103–5.
[64] Mackrell, *Flappers*, pp. 351–2.

IV

Uncanonical
Arts

Silver Paper

Creating a black-and-white photograph used to require paper coated with a light-sensitive emulsion made of an alloy of silver with bromide or chloride suspended in gelatin. When a crystal of silver and bromide (or one of its chemical cousins) is exposed to light, a speck on the surface turns into a small speck of metallic silver. If this speck contains four or more atoms, it undergoes development, turning the entire crystal into metallic silver: this is what 'developing' a photograph used to mean. The areas of the emulsion which receive the most light undergo the greatest development and turn silvery grey; those which receive none remain a deep, velvety black.

One of the purely technical aspects of modernity is that the development of halftone printing in the late nineteenth century allowed the rich chiaroscuro of a silver bromide print to be put into mass circulation easily and cheaply. Geoffrey Baker, for example, observed that 'the spread of modern architecture has been hastened by the perfection...of the half-tone system of reproducing black and white photographs'. So was the spread of modern visual culture in almost all respects. The camera not only reflected reality, it shaped it. When Raymond McGrath remodelled Finella for Mansfield Forbes, the series of photographs taken for the *Architectural Review* by Mark Oliver Dell and H. L. Wainwright broke new ground in the photographic depiction of buildings in England, and did much to establish McGrath's reputation. They were also reproduced in *Vogue*.

> Their use of techniques derived from Modernist photography such as unusual and more expressive viewpoints, startling contrasts of light and shadow and a strong emphasis on dynamic lines and geometrical abstraction. McGrath, who claimed to have discovered the photographic duo, wrote admiringly of their work. 'All day they pursued shadows over the floors and furniture, all night they made moons rise and created other elusive phenomena with their arc lamps,' he enthused. 'They competed in style with my lighting effects. It was better than Pyramus and Thisbe.'[1]

[1] Robert Elwall, 'Dell and Wainwright and the RIBA Library Photographs Collection', http://www.culture24.org.uk, 14 July 2009.

The materials best loved by modernist architecture are concrete, steel, and glass. Fashions in interior design cycled through black, silver, and white; many fashionable surfaces were reflective or transparent. All these respond particularly well to black-and-white photography.

Photographic technology exerted a subtle tyranny over style, because an aesthetic of tonal contrast necessarily governed not only the clothes which looked best in *Vogue*, but also which buildings looked good in the *Architectural Review*, or which interiors looked good in *Country Life*.[2] And feature films were also shot in black and white, so as Anne Hollander observed, 'Colour drained out of elegance.... Draped lamé and sequined satin offered rivulets of light to the eye as they flowed and slithered over the shifting flanks and thighs of Garbo, Dietrich, Harlow and Lombard. These visions were built on the newly powerful sensuality of colourless texture in motion... sequins, marabou, white net and black lace developed a fresh intensity of sexual meaning in the world of colourless fantasy.'[3] Anyone concerned with publicity had to think how a subject would look in black and white. The *Titanic's* sister ship *Olympic's* hull 'was painted a light grey purely so that it would look fantastic in the news reel footage', according to John Graves of the National Maritime Museum in London.[4]

Photography as an experimental art form was of particular interest to the surrealists. Man Ray was probably the most important photographer associated with the Paris movement, but Lee Miller is not a negligible figure, though her great beauty, together with the unabashed sexism of the surrealist movement, defined her until very recently as a muse, not an originator.[5] It is her lips that float in the sky in Man Ray's painting *Observatory Time*; she was the subject of many of his photographs, the statue that comes to life in Cocteau's *Sang d'un poète*, and a *Vogue* model. But she was also a photographer, and a highly competent one. In 1934, after she moved back to New York, *Vanity Fair* named her as one of the seven most distinguished living photographers, together with Hoyningen-Huene and Beaton.[6] Familiar with the basics of photography before she arrived in Paris, she learned a great deal from Man Ray—her lover—and more from *Vogue* photographers Hoyningen-Huene and Horst, with whom she worked as both a photographer and a model.[7] As a photographer she was highly professional and interested in the purely technical and

[2] Gerry Beegan, 'The Studio, Photomechanical Reproduction and the Changing Status of Design', *Design Issues* 23.4 (2007), pp. 46–61.

[3] Anne Hollander, *Seeing through Clothes* (London: Penguin, 1988), pp. 342–3.

[4] Rosie Waites, 'Five Titanic Myths Spread by Films', *BBC News Magazine*, 5 Apr. 2012.

[5] Whitney Chadwick, *Women Artists and the Surrealist Movement* (London: Thames & Hudson, 1991), p. 11.

[6] Burke, *Lee Miller*, p. 139.

[7] Burke, *Lee Miller*, p. 166; Becky E. Conekin, 'Lee Miller and the Limits of Postwar British Modernity', *Fashion and Modernity*, ed. Christopher Breward and Caroline Evans (Oxford and New York: Berg, 2005), pp. 39–61, p. 42.

chemical aspects of the craft. Julien Levy, who was briefly her lover and was passionate about photography as an art, held an exhibition of her photographs in his New York gallery in 1933.[8]

Winifred Casson has fared even worse in the eyes of posterity than Lee Miller, since she has been almost entirely forgotten, but she was a surrealist photographer in London. Her biography is obscure, but she seems to have had money, since John Somerset Murray, who taught her technical tricks such as Man Ray's solarization process, notes that she financed the magazine *Film Art*.[9] This suggests that she was not dependent on pleasing clients. She was a serious surrealist who admired Cocteau and de Chirico, and she was creating surrealist images long before the 1937 International Surrealist Exhibition made it trendy.

Photography as an art form was a minority interest. The main business of photographers was portraiture, and between the wars the most influential portrait photographer was Cecil Beaton, an all but ubiquitous figure in the interwar decorative arts—as photographer, designer, decorator, commentator, and general *arbiter elegantiarum*. His first exhibition of photographs, at the Cooling Galleries in Bond Street, was in November 1927, when he was 23. Osbert Sitwell wrote the introduction to the catalogue. From that time on, for all the agonizing, Pooterish self-doubt revealed by his diary, he became the definitive image-maker of the smart set.

A photograph by Beaton could be a major step up for an arriviste. Pearl Argyle, for example, was widely considered the most ravishing ballerina of her generation, but not the most talented. She was determined to succeed, and in 1934 had the additional advantage that Sacheverell Sitwell was in love with her. Though she was only 24, her career seemed frustratingly stalled. She turned, naturally, to Sachie: 'How I long for a season in the West End. . . . Do you know anyone, the Courtaulds or someone, who would like to back a good cause?' Sir Samuel Courtauld was a well-known balletomane and generous sponsor. Things looked up for her as the year went on, and she was chosen as the star of Andrée Howard's *Mermaid*, for the Ballet Rambert. But she then began pressing Sachie to bring Beaton to photograph her in the role, an indication of the importance he had acquired.[10]

There were many photographers in London, but if a sitter without Pearl Argyle's personal advantages wanted to look thin, beautiful, porcelain-skinned, and lit as if by some inner radiance, there was no one quite like Beaton. As he himself acknowledged, he had learned a great deal from a pre-war photographer, Adolph de Meyer (1868–1946):

By using a soft focus lens of particular subtlety he brought out the delicacy of attractive detail and ignored the blemishes that were unacceptable . . . from the curving spines of

[8] Burke, *Lee Miller*, p. 132. [9] Williams, *Women Photographers*, pp. 116–17.
[10] Sarah Bradford, *Splendours and Miseries* (London: Sinclair-Stevenson, 1993), p. 248.

his sitters with an inevitable hand on a hip and their proud heads...to the sparkle on the silver lace, the tissues, the pearls, the shells, the sunlight catching the pristine petal of a madonna lily...the fireworks bursting among the arabesques of a crystal chandelier – all of these details have been frozen out of time.[11]

De Meyer, who was homosexual, was the only photographer who ever captured anything of the legendary glamour of Vaslav Nijinsky—his ambiguous sexual appeal and his extraordinary presence. Beaton evidently looked and learned; as he indicates, silver, translucent tissue, nacreous surfaces of all kinds, white flowers, and the prismatic effects generated by cut glass were de Meyer tricks of the trade. Beaton realized that they would stand a lot of repetition, provided that his clients were also successfully persuaded that they looked modern. Another important influence on Beaton was Helen MacGregor, who, with her partner Maurice Beck, took most of the pictures for British *Vogue* from 1922 until August 1927: 'She'd inspired me with all sorts of notions for getting amusing textures by varnishing cheap brocades and canvas or taking photos of people reflected in piano tops.'[12]

Schooled by de Meyer and MacGregor, Beaton often photographed his clients against a background of silver foil, which, in a black-and-white print, became shimmering, nacreous, and mysterious in the de Meyer mode. He also used cellophane—another modern material—as a backdrop: attention was drawn away from the continuities with Edwardian glamour, which he was shrewdly exploiting, towards a 'modern' replacement of real silver, lace, and pearls with excitingly inappropriate materials, which just so happened to produce much the same effect within the magic space of a black-and-white print. He sometimes photographed his sitters lying on the floor, or upside down, releasing inhibitions by unconventional posture, just as, decades later, Philippe Halsman talked the likes of Richard Nixon, Marilyn Monroe, and the Duke and Duchess of Windsor into jumping up and down. He also experimented with surreal effects, such as taking a portrait with the sitter's head under a Victorian glass dome.

Beaton's baroque arts of illusion did not end with the staging of the photograph. His sitters were subsequently perfected by detailed studio work which removed double chins, fined down waists (sometimes drastically), and waved a fairy wand over flaws and blemishes; in the days before Photoshop and its competitors, this could be achieved by careful work with pens and pencils. He was a maker of swagger portraits: no less than Anthony van Dyck, he had the gift of projecting glamour. And, also like van Dyck, he put it at the service of the monarchy, with

[11] Cecil Beaton, *The Glass of Fashion* (London: Weidenfeld & Nicolson, 1954), pp. 79, 82. The de Meyers were dubbed 'Pederaste and Medisante' by Violet Trefusis—who counted Olga de Meyer among her lovers—because, as Trefusis observed, 'He looked so queer and she had such a vicious tongue.'

[12] Sarah Bradford et al., *The Sitwells and the Arts of the 1920s and 1930s* (London: National Portrait Gallery, 1994), p. 88.

comparable effectiveness. Under the Fleming's transforming brush, Charles I's toothy, sallow, perpetually pregnant little queen was transformed into a chic, radiant vision with gardenia skin and brilliant, melting black eyes. The sturdy, dowdy Elizabeth Bowes-Lyon, suddenly catapulted into the public eye by the defection of Edward VIII which transformed her shy, stammering husband into the king of England, was disastrously unsuited to contemporary chic. Her sister-in-law Wallis Simpson said brutally that the best thing the new queen could do for British fashion was to 'stay home'. It was Beaton's idea to withdraw her from fashion into fancy dress: the queen was put into crinolines, inspired by Winterhalter's paintings of Queen Victoria and designed by Beaton's friend Norman Hartnell, and caused to project a timeless glamour with a nineteenth-century flavour, set off by bare shoulders, tiaras, and big necklaces, an ensemble which, thanks to the tireless efforts of Walt Disney, remains the defining image of 'a beautiful princess' (see Figure 26).

Equally, the Sitwell myth owes much to Cecil Beaton, and, conversely, it was the notoriety of the Sitwells that did a great deal to propel Beaton into the public eye. When they first met, Beaton, who was only 22, was able to see a beauty in Edith, then nearly 40, that more apparently perceptive observers, such as Virginia Woolf,

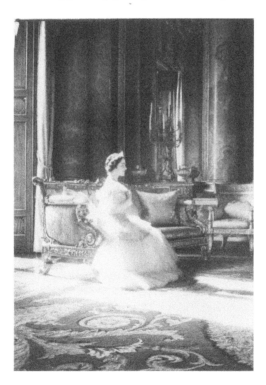

Figure 26 Queen Elizabeth, 1939. Photographer: Cecil Beaton. © Victoria and Albert Museum, London.

237

had missed. He saw 'a young faun-like creature' and, what is more, he made everyone else see it as well.[13] 'We all have the remote air of a legend,' wrote Edith, which was completely untrue. Neither Osbert's nor Sachie's looks were out of the ordinary, but Edith was odd enough for three, and there was a sufficient family resemblance that when they were photographed together, as they often were—mostly by Beaton—they acquired something of her weird, Plantagenet glamour by association. Edith was fully alive to his importance to her:

> Dear Cecil,
> Business first, and friendliness afterwards. Please will you send one of the photographs of myself lying in my tomb (the one with the best hands, as I'm always fussy on that point) to
> Captain Siegfried Sassoon, MC
> 23 Campden Hill Square
> W3
> and another ditto to
> Miss Gertrude Stein
> 27 Rue de Fleurus
> Paris
> and send the lovely account to me.[14]

In 1930, after a photo session at Renishaw, she wrote, 'I simply can't tell you what excitement there is at Renishaw about the photographs.... [We] are longing to have them published in papers.' Which they were.[15]

Olivia Wyndham illustrates the importance of personal connections for successful practice. While Beaton had to struggle to become an 'insider', exploiting and, if necessary, creating every connection with the fashionable world that he could find, Wyndham was part of the world she photographed. Her family had been at the intellectual and arty end of the English élite for generations, patrons of art, and to some extent creative people themselves. Her brother Richard was a painter.[16] She was technically incompetent, as Cecil Beaton acidly observed: 'Never mistress of her camera, a huge concertina affair...the technical aspects were always a bafflement to her: mechanism had a sure way of defying her.'[17] However, she had an eye for an interesting composition, and even Beaton admitted that 'she produced some

[13] Victoria Glendinning, *A Unicorn among Lions* (London: Weidenfeld & Nicolson, 1981), pp. 103, 110.

[14] Letter written in Oct. 1927, *The Letters of Edith Sitwell*, ed. Richard Greene (London: Virago, 1997), pp. 80–1.

[15] Bradford, *The Sitwells and the Arts*, p. 132.

[16] Caroline Dakers and Philip Webb, *Clouds: the Biography of a Country House* (New Haven and London: Yale University Press, 1994) outlines the history of the Wyndhams.

[17] Cecil Beaton and Gail Buckland, *The Magic Image* (London: Weidenfeld & Nicolson, 1975).

beautiful "Mrs Camerons"' (that is, good pictures produced by the method of 'point the camera at the model and hope for the best'), including some of Beaton himself, now in the National Portrait Gallery.

Wyndham and Curtis Moffat, with whom she worked initially, used their connections ruthlessly. Her lover and assistant Barbara Ker-Seymer commented: 'She was invited to a lot of parties where the press were barred but she was allowed to take photographs as she was a friend of the various hosts.'[18] Reporting one of the decade's more notorious bashes, Brian Howard's Great Urban Dionysia, Billy Chappell (a ballet dancer, and a great friend of Ker-Seymer's) wrote, 'I had been at Olivias and dressed them both I stitched Olivia into her clothes and she looked ever so dignified by the time we had finished and then Barbara said why not take Billy as your electrician & Olivia said that's a lovely idea—so I went you would have died we were ever so professional Olivia called me Chappell and I said Miss Wyndham very respectfully and held all the lights and told Tilly Losch and David Tennant what to do with their hands.'[19] The central fact revealed by this narrative is the ambiguous status of the photographer: Wyndham was an invited guest and in costume as Minerva, but she was also exercising her profession. Similarly, Count Étienne de Beaumont, one of Man Ray's first patrons in Paris, invited the American to attend a party and photograph his guests, but told him to wear a dinner jacket so that he would not look 'professional'.[20]

Apart from being hopelessly untechnical and accident-prone, Wyndham, being a Bright Young Person herself, was frequently too drunk to focus the 'concertina'. Ker-Seymer became her assistant: 'My job was to stay up all night after the parties developing and printing the films in order to take them round to the Tatler, Sketch and Bystander, etc.' But as Wyndham's addictions slid out of control, Ker-Seymer started covering for her to the extent of taking the actual pictures, and discovered a genuine talent for photography.

In 1929 Wyndham went to America, and Ker-Seymer opened a studio of her own, a 30-shillings-a-week room above Asprey the jewellers in Bond Street. The decor was utterly of its time: it had black walls, a black ceiling, three full-length curtains— one black, one grey, one white; there were paintings by John Banting and, naturally, a gramophone to amuse her clients.[21] She emerged as 'a sharply radical portraitist of a new English avant-garde'.[22] The people she met at Olivia's parties were highly image-conscious leaders of fashion: where they went, others followed; and they liked her work. Another friend who was almost too helpful was Brian Howard,

[18] Val Williams, Women Photographers (London: Virago, 1986), p. 99 (interview with Barbara Ker-Seymer).
[19] Tate Gallery Archive 939.2.4, BC to EB, undated, but 5/6 Apr. 1929.
[20] Carolyn Burke, Lee Miller, on Both Sides of the Camera (London: Bloomsbury, 2005), p. 101.
[21] Julie Kavanagh, Secret Muses: the Life of Frederick Ashton (London: Faber & Faber, 1996), p. 134.
[22] Kavanagh, Secret Muses, p. 135.

whom she had known from childhood.[23] An archetypal start-but-doesn't-finisher, he was full of enthusiasm and, given his circle of wealthy and avant-garde friends, extremely useful.[24] She photographed Nancy Cunard against tiger-skin in one session, and corrugated iron in another. The tiger-skin photograph became iconic, and was therefore subsequently attributed to Cecil Beaton. Many of her portraits were taken against corrugated iron, which gave an interesting 'modern' texture. As this suggests, photography—portrait photography in particular—had a distinctly baroque aspect by the late twenties. The notion that a camera is a simple instrument of record was only maintained by the hopelessly naïve. The business of photography was illusion, trompe l'oeil and images which drew attention to their own artifice.

As a new profession with modest start-up costs, photography was attractive to women, many of whom became successful. Some, such as Dorothy Wilding, were highly conventional, but others were more adventurous. Edith Plummer (1893–1975) was one of the most interesting woman portraitists. She opened her first studio in 1916, as 'Madame Yevonde', having trained under a still earlier professional woman, Lallie Charles; since she was a feminist and suffragette, she disliked the idea of working under a man.[25] Highly successful—she moved her studio to fashionable Berkeley Square in 1933—she became famous for a series called 'Goddesses', from 1935, in which well-born women posed as mythological figures, like the heroines of baroque paintings. Madame Yevonde's approach to representing Aileen Balcon, wife of Michael Balcon the film producer, as Minerva contrasts interestingly with Sir Peter Lely's baroque portrait of Barbara Villiers in the same role.[26] Villiers is posed with a shield, a long staff (doubtless a spear but the business end is not shown), a come-hither look, and immense quantities of fashionably dressed hair; Mrs Balcon is in profile, accompanied by a stuffed barn owl and a fabric backcloth hanging in diagonal folds which evoke the baroque portraitists' use of enormous taffeta curtains as a backdrop. Like Villiers, she is wearing satin—a heavy smock with a high collar. Her beautiful face is expressionless, and she is heavily made up, with painted nails, but she is also wearing a Tommy's steel helmet with its chinstrap and holding a heavy service revolver as if she knows what to do with it; the stuffed owl adds an element of camp, but she is armed, powerful, and self-contained.

Angus McBean, another great glamour photographer, was taught his craft by Hugh Cecil, who, like Beaton, had been influenced by Baron de Meyer. The enormously successful Cecil created a kind of a temple of photography in an eighteenth-century London town house, 8 Grafton Street, designed by Basil Ionides. The first room one entered had oxidized silver walls and a black ceiling, a niche where the

[23] Lancaster, *Brian Howard*, p. 136. [24] Lancaster, *Brian Howard*, p. 136.
[25] Williams, *Women Photographers*, pp. 90–1. [26] Williams, *Women Photographers*, p. 96.

fireplace had been, of black marble and glass, containing a modernistic statue of a Pierrot in black and silver, a black carpet, and a black glass table standing on silver sphinxes.[27] Even the most obtuse of clients will have recognized that they were entering the domain of black and silver.

McBean learned the art of flattery from Cecil: portraits were taken in an even, subdued light, then ruthlessly worked over by one of the two full-time retouchers Cecil employed. With the theatre contacts he built up through his other skill of making masks, he developed a specialty in the bravura portraits needed by West End actors. He also encountered surrealism as a movement at the 1937 International Surrealist Exhibition at the New Burlington Galleries, and realized that the camp, perverse inventiveness which led him to dress for the Old Vic fancy-dress ball as Queen Victoria but with Lytton Strachey's beard was eminently suited to making surrealism fashionable.

From 1938 McBean began to experiment, influenced in particular by the paintings of William Acton, brother of the influential critic, Harold Acton, who painted photo-realistic—or perhaps, glamour-photo-realistic—society beauties lapped in windblown satin, sometimes reduced to a bust on a plinth, against empty land-scapes in somewhat of a Dalí manner, and in baroque frames which he also designed. McBean realized that the contrast of the rather thinly painted background with the highly finished sitters told extraordinarily well when they were reproduced in *The Sketch*. He produced a series of images in which the sitter's face, or face and upper torso, emerged from surreal entanglements—Actonian/van Dyckian swathes of taffeta, curls of plaster, or structures of wood or bark. These earned him a regular slot in *The Sketch*, while actresses queued up for the privilege of being doubled up in a chest of drawers, corseted in plaster drapery, or buried in sand. As well as being indebted to William Acton and Dalí, McBean's work also evoked the fantasy pictures of 'Goddesses' which Madame Yevonde had been making a few years earlier. What McBean's work shows above all is that surrealism, like cubism, could be translated with complete success into a style, and he thus helped to make a surrealist visual vocabulary acceptable to the general public.

Perhaps the first person to have lived to be photographed is Stephen Tennant. For much of his twenties a manservant doubled as a photographer and followed him about with a movie camera (see Figure 27). His attitude towards his own image in photographs is purely aesthetic: if he had been a model, one would say it was professional, but this was art for art's sake. 'The one that manages to be deer-eyed & quizzical-mouthed is really ravishing,' he wrote to Cecil Beaton, of a successful shoot. Edith Olivier reveals the extent to which his environment existed to be translated into photographs: 'S and I spent the evening and dined in his Silver

[27] Adrian Woodhouse, *Angus McBean, Face Maker* (London: Alona Books, 2006), pp. 66–7.

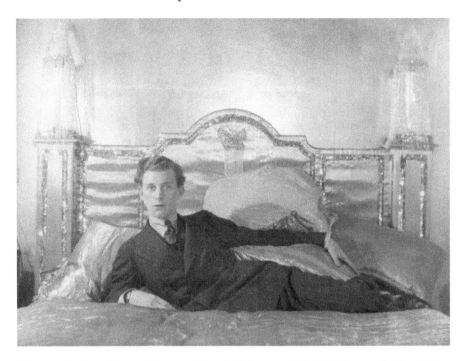

Figure 27 Stephen Tennant. Photographer: Cecil Beaton. © The Cecil Beaton Studio Archive at Sotheby's.

Room [at Mulberry House, Smith Square]. He lay in bed in a black jumper with great piles of silver pillows heaped beside him on the other half of the double bed. The room was exquisite, with very few lights, and lovely gleams and shadows alternating and moving on the silver walls, very magic and as S said Pamela [his mother] used to say "like an ice-berg". The ceiling very dark shining blue, all the curtains real silver. Heaps of Lilies and Orchids and Carnations.'[28]

However, the importance of photography between the wars lay not so much in the silver-framed portraits in drawing rooms as in the mass circulation of images in newspapers and magazines. The press's appetite for celebrity and glamour burgeoned as a result of the halftone printing process, and thus the twenties is the era in which it first became possible to be famous for being photographed emerging from nightclubs. The interwar smart set sat to professional photographers, but the endless parties would have lost much of their point had they not also been photographed, fawningly written up in the *Tatler*, or censoriously exposed by the *News of the World*.

[28] Edith Olivier, *Diary*, p. 86.

'Oh, how badly people do describe balls.'

'Never mind, there'll be the *Tatler*.'

'Yes, they said it was flash all night. Cedric is sure to have the photographs to show us.'[29]

Suddenly high society was permanently in view, and the antics of the 'Bright Young People' made excellent copy: 'The cult of the debutante was a result of the popular newspapers' search for colourful personalities round whom narratives could be built,'[30] and the aftermath of a party was poring over the next morning's papers.

Most of the well-known faces of the twenties and thirties were highly conscious of their image, and regularly photographed. Even W. H. Auden, who thought his face looked like 'an egg on a plate', trotted along to Cecil Beaton to be glamorized in 1930, and when he became better known, did an extended photo shoot with Howard Coster, who advertised himself as 'the photographer of men', in 1937, together with Isherwood and Spender. It was part of the business of being a public figure, even for poets.[31]

[29] Nancy Mitford, *Love in a Cold Climate*.
[30] Stephen Gundle, *Glamour: a history* (Oxford: Oxford University Press, 2008), pp. 141–3.
[31] National Portrait Gallery, NPG P869(3), NPGx134, NPG x2947–52, NPG x3088–90.

Self-Fashioning

Nobody absolutely has to buy art, but everyone has to wear clothes. Thus modernism, to the extent that it aimed at a complete programme for the progressive individual, had to come to terms with dress. Modernist theory tended to regard clothes as purely functional, and to deride women's exercise of choice in particular.[1] In most of the countries of Europe, attempts at rational dress sprouted from within modernist movements.[2] The futurists, particularly Giacomo Balla, were particularly vehement on the subject of men's clothes. TUTA, or the complete futurist synthetic wardrobe, was launched on the world in 1918, to a deafening lack of acclaim.[3]

All of this sets to one side the fact that people wear clothes for all kinds of reasons besides warmth, decency, and having somewhere to put your keys—baroque reasons, such as status, self-expression, sexual display, humour, delight in ornament, and the pleasure of extravagance. Modernist clothes reform for men either over-looked the secondary use of clothes to encode class, wealth, and personal affili-ations, or was an ideologically motivated attempt to outlaw it. But the relative standardization of orthodox male dress compared to that of women seems to have had the incidental effect of creating a highly effective set of universally understood signs: the mass of apparently functionless details—four-buttoned cuffs and so forth—were so socially useful that they were not relinquished until the clothes rationing of the 1940s enforced a rough sartorial democracy arising from scarcity.

Cultural historians have not always been alert to the capacity of clothes to be ironic or reflexive—in fact, to convey messages in an entirely conscious manner. Dress may express private dandyism, exhibitionism, or aggression; it may be a carapace to conceal individuality and sexuality; or equally well, it may fetishize and exaggerate them. One writer who thought extensively about the meaning of women's clothes was Virginia Woolf. She wrote in her diary about 'frock consciousness...people secrete an envelope which connects them, and protects

[1] Penny Sparke, *As Long as It's Pink: the Sexual Politics of Taste* (London: Pandora Press, 1995), pp. 50, 71.
[2] Radu Stern, *Against Fashion: Clothing as Art, 1850–1930* (Cambridge, MA: MIT Press, 2004), p. 13.
[3] Giacomo Balla, 'The Antineutral Dress', and Ernesto Thayaht and Ruggiero Michahelles, 'The Transformation of Male Clothing', in Stern, *Against Fashion*, pp. 157–8, 167–71.

them from others'.[4] In *Orlando*, she sums up: 'There is much to support the view that it is clothes that wear us and not we them. [They] mould our hearts, our brains, our tongues to their liking.'[5] Lisa Cohen argues that Woolf 'uses frocks ... to think about the modernist problem of how to represent character ... the relationships between exteriors and interiors and the way in which consciousness itself is gendered.'[6]

Woolf's friend Madge Garland, the fashion editor of *Vogue*, shared her view, observing that clothes can be 'a weapon to establish a distinctive personality'.[7] They certainly worked for her. Her parents thought her 'charmless', and she was not conventionally pretty. Having therefore grown up convinced that she was hideous, she became rail-thin and devastatingly chic, and dressed her way to a career. Aldous Huxley bumped into her on the stairs after they had both begun working for British *Vogue*, and asked her, 'Are you dressed like that because you're on *Vogue*, or are you on *Vogue* because you're dressed like that?'[8]

Gertrude Stein is not readily associated with fashion, but she clearly understood that it was a reflection of modernity, and argued that it had its own importance. 'There is no pulse so sure of the state of a nation as its characteristic art product which has nothing to do with its material life,' she wrote. 'Fashion is the real thing in abstraction.' What she seems to mean is that fashion reflected the revolutionary ideas and excitement of modernity without troubling itself with theory.[9] Fashion was a way of weaving avant-garde ideas into the fabric of the very culture that avant-gardists despised. Eileen Agar reflected on the women connected with the surrealist movement in the thirties, thinking specifically of herself, Nusch Éluard, Leonora Carrington, and Lee Miller, and observed, 'Our concern with appearance was not a result of pandering to masculine demands, but rather a common attitude to life. Juxtaposition by us of a Schiaparelli dress with outrageous behaviour or conversation simply carried the beliefs of Surrealism into public existence.'[10]

Superficially, fashion between the wars is a straightforward narrative. The Age of Poiret was succeeded by the Age of Chanel, as the practical exigencies of World War I and the simplifying spirit of modernism made Edwardian corsets and aigrettes

[4] Bell, *Diary of Virginia Woolf*, 27 Apr. 1925, p. 12; 14 May 1925, p. 21. Anne Pender, 'Modernist Madonnas: Dorothy Todd, Madge Garland and Virginia Woolf', *Women's History Review*, 16.4 (2007), pp. 519–33. Woolf herself was far from fashionable. Vita Sackville-West once observed of Woolf, 'She had got on a new dress. It was very odd indeed, orange and black, with a hat to match,—a sort of top-hat made of straw, with two orange feathers like Mercury's wings,—but though odd it was curiously becoming, and pleased Virginia because there could be absolutely no doubt as to which was the front and which was the back.' Glendinning, *Vita*, p. 163.

[5] *Orlando*, ch. IV (St Albans: Granada, 1977), p. 117.

[6] Lisa Cohen, '"Frock Consciousness": Virginia Woolf, the Open Secret, and the Language of Fashion', *Fashion Theory*, 3(2) (1999), pp. 149–74, p. 150. See also Cohen, *All We Know*, pp. 259–61.

[7] Lisa Cohen, *All We Know* (New York: Farrar, Straus & Giroux, 2012), p. 201.

[8] Cohen, *All We Know*, p. 235. [9] *Paris, France* (London: Peter Owen, 1971), p. 11.

[10] Carolyn Burke, *Lee Miller, on Both Sides of the Camera* (London: Bloomsbury, 2005), p. 165.

seem increasingly ridiculous. Wartime conditions also put a number of women into uniform, some of whom, for various reasons, were reluctant to relinquish masculinely styled, tailored clothes thereafter. Coco Chanel turned the simple shapes and stretchy fabrics of sportswear into the basic elements of a fashionable wardrobe. Women emerged from this series of historically mandated changes slim, streamlined, short-haired, and androgynous.

Thus it could be said that Chanel liberated Everywoman, making her freer to go about her life, go to work, or drive a car because she was no longer swathed in yards of unnecessary fabric, while, of course, simultaneously enslaving her to her bathroom scales.[11] But the story of Chanel herself illustrates another major aspect of interwar fashion: it provided an avenue of opportunity for outsiders. Fashion, and its ancillary crafts—jewellery, perfume, furnishing, theatrical design, interior decoration, fabrics and rugs, photography, and journalism—were milieux where women could flourish because they didn't count as 'art'. It is also hardly news to observe that interwar fashion also attracted the creative efforts of gay men—Edward Molyneux, Pierre Balmain, Christian Dior, and Hardy Amies among them.

From the point of view of suppliers, rather than consumers, fashion could be a route to self-expression, but also to independence and even wealth. Chanel herself was a penniless girl from the Auvergne who parlayed being set up with a milliner's business by a rich boyfriend into a personal empire; her rival Schiaparelli was deserted by her husband for Isadora Duncan, and began her climb to wealth and fame from a deeply disadvantageous position as a single mother. Madeleine Vionnet, another much-admired designer, was also a divorcee.

The most baroque of the interwar couturières was Elsa Schiaparelli. She treated dress as an art form, and claimed in later life that she would have liked to be a sculptor if she hadn't needed to survive as a single parent, which may even have been true. Her acquaintance with the avant-garde predated her career in fashion: in 1916, in the course of an Atlantic crossing in which she was leaving her husband, she made friends with Gabrielle Picabia, wife of the Dadaist painter Francis Picabia. When Schiaparelli eventually came to Paris in 1922, Gabrielle Picabia introduced her to Man Ray, who himself stood between the worlds of high art and fashion, since a couple of years later he began photographing for *Harper's Bazaar*, *Vanity Fair*, and *Vogue*.

From the very beginning Schiaparelli's work was marked by humour and ambiguity. She first made her name in 1926 with casual sweaters ornamented at the neck with trompe l'oeil bows. The nascent surrealist movement, which published its first manifesto in 1924, was aware of her as a kindred spirit, since her work was featured several times in the surrealist magazine *Minotaure*, launched by André Breton on

[11] Linda Simon, *Coco Chanel* (London: Reaktion, 2011), p. 53.

Edward James's money. One of the most polyvalent photographs to emerge from this entire nexus is of Lee Miller in a silver-lamé couture gown by Vionnet, photographed by Man Ray and lying in an upholstered wheelbarrow by Oscar Dominguez which had a history as a surrealist artwork in its own right (see Figure 28). This photograph appeared *both* in *Vogue*, as a fashion shot, and in *Minotaure*, as a surreal image.

Schiaparelli's two-way collaboration with Salvador Dalí was particularly extensive. Beginning in 1936, it produced a variety of garments which expressed surrealist ambiguities, above all her famous hat shaped like a shoe, but also dresses decorated with printed rips or with lobsters, both of which were motifs Dalí regularly used in paintings. The 'Desk Suit' with drawer-shaped pockets and sham pockets directly references Dalí's *Anthropomorphic Cabinet*, and *Venus de Milo with Drawers*;[12] and

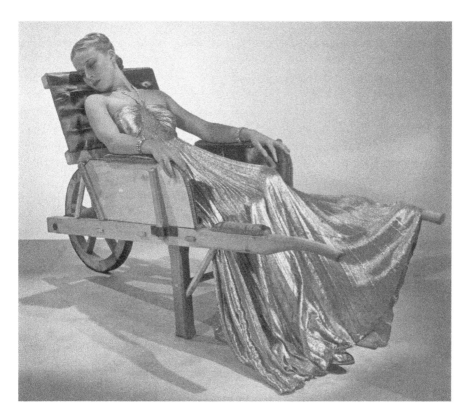

Figure 28 Lee Miller, wearing a Vionnet evening gown and lying in 'Brouette' by Oscar Dominguez. Photographer: Man Ray. © Man Ray Trust/ADAGP, Paris and DACS, London 2015.

[12] Richard Martin, *Fashion and Surrealism* (London: Thames & Hudson, 1988), pp. 118–20.

the 'ripped' dress is a realization of the costume worn by a female spectre in a Dalí painting, *Necrophiliac Springtime*, which Schiaparelli owned.[13] She also turned to Jean Cocteau in 1937. One of his designs for her was based on the optical illusion devised by Danish psychologist Edgar Rubin in 1915: twinned profiles which were also the sides of an urn. Another of his designs was also illusionist: a woman's head and hand snaking round the body of a dinner ensemble.

Schiaparelli's work was also intertextual with that of other contemporary artists who were not directly working for her: in 1935 she issued cotton and silk fabrics printed with her own press clippings, a refraction of Picasso's and Braque's earlier use of cut newspaper in paintings.[14] In Picasso's 1937 portrait of Nusch Éluard, wife of surrealist poet Paul Éluard, the model is wearing an identifiable Schiaparelli jacket and hat. Picasso has responded playfully to the surreal elements of their design.[15]

Another painter who seems to have been directly influenced by Schiaparelli is the Belgian surrealist Paul Delvaux: in 1937 he painted *Break of Day*, in which a group of women are turning into trees from the hips down.[16] One of Schiaparelli's favourite fabrics was heavy rayon 'tree-bark' crêpe, first introduced in 1932, which she made up into columnar dresses.[17] Conversely, Magritte's 1935 painting of long blonde hair spilling out of a pair of shoes seems to have inspired an unsettling pair of Schiaparelli ankle boots (1938), which feature a human-hair-like cascade of the long black fur of colobus monkeys apparently oozing out of the uppers.[18] She drew on Magritte again for her men's perfume—'Snuff'—in a pipe-shaped bottle and presented in a cigar box, a homage to the painter's famous *La Trahison des Images*.[19]

Surrealism as a movement was limited in both aims and achievement. The leading surrealists concerned themselves obsessively with the conundrum of sexual attraction in a highly misogynist fashion, expressed by means of fetishistic reactions to women's bodies and, especially, genitalia. However, in a wider sense, it was an inescapable aspect of the arts in the twentieth century. 'Surrealism was the principal branch of the avant-garde in the visual arts to thrive during the thirties, precisely because it was not linked to a productive ideology,' Wollen comments.[20] The traffic between surrealism as an art movement and as fashion, which is also interested in fetishizing women's bodies, is two-way.

[13] Dilys Blum, *Shocking! The Art and Fashion of Elsa Schiaparelli* (Philadelphia: Philadelphia Museum of Art, 2003), p. 124.

[14] Blum, *Shocking!*, p. 71. [15] Blum, *Shocking!*, p. 120. [16] Blum, *Shocking!*, p. 185.

[17] Blum, *Shocking!*, p. 64. [18] Blum, *Shocking!*, p. 143. [19] Blum, *Shocking!*, p. 147.

[20] Wollen, *Raiding the Icebox*, p. 88.

Hats lent themselves particularly well to surrealist agendas. A frequently referenced Man Ray spread for *Minotaure* addressed the latent content of hats, perceived symbolic female genitals in the dent of a man's trilby, and also featured a 'phallic' woman's hat, which is a Schiaparelli model. Tristan Tzara similarly seized upon other hats by Schiaparelli and argued in *D'un certain automatisme du goût* that they resembled *female* genitalia, and were thus sexual metaphors.[21] In the case of the trilby, the 'meaning' assigned by Man Ray, or the eye of the beholder, has nothing to do with the maker's intentions. In the case of Schiaparelli's one-horned pillbox, it is hard to be quite so sure. Her subsequent 'Shoe' hat, designed by Dalí, was quite consciously a surreal object but was sold as a fashion item (see Figure 29). Eileen Agar also created a surrealist hat in 1936, ornamented with gloves—Schiaparelli gloves, appliquéd with red snakeskin pseudo-fingernails. Whether the result is a surrealist artwork or a fashion item is far from easy to decide, and the same may be said for the gloves themselves.[22]

Figure 29 Shoe Hat, 1937–8; Salvador Dalí in collaboration with Elsa Schiaparelli. Photographer: unknown. © Victoria and Albert Museum, London.

[21] Blum, *Shocking!*, p. 127.
[22] Agar wears a similar hat, 'Ceremonial Hat for Eating Bouillabaisse', in a photograph of *c.* 1938. Martin, *Fashion and Surrealism*, p. 155.

The arousal and deflection of desire which preoccupied the surrealists is inevitably one of the concerns of fashion. Other concerns of fashion, such as playfulness, individuality, perverseness, exoticism, and camp, were all expressible through the visual vocabulary and reference points of surrealism. It is not merely that designers turned ideas into motifs, though an art movement which encouraged chopping up and randomizing pre-existing material could hardly object if it did. Schiaparelli, for one, also engaged critically with the ideas. In 1937, at the Paris Exposition Internationale, in the Pavillon d'Élégance, she offered a tableau of a reclining, nude mannequin bowered in flowers, with an evening dress (suspended on an invisible line) floating in the air several feet away.[23] The mannequin's position brings Manet's *Déjeuner sur l'herbe* to mind—but not that of the female nude in that painting, rather the assertive pose of the young male dandy who sits opposite her, a subtle shift and a contrast to the surrealists' systematic disempowerment of their representations of the female. The array of nude mannequins variously adorned or subverted by Man Ray, Dalí, André Masson, and others created for the Exposition Internationale du Surréalisme at the Galerie Beaux-Arts in the following year are mostly blinded or gagged.[24]

Though fashion thus both expressed the spirit of the times and served the purposes of a variety of ambitious and able women, anti-fashion in the interwar period is also important. One conspicuous variety of anti-fashion for women which was characteristic of the era was male attire. Mainstream fashion in the twenties encompassed severely tailored, masculinely styled jackets and shirts for women, which some lesbians took advantage of, but these were worn with skirts. Actually dressing as a man, trousers and all, was a considerably more radical step, and those women who did had to take the consequences. 'Joe' Carstairs, speedboat racer, was repeatedly photographed in men's casual sports attire of flannels, pullover, shirt, and beret: her combination of wealth, reckless personal courage, and the extreme dangerousness of her hobby seem to have muzzled criticism. Lesbian artists such as Gluck and Marlow Moss who cross-dressed had more problems with the press; as painters, they needed a degree of visibility, but could hardly claim that safety considerations had driven them into trousers, and journalists were censorious.[25]

Negotiating with fashion between the wars was unlike the process of acquiring clothes today. Rather than buying a 'ready-made', even modestly circumstanced women would go to a dressmaker clutching a copy of *Vogue*, which offered a pattern service for the garments they illustrated, from inexpensive stock designs in standard

[23] Martin, *Fashion and Surrealism*, p. 56.

[24] Martin, *Fashion and Surrealism*, p. 193. For example, Masson's model has a caged head, and her mouth is gagged with a pansy (*viola tricolor*).

[25] Laura Doan, *Fashioning Sapphism: the Origins of a Modern English Lesbian Culture* (New York: Columbia University Press, 2001), pp. 117–19. For Marlow Moss, see Margaret Garlake, 'Moss, Marlow (1889–1958)', *Oxford Dictionary of National Biography* (online).

sizes to individual-measure patterns.[26] That was small consolation to those who were gloomily convinced that they would look idiotic despite the 'little woman's' best efforts.

A variety of creative people therefore consciously adopted some kind of anti-fashion statement, and some alternatives to fashion became styles in their own right. 'Dorelia' style was King's Road chic through the twenties and thirties, and much adopted as an anti-fashion statement, as Viva King observed.[27] Named for, and created by, Augustus John's mistress, Dorelia McNeill, the long, full skirts in bright colours worn with a fitted bodice were the antithesis of the tubular styles dictated by mainstream fashion. As well as evoking Romany dress, they also resemble the 'aesthetic' clothes of Rossetti's and Morris's muse, Jane Burden. Virginia Woolf's sister Vanessa followed this trend: 'Tall, a little awkward ... [she] dressed in bizarre clothes made from stuffs bought in Italian rag markets.' There was a practical aspect to this: her clothes were comfortable, and if they were grubby, unironed, and a touch paint-stained, they just looked that much more bohemian. Self-fashioning also allowed her to indulge her unfashionable 'liking for strong colours, both in her painting and her dress, favouring rich purples and vermilions'.[28]

Edith Sitwell crowned her long-nosed, Plantagenet face with toques or turbans. She dressed her tall, lean figure in sweeping, improbable garments made of cheap furnishing fabrics, made a point of displaying her beautiful hands, adorned with semi-precious stones the size of golf balls, and had herself photographed by Cecil Beaton in a mutual publicity pact. Her outré appearance nearly killed the painter David Jones on one occasion: he was about to cross the road when she swept round a corner like a stately scarlet dalek and, catching this apparition in his peripheral vision, he thought he had seen a moving pillar box and was so astonished he nearly went under a bus.[29] Lady Ottoline Morrell, another passionate lover of colour, looked (or so Virginia Woolf implied) half-human, half-macaw, albeit surprisingly sexy.[30] Like Edith Sitwell, she was a conscious and deliberate defier of fashion, who went about in a permanent state of fancy dress (see Figure 30). Also like Sitwell, she was unusually tall and odd-looking. Lady Ottoline's long-nosed, Hapsburg face was evidently sexually appealing, but could never be pretty. She picked up interesting materials on her travels, and she employed a dressmaker, Miss Brenton, who made her highly theatrical outfits, which seldom cost more than three guineas. Revealingly, these garments were not indifferent to fashion but in opposition to it. 'It is so

[26] Nancy Troy, *Couture Culture: a Study in Modern Art and Fashion* (Cambridge, MA: MIT Press, 2003), p. 271.

[27] Viva King, *The Weeping and the Laughter* (London: Macdonald & Jones, 1976), p. 82.

[28] Frances Spalding, *Vanessa Bell* (London: Weidenfeld & Nicolson, 1983), pp. 244–5.

[29] Thomas Dilworth, *David Jones: Engraver, Soldier, Painter, Poet* (London: Jonathan Cape, 2017), p. 288.

[30] Miranda Seymour, *Ottoline Morrell: Life on the Grand Scale* (London: Hodder & Stoughton, 1992), p. 97: Virginia wrote to her sister Vanessa, 'I was so much overcome by her beauty that I really felt as if I'd suddenly got into the sea, and heard the mermaids fluting on their rocks.'

Figure 30 Lady Ottoline Morrell, 1927. Photographer: Cecil Beaton. © The Cecil Beaton Studio Archive at Sotheby's.

difficult to keep out of the fashions,' wrote Miss Brenton, 'as the narrow frocks do suit you so much, but we must make our things quaint and unusual by the colouring or embroidering.'[31] Quaint and unusual hardly does justice to the quite extraordinary appearance of Lady Ottoline in her prime, but the important thing is her desire to look, not beautiful, though she was in her peculiar way, but amazing.

Sara Murphy, an American in twenties Paris, was another woman who took a completely independent attitude to dressing: 'She wore beautiful clothes, not the chic of the day, but wonderful flowing things that suited her perfectly.'[32] The same could be said of Natalie Barney, sapphist salonnière, who dressed 'outside time...she presented herself as a kind of "period piece", never quite belonging to the present, always invoking an indefinable, literary past'.[33]

[31] Seymour, *Ottoline Morrell*, p. 99.

[32] Amanda Vaill, *Everybody was so Young* (London: Warner Books, 1999), p. 116.

[33] Joan Schenkar, *Truly Wilde: the Unsettling Story of Dolly Wilde, Oscar's Niece* (London: Virago, 2000), p. 155.

Murphy and Barney had the face, figure, and money to make fashion work for them, but chose not to. Lady Ottoline and Edith Sitwell, on the other hand, both exemplify why some women could not attempt contemporary chic without looking ridiculous. Not only had they the wrong sort of face and height to look good in ordinary clothes, they also had the wrong sort of income. This is equally true of the garden designer Norah Lindsay, who dressed, Lady Diana Cooper remembered, 'mostly in tinsel and leopard skins and baroque pearls and emeralds'.[34]

One might dress eccentrically for fun. The bohemian Iris Tree wrote joyfully of the brilliant colours—bright red, green, blue—and the eccentric design, with ribbons swirling round her hips, of her new dress. Clothes like this went with a life which included borrowing money, drinking absinthe, and taking numerous lovers (she was counting). But there is an unacknowledged practical aspect to such defiant sartorial individualism. For someone who needed to ask her friends for a loan from time to time, some kind of fancy dress was a way of being something other than dowdy. Embracing fashion as such meant that the wearer's clothes inescapably conveyed a set of all too legible clues about his or her social status and position, and, above all, wealth. Copies of couture models by less skilful hands, using inexpensive materials rather than exclusive and luxurious fabrics, often have a discouraged look.[35]

For the impecunious who interacted socially with potential patrons, there was a choice between looking shabby and looking weird. On the principle that if you can't win you can always change the rules, quite a few opted for the extraordinary. The garden designer Norah Lindsay was not abjectly poor as, say, Henri Gaudier-Brzeska or Mark Gertler were poor (which is to say, virtually penniless), but she can seldom have had a spare five pounds. As part of her working life she spent long periods staying with the almost obscenely wealthy Lady Astor, working on the Astors' garden at Cliveden on the socially difficult terms of friend/employee.[36] As such, she would dine with the Astors and would have to dress for dinner. It must have been far easier to hold one's own as outré in tinsel than by wearing cheap imitations of expensive gowns.

A level of sartorial equality was particularly necessary for a portraitist or muralist, or anyone else who interacted directly with clients: a portrait painter could be a Café Royal bohemian in the style of Augustus John, but could not be poor and dirty. For those whose professional life required them to network at society parties, a set of acceptable evening clothes was absolutely necessary, even if they had to walk home afterwards because they didn't have the price of a bus fare.[37] 'Though we joked

[34] Allyson Haywood, *Norah Lindsay: the Life and Art of a Garden Designer* (London: Frances Lincoln, 2007), p. 42.

[35] Daphne Fielding, *The Rainbow Picnic* (London: Eyre Methuen, 1974), p. 51.

[36] Haywood, *Norah Lindsay*, p. 129.

[37] Winifred Nicholson, *Among the Bohemians* (London: Penguin, 2003), pp. 134–5.

about boiled shirts, they were worn a great deal,' Ethel Mannin remembered.[38] Picasso got the upper hand of his patrons while remaining bohemian in his personal style because there was an impeccably dressed Right Bank dealer, Daniel-Henry Kahnweiler, interposed between him and them. In London, Freddy Mayor of the Mayor Gallery, and Ernest Brown and the Phillips brothers at the Leicester Gallery, were among the important dealers in English modernism who played a similar role. Struggling male artists on both sides of the Channel tended to wear workmen's clothes—corduroy breeches or blue canvas overalls—because they were cheap and sturdy. The 'Slade Cropheads', Dora Carrington and Dorothy Brett, also took to wearing country labourers' corduroy breeches during and after the First World War, at least some of the time; like their short hair, this was an attempt to dress rationally.

Sartorial eccentricity could cause difficulties when it came to meeting potential patrons. Fr Martin D'Arcy approached his friends William and John Rothenstein, father and son, principal of the Royal College of Art and director of the Tate respectively, for advice on who could paint murals in the new Lady Chapel at Campion Hall. John Rothenstein had become a Catholic in 1926, though his father identified as Jewish, but both men were quite clear that the greatest Christian painter in Britain was Stanley Spencer, whose Burghclere Chapel paintings had been completed in 1932.[39] Spencer was extremely short of money and would have been more than glad of Evelyn Waugh's £600 (the work was to be paid for by the royalties from Evelyn Waugh's biography of Edmund Campion). D'Arcy invited him to Campion Hall, and was dismayed: 'So diminutive as to be almost a dwarf in labourer's clothes with a dirty satchel containing all his belongings, he was no ordinary guest.' There were reasons besides his eccentric appearance why D'Arcy chose another painter: he was repelled, for theological as well as personal reasons, by Spencer's conception of Christ, but Spencer's self-presentation clearly didn't help.

There were styles of male dress recognized as 'arty'. Alongside the 'Dorelia' style for women, there was the corresponding gypsy style of Augustus John himself—rings and earrings, coloured shirts and corduroys—and beards, facial hair being an unequivocal indication of commitment to bohemia.[40] Beards, like heavy tattooing in our own day, were stigmatizing. According to Angus McBean, 'In those days a young man with a long beard simply wasn't employable.'[41] Checked fabrics were definitely arty: Paul Nash, whose instincts were dandified, nonetheless 'got a brown check suit that will stagger humanity. My word it is a check suit' (written in a letter to

[38] Ethel Mannin, *Young in the Twenties: a Chapter of Autobiography* (London: Hutchinson, 1971), p. 28.
[39] Paul Gough, *Stanley Spencer: Journey to Burghclere* (Bristol: Sansom & Co., 2006).
[40] Nicholson, *Among the Bohemians*, p. 130. [41] Woodhouse, *Angus McBean*, p. 49.

Carrington, accompanied with a drawing).[42] Even a red tie was read as a statement of nonconformity.

A few individual men had personal theories of dress at least as eccentric as some of their female contemporaries, sometimes for the same reasons. The photographer Angus McBean wore a costume of his own design, based on the dungarees worn by Dutch and Belgian dock workers, with a bib front and drop fly, creased down the sides, which he wore with sharply waisted tweed jackets and waistcoats, and a beard: 'People used to say they couldn't afford to be seen with me because I looked so curious.'[43] This, like Edith Sitwell's clothes, was a way of deflecting attention from the fact that he was dressing very cheaply while working as a glamour photographer. Eric Gill tried to persuade men out of trousers entirely in a 1931 manifesto, *Clothes*, and put his views into practice, attiring himself in tunics and sandals of vaguely biblical appearance, reasonably practical attire for painting or sculpture (and, since he wore no underpants, for the sudden satisfaction of his abnormal sexual appetite), but not suited to more conventional lifestyles.

Individualists found it easy to carry out their ideas, since for men as well as women having clothes made was normal even for the middle class. Harold Acton invented a mid-nineteenth-century look, consisting of grey bowler hat, side whiskers, stock, jacket with wide lapels, and the broad, pleated trousers which became known as Oxford bags. The trousers, though not the whole ensemble, were adopted by other aesthetic young men, and became one of the defining looks of the era, perhaps because, like lesbian chic, they lent themselves to androgyny: it was wide-legged, pleat-fronted Oxford bags that were adopted as feminine beach and resort wear.

Beyond the fancy dress which was permanently assumed by some bohemians and individualists, fancy dress was a dominant motif of the interwar period. Fundraising costume parties, notably the Chelsea Arts Club Ball and the Old Vic Ball, were enormously popular annual events. Subsequent commentators have often put it down to escapism, a refusal of the regular world.[44] Loelia, Duchess of Westminster, observed rather helplessly: 'One of the phenomena of the twenties was our passion for dressing up. It is beyond me to explain why we felt the urge,'[45] but Madge Garland suggests a reason: 'The conduct of everyday people when "dressed up" or in fancy dress is quite other than their normal procedure.... An extra dimension is envisaged and explored which helps to develop the personality and can in some instances alter it.'[46]

[42] Ronald Blythe, *First Friends* (London: Viking, 2009), p. 19.

[43] Adrian Woodhouse, *Angus McBean, Face Maker* (London: Alona Books, 2006), p. 64.

[44] Stephen Gundle, *Glamour: a History* (Oxford: Oxford University Press, 2008), p. 154.

[45] Loelia, Duchess of Westminster, *Grace and Favour: the Memoirs of Loelia, Duchess of Westminster* (London: Weidenfeld & Nicolson, 1961), p. 110.

[46] Madge Garland, *The Changing Form of Fashion* (London: J. M. Dent & Sons, 1970), p. xii.

The reference point for twenties dressing-up is often the eighteenth century, and Watteau in particular. *L'Embarquement pour Cythère* is discussed by Sacheverell Sitwell in a late work, but as something he first came across (in a book) at 14 or 15, and was strongly attracted to at that time.[47] The figures are leaving the real world for the Isle of Venus and show a certain reluctance to depart, as if aware that a world of illusion comes at a price. But as Sitwell points out, they are themselves in fancy dress. There is illusion within illusion, for the subject is taken from a comedy, *Les Trois Cousins*, which came out in 1702, fifteen years before the painting, suggesting the idea's hold on Watteau himself. It is a painting of regret and nostalgia for the world which is being abandoned, but also of a highly deliberate and exquisite artifice, a model for the preciosity of his own social circle.

One of the most iconic images of the Bright Young People is Cecil Beaton's frequently reproduced fancy-dress portrait of a group of his friends at Ashcombe in 1927: Rex Whistler, Beaton himself, Georgia Sitwell (Sacheverell's wife), William Walton, Stephen Tennant, and Zita and Teresa Jungman. Young, slender, and beautiful, they all have short hair and painted faces and look splendidly androgynous in eighteenth-century-style ruffled shirts, satin knee breeches and waistcoats, posing on a bridge. In another photograph they sit on the grass with baskets of flowers. The mode is eighteenth-century pastoral: a twenties recreation of Watteau's lovers embarking for Cythera.

Brian Howard's essay for *Cherwell*, 25 June 1927, expressing nostalgia for 'his' Oxford, records a fête champêtre which also clearly had the elegancies of Watteau as a reference point. At sunset the guests punted up the Thames for a mile or so above Magdalen, to find tables complete with snowy linen set out in a field by the college servants.

> After the night had come...the simple smells of clover and wet grass had changed, suddenly, into a fragrance that suggested the proximity of parterres, I thought I saw a figure leaning against one of the willows. A figure that might have wandered out of a Watteau, in crumpled white silk, and holding a ribboned guitar...but then, I think it must have been merely Mr. X, with his coat off, playing his ukulele, seen through a glass of wine.[48]

Stephen Tennant's brother David also attempted to evoke eighteenth-century elegance with his notorious Mozart Party, held in 1924. Having danced all night in the dress of 1760, his guests emerged at dawn to swoop down on a gang of workmen who were digging up the road in Piccadilly and posed for photographs: less in the

[47] Sacheverell Sitwell, *Cupid and the Jacaranda* (London: Macmillan, 1952), pp. 10–12.

[48] Marie-Jacqueline Lancaster, *Brian Howard: Portrait of a Failure* (London: Timewell Press, 2005), p. 113.

spirit of Mozart than of Marie Antoinette, though this passed for acceptable high spirits in the media of 1924.

It has to be said that even in Bright Young circles, not everyone was convinced by the charm of fancy dress, and some were moved to active sabotage. Constant Lambert wrote to Antony Powell, 'I expect you are by now dressing for David Tennant's Mozart-cum-bottle party. I meant to suggest that you should go as a character from the Magic Flute—there is a dragon in the 1st Act and 2 men in armour later on. 3 people between them could more or less finish off the Watteau atmosphere. I suppose Harry Walker will go as Leporello and Stephen [Tennant] as the Queen of the Night.'[49]

However, for the sexually unorthodox the chance to cross-dress held particular attractions. 'The shape-changing parties of the 1920s perfectly suited the half-secretive, half-flamboyant lesbian demi-monde,' Kate Summerscale observes. 'These disguises were at once deceptions and proclamations.'[50] Barbara Ker-Seymer usually wore sailor's trousers at parties, thus illustrating several different aspects of fancy dress simultaneously: she was a lesbian, androgynous dress suited her neat, spare figure, and a pair of bell-bottoms were very cheap. Other girls did the same, to judge from surviving photographs of 'Bright Young People' at play (see Figure 31). Equally, Brian Howard was far from being the only male socialite inclined to reach for a wig and a frock on the slightest pretext. Edith Olivier recorded a dinner given by Stephen Tennant, on 16 October 1927: 'After I arrived, some time after—they began to dress for a fancy dress dinner.... Cecil [Beaton] looked a pretty creature in gold

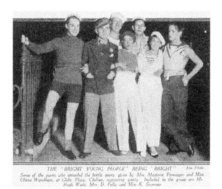

THE "BRIGHT YOUNG PEOPLE" BEING "BRIGHT"
Some of the guests who attended the bottle party given by Mrs. Marjorie Firminger and Miss Olivia Wyndham, at Glebe Place, Chelsea, registering gaiety. Included in the group are Mr. Hugh Wade, Mrs. D. Pelly and Miss K. Seymour

Figure 31 The 'Bright Young People' being 'bright': guests at a party given by Marjorie Firminger and Olivia Wyndham at Glebe Place, Chelsea; from *The Bystander*, 30 October 1929. Barbara Ker-Seymer is fourth from the left. Photographer: unknown. © Illustrated London News Ltd/Mary Evans.

[49] Richard Shead, *Constant Lambert* (London: Simon Publications, 1973), pp. 78–9.
[50] Kate Summerscale, *The Queen of Whale Cay* (London: Fourth Estate, 1997), p. 94.

and rose coloured gauzy tissue with a rose coloured cloak and lots of rouge....
Stephen at last came in a white Russian suit with silver train and a bandeau round
his head.'[51]

Fancy dress came to be seen as one of the twenties' most camp and frivolous
aspects, the hedonism which, in the politicized thirties, looked less and less forgiv-
able. By this reading, dressing up was a careless display of privilege. The occasion
which was subsequently seen as sounding the death knell for fancy-dress parties was
Arthur Jeffress's Red and White Party in November 1931, two years after the Wall
Street Crash. The new government had been elected on an austerity ticket. Jeffress,
the 26-year-old heir to a tobacco fortune, wore white angel-skin pyjamas, white
elbow-length kid gloves, ruby-and-diamond bracelets, and carried a muff of white
narcissi, while the Bright Young People turned up in red and white. The papers
the next morning were deeply censorious: it was written up as something like the
'Last Days of Pompeii', decadence calculated to provoke socialist revolution.

But the vulgarity of Jeffress's party is not the whole story of interwar fancy dress.
One person who had a particular stake in its popularity was Cecil Beaton. He dealt
with the potential social difficulties of his parties at Ashcombe by configuring them
as an escape into never-never land. Guests came expecting 'to exchange reality for a
complete escape into the realm of fantasy'. They were encouraged to bring fancy
costumes, and if they did not, to raid the dressing-up chest.[52] Cecil Beaton decreed in
Vogue, 'It is embarrassing to appear in anything elaborate. Anyone can hire from a
costumier's.'[53] This dictum turns fashion the other way up: the balance of power
tilts away from the merely rich towards the clever and inventive. Instead of being a
vehicle for vulgar display, it becomes a vehicle for wit and fancy, a device for
temporarily stepping aside from the constant reminder of social distinctions and
wealth which was afforded by conventional dress: in a decade when details such as
cufflinks and turn-ups carried minutely detailed messages, charging about wearing
carriage rugs and paper bags must have been socially liberating.

The adoption of fancy dress of various kinds could thus be expressive, a release
from the tyranny of fashion, and a declaration of allegiance. Rather than being a way
of not facing facts, unconventional clothes could be a way of reserving facts—poverty
above all—that one was not anxious to broadcast, or perhaps a way of selecting the
aspects of one's personal identity which one chose to share.

[51] Edith Olivier from her Journals, ed. Penelope Middleboe (London: Weidenfeld & Nicolson, 1989), p. 62.
[52] Julie Kavanagh, Secret Muses: the Life of Frederick Ashton (London: Faber & Faber, 1996), p. 238.
[53] Carolyn Hall, The Thirties in Vogue (London: Octopus, 1984), p. 66.

14

Masks

On the face of things, writers of the twenties and thirties appear to champion naturalness and escape from the stifling conventionality of the Victorian era. It is therefore curious that masks were pervasive in the arts. It is no accident that Edith Sitwell's most popular work is called *Façade*, and Noël Coward made a character say, 'It's all a question of masks, really; brittle, painted masks. We all wear them as a form of protection.... We must have some means of shielding our timid, shrinking souls from the glare of civilization.' The idea of shielding or reserving the self obviously resonated with much of his audience, though he may have been understood most clearly by those who happened to be homosexual.[1]

Much of the African, Oceanic, and North American Indian art which was collected by avant-gardists consisted of masks, for reasons of supply as well as demand, since a variety of cultures worldwide made use of ritual and ceremonial masks in one context or another. Fang masks from West Africa were popular for their expressively abstract treatment of human features, and were very influential on modern art: Paul Guillaume's journal, *Les Arts à Paris*, founded in 1919, acknowledges this by putting one on the cover.[2] Calm, polished Baule masks from Gabon were also collected: a well-known series of photographs by Man Ray of his mistress Kiki shows her expressionless face, whitened and de-individualized with make-up, juxtaposed with a Baule mask of black wood. Both positive and negative versions of the photograph were made.[3]

The mask collection in the Paris Musée de l'Homme (also called the Trocadéro) is of particular significance, since this was the place where Picasso and other cubists first encountered African art.[4] Picasso confirms their importance: '[I was] all alone in that awful museum with the masks...the dusty mannequins. *Les Demoiselles*

[1] *Design for Living*, quoted in Hoare, *Noël Coward*, p. 250.

[2] Petrine Archer-Shaw, *Negrophilia* (London: Thames & Hudson, 2000), p. 61.

[3] Archer-Shaw, *Negrophilia*, pp. 98–100.

[4] Francine Ndiaye, *Secrets d'initiés: masques d'Afrique noire dans les collections du Musée de l'homme* (Paris: Editions Sépia, 1994); Peter Stepan, *Picasso's Collection of African and Oceanic Art: Masters of Metamorphosis* (Munich, London, New York: Prestel, 2006); William Rubin, 'Primitivism', in *Twentieth Century Art*, 2 vols (New York: Museum of Modern Art, 1984).

d'Avignon must have been born that day.'[5] What is more, the Musée presented its collections *as* art, as Ihor Junyk points out: 'Instead of situating the works in a cultural context as manifestations of particular "primitive" societies, they were presented as discrete aesthetic objects just as the works of the European masters in the Louvre or the European avant-garde in the Musée d'Art Moderne. The reception of these works seemed to further underscore the cultural levelling performed by their presentation as aesthetic objects. The Troca became a favorite haunt of the avant-garde, particularly the surrealists and cubists, who studied the works on display and borrowed from them in their own artistic experiments.'[6]

Apart from the non-European masks which helped a number of major twentieth-century artists down the road to abstraction, classical and other traditions of masks in drama were an important aspect of modernist and experimental theatre. They were widely used, especially for choruses, in imitation of the ancient Greeks; or, for Yeats and some of his followers, in imitation of the Noh drama of Japan; or to simplify and depersonalize. Max Reinhardt used masks in many productions, including *The Miracle* (1911), staged by Cochran. Cocteau used masks repeatedly: in the 1922 *Antigone*, Antigone herself wore a white mask, and the chorus spoke through a hole in the backcloth attached to a megaphone, surrounded by masks of boys, women, and old men from designs by Picasso.[7] In the rewritten version staged in 1927, the actors wore transparent masks like those of fencers, with features sketched on them in white millinery wire.[8] T. S. Eliot and his director, E. Martin Browne, used half-masks for the chorus in *The Rock* (1934) but not for *Murder in the Cathedral* the next year, where they were not considered appropriate; however, masks were resorted to again in *The Family Reunion* (1939).[9] Masks were also a solution to staging the good and evil Microbes in the first West End production of Shaw's *Too True to be Good*.[10]

Avant-garde dance of all descriptions reached for masks to de-individualize performers. Oliver Messel's first professional commission, in 1925, was to design neo-Greek masks for Diaghilev's experimental jazz ballet *Zéphyre and Flore*, otherwise designed by Georges Braque and choreographed by Massine and Vernon Drake.[11] The more experimental the ballet, the more likely the designer was to put its dancers

[5] Shelly Erringon, 'What Became Authentic Primitive Art?', *Cultural Anthropology*, 9.2 (May 1994), pp. 201–26.

[6] 'The Face of the Nation: State Fetishism and "Métissage" at the Exposition Internationale, Paris 1937', *Grey Room*, 23 (spring 2006), pp. 96–120, p. 109.

[7] Susan Valeria Harris Smith, *Masks in Modern Drama* (Berkeley and London: University of California Press, 1984), pp. 71–2.

[8] *Five Plays* (New York: Hill & Wang, 1961), p. 49. [9] Smith, *Masks*, p. 61.

[10] Adrian Woodhouse, *Angus McBean, Face Maker* (London: Alona Books, 2006), p. 56.

[11] Charles Castle, *Oliver Messel* (London: Thames & Hudson, 1986), p. 43.

into masks. In *Ode*, one of Diaghilev's last and most experimental productions, 'a white-clad and masked group danced within a geometric limitation of spaces bounded by cords which were passed from hand to hand, creating an infinite succession of Euclidean forms about which the figures wove a complementary notation of space-images'.[12] A number of Ballets Suédois productions were masked, notably the African-styled ballet *La Création du Monde*, and Kurt Jooss, in his famous *The Green Table* of 1932, put his warmongers into masks.

The masks discussed thus have served identifiably modernist purposes of abstraction and de-individuation. But other ways of using masks were camper, or purely decorative. Masks were hung on walls, particularly in 'studios', a term for small and inconvenient flats occupied by the fashionably arty.[13] Ceramic wall masks representing fashionable women were made for purely decorative purposes by mass-market designers such as Clarice Cliff. 'They were all black and silver at first,' Angus McBean recalled, but as colour crept back, they could be lifelike or even garish.[14] The period's fascination with commedia dell'arte also made Harlequin's black eye-mask and Pierrot's white face with formalized tears beneath the eyes into a kind of shorthand for romance.

An episode in Cochran's 1921 revue, *League of Notions*, in which the dancer Grace Christie performed in a series of eerily lifelike masks made by a Polish-American specialist, W. T. Benda, was so striking that it apparently started a trend of actually *wearing* masks. Benda's masks became hugely fashionable for party wear, according to *John O'London's Weekly*, which is not necessarily reliable.[15] Life masks, made by Paul Hamann, also enjoyed a vogue. The Warren Gallery announced an exhibition of his 'Mask Portraits' in June 1930: 'Herr Paul Hamann has now perfected a substance with which life-masks can be taken subtly and painlessly. His preparation looks like tomato soup and smells faintly of vanilla.…It is the gentlest, kindliest, most coaxing process imaginable.…And the result, as you observe, is magnificent.…All this will be achieved by you and Herr Hamann if you consent to sit patiently in a chair for forty minutes.'

Oliver Messel and Rex Whistler absorbed this fashionable interest in masks, and started to make them in friendly competition when they were 17-year-olds starting at the Slade, in 1922. Having mastered the art of papier mâché, they would each make one over the weekend so as to surprise the other on Monday. The first ones were simple, based on the plaster casts of classical heads at the Slade, but they rapidly became more ambitious. Messel wrote, 'Feathers, wire, pipe cleaners, sticky

[12] Lynn Garafola, 'Dance, Film, and the Ballets Russes', *Dance Research: The Journal of the Society for Dance Research*, 16.1 (summer 1998), pp. 3–25, pp. 17–18, quoting dance critic A. V. Coton.
[13] Woodhouse, *Angus McBean*, p. 78. [14] Woodhouse, *Angus McBean*, p. 43.
[15] 'An Episode in Benda Masks', *John O'London's Weekly*, 12 Feb. 1921.

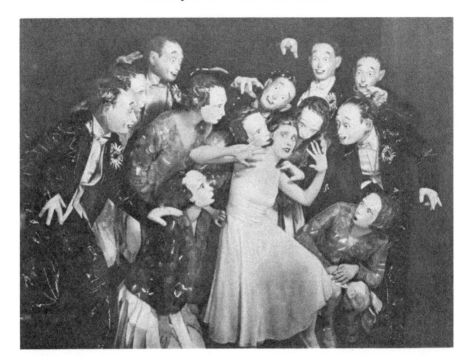

Figure 32 Miss Laurie Divine in Noël Coward's 'Dance, Little Lady', with chorus wearing masks by Oliver Messel, 1928. Photographer: Maurice Beck and Helen Macgregor. © Courtesy of *Dancing Times.*

paper and string, twisted into lace or curls and set with jewels...were added to complete the startling effect.'[16]

It was Messel who got really interested, and he subsequently held an exhibition of his own more elaborate pieces. Diaghilev became aware of them, hence the *Zéphyre and Flore* commission. Messel's mask exhibition was also seen by Cochran, who proceeded to commission several for a Noël Coward number, 'Dance, Little lady', in another revue, *This Year of Grace* (1928), where they were used to moralistic effect (see Figure 32). Cochran, pleased, said they 'faithfully reproduced the mirthless, vacuous expressions that could be seen any night in smart restaurants and clubs, where empty-looking youths danced with empty-looking girls in an empty shuffle'.[17] Whistler rapidly got bored with actually making masks, but in one of his earliest surviving works—the mural he and Mary Adshead painted for the Highway Club

[16] Laurence Whistler, *The Laughter and the Urn: the Life of Rex Whistler* (London: Weidenfeld & Nicolson, 1985), p. 56.
[17] Sarah Woodcock, 'Messel on Stage', *Oliver Messel in the Theatre of Design*, ed. Thomas Messel, pp. 54–84, p. 58.

for Boys' Memorial Hall in Shadwell, London, in 1924–5—he represents himself and Adshead as Tragedy and Comedy respectively, each one holding up a screening mask in a classical style.

Angus McBean, who was the same age as Messel and Whistler, was inspired to make masks by *Wake Up and Dream*. Unable to afford art school, he taught himself how to make masks when he was 18 and working in a bank; five years later, working for Liberty in London, he began making wall masks for sale and wearable masks for amateur theatricals.[18] He drifted into theatre design after parting company with Liberty on account of whacking a customer on the bottom with a 50-inch roll of tapestry fabric in a moment of uncontrollable exasperation, but there was clearly room for more than one mask specialist in West End theatre, because much of his income came from making masks for theatrical productions before he made his name as a photographer.[19]

Another form of masking which developed as an aspect of modernity was make-up. Twenties fashions revealed far more of a woman's body shape than had been the case for several generations, but faces, apparently perversely, were increasingly concealed beneath layers of multicoloured goo.[20] Make-up could be a brash statement of aggressive independence, and it was often read thus by men. Beverley Nichols's *Crazy Pavements* (1927) shows a nauseated fascination with make-up and its application.[21]

Make-up is artifice, mere surface decoration, which suggests that it is one of the aspects of feminine taste which modernism sought to control. However, it is far from certain whether the increasing social importance of make-up had to do with individualism and self-expression, or with reducing women to interchangeable units. The apparent uniformity of the Tiller Girls and similar dance troupes depended on the anonymizing effects of rouge and lipstick as well as on the physical disciplines of dance. The interwar period is also the point where women enter the white-collar workforce in significant numbers. Thus make-up, like fancy dress, was not merely in the service of personal fantasy. While from one point of view make-up might be considered a cynical exploitation of women's anxieties in the arena of crude sexual competition, from another it was also a way of reserving the private self.

Make-up was also a symptom of women's emancipation. The socially conservative were almost as horrified by the painted faces of girls as they were by boys wielding powder puffs. The women's movement of the 1970s came to see make-up as a conspiracy against women, but that was only part of a longer historical process which began with make-up as an act of social defiance. Elizabeth Arden (the woman,

[18] Woodhouse, *Angus McBean*, pp. 20, 43. [19] Woodhouse, *Angus McBean*, pp. 56–60.
[20] Pre-war fashion plates for Paul Poiret already show mask-like faces, with blue eyelids and red lips, but this did not reflect the ordinary style of fashionable women.
[21] Nichols, *Crazy Pavements*, pp. 39–40.

not her make-up line) was taken up as a protégée by Elisabeth Marbury, political activist, feminist, and lesbian, in the 1920s.[22]

Also, since it was a new art, cosmetics also gave opportunity to women entrepreneurs. While a cosmetic chemist has observed dryly that 'ninety per cent of the cosmetics on the market at any one time could be made by anyone with sufficient technical skill to mix a white sauce without lumps', it took remarkable personal qualities to become Elizabeth Arden.[23] Selling dreams is just as hard as selling anything else, if not harder. Arden's arch-rival Helena Rubinstein once observed, 'I believe in hard work. It keeps the wrinkles out of the mind and the spirit.'[24] But because a cosmetic empire could start from mixing up small amounts of basic ingredients in one's kitchen, the first black (American) woman to become a millionaire entirely by her own efforts was Sarah Breedlove, who created hair and beauty products for women like herself and traded as Madam C. J. Walker.[25] Her daughter A'Lelia Walker became a major salonnière of the Harlem Renaissance and patron of the arts. Helena Rubinstein, Polish by origin, emigrated to Australia, and developed her first cosmetics for European women desiccating in Australia's unforgiving sun.

Stylish and fashionable looks for women in the twenties and thirties were heavily influenced by the cinema and theatre. Imitating the stars' enamelled faces, dark, bee-stung pouts, and heavy eye make-up was daring, but fashionable. Silent-film actors needed to emphasize the eye for expressive purposes. Thus Charlie Chaplin as the 'Little Tramp' wore almost as much kohl and mascara as Gloria Swanson. Offstage, few men actually wore make-up in public, other than as fancy dress, though a few did: the 'West End Poof' was already recognizably part of the London scene, and some upper-class homosexuals—such as Stephen Tennant, Brian Howard and Neil 'Bunny' Roger, all of whom had enough money and connections behind them to weather any difficulties which might ensue—were overtly effeminate in their personal style.[26]

The widespread adoption of make-up by ordinary women also had to do with practical advances in the make-up itself. Before the First World War, lip paint, powder, eye paint, and nail decoration had been so time-consuming to apply and so evanescent that they proclaimed the wearer as professionally glamorous (whether haut monde or demi-monde). In the twenties and thirties face powder began to be pressed into compacts and became portable, and a swivel-up tube for lipstick was patented in 1923, so lip colour also became easy to carry. Jewellers were

[22] Wilson, *Adorned in Dreams*, p. 110.

[23] Terence McLaughlin, *The Gilded Lily* (London: Littlehampton Book Services, 1972) p. 142.

[24] Susanne Slesin, *Over the Top* (New York: Pointed Leaf Press, 2003), p. 62.

[25] Kathy Peiss, *Hope in a Jar: the Making of America's Beauty Culture* (Philadelphia: University of Pennsylvania Press, 1998), pp. 69–96, discusses Mrs Walker and more generally, the opportunities the beauty business offered for entrepreneurial women, even the grossly disadvantaged.

[26] Matt Houlbrook, *Queer London: Perils and Pleasures in the Sexual Metropolis, 1918–1957* (Chicago: University of Chicago Press, 2005), pp. 139, 144–9.

quick to realize that powder compacts could be made of precious materials, and they also invented a new accessory, the minaudière—a tiny evening bag/make-up kit in precious metals.

Eye make-up ceased to be the mark of an actress: Nancy Cunard, for example, was photographed with darkly ringed eyes. The ancient Middle Eastern cosmetic, kohl, was augmented by the newly invented cake mascara (invented twice, in fact, by Eugène Rimmel in 1913 and by T. L. Williams, who called his firm Maybelline, in 1917).[27] Their cake mascaras used soap as a base, so the stuff stung if it got in your eyes. The technique for weeping in old-style mascara is recorded by Colette in one of her tales of music-hall life: dabbing a tube of tightly rolled blotting paper against alternate tear ducts.[28]

Fingernails also acquired a new decorative importance. In the nineteenth century fingernails which had been polished, i.e. buffed to a shine, and perhaps stained with carmine, were an indication of complete freedom from manual labour. After a durable product was developed out of nitrocellulose car enamel by Cutex, first put on the market in 1917, the fashionable began to enamel their nails, especially the devotees of the new fad for sunbathing.[29] Pale nails with tanned fingers were considered unattractive, perhaps because the effect was Negroid, but it is probably more important that the pre-enamel semiotics of polished nails proclaimed their owner as a woman of leisure, which may go far to explain their extraordinary success. Also, like mascara, nail decoration suited film actresses by showing up effectively in black and white, and so was readily associated with glamour. But a woman wearing nail enamel could pound a typewriter all day, prepare a meal in the evening, and, with luck, go out dancing, looking—at least as far as her hands were concerned—as if she had done no such thing.

Compacts, lipstick, and nail enamels thus made glamour much more democratic, attainable in token form by thousands of young working women. Make-up rapidly came to be seen as so necessary when rationing was imposed in World War II that the availability of lipstick was considered an aspect of national morale, and thus it was not rationed, even though it had only been part of respectable women's armoury for a generation. The irresistible rise of the cosmetics industry suggests that women's response to the challenge of life in a modern city was to reach for a mask. Perhaps the surprising thing is that men did not follow their example—though it may be that the extreme conventionality of men's clothes and short-back-and-sides hair was sufficiently de-individualizing to allow them to present their naked faces to the world.

[27] Both these mascaras were soap-based and not waterproof, but were a considerable improvement on traditional lampblack.

[28] Colette, *The Rainy Moon and Other Stories*, trans. Antonia White (Harmondsworth: Penguin, 1975), p. 89.

[29] Kate Forde, 'Celluloid Dreams: the Marketing of Cutex in America, 1916–1935', *Journal of Design History*, 15.3 (2002), pp. 175–89.

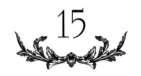

Four Dozen
White Lilies

Flowers may be baroque by virtue of being excessive, or surprising. The baroque flower paintings of Golden Age Holland are both: enormous pyramids of blooms that bring together flowers which, at that time, could never have been seen together—spring tulips, May peonies, and late summer roses, at once exquisitely naturalistic and prodigiously unnatural. Painters such as Jan van Huysum assembled their monumental compositions from sheaves of individual flower studies in notebooks.

Beyond that, Sacheverell Sitwell wrote extensively about baroque flowers and focused on the artificiality of the blooms themselves, as the seventeenth century developed them: 'By 1600, we may say that the florist's cult had been established. The variety of Pinks, Tulips, or Auriculas were, to them, a gallery of conceits or curios. It is easy to read, in the early garden books, that those who excelled in this art were regarded as virtuosos, in the old sense of that hard-tried word. Their flowers were objects of virtue, the proofs of cleverness and husbandry, more valued still for their rarity. As soon as this was acknowledged it would be the unlikely and unusual that won most applause. The fascination of flowers that were striped or feathered, that had an artificial rather than a natural effect, becomes evident. But "artificial" means a thing made or fashioned by art, and it is in this precisely that the florist's flowers consisted.'[1]

Two equally valid twentieth-century answers to the question 'what is a baroque flower?' are provided by Ronald Firbank in the same paragraph: they are either flowers that are theatrical in form and displayed in vast quantities, or flowers that are rare, exotic, out of season, and/or extraordinary in shape. In *Prancing Nigger*, set in the West Indies, Mr Mouth comments, 'She seem fond ob flowehs, pausing to notice the various plants that lined the way: from the roof swung showery azure flowers that commingled with the theatrically-hued cañas, set out in crude, bold,

[1] Sacheverell Sitwell, *Old-Fashioned Flowers* (London: Country Life, 1939), p. 2.

colour-schemes below, that looked best at night. But in their malignant splendour the orchids were the thing. Mrs. Abernathy, Ronald Firbank (a dingy lilac blossom of rarity untold), Prince Palairet, a heavy blue-spotted flower, and rosy Olive Moonlight, were those that claimed the greatest respect from a few discerning connoisseurs.'[2]

'Orchidaceous' is a polite term of the period for overwritten prose. And of all the prose styles in the world, Firbank's may be the one which most deserves to have orchids cast at it. He here shows how flowers can either be astonishing in themselves, or be used to create a theatrical setting, a statement of luxury, a startling yet temporary effect. Baroque art, as Croce pointed out, is 'dominated by the need to astonish'.[3]

Flowers were an indispensable adjunct to glamour and fashionable astonishment. After his career was established by the huge success of *Richard of Bordeaux* (1932–4), John Gielgud spent lavishly on flowers for his dressing room, supplied by Constance Spry: all part of being an actor in the grand manner. Two of Spry's other contracts were to decorate the salons of the couturiers Victor Siebel and Norman Hartnell when they showed their preview collections.[4] French couturiers also spent massively on flowers. In the mostly glass house of the Parisian celebrity hairdresser Antoine, discussed in chapter 6, 'the cold austerity [was] softened by the huge bunches of white lilies which were replaced daily'.[5] Gossip columnists reported on flowers as well as frocks: on Lady Ribblesdale's luncheon table decorated with flame-coloured azaleas and blue delphiniums, which will have been colourful to say the least; on Lady Astor's house 'literally lined with lilacs' for a ball;[6] or Philip Sassoon's parties, where 'every inch of unused floor in hall and gallery was packed with sweet hyacinths'.[7]

Excess is an important baroque quality of the interwar use of flowers. Practically any flower can be baroque if there's enough of it. One word often attached to flowers by interwar aesthetes is 'massed'. Of the medieval Gothic windows newly installed in his bedroom, Stephen Tennant gasped, 'They are so beautiful—I nearly fainted, they open into the room and mauve magnolias, white lilac & pinks are massed in them & floodlit—no words can describe the loveliness of the juxtaposition of fresh foliage & petals with the 14th century stone.'[8]

Lady Ida Sitwell spent £16 15s. 8d. on exotic flowers in the month of February 1904: tuberoses, gardenias, carnations, lilies, lilies of the valley, lilac, and a whole orange tree. 'Her love of flowers,' her son Sacheverell recalled, 'was

[2] Ronald Firbank, *Prancing Nigger*, first published as *Sorrow in Sunlight* (London: Brentano's, 1924), pp. 96–7.
[3] Benedetto Croce, *La Storia de l'età Barocca in Italia* (Bari: Laterza, 1957), p. 34.
[4] Dorothy Cooke and Pamela McNicol, *A History of Flower Arranging* (London: Heinemann, 1989), p. 188.
[5] Martin Battersby, *The Decorative Twenties* (New York: Walker, 1969), p. 79.
[6] Susan Shepherd, *The Surprising Life of Constance Spry* (London: Macmillan, 2010), p. 118.
[7] Philip Tilden, *True Remembrances: the Memoirs of an Architect* (London: Country Life, 1954), p. 41.
[8] Philip Hoare, *Serious Pleasures: the Life of Stephen Tennant* (London: Hamish Hamilton, 1990), p. 223.

overwhelming: the rooms, summer and winter, were crowded with lilies and tuber-oses and stephanotis.'[9] To put this figure in proportion, the annual wages of a lady's maid in the 1900s were £32, those of a kitchen maid, £24. Flowers are more expensive in winter, but this figure suggests that Lady Ida must have spent a good £150 a year on them. She would have said that her passion for flowers was self-explanatory, but there are other reasons why her extravagance took this particular form: she could, after all, have filled her room with perfume by alternative means. But hothouse flowers were so expensive that they were an immediate index of wealth and, for other reasons, flowers were a marker of elegance and status.

It is worth pausing over the practical aspects of keeping a room full of flowers year-round. One important issue with cut flowers, given their short shelf life, is where they come from. Before the First War, the capacity to display elaborate floral decoration emerged out of a country house economy. Many of the flowers which appeared in smart London drawing rooms were grown in glasshouses on their owners' country estates and sent up to London for use in the owner's town house. It was the head gardener's duty to ensure there was a supply, which meant glasshouses and, often, hothouses. The flowers were carefully packed in wooden boxes, sprayed with water, and sent up by train.[10] If necessary, or for grand occasions, they were supplemented via London's great flower market at Covent Garden. Thus flowers were, like pheasant and venison, a symbol of an aristocratic way of life. It is for this reason that, in 1927, the 22-year-old Edward Burra sends a present of garden stuff from his parent's mansion at Playden to his best friend Billy's mother in Balham, and is also why it was so gratefully received (Billy's mother was 'a lady', living in reduced circumstances after an imprudent bohemian marriage). 'Edykins,' Billy writes, 'Mama says ta for the peas the gooseberries the roses what a lush still life the words produce. Mother is touched to the quick and says thank you thank you thank you.'[11]

In the twenty-first century flowers are grown in the tropics and flown to Britain in their millions, provoking a good deal of hand-wringing on the twin topics of sustainability and environmental damage: 10,000 tonnes of Kenya-grown roses are bought and sold for Valentine's Day alone, four months before their natural season in Britain.[12] They have become a cheap indulgence, but they used to be an extremely expensive luxury, especially in the winter months. Doris Langley Moore, who was sensible, solidly wealthy, married to a wool merchant and living near Harrogate, wrote in 1936, 'Unless you are so absurdly rich, and so unbearably ostentatious, that you can afford to have flowers sent by aeroplane from foreign climes when those you fancy are unprocurable here, you will be limited to what the

[9] Sarah Bradford, *Splendours and Miseries* (London: Sinclair-Stevenson, 1993), pp. 27, 32.

[10] Toby Musgrave, *The Head Gardeners* (London: Aurum Press, 2007), p. 87.

[11] Tate Gallery Archive 939.2.4, BC to EB 14 July 1927 from 35 Darnton Road.

[12] Ashley Seager, *The Guardian*, Wednesday, 14 Feb. 2007.

season, or at any rate the hothouse, yields.'[13] But absurd riches and unbearable ostentation were not unknown between the wars: as early as 1933 cut flowers constituted more than a fifth—22 per cent—of the airfreight carried by Lufthansa, and were the eighth most common airfreighted item in the USA.[14] When Constance Spry did the flowers for Lady Mendl's Circus Ball in 1938, she shipped three planeloads of blooms over to Paris packed in cotton wool. Lady Mendl took a whole year to pay the flower bill for that particular party.[15]

Given the British climate, winter was obviously difficult for flower addicts unless they really were absurdly rich, or as extravagant as Lady Ida. Gertrude Jekyll declared, with some optimism, in 1907 that 'in large places, there will be stove-grown orchids throughout the year, including winter', and some other plant species can be coaxed into winter flowering by a skilled gardener, notably geraniums and jasmine. Fragrant mimosa, a hybrid between Australian and European acacias, remains true to a southern hemisphere timetable so is naturally winter-flowering, though unfortunately it is not hardy beyond the southern Mediterranean. Its sprays of scented yellow pompoms were brought from the Côte d'Azur by train in slatted wicker baskets, a trade which began when the rail link from the Channel to the Mediterranean was established in the 1870s. Other flowers which were sent by train from the south of France included spring-flowering ranunculus, anemones, parma violets, and eucalyptus (both the handsome grey-green foliage of various species, and the white, winter-appearing flowers of E. globulus).[16] Trade in flowers from further afield was undeveloped, though by the thirties chincherinchee (Ornithogalum)—white, fragrant, and amazingly long-lived as a cut flower—was sent by ship from South Africa, in cold storage. The Cape Mail Express took nineteen days over the journey, and nothing else lasted long enough to be worth carrying.[17] When Loelia Ponsonby was being energetically wooed by Bendor Grosvenor, the hugely wealthy Duke of Westminster, there were 'almost daily deliveries of flowers. For some reason he always sent South African chincherinchee'.[18] Miss Ponsonby was evidently too nicely brought up to realize that the reason was that they were shatteringly expensive.

Even in the 1930s there was only a handful of flower shops in London, notably Edward Goodyear, who supplied Buckingham Palace, Moyses Stevens and Felton in the West End, and Longman's and William Hayford in the City.[19] Otherwise,

[13] June and Doris Langley Moore, The Pleasure of Your Company (London: Rich & Cowen, 1936), p. 89.

[14] Wayne L. McMillen, 'Air Express Service in the United States', The Journal of Land & Public Utility Economics, 11.3 (Aug. 1935), pp. 266–77, pp. 271, 273.

[15] Shepherd, Constance Spry, p. 203.

[16] Cooke and McNicol, A History of Flower Arranging, p. 183.

[17] Constance Spry, Flower Decoration (London: John Dent & Sons, 1934), p. 38.

[18] Grace and Favour: the Memoirs of Loelia Duchess of Westminster (London: Weidenfeld & Nicolson), p. 152.

[19] Cooke and McNicol, A History of Flower Arranging, p. 181.

customers could go to the Floral Hall at Covent Garden and buy directly from the wholesalers, or buy from the real-life Eliza Doolittles who hawked bouquets and buttonholes from barrows or, at an even more marginal level, from baskets. These poor women usually had to borrow the capital outlay for their day's investment, at extortionate interest, and it followed that they only carried the cheapest seasonal flowers. Displaying exotic blooms therefore connoted wealth and social standing to an extent which went beyond their monetary value, though that was certainly considerable.

Surprisingly often, the flowers which created mass theatrical effects, or stunned ball-goers with their perfume, were white. All of Lady Ida's favourites were white, and white flowers such as lilies, tuberose, and gardenia are central to the narrative of beauty, luxury, and glamour in the twenties and thirties. This mania for white flowers may have been partly to do with the era's penchant for monochrome, but another major reason is that many showy and highly perfumed flowers simply *are* white, for botanical reasons. Small and simple flowers, like apple blossom, or the many species with multiple small florets, such as lime and lilac, are pollinated by bees and other day-flying insects. Flowers which are individually large and sculpturally shaped are generally pollinated by night-flying moths, and therefore tend to be white, because it shows up best at night: if one walks in a garden at twilight, the flowers start to disappear, and the white blooms are the last to vanish. These are also the flowers which invest in producing powerful perfumes, to help moths find them in the dark.

In conventional pre-war households it was considered good form not to mix flowers. Arrangements consisted of sweet peas, peonies, roses, or chrysanthemums, according to the season.[20] It was Constance Spry, more than any other individual, who revolutionized the world of flowers as decoration in the interwar period. She suddenly erupted out of a meritorious but drab career in education and social reform at the behest of two aesthetic bachelors whom she met at a lunch party in 1928: Sidney Bernstein, a media mogul in the making (much later, he founded Granada TV), and the theatre designer Norman Wilkinson, whose best-known work at the time was the set and costumes he designed for Harley Granville-Barker's famous production of A Midsummer Night's Dream at the Duke of York's Theatre in London in 1914. This was notable for its iridescent forest, and its fairies in gilded make-up with crimson eyebrows and bronze costumes.[21]

Struck by her personal style and the engaging way she talked about flowers, Bernstein asked Spry to design flowers for his chain of cinemas; Wilkinson, simultaneously, begged her to do shop-window displays for a newly built parfumier, Atkinson's in Bond Street. Atkinson's was a very upmarket firm: it was they who

[20] Lesley Lewis, *The Private Life of an English Country House 1912–1939* (Stroud: Alan Sutton, 1992).
[21] Shepherd, *Constance Spry*, p. 91.

Figure 33 Atkinson's Scent Shop. Photographer: Unknown. © *Country Life.*

were asked to supply Her Majesty's miniature toilet requisites for Queen Mary's doll's house.[22] After a brief hesitation, she threw up the day job.[23]

Wilkinson himself was passionate about flowers, and a devotee of 'massing'. On her first visit to his home, an early eighteenth-century mansion overlooking the Thames, Strawberry House in Chiswick, Spry saw shallow, straight-edged dishes tight-packed with narcissi and, in alcoves in the dining room, two sanguinary arrangements: large, shallow marble bowls filled with a tight mass of scarlet geraniums, red camellias, and dark-red roses, lit from above by concealed spotlights in the alcove ceilings.

Wilkinson's design for Atkinson's art deco parfumier's had the subaqueous feel so common in modern baroque interiors (see Figure 33). The walls were covered in special mirror glass with a silvered, antiqued finish which dimmed and subdued the reflections. There were chandeliers set in silver starbursts, and cascading chains of lustres illuminated by spotlights, a decor which seems designed to be photographed in black and white, and probably was. Constantly renewed fresh flowers were a final

[22] Mary Stewart-Wilson, *Queen Mary's Dolls' House* (London: Bodley Head, 1988), p. 88.
[23] Shepherd, *Constance Spry*, p. 83.

touch of elegance and luxury suitable for such an upmarket concern. The twin demands which Wilkinson made of his new collaborator were that the flowers she used should be dramatic and unusual, and also, if possible, that they should be scented. Spry exceeded expectations by invoking another baroque principle, that of unexpected juxtapositions and unusual materials. Her outré arrangements, involving leaves, berries, and seed heads along with expensive exotic flowers, brought crowds to the shop window each day to see what she would do next.

Thus far the legend. Constance Spry's arrangements were actually not quite as original as they appeared. Gertrude Jekyll published a book on flower arrangement in 1907. For winter she recommended combining greenhouse arums with the leaves of evergreen shrubs and the bright berries of *Iris foetidissima*; in April, using whole branches of *Magnolia stellata*, japonica, and rhododendron, and combining these with white and purple tulips. She also suggested combing the hedges for wild plant material, recommending rose hips, wild arum, and black ivy berries to complement imported anemones sent from the south of France.[24] It seems therefore ungenerous, not to say disingenuous, of Constance Spry to dismiss her predecessor, as she does: 'There are books by eminent gardeners whose knowledge and love of flowers is so great that their views command respect, but it is natural that they should treat the subject from the point of view of displaying flowers rather than decorating rooms.'[25] However, there is no doubt that Constance Spry's ravishingly up-to-date-looking book of 1934, with its modernist cover of grey and black blocks some way after Mondrian and its sans-serif lettering, was infinitely more influential; even if not all the ideas in it were quite new, they were put over with stunning confidence.

The fashion for foliage spread out in avant-garde circles: as early as 1930, Edward Burra writes about a bouquet made to be presented to the prima ballerina Lydia Sokolova after a London performance of *Le Sacre du Printemps*: the designer, Sophie Fedorovitch, 'insisted on having corn so having climbed over a high hedge full of brambles we picked an imense [*sic*] sheaf of corn & staggered back with it looking like a bit of old Russia as Gerry [the economist Gerald Reitlinger] said such a useful bouquet as with a little grinding & kneading you could make ever such an economical pudding with it.'[26]

Another recommendation of Constance Spry's which is not as original as it might be, since she had seen such arrangements at Norman Wilkinson's house, was to display close-packed flowers in rectangular tanks. This particularly suited modernist rooms: Sheila Macqueen, who worked for Constance Spry Ltd in the thirties, was regularly sent to arrange rectangular glass accumulator tanks in the house of the

[24] Gertrude Jekyll, *Flower Decoration in the House* (London: George Newnes, 1907), pp. 29, 150–8.

[25] Constance Spry, *Flower Decoration* (London: J. M. Dent, 1934), p. 4.

[26] Edward Burra, *Well Dearie! The Letters of Edward Burra*, Aug. 1929, ed. William Chappell (London: Gordon Fraser, 1985), p. 71.

indefatigably fashionable Mrs Wallis Simpson.[27] She did not appreciate them. 'She had these three horrible battery flasks. Rubbish things. They probably don't exist any more—simple plain glass containers in which they used to put old-fashioned accumulator batteries. I had to display my bouquets in those. I expected her to have had some magnificent pieces. They were awful.'[28] Macqueen may not have liked them, but this particular idea had a highly respectable interwar baroque pedigree, since it originated with Jean-Michel Frank. When the painter Thomas Lowinsky suggested up-to-date table decorations in his wife Ruth's 1931 cookbook, *Lovely Food*, they included 'two dead branches, one painted red and the other white to resemble coral, in an accumulator jar'. After nearly a hundred years, the idea still seems to have plenty of life in it, since almost every florist still sells rectangular tanks.

Spry was partial to the shock value of extreme contrast: 'In a room of verdigris green,' a highly fashionable shade for those not devotees of the all-white look, 'put a vase of magenta flowers.' She also appreciated mixing 'scarlet and crimson, vermilion, rose and magenta. Add quite crude and strong shades of pink and reddish-purple, and you will achieve an effect, not harsh and clashing, but brilliant and alive', an idea which is doing sterling service, eighty years later, in the capable hands of Sarah Raven.[29] Or alternatively she suggests that, 'In a white room, an alcove or niche filled with white lilac is a highlight. Take off the leaves of the white lilac.'[30] It was arrangements of this kind that she made for the rooms of Syrie Maugham and her clients. Cecil Beaton, typically, went one better and replaced the leaves of his white lilac with artificial ones made of cellophane.

Much of Spry's treatment of flowers was highly artificial. For a wedding bouquet to be carried by a bride in gold lamé she mounted individual camellia heads on long wires bound with gold gauze, so that the stems disappeared, producing the effect of a disembodied camellia star.[31] Whatever else you could say about Spry's arrangements, they would not have come cheap. For January she envisaged hyacinths, tulips, lilies of the valley, pure white cyclamen, and carnations massed in long shallow bowls. 'In winter,' she says breezily, 'we get sent from South Africa chincherinchee...use it in quantity.'[32] She was, after all, in business to sell flowers (see Figure 34).

According to Oliver Messel, Syrie Maugham was one of the first people to use Constance Spry's flower arrangements for parties. For Maugham, Spry set *Magnolia soulangeana*, the petals of which are purple outside and white inside, with blackish-purple *Iris susiana* in Victorian soup tureens modelled in the form of green

[27] Cooke and McNicol, *A History of Flower Arranging*, p. 187; *Flower Decoration*, p. 28.

[28] Interview, John Edwards, 'Flowers fit for a king's mistress', *Daily Mail*, 21 May 2003.

[29] *Grow Your Own Cut Flowers* (London: BBC Books, 2002). [30] Spry, *Flower Decoration*, p. 6.

[31] Spry, *Flower Decoration*, p. 82. [32] Spry, *Flower Decoration*, pp. 12, 38.

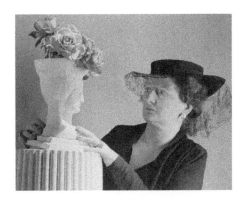

Figure 34 Constance Spry contemplating an arrangement which seems indebted to several 'Femme à la tête de rose' predecessors: Cocteau's jacket for Schiaparelli, Dalí's painting of that name, and the rose-headed woman at the International Surrealist Exhibition, London, 1936. Photographer: André Kertész. © Estate of André Kertész/Higher Pictures.

cabbages—humble imitations of the exquisite Chelsea porcelain trompe l'oeil dishes of the eighteenth century.[33] The fact that violet, white, and green were the suffragette colours is probably adventitious. Highly avant-garde people unconnected with Spry had similar ideas, suggesting that daring flower arrangements had become an important part of smart interiors. Another of Lowinsky's arrangements was 'any large Staffordshire cottage surrounded by big white roses'. He means a nineteenth-century glazed terracotta mantelpiece ornament, Victoriana perversely liked by interwar aesthetes. Just as Spry used decorative kales and other vegetables in her arrangements, Sara and Gerald Murphy's Paris apartment (stark white walls, glossy black floor, white rugs) was adorned with stalks of pale green celery in black or white opalescent vases.[34]

It is perhaps due to Mrs Spry's capacity to think of new ways of displaying them, coupled with her association with Syrie Maugham, that flowers became more and more of a feature of fashionable parties. Spry invented wall vases, flat on one side, which could be hung on the wall of a ballroom or marquee out of harm's way. For a truly grand effect, she suggested swags of flowers on the walls: 'They take an enormous quantity of flowers.'[35] A less expensive version could be achieved with swagged ropes of muslin or tarlatan, tied with knots of flowers at intervals. In either case, the effect would have been eighteenth-century, an evocation of the floral swags characteristic of fine rococo plasterwork, but using real flowers.

[33] Charles Castle, *Oliver Messel* (London: Thames & Hudson, 1986), p. 93; Spry, *Flower Decoration*, p. 16.
[34] Amanda Vaill, *Everybody was so Young* (London: Warner Books, 1999), p. 116.
[35] Spry, *Flower Decoration*, p. 92.

Spry grew surprisingly large quantities of her material herself, especially foliage and old roses, since her unusual demands were not initially catered for by the flower trade; and, like Sophie Fedorovitch, she pillaged fields and hedgerows. All the same, early-morning visits to the great flower market at Covent Garden were essential for her; she needed the hothouse show-stoppers which blazed among her dead bracken, curly kale, and rhubarb: the orchids and lilies and narcissi. She also used a great many shrub flowers, and where these came from is quite a question. Lilies, tuberose, et cetera are bulbs and therefore quick-growing, so supply could quite rapidly be brought into line with demand, but if a florist wants to harvest 3-foot branches of woody shrubs in vast quantities, then somewhere in the background there must be gardens with huge mature plants, and these cannot be conjured out of thin air in answer to changing fashions.

Fortunately, the scale of Edwardian grand gardening had been awe-inspiring and, consequently, the great gardens of England had acquired a commercial aspect by the twenties. As Toby Musgrave explains, a head gardener was running three sub-businesses: 'There was the market garden—the open space and glasshouses growing all the vegetables and fruits for the dining table; the floristry—cut flowers and pot plants raised for house decorations and to fill the conservatory; and the nursery—each year (tens of) thousands of seasonal bedding plants had to be raised in order to fill the formal gardens.'[36] At the turn of the twentieth century, when labour was extremely cheap, there were seventy gardeners at Cragside, Northumberland, and at Waddesdon Manor, Bucks., a hundred.

Part of the contractual agreement made between a head gardener and his employer was that he was entitled to sell surplus produce. Lionel de Rothschild bought Exbury, with a 250-acre estate, in 1912, to feed his personal passion for azaleas and rhododendrons, which he hybridized with great success. Successive members of the Rothschild family continued his work and made it into a great garden. But in the late twenties the head gardener's glasshouses were also producing industrial quantities of lilies and white arums for Constance Spry, at the behest of Basil Unite, who was in charge of the lily department of Munro's, the biggest wholesale florist in Covent Garden. Flowers for the 'big house' were selected and arranged by the head gardener, which raises something of a question as to how invariably the proprietor was aware of his garden staff's business activities, and whether the big house necessarily got the pick of the crop.[37] Possibly, given the increasing difficulty of keeping up with the running costs of such estates in a post-war world, owners took a cut.

[36] Musgrave, *The Head Gardeners*, p. 94.

[37] Sarah Bradford et al., *The Sitwells and the Arts of the 1920s and 1930s* (London: National Portrait Gallery, 1994), p. 19.

The relationship between Mrs Spry and Lady Mount Temple, who had a great garden at Broadlands in Hampshire, certainly suggests a possible symbiosis between landowners and flower sellers. Lady Mount Temple employed ten male gardeners and two girls. The girls' main work was to pick and arrange flowers for the large weekend house parties. That used up flowers which came into bloom Wednesday–Thursday–Friday. But they also made up baskets of cut flowers for Constance Spry's shop, which were dispatched to town early on Monday morning, and therefore made good use of the blooms from the other half of the week which would otherwise have gone to waste. If Lady Mount Temple wanted flowers for Gayfere House, her London home, she bought them from Mrs Spry, who in the end became the actual employer of the girls as her business expanded.[38] The arrangements for Gayfere House which appeared in *Country Life* photographs were modelled on Dutch baroque flower-pieces, and 'the choice, arrangement and positioning of flowers also played a significant part in the decoration of the room: this must have been considered novel at the time, because the two vases of real flowers and the arrangement of artificial ones...are mentioned in the article as being by Flower Decorations' (i.e. Constance Spry).[39]

Mrs Spry's need for big branches of flowering trees such as magnolia and rhododendron was supplied by the huge, established gardens of the great plantsmen—though again, whether this was entirely with the owners' knowledge and consent is far from clear. Flowering trees need to be pruned and thinned, to be sure, but this is not generally undertaken at the point when they are about to burst into bloom. Exbury, as well as providing lilies, gave Spry some of her rhododendrons; Caerhays supplied her with large quantities of its magnolias and camellias; the Fox family's Glendurgan, near Falmouth, because of the mild Cornish climate, could supply early blossoms, as could Trebah, also in Cornwall, which had collections of hydrangeas and rhododendrons. Excess and surprise were spectacularly catered for, and flowers, almost by virtue of being supremely unnecessary, had become a cornerstone of what it meant to be wealthy and fashionable.

[38] Shepherd, *Constance Spry*, p. 110.
[39] John Cornforth, *London Interiors from the Archives of Country Life* (London: Aurum Press, 2009), p. 29.

16

Flowers in the Abstract

Women such as Lady Ida Sitwell evidently valued flowers for their perfume as well as their shapes, since most of their favourites were heavily scented. They were apparently attracted to odours which they could not have worn, since scent was socially coded.[1] The demi-monde of prostitution was associated with, and often favoured, sensual animal-musk perfumes, but the heavy, tropical, white-flower perfumes such as tuberose, frangipani, and stephanotis were also associated with courtesans. The association of catching a whiff of such a perfume from a woman was racy, and perhaps illicit. The oriental perfumes, such as frankincense, myrrh, and patchouli, carried a variety of associations, notably with incense and therefore with Catholic churches, and also, not coincidentally, with decadence. Consequently, before the First World War respectable women wore simple fragrances based on single flowers such as rose, lavender, violet, or lily of the valley, such as Coty's 'La Rose Jacqueminot', a top seller.[2] Alternatively, they wore the even lighter semi-medicinal, citrus-scented eaux de cologne which were used throughout the nineteenth century to ward off headaches or to refresh the skin, and were also used by men. In Joris-Karl Huysmans' notorious *À Rebours* (1884), he represents perfume blending as self-evidently baroque and decadent: his anti-hero des Esseintes goes in for it, 'forcing, to grow together, in despite of seasons and climates, trees of diverse essences, flowers of colours and fragrances the most opposite, creating by the blending and shock of all these tones one common perfume, unknown, unforeseen, extraordinary'.

Perfumers, like other contemporary artists, found that their field of endeavour was revolutionized by the invention of new materials, and also by the fascination with abstraction which was an inescapable aspect of modernity. Their particular new materials were aldehydes: laboratory-made organic molecules based on carbon, most of which are strongly scented. The aldehydes changed perfume for ever. Tinkering with their molecular structure produced one strong smell after another,

[1] As was what it was called. Subsequent elaborations of Nancy Mitford's/Alan Ross's celebrated distinction between U and non-U speech habits assert that 'scent' is U, 'perfume' non-U.

[2] Tilar J. Mazzeo, *The Secret of Chanel No. 5* (New York: HarperCollins, 2010), p. 43.

some of them lovely, others revolting; now waxy, now citrusy; or shading to liquorice, or to rotten fruit. Some, such as vanillin and coumarin (which smells like freshly cut hay), resembled natural odours; others did not. As Tilar Mazzeo observes, 'This molecular precision freed perfumes from the bonds of representational art as surely as Pablo Picasso freed painters.'[3] Perfume had thus become an abstract art.

Aimé Guerlain's 'Jicky' (1889), which combines 'good' lavender and 'bad' patchouli with vanillins and coumarin, and, like a cologne, was unisex, was one of the first successful perfumes to exploit these synthetics (it is still made). Another milestone was Houbigant's 'Quelques Fleurs' (1912), which, as the name suggests, was flowery, but indeterminate. As the name implies, it was a bouquet, a new concept in itself, and bad girls' tuberose and jasmine are in there along with good girls' orange blossom and lily. As war approached and the cubists started cutting up and reassembling the human face, perfumers had, in their own field, also taken an important step away from naturalism.

The existing semiotics of perfume was triumphantly abolished by perhaps the greatest, and certainly the most successful, perfume of all time: 'le monstre', as parfumiers apparently call it. 'Chanel No. 5' is a truly abstract scent, and in that respect both modern and profoundly baroque. Chanel declared: 'I want to give women an artificial perfume. Yes, I do mean artificial, like a dress, something that has been made.'[4] She worked together with perfumer Ernest Beaux, who overhauled an earlier invention of his, 'Rallet No. 1', which he had made for the Russian market before the revolution. 'Chanel No. 5' includes enormous quantities of jasmine along with ylang-ylang, which is a 'heavy white' flower perfume with an almost rotten–ripe quality, and the wholly respectable *Rosa centifolia* which had formed the base of Coty's 'La Rose Jacqueminot'. Light and fresh neroli, also known as orange-flower, plays a part in it, as does 'oriental' sandalwood— again, crossing semiotic categories. But additionally, like its prototype 'Rallet No. 1', 'Chanel no. 5' includes synthetic aldehydes. Beaux chose molecules with the cold, austere scents of winter, Arctic snow, and clean, fresh linen, which cut the sweetness, as Beaux himself said, like lemon on strawberries. Chandler Burr, the *New York Times* perfume critic, memorably described the result as 'like a bank of hot searchlights washing the powdered stars at a movie premiere in Cannes on a dry summer night'.[5]

'No. 5' was the perfect quintessence of the new possibilities open to the flappers who had cut their hair and their skirts, worked for a living, took lovers, drank, and smoked. The costume historian James Laver described them thus:

[3] Mazzeo, *The Secret*, p. 45. [4] Mazzeo, *The Secret*, p. 103.
[5] Kate Shapland, 'Chanel no. 5: enduring love', *Daily Telegraph*, 7 May 2009.

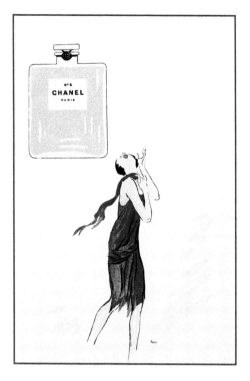

Figure 35 'Sem' (Georges Goursat, 1863–1934), 'Chanel No. 5', watercolour.

Mother's advice, and Father's fears,
Alike are voted—just a bore.
There's Negro music in our ears,
The world's one huge dancing floor...
We've silken legs and scarlet lips,
We're young and hungry, wild and free,
Our waists are round about the hips
Our skirts are well above the knee

We've boyish busts and Eton crops,
We quiver to the saxophone.
Come, dance before the music stops,
And who can bear to be alone?
Come drink your gin, or sniff your 'snow',
Since Youth is brief, and Love has wings,
And time will tarnish, ere we know,
The brightness of the Bright Young Things.[6]

[6] Writing as 'Jacques Reval', *The Woman of 1926* (s.n., s.l., 1926).

For girls of this kind, or girls who wanted to be taken for girls of this kind, 'La Rose Jacqueminot' was no use, and neither were courtesan scents such as 'Chypre'. No wonder 'Chanel No. 5' became the perfume of the era. The caricaturist Georges Goursat ('Sem') summed up its effect in a drawing of 1921 which depicts a young woman with bobbed hair, a long scarf, and a knee-length frock, head thrown back with Dionysiac abandon as she worships a giant bottle of 'Chanel No. 5'. This was not an advertisement, though it looks like one (see Figure 35): it was social comment.

17

The Ghost of a Rose

Ballet is one of the pivotal arts of the interwar period, because it was embraced by the avant-garde in both England and France. Ethel Mannin, very much a figure of the left, wrote simply of the twenties, 'The decade is redeemed by the fact that it was the decade of the Russian Ballet.... There was nothing like the Russian Ballet for making one feel that one had grown wings and soared amongst the stars.'[1] But ballet is unexpected as a central form of aesthetic expression in the era of modernism. It is a baroque art in several senses. Historically, it originates at the French court in the seventeenth century; like opera, fireworks, and high fashion, it is ephemeral and an art of spectacle; it is intrinsically collaborative, and it is also dependent on patronage. Any art which requires dozens of individuals to be supported through years of dedicated training can never be a fully commercial proposition. When Lincoln Kirstein told potential backers for the embryonic New York City Ballet that 'this was the art form that brought together the greatest range of creative people ... out of which everyone might receive a cut from the box office', he was either monumentally naïve or, more probably, disingenuous.[2] But he was right about the range of creative excellence required. To make a great ballet, the costumier and set designer, choreographer and composer all have to achieve at the highest level; the idea of the ballet must have been a good one in the first place, and without top-class dancers to embody it, nothing will come over at all.

Ballet's relationship with modernism is uneasy. It is collective and collaborative rather than individualistic, which sets it at an angle to any idea of art as the product of a purely individual consciousness. Balletic training replaces natural walking, running, and bounding with a set of subtly modified movements which, after a gruelling amount of work, become, in the most literal sense, second nature. As Levinson pointed out in the twenties, 'There is nothing more unnatural than the fundamental posture of the ballet technique, the feet turned directly outwards, but the result of this habit achieved by years of gymnastic training is not only a balance

[1] Ethel Mannin, *Young in the Twenties* (London: Hutchinson, 1971), pp. 112, 114.
[2] Nicholas Fox Weber, *Patron Saints: Five Rebels who Opened America to a New Art, 1928–1943* (New Haven and London: Yale University Press, 1995), p. 187.

which surmounts all difficulties, but also an extraordinary amplitude of movement.... The accomplished dancer is an artificial being, an instrument of precision.'[3] Thus modified, the dancer's body can perform movements which, if attempted by the untrained, would result in serious injury. The necessary relationship with tradition implicit in this was an obvious target for modernist iconoclasm. Clement Greenberg's definition of modernist art was that it 'lies in the use of the characteristic methods of a discipline to criticize the discipline itself'.[4] That is possible for ballet only up to a point, without its ceasing to be ballet.

Both modernist art and modernist writing tended to place the artist's own activity centre stage. Just as modernist literature most typically explores language, modernist painting elaborates problems of the medium and is about abstract light, space, and colour.[5] In the same spirit, the modernist approach to dance was to deconstruct ballet's venerable and subtle art and start again from the ground up. In their different ways, artists such as Isadora Duncan, Rudolf von Laban, Kurt Jooss, and Martha Graham evolved expressive dance forms based on natural movement. Each, in his or her own way, was highly successful, but what they produced was not ballet.

The man who made ballet a crucible of the new rather than a violet-scented echo of the past was Sergei Diaghilev. It is not merely that he was one of the genius impresarios of history, able to assemble a troupe of the best dancers in the world and showcase their abilities effectively, but, because he made ballet a fashion, he created a milieu in which almost everyone with any pretension to culture flocked to see Nijinsky, Karsavina, Fokine, and their post-war successors, and in so doing found themselves exposed to avant-garde music and art which would otherwise have struggled to find an audience.

One of the most important things Diaghilev achieved, as Lynn Garafola observed, was to change the status of the artists who worked with him.

> Diaghilev's role in the creation of the market for modern art is a neglected aspect of his multifaceted career. Yet there is evidence suggesting that his intervention at this time was crucial, not so much as the catalyst of a phenomenon that was well under way, but in expanding the market and accelerating the commercialization of work by younger artists.[6]

A ballet commission from Diaghilev was a way of establishing commercial value, because it put specimen work in front of a large audience of wealthy opinion-formers with an interest in the arts, and also because his reputation as a talent

[3] *André Levinson on Dance*, ed. Joan Acocella and Lynn Garafola (Hanover and London: Wesleyan University Press, 1991), pp. 33, 47.

[4] *Forum Lectures* (Washington, DC: Voice of America, 1960), reprinted in *Arts Yearbook* 4 (1961).

[5] Elizabeth Wilson, *Adorned in Dreams: Fashion and Modernity* (London: Virago, 1985), p. 62.

[6] Lynn Garafola, *Diaghilev's Ballets Russes* (Oxford: Oxford University Press, 1990), p. 257.

spotter was so strong. When he commissioned Picasso, he was not taking advantage of the painter's following so much as helping to set him on the road to fame and fortune. Picasso had, as Steegmuller puts it, 'left poverty behind' when he designed *Parade* in 1917, but he had not yet achieved either fame or affluence.[7]

Diaghilev was a constant innovator, and was often ahead of the game. Many, even most, of those pressed into his service were not yet famous. There is an illuminating letter from the young composer George Antheil to his fellow American Ezra Pound which reveals Diaghilev's role as kingmaker and, incidentally, the importance of Osbert Sitwell as well as that of Pound himself: 'I wish you would have another go at Sitwell to get at Diagiliew. Don't tell him that Kochnow [Boris Kochno, Diaghilev's right-hand man] has made a tentative acceptance, but make him get at Diagiliew, just as if nothing had happened.'[8]

In 1910 Igor Stravinsky arrived in Paris for the first time to hear the first ballet Diaghilev had commissioned from him, *The Firebird*. He was then 28. 'Take a good look at him,' Diaghilev said to the orchestra. 'He's about to be famous.'[9] Stravinsky went on to produce a series of remarkable works for Diaghilev. Though *The Rite of Spring* is the most famous, *Les Noces* (1923) was musically revolutionary in the way it was built up, especially in using a chorus quasi-instrumentally.[10]

The visual impact of the Ballets Russes was equally extraordinary. Before World War I Russian designers such as Léon Bakst and Sonia Delaunay detonated an explosion of colour which changed smart taste overnight. The iconic images of the Ballets Russes, such as the Fokine–Bakst–Rimsky-Korsakov *Schéhérezade*, are from before the First World War, and Nijinsky, the male dancer most enduringly associated with the Ballets Russes, was actually fired in 1914, but their influence on the interwar period was considerable. Ballets Russes orientalism changed fashions in clothing. It helped to make the fortune of Paul Poiret, the most notable couturier to translate Bakst from the stage to the drawing room, banishing corsets, advocating the nearest thing yet seen to trousers for women (*jupes-culottes*), and encouraging the use of make-up, all of which were seeds of the future.

However, the problem with being the height of fashion is what happens when that particular wave has crashed on the beach. On the approach of the First World War, Diaghilev's sensitive antennae told him that orange, emerald, and turquoise had had their day, and so had melodrama. He did not want the Ballets Russes to be left behind as the spirit of an age, however glorious.[11]

[7] Francis Steegmuller, *Cocteau: a Biography* (London: Constable, 1982), p. 191.

[8] 'George Antheil and the Dance', in Lynn Garafola (ed.), *Legacies of Twentieth Century Dance*, p. 259.

[9] Steegmuller, *Cocteau*, p. 83.

[10] Howard Goodall, 'Music and the Ballets Russes', *Diaghilev*, ed. Jane Pritchard, pp. 169–83, p. 180.

[11] Richard Buckle, *Diaghilev* (London: Hamish Hamilton, 1984), p. 292. He said, 'Fokine's choreography is undoubtedly perfect of its sort but it has now got to make way for something else. One will come back

One of the last major spectacles to feature Nijinsky was a sub-*Schéhérezade* 'Indian' ballet, *Le Dieu Bleu*, in 1912, devised by the youthful Jean Cocteau, and it was not a success. *Le Coq d'Or* (1914), Fokine's last ballet for Diaghilev, and the designer Natalia Goncharova's first, was the last unqualified triumph to feature the riot of colour audiences had come to expect. But, subtly, it also marked changing times by having a subtext: the story was a political allegory, intended as an exposé of the tsarist regime, then on its last legs, and its author, Rimsky-Korsakov, had been refused permission to stage it in Russia itself for that reason.

Jean Cocteau is a key figure in Diaghilev's capacity to reinvent the Ballets Russes. As a leading figure in the bohemian haut monde of Paris, he was an early enthusiast for the new art. Notoriously, Diaghilev turned on the young Frenchman (Cocteau was then only 23) in 1912, and demanded, 'Astonish me!' Well aware that Diaghilev was far from easy to astonish, Cocteau went off and thought about it off and on for the next five years. What he came to realize was that, whereas Diaghilev was deeply and widely knowledgeable about music and capable of identifying Stravinsky as a future star, he was much less informed about what was new in painting. The cutting-edge modernists of Montmartre and Montparnasse were not yet interested in the ballet, which they perceived as fundamentally aristocratic and therefore beneath contempt. Equally, Diaghilev knew nothing about them.

Cocteau, however, did. When he fell under Picasso's spell in 1915, he realized that at last he held the key to astonishing Diaghilev, which was to retire professional designers such as Léon Bakst and Alexandre Benois, and use avant-garde easel painters in their stead. By New Year 1917 Diaghilev was buying a picture collection for Léonide Massine, Nijinsky's successor in his affections, in order to form his taste. It included works by Picasso, Gris, Léger, and Braque, so the great impresario had evidently got the message.[12] For much of the twenties designers, rather than choreographers or composers, were the brightest stars in the constellation of talent necessary to creating a spectacular ballet. An astounding variety of interwar painters designed at least one ballet. They include Ben Nicholson, Paul Nash, Naum Gabo, Georges Rouault, and Josep Maria Sert, to name merely some of the more implausible.

Another aspect of this adjustment of priorities is the importance of Diaghilev's patronage for the painters themselves. Once Europe went to war, the market for modern art suffered grievously. Some artists were actually combatants: Fernand Léger, for example, was at Verdun and the Aisne, and spent three years without touching a brush. But non-combatants were also profoundly affected, because the pre-war dealer who had done most to sell and promote new art in Paris, Daniel-Henry

to it later on, in fifty years, when, like everything else that has been lost and found again, it will seem amusing and then become a classic.'

[12] Steegmuller, *Cocteau*, p. 172.

Kahnweiler, was a German national.[13] As an enemy alien, his entire stock of work was sequestered and he was prevented from conducting business, so he retreated to neutral Switzerland. In the aftermath of the conflict, no one had any money. Diaghilev was offering painters a new source of income at a time when this was urgently needed. Juan Gris, for example, one of the group of cubists who had benefited from Kahnweiler's salesmanship, developed a sudden enthusiasm for set design following Picasso's work on *Parade* in 1917. 'A ballet will help to make me known and bring me admirers,' he said, accurately.[14] Ballets not only put the work of a painter or composer in front of a larger audience than they could conceivably hope to reach by any other means—a substantial part of that audience was rich, and interested in new art.

One important fact about the easel painters Diaghilev recruited is that they had no idea what they were doing, and therefore proceeded with the temerity of ignorance. The designers he had used before the war were highly professional and working within a tradition. Because painters such as Picasso and Léger were not, the results were radical and surprising, Picasso's above all. For *Parade*, the front curtain, essentially a large painting, was much admired, and the costumes disliked, while the actual set made no great impression; however, his second ballet commission, *Tricorne*, with a score by Manuel de Falla, showed the real benefit of recruiting an original eye. Kenneth Clark stresses its importance: 'Picasso's *Tricorne* [a spare, highly abstract evocation of southern Spain] provided a model for ballet design up to the present day. The reason is that it showed how space can be suggested by purely pictorial means.'[15]

There was a downside. Easel painters' lack of technical skill required their designs to be interpreted by professional scene painters.[16] Vladimir and Elizabeth Polunin and Prince Alexandr Schervashidze were Diaghilev's mainstays: it was Schervashidze who actually painted the famous 'Picasso' front curtain of two running women for *Le Train Bleu* from an original a little more than a foot high—so successfully that Picasso cheerfully signed it.[17] Picasso did some work on the sets for *Parade* and *Tricorne* himself, since Sacheverell Sitwell saw him painting *Tricorne* in the Polunins' studio near Leicester Square in 1919,[18] and André Derain painted parts of *La Boutique*

[13] Briony Fer et al., *Realism, Rationalism, Surrealism* (New Haven and London: Yale University Press, 1993), p. 16. Another problem was 'Munichismus' and the 'rappel à l'ordre' discussed in Kenneth Silver, *Esprit de Corps: the Art of the Parisian Avant Garde and the First World War, 1910–1925* (Princeton: Princeton University Press, 1989).

[14] Garafola, *Ballets Russes*, p. 258.

[15] Kenneth Clark, 'Ballet Décor', *Gala Performance*, ed. Arnold Haskell, Mark Bonham Carter, and Michael Wood (London: Collins, 1955), pp. 133–8, p. 135.

[16] Vladimir Polunin, *The Continental Method of Scene Painting* (London: for Cyril Beaumont, 1927) outlines the specific technical challenges entailed in painting a set.

[17] Jane Pritchard, 'Creating Productions', *Diaghilev*, ed. Pritchard, pp. 71–91, p. 88, and John Fowler, 'Front Cloths', ibid., pp. 120–1, p. 121.

[18] Sarah Bradford, *Splendours and Miseries* (London: Sinclair-Stevenson, 1992), p. 94.

fantastique, but this was not the norm. However, the additional costs and complication of hiring amateurs were worth it to Diaghilev, because it ensured that his audiences could always expect the unexpected.

At the same time as Cocteau was working on *Parade*, Diaghilev's search for new directions caused him to pay serious attention to the futurists as another possible key to combining the baroque art of ballet with modernity. The futurist principles of brevity and compression, the abandonment of narrative, and the embracing of speed, simultaneity, and impersonality interested him, and seemed to him compatible with what he was learning from Cocteau's circles in Paris. One governing principle which stood out was eclecticism. Like Cocteau, the futurists were building bridges between popular entertainment and the avant-garde, which Diaghilev could no longer afford to scorn. Marinetti, for example, championed the variety theatre, because it was 'fed by swift actuality', distracted the public with comic effects and imaginative astonishment, enriched its programme with cinematic visions, and plumbed 'abysses of the ridiculous'.[19] The same might be said of *Parade*, with its references to the popular Hollywood serial *The Perils of Pauline*.

Half a dozen futurist collaborations were considered between 1914 and 1917, though only one came to fruition—*Fireworks*, with music by Stravinsky.[20] This was designed by a futurist, Giacomo Balla, who broke new ground for the ballet by focusing visual attention on lighting rather than mise en scène or costumes. But, as Lynn Garafola comments, 'The emphasis on light, the idea of phenomena in constant mutation, and the use of images inspired by the natural world suggest an influence on Balla even more powerful than futurism—that of Loie Fuller.' This brings the story back to the popular culture of Paris.[21]

Loie Fuller, an unsung heroine of modernism, was once extremely famous. She was a pre-war star of the Folies-Bergère, an American, and highly innovative in the development of theatrical lighting as a significant element of stagecraft.[22] Her most characteristic works were solo dances in which, under a carefully directed battery of coloured lights, a vast white silk costume which she manipulated with long, flexible sleeve rods held in her hands became a giant, multicoloured sculpture—a butterfly, or a flower. Other ensemble performances prefigured—or inspired—interwar ballets. Fuller hired and maintained an independent crew of up to thirty electricians for her shows, and was extremely secretive about her equipment, some of which she patented. Her use of light and projections was enormously influential on both popular theatre and high culture. The London-based revue impresario André

[19] Garafola, *Ballets Russes*, p. 81. [20] Garafola, *Ballets Russes*, p. 81.

[21] Lynn Garafola, 'Dance, Film, and the Ballets Russes', *Dance Research: Journal of the Society for Dance Research*, 16.1 (summer 1998), pp. 3–25.

[22] Rhonda K. Garelick, *Electric Salome: Loie Fuller's Performance of Modernism* (Princeton: Princeton University Press, 2007), p. 14.

Charlot rated Fuller's intelligence and stagecraft very highly, describing her as 'an artist of the first rank without effort', and he was influenced by her in his sophisticated use of stage lighting.[23]

Diaghilev's *Ode*, designed by Pavel Tchelitchew in 1928, is clearly indebted to Fuller's art. It made extensive use of projected images, a creative fusion between ballet and the new art of the cinema. The critic A. V. Coton recalled: 'The unearthly beauty created in most of the scenes by a revolutionary use of light ... floods, spots, panoramic effects, projections against a screen and great bursts of light suggesting the sudden animation of pyrotechnical set-pieces, as the groups of dancers and static figures were bathed in pools of glowing illumination, swiftly dimmed and flooded again, almost imperceptibly changing colours.'[24]

But this combination of projections together with live performance was not as revolutionary as Coton asserted, for in Fuller's 1914 *Dance d'Acier* (*Dance of Steel*) she had projected abstract geometric shapes onto a backdrop during the performance.[25] Another of *Ode*'s clear borrowings from Fuller is from a production of hers called *La Mer* (*The Sea*, 1925), in which 4,000 square metres of iridescent silk taffeta overlaid a troop of seventy-five never-visible young dancers, who moved rhythmically underneath it to Debussy's 1905 tone poem of the same name. As the dancer Alexandra Danilova recalled, Tchelitchew 'made up his mind he wanted the stage to look like water, so he covered us with a net and made us crawl on our elbows, turning around and around under the net'.[26] High culture and popular spectacle have met, and the common ground is a ballet.

Another indication of Diaghilev's acute new sensitivity to avant-garde painting is his choice of designers for a ballet he commissioned from yet another enfant terrible, the 20-year-old British composer Constant Lambert, in 1926. Diaghilev decided it was to be *Romeo and Juliet*, though the composer's original intention had been a work on Adam and Eve. This was a modernist ballet: like *Parade*, it was a show about a show, and there is also futurist influence on how it was handled; in an intermezzo, the curtain was lowered so that the dancers were only visible from the knees down, a device which Filippo Marinetti had used some years before. Lambert took this in his stride when he arrived in Monte Carlo for rehearsals, but he was horrified to find that Diaghilev had rejected the designs made by his English friend and contemporary Christopher Wood, and turned to 'two 10th-rate painters from an imbecile group called the "surréalistes"' for design work. This tells us something

[23] James Ross Moore, *André Charlot: the Genius of Intimate Musical Revue* (Jefferson, NC and London: McFarland & Co., 2005), p. 25.

[24] Garafola 'Dance, Film', pp. 17–18. [25] Garelick, *Electric Salome*, pp. 53–4, 182.

[26] Lincoln Kerstein, *Tchelitchew* (Santa Fe: Twelvetrees Press, 1994), p. 51. Similarly, Tchelitchew's decor of white muslin strips lit from behind with lights that changed colour for a 1933 ballet, *L'Errante* (for Edward James's short-lived company), is equally evidently indebted to Fuller's work. Garelick, *Electric Salome*, p. 184.

important about how far ahead Diaghilev was, since their names were Joan Miró and Max Ernst.[27] André Breton's *Surrealist Manifesto* came out in 1924 and, as Lambert's reaction suggests, hardly anyone had heard of Miró or Ernst in 1926. But Diaghilev had.

Thus, Cocteau pointed Diaghilev towards a new relationship with contemporary easel paintings and other manifestations of contemporary culture, including cinema, but the Ballets Russes's post-war metamorphosis is also connected with Diaghilev's changing relationship with high fashion. In the pre-war era, though he and couturier Paul Poiret were linked in the public mind, they were not collaborators. The Ballets Russes's first involvement with fashion as such came through Nijinsky's *Jeux* in 1912. According to his 1918–19 *Diary*, this ballet was conceived as 'about three young men making love to each other....I changed the characters, as love between three men could not be represented on the stage.'[28] Apart from its concealed subtext, the ballet was new in other respects: the choreography was influenced by Nijinsky's study of eurhythmics, and the music, by Debussy, was almost as harmonically challenging and disorientating as *The Rite of Spring*, which was produced in the same season.[29] Also, in stark contrast to the orientalist splendour of other pre-war ballets, the dancers wore plain white 'sports' costumes. The women's outfits were knee-length skirts and jumpers, while Nijinsky wore calf-length, close-fitting trousers and a shirt. Bakst, who was credited as designer, had some difficulty in adapting to this new idiom and the outfits were made by the couturière Jeanne Paquin. In the following year, Bakst designed street clothes for Maison Paquin which were related to his interpretations of ancient Greek costume for Diaghilev—layered ensembles with overtunics reaching to mid-thigh, and narrow, ankle-length underskirts. These were very much pre-war clothes, ostentatiously luxurious, which proclaimed their wearers to be women of leisure.[30]

Jean Hugo, himself a figure of the bohemian haut monde of interwar Paris, suggested that the first two decades of the twentieth century were the Age of Poiret, succeeded in 1918 by the Age of Chanel.[31] Diaghilev seems to have come to a similar conclusion. His involvement with Chanel came via both Cocteau and one of his few women friends, Misia Sert.[32] Sert herself did not cut a very modern figure. Born in 1872, she was a Renoir beauty with voluptuous curves and long, honey-coloured

[27] Richard Shead, *Constant Lambert* (London: Simon Publications, 1973), p. 56.

[28] *The Diary of Vaslav Nijinsky*, ed. and trans. Romola Nijinsky (London: Jonathan Cape, 1937), pp. 140–1.

[29] Howard Goodall, 'Music and the Ballets Russes', *Diaghilev and the Golden Age of the Ballets Russes*, ed. Jane Pritchard (London: V&A Publications, 2010), pp. 169–83, p. 176.

[30] Samantha Vettese, 'The Ballets Russes Connection with Fashion', *Costume*, 42.1 (Jan. 2008), pp. 130–44.

[31] Patrick Mauriès, *Cocteau* (London: Thames & Hudson, 1998), p. 19, quoting Jean Hugo writing in March 1954.

[32] Steegmuller, *Cocteau*, p. 70.

hair; Renoir himself was one of several men painfully in love with her. She was rich—a state achieved by old-fashioned means via a series of advantageous marriages—Polish by origin, intensely musical, and one of the first Paris tastemakers to embrace the Russian ballet when it arrived in Paris in 1907. But also, regardless of the ups and downs of their respective sexual histories, in 1917 she became the intimate and lifelong friend (not lover) of a very different personality—the self-made, thin, intense, and driven Coco Chanel.

Sert introduced Chanel to Diaghilev in Venice in 1920. This had an impact on Chanel's own art. The serious affair which she proceeded to have with Stravinsky at a time when both of them were interested in stripping down, refining, and simplifying in their respective fields of endeavour may have helped her to develop the 'Chanel style' which became a hallmark of the new era.[33] She certainly had an impact on the ballet: that autumn, she gave Diaghilev 300,000 francs to restage Stravinsky's *Rite of Spring*.[34] Her motives may have been mixed: loyalty to Stravinsky, and the competitive aspect of her relationship with Misia Sert, who had bailed Diaghilev out more than once, played a part, but part, surely, was the value she perceived in having the Ballets Russes as an ally.

Patronage meant different things to different people. For Sert, who was a socialite, albeit an extremely sophisticated one, supporting Diaghilev's productions earned her social capital. For Chanel, a professional designer, involvement with Cocteau and Diaghilev was a way of linking herself with avant-garde art as a fellow artist: the ballet was a useful middle term. Getting out her cheque book for the aristocratic Diaghilev must have had a certain satisfaction in itself for a self-made arriviste, but it also allowed her to reposition herself socially and culturally as an artist to be taken seriously. Her first theatrical work, in 1922, was for Cocteau's production of *Antigone*, staged at a fashionable experimental theatre, with a set and masks by Picasso, which was very well received. In 1924 she dressed a ballet for Diaghilev, *Le Train Bleu*, which addressed fashion directly in that it reflected the rich and trendy back to themselves: the dancers were dressed in versions of the jersey beachwear which she sold in her boutiques. This was in fact a nightmare for the dancers, because in keeping with the overall theme of athletic modernity Bronislava Nijinska devised a highly acrobatic choreography, and though Chanel's chic costumes allowed freedom of movement, they were loose and slightly stretchy. Optimal ballet costumes fit snugly to the torso, and in those pre-Lycra days, the principal fabric for sportswear was knitted wool stockinette, which was fine for playing golf in Deauville but added an extra element of risk to already dangerous throws, lifts, and catches.[35] Further, the indirect influence of Chanel is also shown in the utter simplicity of Ludmila Gontcharova's

[33] Mary E. Davis, *Ballet Russes Style: Diaghilev's Dancers and Paris Fashion* (London: Reaktion, 2010), p. 204.
[34] Buckle, *Diaghilev*, p. 368.
[35] Sarah Woodcock, 'Wardrobe', *Diaghilev*, ed. Pritchard, p. 144.

designs for *Les Noces* (1923), dark-brown and white tunics and shirts for the women, and shirts and trousers for the men, the first of many ballets to be dressed in a version of practice clothes.

Diaghilev, for his part, was fully alive to the mutual benefit of working with French tastemakers such as Chanel and Cocteau. But another factor which he had to keep firmly in mind is that ballet is, of its nature, expensive, and to sustain the glamour of the enterprise the finance had to look as effortless as the jumps. The original Russian ballet was sponsored by the Russian imperial court and had schools, permanent premises, career progression for dancers, and pensions. Diaghilev refused to count the cost when it came to realizing an artistic project: *The Rite of Spring* needed nearly a hundred musicians, *Les Noces* called for four pianos and a chorus, and Diaghilev was perfectly capable of having the giant theatre curtain of the London Coliseum remodelled if he thought it might otherwise spoil an effect.[36] But without a state apparatus behind him, he had to cut extraneous expense wherever he could. Neither he nor his assistant Boris Kochno had a salary, and there were, in fact, no accounts. The thousand or so costumes he toured each season had to be paid for, the corps de ballet and orchestra had to be supported somehow.

Diaghilev used his own personality effectively to draw attention away from these mundane and grubby facts. He was a notorious lover of young men, openly a tubby, liquid-eyed potentate presiding over a court of handsome protégés; but the scandalous aspects of his behaviour drew the eye away from a prosaic aspect of the overall situation—which Lynn Garafola has nonetheless noticed—which is that after golden boys become established stars, they turn expensive and, frequently, ungrateful. Diaghilev's endless 'discoveries' were, in most cases, genuine talents. But they were also cheap. Young prodigies were prepared to put up with ungenerous terms and conditions because they could see for themselves what the Ballets Russes machine had done for their predecessors. The mutual benefits were obvious, though the results were sometimes hard on the dancers, who might find themselves struggling with unwearable costumes or arrhythmical music.

Diaghilev's antennae were thus sensitive to different varieties of contemporary expressiveness. It is unsurprising to find that, as the twenties proceeded, there were ballets which emerged from a slyer, and queerer, aesthetic than had characterized the first phase of the Ballets Russes. One pre-war ballet which pointed the way was *Le Spectre de la Rose* (1911), in which the characters are a young girl and the ghost of the rose she wore at her first ball. The title role is perhaps the least macho male role in the history of dance, but because it is that of a non-human entity the ballet could exploit Nijinsky's weird, androgynous glamour without raising the spectre of sexual deviance too directly. It might have been thought reasonable to let the ballet die after

[36] Buckle, *Diaghilev*, p. 346.

his career ended, but in fact it kept being revived. Both the Vic-Wells and the Ballet Rambert mounted it in 1932, with Anton Dolin and Billy Chappell respectively as the ghost of the rose; all three of the post-Diaghilev Russian ballets adopted it into their respective repertoires; and Fokine, the original choreographer, taught it to the American Ballet Theatre, who put it on in 1941. The Sadler's Wells Ballet then mounted a new production in 1944, with a set and drop curtain by Rex Whistler, master of romantic nostalgia. As danced by Nijinsky, the ballet was famous for his final leap which seemed to go on forever, but its extraordinary subsequent success must result from other qualities, perhaps most saliently that the story, insofar as there is one, is a dream about passively yielding to the embrace of a beautiful, sensual, effeminate male.

Les Biches (1924) is another ballet of sexual ambiguity but, as the product of a post-war world, more explicitly so. Bronislava Nijinska, the choreographer, exploited the androgyny of her own powerful physique and face, and her resemblance to her brother, while Poulenc's music is an evocation of Watteau's paintings of Louis XV and various women in his *Parc aux biches*—a *biche* being a doe (not a female dog)—though the ballet is modern in treatment, music and decor, not pastiche eighteenth-century (see Figure 36). What it takes from Watteau is an idea of sexual conquest pursued with elegance, sophistication, and an underlying melancholy. The drop curtain and designs are by Marie Laurencin, whose paintings evoke a similar mood from a lesbian perspective. Poulenc described his work as a 'contemporary drawing room party suffused with an atmosphere of wantonness, which you sense if you are corrupted, but of which an innocent-minded girl would not be conscious'.

As choreographed by Nijinska, *Les Biches* becomes a sly, funny, sophisticated ballet about sex. On the one hand there are Girls in Pink, on the other Athletes in Blue, though not enough to go round. But the traditional spectacle of lads choosing their lasses from the little herd of pink girls is interrupted and challenged: there are also two Girls in Grey, who have eyes only for one another, and the Hostess, an almost transvestite figure who presides over all. This was Nijinska's own role; in a surviving photograph she looks extraordinarily like Tim Curry as Frank N. Furter in *The Rocky Horror Show*. The ballet also featured a singleton, the Garçonne, a female role, but for those with eyes to see perhaps legible as a *travesti* representation of an effeminate boy, since she/he wears blue. The Garçonne contrives to ensnare one of the Boys, and Diaghilev made his intentions for the character's sex appeal quite clear when, standing in the wings, he took a pair of scissors to the costume—and Vera Nemchinova, to her dismay, found herself going on skirtless in trunks and a velvet tunic which barely covered her bottom.[37]

Though this summary suggests that this ballet has considerable potential to shock, Peter Stoneley observes that it was danced at such high speed that the more scandalous

[37] Buckle, *Diaghilev*, p. 420.

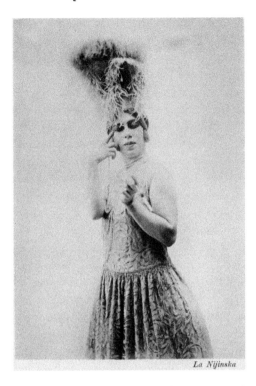

La Nijinska

Figure 36 *Les Biches*, 1924: Bronislava Nijinska as 'The Hostess'. Photographer: Georges Detaille. © Marie-Louise Detaille.

combinations had a slapstick quality, as if they were somehow inadvertent.[38] *Les Biches* is not over-serious, but high camp of the most sophisticated variety, part of its quality being the sense that the ballet is hiding its message in plain sight, as Poulenc himself hinted, speaking over the heads of the less sophisticated members of its audience to an inner circle sensitive to sexual deviance.

From the Russian ballet's first tour abroad, Diaghilev had made it a vehicle for showing off beautiful and desirable male bodies, and even at the time commentators observed that there was a distinct homosexual element among his audience; but his pre-war productions were not camp, with the possible exception of *Spectre de la Rose*. Even ballets such as *Schéhérezade* and *Thamar*, which were wildly over the top, were wholehearted melodramas, but after the war sophisticated audiences could no longer take melodrama seriously.[39] *Les Biches* was as much a ballet for its era as *Schéhérezade* had been before the war, picking up the more cynical, detached, and

[38] Peter Stoneley, *A Queer History of the Ballet* (Abingdon: Routledge, 2007), p. 84.

[39] The *Immortal Hour* (1922), based on Irish fairy legends, and *Hassan* (1923), a sumptuous orientalist fantasy, both ran for hundreds of performances in London, and suggest that the taste for melodrama had not

ironic mood of its time. Nijinska herself stressed its combination of modernity with tradition: 'In its form and rhythm, *Les Biches* reflected modern life. Yet *Les Biches*, like everything created by me, has been raised on the basis of the classical dance.'[40]

Osbert Lancaster considered *Les Biches* the defining ballet of its time: 'Of all the works to which these surroundings [the Paris opera] lent an additional glitter, it is *Les Biches*, that here seemed a brilliant contemporary extension of the world immediately outside, of which the memory remains the most vivid.'[41] Madge Garland, similarly, believed that the scenery and costumes 'summed up the sophisticated simplicity' of the 1920s,[42] and Francis Savage, commenting on the 1937 revival, thought the only ballet which was at all comparable in the way it delighted both the sophisticated and the simple was *Façade*.[43]

The nascent English ballet picked up this camp, coded note in contemporary ballet immediately. Frederick Ashton went to the London premiere of *Les Biches* in October 1925 and thought 'it was the most wonderful thing I'd ever seen. The chic, the elegance, the complete evocation of what life was like at that time was staggering to me.'[44] One of his own first choreographic ventures was *A Tragedy of Fashion* (1926), like *Les Biches* a nod and a wink to those in the know. Frederick Ashton explained subsequently, 'Just as people are called fag-hags, now, I used to be escort to a host of lesbians.'[45] Among his 'bosoms' (as his set called bosom friends) were Dody Todd and Madge Garland; he and they lodged in the same house for a time, along with the biographer Peter Quennell.[46] In *A Tragedy of Fashion* Ashton played a designer, Duchic, displaying styles to the Viscount and Viscountess Viscosa, who stand for the balletomane and synthetic-textile tycoon Samuel Courtauld and his wife Lil. Marie Rambert was his partner Orchidée, a send-up of the stout and mannish Todd: the name was taken from that of a member of Loie Fuller's notably lesbian dance troupe. One of the models is based on Madge Garland, and her dance is a homage to Nijinska's steps for the Garçonne in *Les Biches*.[47]

Les Masques, also for the Ballet Rambert, is another ballet which plays with sophisticated, camp sexuality. Like *Les Biches*, its score was by Poulenc, his Trio for

evaporated. But it was no longer a mode exploitable by a company offering sophisticated avant-garde entertainment.

[40] Bronislava Nijinska, 'Reflections on the Production of *Les Biches* and *Hamlet* in Markova-Dolin Ballet', *Dancing Times*, NS, 317 (Feb. 1937), pp. 617–29, p. 618.

[41] Lancaster, *An Eye to the Future*, p. 102.

[42] Garland, 'The World of Marie Laurencin', *The Saturday Book*, 23 (London: Hutchinson, 1963), pp. 45–59, p. 47.

[43] Francis B. Savage, 'The Markova-Dolin Ballet and La Nijinska: a Revival of "Les Biches"', *Dancing Times*, NS, 321 (June 1937), pp. 282–4.

[44] Julie Kavanagh, *Secret Muses: the Life of Frederick Ashton* (London: Faber & Faber, 1996), p. 63.

[45] Kavanagh, *Secret Muses*, p. 73.

[46] Peter Quennell, *The Marble Foot: an Autobiography, 1905–1938* (London: Collins, 1976), p. 149.

[47] Kavanagh, *Secret Muses*, pp. 77–8.

Oboe, Bassoon, and Piano. A contemporary was reminded of the Chelsea Arts Club Ball, 'where people were in sort of disguise and nobody ended up with whom they arrived',[48] though another reference point may well be *The Marriage of Figaro*, in which Count Almaviva attempts to seduce his own wife under the impression that she is Figaro's fiancée Susanna. A Personage (Ashton) goes to a masked ball with his Lady Friend (Alicia Markova) and is drawn to another woman (the beautiful Pearl Argyle), who is there with a black boyfriend (Walter Gore). At the final unmasking she turns out to be his wife.[49] The ballet featured 'neoclassical steps and a general atmosphere of veiled wantonness'. The set, by Sophie Fedorovitch, was black, white, and silver, as were the costumes—the colours of glamour in that era of black-and-white films. Markova carried a transparent mica muff.

The history of ballet between the wars thus brings together many of the threads pursued in this book: patronage, queerness, the Sitwells, and interactions between fine art, design, and popular culture. It is also very much to do with one man. Diaghilev took a false step with *Parade* in 1917 Paris, but he recovered nimbly, as we have seen. He made another truly monumental error in London in 1921, offering a classical ballet, the Tchaikovsky/Petipa *Sleeping Princess*, to an audience he had taught to expect the contemporary.[50] The production costs were somewhere on the wrong side of £20,000, only for him to find Lytton Strachey, speaking for the intelligentsia, react by saying 'that it made him feel sick' to Sacheverell Sitwell, who was far more willing to engage with it. The *Sunday Times* summed up the general response by writing about 'the suicide of the Russian Ballet'.[51] Hardly anyone, except perhaps Cochran, could have survived a disaster on this scale, but in fact Bloomsbury had barely stopped complaining before Diaghilev was off in another direction, enlisting the artists of the avant-garde in a pact of mutual salvation. It was thanks to his extraordinary resilience that ballet outlived him as a major cultural phenomenon.

[48] Kavanagh, *Secret Muses*, p. 153. The quotation is from a dancer, Elizabeth Schooling.
[49] Kavanagh, *Secret Muses*, p. 154. [50] Buckle, *Diaghilev*, pp. 386–92.
[51] Buckle, *Diaghilev*, pp. 392–3.

Epilogue

The various works called *Façade* form, between them, a quintessence of modern baroque aesthetic achievement. *Façade* started off as a suite of poems by Edith Sitwell. The poems then became the basis of a work created collaboratively with William Walton. Its first performances generated interest and outrage in equal measure, and it was enough of a cause célèbre that Noël Coward devoted a number in his first revue, *London Calling* (1923), to satirizing the siblings as the 'Swiss Family Whittlebot'. William Walton's *Façade* subsequently proceeded to develop a life of its own as ballet music, at which point it became Frederick Ashton's *Façade* as well, with a set and costumes by John Armstrong. Armstrong, a member of England's most visibly modern-movement alliance of visual artists, Unit One, also painted murals and designed ceramics for large-scale commercial production.[1] Both versions of *Façade*—the ballet and the words with music—are among the manifestations of the interwar baroque spirit which have most successfully outlived their original moment.

Eugenio d'Ors suggests that a leading characteristic of the baroque arts is that they take on aspects of one another:

> In epochs baroque in tendency, the gravitation proceeds in the opposite direction: it is the architect who turns sculptor, sculpture which approaches the condition of painting; painting and poetry which dress themselves with the characteristics proper to music. In the same way as all baroque sensibility tends to pantheism, all baroque writing tends to music.[2]

This is to a very marked extent true of Edith Sitwell. She trained very seriously as a pianist, and achieved a near-professional standard as an executant musician. It is not surprising to find that she placed an unusually high value on rhythm and verbal

[1] In 1933 Paul Nash sent a letter to *The Times* announcing the formation of a new modern art movement, 'Unit One'. It sprang from Nash's sense that it was essential to create a unified, identifiable modern movement in English art if anyone, at home or abroad, was going to pay attention to what was going on, and involved painters, sculptors, architects, and critics.

[2] Eugenio d'Ors, *Du Baroque*, trans. Agathe Rouart-Valéry (Paris: NRF/Gallimard, 1968), first ed. 1935, p. 118.

music in her poetry. She was also impressed by Roger Fry's view that the key problem for a painter was to discover 'what arrangements of form and colour are calculated to stir the imagination most deeply.... This is exactly analogous to the problem of music, which is to find what arrangements of sound will have the greatest evocative power.' Her intensive reading of French symbolist poets underscored Fry's argument and exacerbated her sense of the interrelatedness of the arts: the symbolists taught her to value the fragmentary, suggestive, and synaesthetic: and when she wrote verse herself, to think first in terms of sound, then of images.[3]

Edith Sitwell's *Façade* seemed to many of its first readers, and certainly to Noël Coward, to be complete nonsense—a Dadaist, or surrealist, assembly of words, privileging sound over meaning. But meaning there is, of an intensely personal kind. The poems interweave a number of thematic strands. One is Edith's sense of being at the mercy of parents and other elders who had never troubled themselves to understand her, yet assumed their right to control her life: many of the poems feature Victorians in hell, type figures of an older generation who have reduced themselves to a set of mechanical responses and shibboleths—the pompous, faded ghosts of nineteenth-century patriarchy. Among others, there is Sir Beelzebub, impotently roaring in a hotel—a portrait, perhaps, of her father; a group of philistine Scottish gentry, also in a hotel; the futile retired admiral, Sir Joshua Jebb, trapped by propriety in death as in life—outraged, as his daughters try to break for freedom, he yaps, 'Hell is just as properly proper as Greenwich, or as Bath or Joppa.' There is also a more genuinely ogreish figure, 'Black Mrs Behemoth', an evocation of the mother Edith loathed.

Another strand of the *Façade* poems is more nostalgic and resurrects the lost, golden world of country-house pastoral. Revenants from a privileged Edwardian childhood, Old Sir Faulk and the bucolic satyrs of 'Country Dance' drift through the poems, and the bright images of nineteenth-century theatre prints are evoked in 'Polka' and 'Hornpipe'. These are poems of nostalgia for a world dead and gone: Lily O'Grady, silly and shady, walking in the summer sun by the lake while blonde children gather strawberries, seems for most of the poem to be a light-heartedly conceived figure; but the last two lines are, 'And shade is on the brightest wing and dusk forbids the bird to sing.' They suggest that Lily is dead and gone, a foolish little ghost of Edwardian high summer.

A third strand in the imagery is southern baroque, notably in 'Tango-Pasodoble' and 'Noche Espagnola', in which Spanish dons and dancers posture in the cruel white light of Seville. This must to a great extent have emerged from conversations with Sacheverell. Edith's principal travels had been in France and Germany, though she had been to Sicily with her family, where she and Osbert repeatedly watched

[3] See Allan Pero, and Gyllian Phillips, eds., *The many facades of Edith Sitwell* (Gainesville: University Press of Florida, 2017). Richard Greene, *Edith Sitwell: Avant Garde Poet and English Genius* (London: Virago, 2010), p. 75.

plays staged in a disused church by a member of the Italian acting dynasty of Grasso.[4] In this respect the poems draw on the crucial modern baroque trope of bringing the south to the north, which was vital to all three Sitwells as tastemakers over two generations. Minor figures throughout the poems, such as the 'turbaned Chinoiserie', seem to have escaped from the tapestries at Renishaw which meant so much to all three siblings.

The title of the sequence reflects the era's fascination with masks, and came from Edith's charlady; Walton remembered that 'she said to Edith one day—all this carry on is just one big façade, isn't it? And Edith liked it so much that she used it.'[5] In its original form, the poems were spoken from behind a façade, through a Senger-phone. Most of the poems reveal Edith's profound sense that everyday reality is a false floor: hell, darkness, and despair are the true reality, concealed behind the thinnest of barriers. She was a person of strong religious sense, but more readily convinced of the immanence of hell than heaven. Sylvia Townsend Warner said of T. F. Powys, 'His despair of the universe is an intellectual thing, he knows that there is nothing good, nothing true, nothing kind, that until he is dead he is at the mercy of life.'[6] This could equally well have been said of Edith.

When Walton set the poems to music, he and Edith worked together in two- and three-hour sessions, going over them together while Walton made notes of stresses, emphases, and inflections.[7] The music he produced drew eclectically on popular musical forms, deepened and altered with acid harmony and high tessitura; it is a brittle soundscape altogether. There is a foxtrot, a tango, and a variety of cabaret and music-hall tunes in the mix. His treatment of the texts suggests his familiarity with Stravinsky's similarly sparse and acidic *Histoire du Soldat*, a Faustian folk tale about a soldier and the devil which was to be 'read, played, and danced' by three actors, one or more dancers, and seven instrumentalists; like the Stravinsky piece, *Façade* used a small orchestra, which crept up from three to five as it evolved, and included a drum kit. Satie's parodistic score for *Parade* is also among *Façade*'s antecedents, using bright and catchy popular music to tell of failure: in *Parade*, however energetic the performance, nobody stays to see the actual show.

Walton's score does not have the dark undertones of Edith's verse, and because it was a highly sophisticated parody of different types of popular tunes, it made the perfect basis for a divertissement ballet, since characters were naturally suggested by the musical idiom of each section—a tango, Scottish dance, tarantella, and so forth. Divertissements were a feature of classical ballet; the series of character dances in the last act of *Sleeping Beauty* is a familiar example. A ballet was made from *Façade* as early as 1929, by the choreographer Günter Hess for the German Chamber Dance

[4] Greene, *Edith Sitwell*, p. 79. [5] Greene, *Edith Sitwell*, p. 156.
[6] Sylvia Townsend Warner, *Letters*, ed. William Maxwell (New York: Viking Press, 1983), p. 6.
[7] Greene, *Edith Sitwell*, p. 155.

Theatre,[8] but more importantly, in 1931 Ashton choreographed it for the Camargo Society. It was taken into the Vic-Wells repertory and remains one of Ashton's most popular and most frequently revived works. The wittiness of Ashton's treatment includes its parodistic relationship to the art of ballet itself, as well as to popular acts such as Jack Buchanan's soft-shoe shuffle, neatly taken off in his version of 'Popular Song', with added homoerotic overtones.

Another ballet venture with a Sitwellian origin was similarly a complex and successful appropriation. Sacheverell published a poem, 'Rio Grande', in *The Thirteenth Caesar and Other Poems* (1924) about the culture of Brazil, the chief point of which is that the baroque of South America is yet more hybrid than the Iberian baroque of southern Spain. He briefly evokes the last chapter of his own *Southern Baroque Art*, 'the King and the Nightingale', only to set it to one side and to say that Brazil's is an exotic, mestizo baroque, with drums and marimbas. This perception, since he had not then visited Brazil, suggests his familiarity with Darius Milhaud's music for Cocteau's ballet *Le bœuf sur le toit* (1920), which makes use of a tango and other popular Brazilian music, and perhaps with Milhaud's *Saudades do Brasil*, a suite of twelve dances evoking twelve neighbourhoods in Rio. These perhaps caused Sacheverell, who seldom let himself get unduly bothered by details, to muddle up Rio de Janeiro, in Brazil, with the Rio Grande, which flows from Colorado to the Gulf of Mexico.

Constant Lambert was attracted to the poem, and used part of it as the libretto of what may or may not be his best, but is certainly his most-performed and most-recorded, work. 'Today, *Rio Grande*, a mere quarter of an hour of music for chorus and orchestra, is considered to be a masterpiece, equalling Milhaud's *La Creation du Monde* as a classic of transfigured jazz.' [9] (Milhaud's *Creation* had similarly formed the basis of a major production by the Ballets Suédois.) Lydia Lopokova saw the potential of Lambert's composition as ballet music, and Ashton, ignoring Sacheverell's text but highly sensitive to the texture of Lambert's music, choreographed it as a tale of sailors and prostitutes in Toulon, well known to his circle as a place to go for cheap holidays. This theme was tailor-made for his friend Edward Burra, who had been painting watercolours based on his observation of dockside life in Toulon and Marseilles since 1927. The costume he designed for the Queen of the Port, Lopokova's role, shows Burra's interest in film, since it is a version of Olga Baclanova's outfit in Josef von Sternberg's 1928 film, *The Docks of New York*.[10] The front cloth, sadly, does not survive even in a photograph, since Ashton recalled:

[8] Julie Kavanagh, *Secret Muses: the Life of Frederick Ashton* (London: Faber & Faber, 1996), pp. 130–1.

[9] Kavanagh, *Secret Muses*, p. 140.

[10] Edward Burra, *Well, Dearie! The Letters of Edward Burra*, ed. William Chappell (London: Gordon Fraser, 1985), p. 70.

The buzz of surprise in the audience... when the curtain rose on the front cloth of Rio Grande, showing a row of houses in the brothel quarter of a southern sea port; the shutters open to reveal in every window the most wonderfully outrageous tarts. It produced the same kind of buzz — slightly startled, half affronted, half delighted — that greeted Picasso's front cloth for *Le Train Bleu* at the Coliseum in the nineteen twenties.[11]

These highly original hybrid works with which the Sitwells were, in one way or another, involved are collaborations which show a fluid interplay between literary arts, visual art, and music, in which work conceived in one medium gives rise to a masterpiece of a quite different kind in another. All of them also show a constant fertilization from popular arts, both historical—such as English theatre prints and traditional dance forms—and current, such as jazz.

The lost golden world—the image of the south in the north—which features so strongly in *Façade*, also dominates one of the last and most supremely accomplished expressions of a baroque spirit in interwar England, Rex Whistler's murals at the Marquess of Anglesey's country house, Plas Newydd. The affinity between the spirit of *Façade* and his own work was felt by Whistler himself. As his brother recollected, '[Sitwell's] ribald verses in *Façade* had been brilliantly set to music by the young William Walton, and today this record, frequently on Rex's turntable, more than anything else, except perhaps *Les Biches*, also known to Rex and described by Poulenc as a "ballet for pleasure's sake" breathes that air of the Twenties, at once tart, nostalgic and irresponsible, which his paintings and drawings of the decade more wistfully give out.'[12]

The Plas Newydd mural is a baroque painting from the year of the Munich crisis (1938); achieved by baroque means with eighteen vanishing points, in the mode taught by the brilliant Counter-Reformation Jesuit, Andrea Pozzo, in his *Perspectiva pictorum et architectorum* (1693), and practised by him in the technically unsurpassed ceiling paintings of Sant'Ignazio in Rome with its trompe l'oeil dome. Sacheverell Sitwell observes in *German Baroque Art*: 'He had considerable influence, even in this country.... Fratel Pozzo... introduced a much more serious and scientific manner of considering the problems likely to baffle... the inventor of false architecture.' This was made possible by an eighteenth-century English translation, *Rules and examples of perspective proper for painters and architects, etc... containing a most easie and expeditious method to delineate in perspective all designs relating to architecture.*[13] The book could easily have come into Whistler's hands, since he attended a year's course of

[11] Ashton, in *Edward Burra: a Painter Remembered by his Friends*, ed. William Chappell (London: André Deutsch, 1982), p. 61.

[12] Laurence Whistler, *The Laughter and the Urn: the Life of Rex Whistler* (London: Weidenfeld & Nicolson, 1985), pp. 96, 118.

[13] London: John Sturt, 1707.

lectures on architectural history by Sir Albert Richardson, and later read intensively in the library of the British School at Rome.[14] He also visited the baroque churches of Rome, and is unlikely to have omitted Sant'Ignazio.

Like all Whistler's best murals, the overall tonality of the Plas Newydd piece is greenish-turquoise with soft, mouse's-back, greyish browns—colours which impose nostalgia and distance. It must have looked long ago and far away even when it was new; its town square, its islands and boats, are small and distant, seen from a stone terrace and across water. One whimsical trompe l'oeil detail ties it into the room: Neptune's trident leans casually against a balustrade, and wet footprints wander towards, and apparently into, the room itself. Otherwise, the fictive world of the mural is self-contained.

It benefits enormously from its context, because it covers one long wall, extending onto the short walls at either end, and opposite it are long windows overlooking the Menai Strait with, between them, mirror—not in enormous sheets, but in 18-inch squares joined at the corners with glass buttons, which are not quite perfectly trued, making the mural's reflection irregular, broken, and ambiguous. In summer the natural light over the calm waters of the Menai Strait is silver to goldish and opalescent, flattening out the details of the great mountains of Snowdonia and transforming their noble bulk into shimmering masses of colour. The mural responds to these features: it is tonally very even, at no point darker than mid-grey, painted in flat washes of opaque pigment, upon which minute, extremely precise details are picked out with a small brush, but again using a tightly controlled range of tints. The result is a paint surface which offers no distraction in itself, and is equally effective in extreme close-up or from its natural viewing distance of about six to ten feet. The draughtsmanship is absolutely sure.

The antecedents of this mural are the sea-and-harbour paintings of Claude Joseph Vernet and Claude Lorrain, with their celebrated golden, late-afternoon light and grand baroque architecture, while the general design is based on the vista in the background of Giulio Romano's fresco of *The Triumph of Titus and Vespasian* in the Vatican, which Whistler will have seen in Rome. Apart from being baroque in method and rococo in inspiration, the Plas Newydd mural is also baroque in expressing a clearly worked-out personal iconography. Like Edith Sitwell's *Façade* poems, it expresses a sense of personal hopelessness while being 'amusing', and it conveys a strong sense of the passage of time. Unusually for a mural in the baroque tradition, it is not evenly lit, but moves from early morning to late afternoon. The mural is an idealization of a world which had ended: it was conceived when war was on the horizon, and completed after Whistler had joined the army, during periods of leave. A poignantly unfinished-looking passage in the otherwise immaculate

[14] Whistler, *The Laughter and the Urn*, p. 58.

Figure 37 Rex Whistler, self-portrait as a gardener's boy from the dining-room mural at Plas Newydd. Photographer: unknown. © National Trust.

surface marks his last intervention, when he decided to paint over a ship but ran out of Chinese white, since paint was sometimes hard to get during the war. A full restoration of the surface was promised for another visit, which never took place because, shortly afterwards, he was killed in action.

On a personal level, the mural expresses his tormented relationship with the icily beautiful daughter of the house, Caroline Paget, who tolerated him as an escort, and even occasionally as a lover, but was emotionally and sexually committed to the actress and playwright Audrey Carten.[15] In the central panel a fictive, mostly Mediterranean kingdom by the sea basks in nostalgic golden light which sparkles on tranquil waves; in parts, notably the central belvedere, it is ruined and patched up. The tiny, solitary figure of Caroline is piloting a little pleasure yacht with red sails. On the end wall, Whistler has painted himself as a gardener's boy at evening,

[15] Carten became an actress around 1920 and, later in the decade, was Tallulah Bankhead's 'friend and travelling companion'. In the thirties she became a successful playwright, whose work was produced both in the West End and on Broadway. Her *Gay Love* was filmed in 1934, with the singer Sophie Tucker as its star.

at summer's end, with a red neckerchief. The lantern over his head has guttered out, leaving only a wisp of smoke, the swallows are leaving, and he is sweeping up the petals of a red rose (see Figure 37). Genuine anguish is expressed in fancy dress: a statement that his heart is broken, but made 'amusingly', in a context where he is a hired entertainer—baroque sentiment expressed in baroque terms, emblematically. His social demotion of himself from protégé to servant is a bitter statement of a social and practical reality in this truth-telling masquerade. As an expression of sophisticated melancholy, it bears comparison with the English baroque of post-Civil War cavalier verse: the evocation of halcyon days, forever gone.

BIBLIOGRAPHY

Adamson, Walter L., *Embattled Avant-gardes: Modernism's Resistance to Commodity Culture in Europe* (Berkeley: University of California Press, 2007).

Anscombe, Isabelle, *A Woman's Touch* (London: Viking, 1994).

Archer-Shaw, Petrine, *Negrophilia: Avant-Garde Paris and Black Culture in the 1920s* (London: Thames & Hudson, 2000).

Baer, Nancy Van Norman, ed., *Paris Modern: the Swedish Ballet 1920–1925* (San Francisco: Fine Arts Museum of San Francisco, 1995).

Beaton, Cecil, *The Glass of Fashion* (London: Weidenfeld & Nicolson, 1954).

Beaton, Cecil, *The Wandering Years* (London: Weidenfeld & Nicolson, 1961).

Berman, Marshall, *All That is Solid Melts Into Air* (Harmondsworth: Penguin, 1982).

Blum, Dilys, *Shocking! The Art and Fashion of Elsa Schiaparelli* (Philadelphia: Philadelphia Museum of Art, 2003).

Bradford, Sarah, et al., *The Sitwells and the Arts of the 1920s and 1930s* (London: National Portrait Gallery, 1994).

Breward, Christopher, and Caroline Evans (ed.), *Fashion and Modernity* (Oxford and New York: Berg, 2005).

Calloway, Stephen, *Baroque Baroque: the Culture of Excess* (London: Phaidon, 1994).

Castle, Terry, *Noël Coward and Radclyffe Hall: Kindred Spirits* (New York: Columbia University Press, 1996).

Cleto, Fabio, ed., *Camp: Queer Aesthetics and the Performing Subject* (Edinburgh: Edinburgh University Press, 1999).

Cohen, Lisa, *All We Know* (New York: Farrar, Straus & Giroux, 2012).

Cooke, Dorothy, and Pamela McNicol, *A History of Flower Arranging* (London: Heinemann, 1989).

Core, Philip, *Camp: the Lie that tells the Truth* (London: Plexus, 1984).

Core, Philip, *The Original Eye: Arbiters of Twentieth Century Taste* (London: Quartet Books, 1984).

Cornforth, John, *The Search for a Style: Country Life and Architecture, 1897–1935* (London: Harper-Collins, 1988).

Cornforth, John, *London Interiors from the Archives of Country Life* (London: Aurum Press, 2009).

Crow, Thomas, *Modern Art in the Common Culture* (New Haven and London: Yale University Press, 1996).

Darling, Elizabeth, 'Finella, Mansfield Forbes, Raymond McGrath, and Modernist Architecture in Britain', *Journal of British Studies*, 50.1 (January 2011), pp. 125–55.

de Certeau, Michel, Luce Giard, and Pierre Mayol, 'Ghosts in the City', in *The Practice of Everyday Life II: Living and Cooking*, trans. Timothy J. Tomasik (Minneapolis and London: University of Minnesota Press, 1998), pp. 133–43.

Doan, Laura, *Fashioning Sapphism: the Origins of a Modern English Lesbian Culture* (New York: Columbia University Press, 2001).

Doan, Laura, and Jane Garrity, eds., *Sapphic Modernities: Sexuality, Women and National Culture* (New York: Palgrave Macmillan, 2006).

d'Ors, Eugenio, *Du Baroque*, trans. Agathe Rouart-Valéry (Paris: Gallimard, 1935).

Eksteins, Modris, *Rites of Spring: the Great War and the Birth of the Modern Age* (London: Bantam Press, 1989).

Faltejskova, Monika, *Djuna Barnes, T. S. Eliot and the Gender Dynamics of Modernism* (New York and Abingdon: Routledge, 2010).

Friedman, Alice T., *Women and the Making of the Modern House: a Social and Architectural History* (New Haven and London: Yale University Press, 2006).

Gallagher, Lowell, Frederick S. Roden, and Patricia Juliana Smith, eds., *Catholic Figures: Queer Narratives* (Basingstoke and New York: Palgrave Macmillan, 2007).

Garafola, Lynn, *Diaghilev's Ballets Russes* (Oxford: Oxford University Press, 1990).

Garland, Madge, *The Indecisive Decade* (London: Macdonald, 1968).

Gee, Malcolm, *Dealers, Critics and Collectors of Modern Painting* (New York and London: Garland, 1981).

Goff, Jennifer, *Eileen Gray: Her Work and Her World* (Sallins: Irish Academic Press, 2015).

Graves, Robert, and Alan Hodge, *The Long Week-End: a Social History of Great Britain 1918–1939* (London: Reader's Union, 1941).

Gundle, Stephen, *Glamour: a History* (Oxford: Oxford University Press, 2008).

Harris, Alexandra, *The Romantic Moderns: English Writers, Artists and the Imagination from Virginia Woolf to John Piper* (London: Thames & Hudson, 2010).

Huyssen, Andreas, *After the Great Divide: Modernism, Mass Culture, Postmodernism* (Indiana: Indiana University Press, 1986).

Hynes, Samuel, *The Auden Generation* (Princeton: Princeton University Press, 1972).

Jackson, Anthony, *The Politics of Architecture: a History of Modern Architecture in Britain* (Toronto: University of Toronto Press, 1970).

Jacques, David, and Jan Woudstra, *Landscape Modernism Renewed: the Career of Christopher Tunnard, 1910–1979* (London and New York: Routledge, 2009).

Jaffe, Aaron, *Modernism and the Culture of Celebrity* (Cambridge: Cambridge University Press, 2005).

Jerram, Leif, *Streetlife: the Untold History of Europe's Twentieth Century* (Oxford: Oxford University Press, 2011).

Lancaster, Osbert, *With an Eye to the Future* (London: John Murray, 1968).

McKibbin, Ross, *Classes and Cultures: England 1918–1951* (Oxford: Oxford University Press, 1998).

Mannin, Ethel, *Young in the Twenties: a Chapter of Autobiography* (London: Hutchinson, 1971).

Mazzeo, Tilar J., *The Secret of Chanel No. 5* (New York: HarperCollins, 2010).

Mundy, Jennifer, *On Classic Ground: Picasso, Léger, de Chirico and the New Classicism, 1910–1930* (London: Tate Gallery, 1990).

Pender, Anne, '"Modernist Madonnas": Dorothy Todd, Madge Garland and Virginia Woolf', *Women's History Review*, 16.4 (2007), pp. 519–33.

Potvin, John, *Bachelors of a Different Sort: Queer Aesthetics, Material Culture and the Modern Interior in Britain* (Manchester: Manchester University Press, 2014).

Powers, Alan, *Oliver Hill: Architect and Lover of Life* (London: Mouton Publications, 1989).

Powers, Alan, *Britain: Modern Architectures in History* (London: Reaktion, 2007).

Powers, Alan, *British Murals and Decorative Paintings, 1920–1960* (London: Sansom & Co., 2013).

Pritchard, Jane, ed., *Diaghilev and the Golden Age of the Ballets Russes 1909–1929* (London: V&A Publishing, 2010).

Rainey, Lawrence S., *Institutions of Modernism: Literary Elites and Public Culture* (New Haven: Yale University Press, 1998).

Rainey, Lawrence S., *Revisiting The Waste Land* (New Haven and London: Yale University Press, 2005).

Rault, Jasmine, *Eileen Gray and the Design of Sapphic Modernity* (Aldershot: Ashgate, 2011).

Reed, Christopher, ed., *Not at Home: the Suppression of Domesticity in Modern Art and Architecture* (London: Thames & Hudson, 1996).

Reed, Christopher, *Bloomsbury Rooms: Modernism, Subculture and Domesticity* (New Haven and London: Yale University Press, 2004).

Reed, Christopher, 'A *Vogue* that Does Not Speak its Name: Sexual Subculture during the Editorship of Dorothy Todd, 1922–26', *Fashion Theory*, 10.1/2 (2006) pp. 39–72.

Richards, J. M., *Castles on the Ground* (London: Architectural Press, 1946).

Silver, Kenneth, *Esprit de Corps: the Art of the Parisian Avant Garde and the First World War, 1910–1925* (Princeton: Princeton University Press, 1989).

Sparke, Penny, *As Long as It's Pink: the Sexual Politics of Taste* (London: Pandora Press, 1995).

Stern, Radu, *Against Fashion: Clothing as Art, 1850–1930* (Cambridge, MA: MIT Press, 2004).

Stevens, Hugh, and Caroline Howlett, eds., *Modernist Sexualities* (Manchester: Manchester University Press, 2006).

Stoneley, Peter, *A Queer History of the Ballet* (Abingdon: Routledge, 2007).

Strychacz, Thomas, *Modernism, Mass Culture, and Professionalism* (New York: Cambridge University Press, 1993).

Summerson, John, *Heavenly Mansions* (London: Cresset Press, 1949).

Tickner, Lisa, *Modern Life and Modern Subjects: British Art in the Early Twentieth Century* (New Haven and London: Yale University Press, 2000).

Todd, Dorothy, and Raymond Mortimer, *The New Interior Decoration* (London: Batsford, 1929).

Troy, Nancy J., *Modernism and the Decorative Arts in France: Art Nouveau to Le Corbusier* (New Haven and London: Yale University Press, 1991).

Troy, Nancy J., *Couture Culture: a Study in Modern Art and Fashion* (Cambridge, MA: MIT Press, 2003).

Walz, Robin, *Pulp Surrealism* (Berkeley and Los Angeles: University of California Press, 2000).

Weiss, Jeffrey, *The Popular Culture of Modern Art: Picasso, Duchamp and Avant-Gardism* (New Haven and London: Yale University Press, 1994).

Whistler, Laurence, *The Laughter and the Urn* (London: Weidenfeld & Nicolson, 1985).

Whiteley, Nigel, 'Whitewash, Ripolin, Shop-Girls and Matière: Modernist Design and Gender', in *Modernism, Gender and Culture: a Cultural Studies Approach*, ed. Lisa Rado (London and New York: Garland, 1997), pp. 199–228.

Wigley, Mark, *White Walls, Designer Dresses: the Fashioning of Modern Architecture* (Cambridge, MA: MIT Press, 1995).

Wilson, Elizabeth, *Adorned in Dreams: Fashion and Modernity* (London: Virago, 1985).

Wilson, Elizabeth, *The Sphinx in the City* (London: Virago, 1991).

Wollen, Peter, *Raiding the Icebox: Reflections on Twentieth-Century Culture* (London: Verso, 2008).

Wood, Ghislaine, ed., *Surreal Things: Surrealism and Design* (London: V&A Publications, 2007).

INDEX

Aberconway, Christabel, Lady 30
Acton, Harold 33, 78, 80, 84, 85, 116, 122, 164, 255
Acton, William 80, 164, 241
Adorno, Theodor 7, 8, 92, 137
Adshead, Mary 217, 218, 225, 262–3
African art 7, 20, 78, 105, 120, 182, 184, 185
 Masks 17, 259–60
Agar, Eileen 245, 249
Aldehydes 277–8
Allan, Maud 54
Alterity 6, 41, 42, 48, 117, 119, 121–5, 132, 145, 196, 201, 206
Amies, Hardy 51, 246
'amusing' 18, 43, 52, 66, 73, 112, 132, 185, 189, 236, 284, 300, 302
Ancient Greece 99, 114, 116, 205, 288
Anderson, Margaret 106
Androgyny 47–8, 52, 246, 255, 257
Anglo-Catholicism 205, 206, 208, 211
Anson, Peter 207, 209
Antheil, George 106, 283
Antique textiles 38, 76, 175, 211, 212
Antiques 14, 77–81, 84, 116, 177, 179, 182, 184, 187–8, 194, 197, 199, 209–11, 212, 214
Antoine de Paris (Antek Cierplikowski) 139–40, 267
Apollinaire, Guillaume 99, 116
Aragon, Louis 131, 170
Architectural Review 51, 160, 180, 233, 234
Arden, Elizabeth 263, 264
Argyle, Pearl 235, 294
Arlen, Michael
 The Green Hat 34, 37
Armory Show (International Exhibition of Modern Art) 169
Armstrong, John 177, 219
 Façade 295
Art dealers 25, 60, 70, 75, 82, 84, 150, 168, 169, 171–2, 176, 195, 215, 218, 254, 284–5
Art deco 168, 170, 182, 190, 194, 208, 217, 271
Arup, Ove 141–2
Ashbee, Charles Robert 224
Ashcombe 14, 147, 189, 256, 258
Ashton, Frederick 14, 16–17, 26, 29–30, 31, 32, 33, 35, 69, 293, 294
 Façade 295, 298
 The First Shoot 70
 High Yellow 106

Rio Grande 69
A Tragedy of Fashion 293
Asquith, Emma Alice Margaret ('Margot'), Lady 25, 31
Astley Cooper, Eva 29
Astor, Nancy 163, 253, 267
Astor, Waldorf 163
Atelier Martine 61, 174, 185
Atkinson's 270–1
Auden, Wystan Hugh 90, 94, 110, 113, 122, 124, 127, 131, 134, 203, 204, 205, 243
 The Ascent of F6 111
 The Dance of Death 110
 Letter to Lord Byron 122, 124–5
 Letters from Iceland 125
 Night Mail 111
 On the Frontier 127
 The Orators 124
 Paid on Both Sides 111
Auric, Georges 108
Austin, Alfred ('Chick') 81, 173
Avant-garde 1, 3, 5, 10, 15, 19, 23, 24, 25, 36, 39, 41, 47, 51, 52, 57, 65, 68, 89, 102, 103, 104, 108, 110, 113, 115, 119, 120, 131, 140, 170, 179, 194, 213, 216, 219, 229, 239, 240, 245, 246, 248, 259, 260, 272, 274, 281, 282, 284, 286, 287, 289, 294

Bacon, Francis 177
Badovici, Jean 3, 56
Baker, Geoffrey 233
Baker, Herbert 167
 'Port Lympne' 146
Baker, Josephine 3, 51, 53, 106–7, 109, 119
Bakst, Léon 283, 284, 288
Balanchine, George 11, 106, 110
 Island in the West Indies 107
 The Triumph of Neptune 69
Balcon, Aileen 240
Balla, Giacomo 234
 Fireworks 286
Ballet Rambert 26, 235, 293
 Les Masques 293–4
 A Tragedy of Fashion 293
Ballets Russes 19, 40, 69, 94, 102, 106, 109, 281, 283, 288
 Les Biches 291–2, 293, 299
 La Boutique Fantastique 285–6
 Le Coq D'Or 284

Ballets Russes (*cont.*)
 Cuadro Flamenco 170
 Le Dieu Bleu 284
 Fireworks 286
 La Légende de Joseph 223
 Les Noces 283, 289–90
 Ode 261, 287
 Parade 103–4, 105, 282, 285, 286, 287, 294, 297
 Romeo and Juliet 287
 Le Sacre du Printemps 272, 283, 288, 289, 290
 Schéhérezade 283, 284, 292
 The Sleeping Princess 294
 Le Spectre de la Rose 290–1, 292
 Thamar 292
 Le Train Bleu 285, 289, 299
 Tricorne 285
 Zéphyre et Flore 260
Ballets Suédois 105, 106
 La Création du Monde 261, 298
Bankhead, Tallulah 51
Banting, John 33–4, 199, 218, 228, 238
Barnes, Djuna 3, 41, 125, 128
 The Ladies Almanack 42, 128–30
 Nightwood 54–5, 126, 128, 130–1, 175
Barney, Natalie 41, 42, 54, 57, 117, 128, 170, 229, 252
Barron, Phyllis 176, 185, 195
Bathrooms 20, 63, 151, 189–90, 191, 223
Battersby, Martin 8, 220
Beach, Sylvia 25, 41
Beardsley, Aubrey 206
Beaton, Barbara ('Baba') 198
Beaton, Cecil 1, 3, 14, 15, 18, 20, 26, 27, 28, 29, 30, 31,
 32, 33, 34, 35, 40, 51, 64, 68, 70, 108, 110, 147,
 183, 189, 197, 198, 229, 234, 235, 237, 238, 240,
 241, 243, 251, 252, 256, 257, 258, 273
 The Book of Beauty 30
Beaux, Ernest
 'Rallet no. 1' 278
Beaverbrook, Lord (William Maxwell Aitken) 218
Beck, Maurice 236, 262
Beckett, Samuel 112
Bedford, Sibylle 23, 41–2
Beggars' Opera 15
Beistegui, Charles de 8, 9, 11
Bell, Vanessa 69, 177, 185, 224, 225, 251
Benjamin, Walter 47, 92, 99, 133, 181, 218
Bennett, Arnold 223
Benois, Alexandre 284
Benson, Edward Frederic 13
Benson, Hugh 123
Bentley, Gladys 44
Bentley, Nicholas
 Gammon and Espionage 37
Bérard, Christian ('Bébé') 100, 173
Berlin, Irving 104
Berman, Eugène 9, 81, 173
Berman, Marshall 169
Berenson, Bernard 165, 184

Berenson, Mary 142, 165
Berners, Lord (Gerald Hugh Tyrwhitt-Wilson) 23,
 26, 28, 31, 32, 69, 123, 145, 190, 227
 The Girls of Radcliff Hall 125
 Luna Park 110
 The Triumph of Neptune 69
Bethell, Ethel (Mrs Guy) 175
Betjeman, John 26, 27, 71, 179, 204
Betty Boop 98, 120
'Blackbirds' 119
Bloomsbury Group 20, 50, 60, 69, 110, 117, 164,
 182, 185, 202, 225, 226, 294
Blunt, Anthony 84, 125
Bohemians 24, 36, 37, 52, 79, 195, 209, 218, 226, 251,
 253, 254, 255, 268, 284, 288
Bongard, Germaine 170, 195
Borenius, Tancred 82, 83
Borges, Jorge Luis 133
Borlin, Jean 105
Boudin, Stéphane 82, 184, 188, 192
Boulestin, Marcel 184–5, 196, 217
Bowen, Elizabeth 41
 The Hotel 42
Bower, Stephen Dykes 211
Braddel, Thomas Arthur Darcy 222
Bradley, Buddy 106
Brand, Stewart 137
Brangwyn, Frank, Sir 204, 212, 213
Braque, Georges 60, 79, 171, 176, 248, 284
 Zéphyre et Flore 260
Breton, André 119, 195, 246, 288
 Nadja 99
Breuer, Marcel 179
Bridges, Robert 204
Briggs, Martin Shaw 73
'Bright Young People' 24, 25, 37, 81, 238, 241, 256,
 257, 258, 279
Britten, Benjamin 111
Brooks, Romaine 57, 58–9, 128
Brown, Lancelot ('Capability') 160
Bryher (Annie Winifred Ellerman) 25, 28, 41, 68
Buchan, John 46
 Greenmantle 40
 The Three Hostages 101
Burney, Frances 183
Burra, Edward 3, 13–14, 36, 45, 268, 272
 Rio Grande 298–9
Butts, Mary 41, 91, 115, 117, 131, 133, 204
 Armed With Madness 117
Byron, Robert 52

Café Royal 30, 85, 121, 253
Calder, Alexander 169
Caldey Island Monastery 207
Caledonian Road Market 10, 14, 15
Calthrop, Gladys 44
Camargo Society 106, 110
 Rio Grande 298–9

Cambridge University 27, 81, 118, 224
Camp 18, 73, 79, 124, 153, 186, 196, 201, 202, 207, 215, 240, 241, 292
Campion Hall 167, 213–15, 254
Carrington, Dora 254, 255
Carrington, Leonora 125, 245
Carroll, Lewis (Charles Lutwige Dodgson) 98, 122, 131
 Alice in Wonderland 131
Carstairs, Marion ('Joe') 36, 250
Carten, Audrey 44, 301
Caselli, Daniela 42, 128
Casson, Hugh 144
Casson, Winifred 235
Castle, Terry 54
Castlerosse, Doris, Lady 28, 35
Catholicism 122, 123–4, 131, 205–6, 212–15
Cecil, David 32
Cecil, Hugh 34, 240–1
Cellophane 193, 236, 273
Césaire, Aimé 119
Cézanne, Paul 2
Chadwick, Whitney 195
Champcommunal, Elizabeth ('Champco') 50
Chanaux & Co. 145, 173, 184, 186
Chandeliers 8, 10, 65, 82, 183, 188, 236, 271
Chanel, Gabrielle Bonheur ('Coco') 4, 14, 65, 80, 173, 184, 187, 188, 245–6, 288–9, 290
 'Chanel No. 5' 278, 279, 280
 Le Train Bleu 285, 289, 299
Channon, Henry ('Chips') 81, 146, 199
Chaplin, Charlie 94, 96–8, 104, 106, 120, 264
 Modern Times 98
Chappell, William ('Billy') 239, 268, 291
Charles, Lallie (Charlotte Elizabeth Martin) 240
Charlot, André 29, 287
Chateau Solveig 179, 188, 192
Chauncy, George 94
Checkley, George
 'Thurso House' 137, 141
Chesterton, Gilbert Keith 130, 202, 203, 204
Child, Maurice 208, 209
Children's books 122, 131, 132, 135
Chincherinchee 268, 273
Chinese wallpaper 8, 187, 188, 225
Chinoiserie 186–8, 194
Christie, Agatha 101, 136
 The Man in the Brown Suit 101
Cinema 3, 15, 94, 95, 96–7, 98, 99, 104, 106, 111, 138, 234, 235, 264, 265, 270, 286, 287, 288, 294, 298
Circus 94, 105, 106–7, 108, 217
Cirque Médrano 107
Clark, Kenneth 73, 214, 285
Cleto, Fabio 74
Cliff, Clarice 169, 178, 195, 261
Cliveden 163, 167, 253
Coates, Wells
 Isokon Building 4

Cochran, Charles Blake 31, 40, 69–70, 108, 109–10, 262, 294
 Dover Street to Dixie 109
 Follow the Sun 70
 Helen! 200
 League of Notions 108–9, 261
 The Miracle 260
 This Year of Grace 262
Cocteau, Jean 3, 40, 50, 94, 102, 103, 106, 170, 235, 248, 274, 284, 286, 288, 289, 290
 Antigone 260, 289
 Le Boeuf sur le Toit 108, 298
 Les Mariés de la Tour Eiffel 105
 Orphée 125
 Le Sang d'une Poète 234
Cohen, Lisa 245
Colefax, Sybil 1, 23, 31, 32, 33, 35, 37, 68, 186
Colette 18, 41, 54, 60
Collier, John
 His Monkey Wife 132
Commedia dell'Arte 94, 96, 104, 261
Comper, Ninian, Sir 209
Compton-Burnett, Ivy 122
Concrete 139, 140–2, 152, 157, 159, 219, 234
Connell, Amyas
 'High and Over' 142, 143, 153, 159
Connolly, Cyril 120
Contraception 35
Cooper, Susan ('Susie') 169
Core, Philip 35, 228
Cornforth, John 220
 English Country Houses: Caroline 150
Coromandel screens 20, 184, 188
Coster, Howard 243
Coton, A. V. (Edward Haddakin) 287
Coty, François
 'La Rose Jacqueminot' 277, 278, 280
Country Life 152, 159, 166, 191, 194, 222, 223, 227, 234, 271, 276
Courtauld, Samuel, Sir 187, 235, 293
Courtesans 16, 18, 280
Couturier, Marie-Alain, O. P. 212
Covarrubias, Miguel 169
Coward, Noël 26, 27, 28–9, 32, 33, 37, 44, 65, 79, 94, 146, 199, 229, 296
 Bitter Sweet 32
 Blithe Spirit 44
 'Dance, Little Lady' 262
 Design for Living 259
 London Calling 29, 295
 On With the Dance 109
 The Vortex 37
 This Year of Grace 40, 44, 262
Croce, Benedetto 267
Cross-dressing 44, 47, 51, 52, 246, 250, 254, 257
Cubism 18, 58, 61, 90, 102, 103, 104, 158, 168–9, 171, 195, 241, 259, 260, 278, 285
'Cubist House' ('Maison Cubiste') 58, 61, 220

Cunard, Emerald, Lady 19, 26, 31, 32, 34, 36, 69, 79
Cunard, Nancy 24, 25, 33, 50, 68, 71, 119, 121, 132, 170, 183, 240, 265
Currie, John 24
Curzon Street Baroque 1, 37, 143, 211
Cuttoli, Marie 176, 177

Dada 51, 105, 112, 117, 246, 296
Dalí, Salvador 8, 10, 145, 146, 170, 173, 184, 241, 247, 250, 274
 Anthropomorphic Cabinet 247
 Necrophiliac Springtime 248
 'Shoe hat' 249
 Venus de Milo with Drawers 247
Damia 58
Dancing 6, 15, 16, 31, 69, 95, 96, 98, 103, 106, 109, 113, 119, 260–1, 262, 279, 282–94, 299
D'Arcy, Martin Cyril, Fr, SJ 167, 205, 213, 254
Darling, Elizabeth 147
Davidson, Peter 10
De Beaumont, Étienne, Count 239
De Beisegui, Charles 8, 11
Debussy, Claude
 Jeux 290
 La Mer 287
De Certeau, Michel 92, 94
De Chirico, Giorgio 70, 169, 184, 235
De Gramont, Élisabeth, Duchesse de Clermont-Tonnerre 54
De La Mare, Walter
 Memoirs of a Midget 132
Delaunay, Robert 171
Delaunay, Sonia 170, 195, 283
De Lempicka, Tamara 228–9
Dell, Mark Oliver 233
Delvaux, Paul
 Break of Day 248
Delysia, Alice 52, 109
De Maré, Rolf 105, 106
De Meyer, Adolph 235–6, 240
Demi-monde 15, 18, 277
Denby, Elizabeth
 Sassoon House 141
Denis, Maurice 229
De Noailles, Anna 60
De Noailles, Charles, Vicomte 158
De Noailles, Marie-Laure 80, 184
Derain, André 70, 170
 La Boutique Fantastique 285–6
D'Erlanger, Baroness Catherine 10
De Falla, Manuel
 Tricorne 285
Desiderio, Monsù 81
Desnos, Robert
 Complainte de Fantômas 99
Detective stories 37, 101–2
Deviance 15, 94, 121, 206, 250
De Wolfe *see* Mendl

Diaghilev, Sergei 3, 30, 39, 40, 68, 69, 96, 98, 103, 108, 193, 223, 229, 260, 261, 282, 283, 284, 286, 287, 288, 289–90, 294
Dickens, Charles 226
 Bleak House 223
Disraeli, Benjamin 182
Disney, Walt 14, 237
Dixon-Spain, John Edward 212
Doan, Laura 48
Dominguez, Oscar 247
 Brouette 247
Dorn, Marion 4, 17, 51, 169, 185, 195, 198
D'Ors, Eugenio 2, 295
Doucet, Jacques 79
Drake, Vernon
 Zéphyre et Flore 260
Drakelowe Hall 223
Driberg, Tom 68
Duchamp, Marcel 99
Duff, Lady Juliet 96, 223
Dufy, Raoul 70, 176
Dukes, Ashley 110
 The Man with a Load of Mischief 110
Dunand, Jean 170, 182
Dunbar, Evelyn 217
Duncan, Isadora 246, 282
Dupas, Jean 217, 228
 Les Perruches 229
Durham Cathedral 211

Eco, Umberto 12
Edward VIII, Duke of Windsor 203, 236, 237
Eiffel Tower (restaurant) 121, 226
Eighteenth-century style 15, 20, 62–3, 75, 78, 80, 81, 146, 183, 186–7, 188, 189, 194, 224, 256, 274
Eksteins, Modris 90
Eliot, Thomas Stearns 2, 6, 25, 68, 110, 113, 116, 117, 128, 146, 204, 209
 The Family Reunion 260
 Murder in the Cathedral 110, 260
 The Rock 110, 260
 Sweeney Agonistes 110, 113
 'Tradition and the Individual Talent' 125
 The Waste Land 37, 72, 114, 116, 117
Elizabeth, the Queen Mother 30, 237
Elliot, Bridget 60
Éluard, Nusch 245, 248
Empire style 183, 192, 223
Epstein, Jacob 150
Ernst, Max
 Romeo and Juliet 288
Eton College 26, 27, 73, 84, 85

Fancy dress 63, 124, 237, 251, 255–8, 264, 302
Fantasy 1, 11, 16, 20, 43–4, 63, 100, 101, 119, 120, 131–5, 137, 138, 144, 146, 150, 153, 181, 187, 240–1, 258, 263
Fantômas 94, 99–100, 101, 102

Farjeon, Herbert 40
Farrar, Gwen 47, 52, 94
Fedorovitch, Sophie 36, 272, 275
 Les Masques 293–4
Femininity 2, 46, 59, 61, 63, 140, 263
Feminists 16, 57, 60, 64, 128
Feuillade, Louis 99
 Les Vampires 100
Ffrangcon-Davies, Gwen 44, 52
Fini, Leonor 125, 169, 170
Firbank, Ronald 3, 121, 206
 Concerning the Eccentricities of Cardinal Pirelli 121, 123
 The Flower Beneath the Foot 43, 122
 Prancing Nigger 266–7
Fireworks 11, 146
Firminger, Marjorie 257
 Jam To-Day 36, 41
Fiske, Minnie Maddern 97
Flower paintings 151, 220–1, 267, 276
Flowers 19, 37, 158, 198, 220–1, 236, 242, 250, 256, 266–76
Fokine, Michel
 Le Coq D'Or 284
 Le Spectre de la Rose 290–1
Fonteyn, Margot 16–17
Forbes, Mansfield 1, 146, 153, 233
Fowler, John 1, 181, 185, 186, 187, 196, 211
Frank, Jean Michel 55, 82, 172, 183, 184, 185, 198, 273
Fratellini, Paul, François and Albert 108
Frazer, James
 The Golden Bough 114
Freud, Sigmund 5, 6, 91, 95, 114
Fry, Maxwell
 Sassoon House 141
Fry, Roger 51, 69, 83, 84, 177, 216, 224, 225, 296
Fuller, Loie 49, 94, 286–7, 293
 Danse d'Acier 287
 La Mer 287
Futurism 112, 286
Futurist Manifesto of Architecture 219

Gabo, Naum 284
Garafola, Lynn 282, 286, 290
Garcia Villa, José 68
Gardens 8, 9, 56, 63, 75, 76, 79, 142, 157–67, 201, 214, 268, 275–6
Gargoyle Club 34
Garland, Madge 30, 36, 42, 45, 49, 50, 51–2, 60, 65, 66, 71, 177, 185, 190, 199, 218, 245, 255, 293
Garnett, David
 Lady Into Fox 132
Garnett, Eve 217
Garsington Manor 20, 164–5, 166
Gathorne-Hardy, Edward 35, 36
Gauguin, Paul 61, 168
Gaunt, William 84
Gee, Malcolm 195

Gerard, Teddie 44, 52
Gerhardie, William 122
Gertler, Mark 24, 253
Giacometti, Alberto 8, 145, 170, 173
Giacometti, Diego 185, 197
Gibbons, Stella
 Cold Comfort Farm 52
Gide, André
 Si le Grain ne Meurt 40, 72
Gill, Eric 150, 204, 214, 255
Gimpel, René 168
Glass 7, 8, 14, 53, 62, 79, 89, 90, 116, 137, 139, 147–8, 150, 151, 157, 190, 200, 201, 209, 211, 223, 226, 235
Glass buildings 53–4, 92, 139–40, 148, 150, 152, 194, 218, 219, 233, 267
Glass furniture 38, 172–3, 177, 179, 190, 198, 199
Gloag, John
 The House We Ought To Live In 178
Gluck (Hannah Gluckstein) 151, 220–1, 250
Goldhagen, Sarah Williams 142
Gontcharova, Natalia
 Le Coq D'Or 284
 Les Noces 283, 289–90
Grant, Duncan 3, 177, 185, 217, 224, 225
Graves, Robert
 Goodbye to all That 72
Graves, Robert, and Alan Hodge
 The Long Week-End 15, 39, 96, 179, 194–5, 197
Gray, Eileen 3, 41, 51, 53–7, 58–9, 64, 79, 144, 176
 E.1027 56
 'Transat' chair 179
Great Depression 16, 163
Greenberg, Clement 23, 94, 95, 114, 174, 282
Greene, Graham 204
Greville, Margaret 32
Grey, John, Canon 212
Grey, Nicolete 214
Grierson, Janet 212
Grimaldi, Joe 97
Gris, Juan 70, 99, 171, 284, 285
Gropius, Walter 50, 81, 181
 Bauhaus 138
Grosvenor, Loelia, Duchess of Westminster 35, 197, 255, 268
Grotto furniture 20, 78–9, 80, 188
Groult, André 168, 185
Groult, Nicole 50, 61, 170
Guardi, Francesco Lazzaro 75
Guerlain, Aimé
 'Jicky' 278
Guevara, Alvaro ('Chile') 34, 35, 84
Guevrekian, Gabriel 157, 158, 159
Guillaume, Paul 259
Guinness, Beatrice 31–2
Guinness, Bryan
 Singing out of Tune 37
Guinness, Meraud 34, 35

Guitry, Lucien 188
Guitry, Sacha 96

Haire, Norman 35
Hall, Radclyffe 48–9, 52, 54, 64, 206
 The Master of the House 206
 The Well of Loneliness 36, 41, 42, 43, 48
Hamann, Paul 261
Hamilton Finlay, Ian 11
Harlequin 97, 120, 261
Harper, Allannah 30, 34, 41–2, 51
Harrison, Jane Ellen 116, 117
 Prolegomena to the Study of Greek Religion 115
 Themis 115, 117
Harrow School 81
Hartnell, Norman 247, 267
Haut monde 18, 69–70, 284, 288
H.D. (Hilda Doolittle) 115
Heal's 12, 68, 70, 185
Hecht, Ben 97
Helpmann, Robert 16–17, 32
Hemingway, Ernest 122
Henderson, Wyn 36
Hepworth, Barbara 4, 6, 90, 177, 195
Herbert, David 28, 36
Hidcote Manor 162, 163
Hill, Oliver 3, 150–1, 159, 190, 191, 194, 220, 221
 Cock Rock 150
 Devonshire House 221
 English Country Houses: Caroline 150
 Gayfere House 151, 275
 Joldwynds 151, 153
 Venice Yard House 150
 Vernon House 151, 221
 Woodhouse Copse 150
Hillier, Tristram 220
Hodgkins, Frances 195
Hogarth Press 116, 117
Hollander, Anne 234
Holst, Gustav 211
Holt, Nora 37
Homophobia 39, 48, 55, 128, 167
Homosexuality 5, 15–16, 27, 29, 39–40, 44, 94,
 124–5, 132, 144, 205, 292
Homosociality 118
Hopkins, Gerard Manley 204
Horst, Horst P. (Horst Paul Albert Borhmann) 234
Houbigant Perfum
 'Quelques Fleurs' 278
Houlbrook, Matt 94
Hours Press 24, 131
Howard, Andrée
 Mermaid 235
Howard, Brian 33–4, 35, 85, 124, 239, 256, 257, 264
Hoyningen-Huene, George 234
Hughes, Langston 119
Hugo, Jean 288
Hunt, John and Gertrude 214

Hunter, Alberta 44
Hutchinson, Arthur Stuart-Menteth
 If Winter Comes 204
Hutchinson, Mary 60
Huxley, Aldous 50, 68, 179, 245
Huysman, Joris-Karl
 À Rebours 277
Huyssen, Andreas 12

Individualism 11–12, 93, 180, 218, 250, 253, 255
Inge, William, Dean 207
Interior decorators 1, 3, 6, 9, 10, 11, 14, 19, 33, 35, 37,
 39, 41, 55, 58, 59, 61, 62, 63–5, 66, 78–80, 81, 82,
 84, 144, 146, 148, 163, 167, 168, 169, 170, 173, 174,
 175, 176, 178, 181, 182–96, 197–9, 209, 211, 221,
 223, 224, 246, 261, 267
International Exposition of Modern Industrial and
 Decorative Arts (Exposition Internationale
 des Arts Décoratifs et Industriels
 Modernes) 176, 230
International Style 140–3, 151
International Surrealist Exhibition 235, 241, 274
Ionides, Basil 240
Iribe, Paul 60, 102, 185
 La Choix 103
Isherwood, Christopher 74, 124, 126, 133, 243
 Goodbye to Berlin 41
 On the Frontier 127
Italy 26, 73, 76, 142, 160, 164, 165, 225

Jackson, Anthony 140
Jacob, Max 99
Jacobethan 13, 180
James, Edward 1, 10, 144–5, 146, 153, 173, 190, 247
James, Montague Rhodes 131
Jansen, Maison 82, 179, 184, 192
Jazz 17, 44, 104, 105, 106, 114, 119, 260, 279, 298
Jeffress, Arthur Tilden 81, 173, 258
Jekyll, Gertrude 161, 211, 272
Jellicoe, Geoffrey 160, 165
Jennings, Humphrey 111
John, Augustus 3, 85, 251, 253, 254
John, Gwen 3, 60
Johnson, Lawrence, Major 161, 162, 163
Jones, Barbara 13
Jones, David 204, 251
Jooss, Kurt 261, 282
Joyce, James 2, 25, 112, 113, 115, 136, 146
 Ulysses 112, 114, 115
Jungman, Teresa ('Baby') and Zita 25, 31, 34, 256
Junyk, Ihor 260

Kafka, Franz 112, 131
Kahlo, Frida 125
Kahnweiler, Daniel-Henry 171–2, 176, 254, 285
Keable, Robert
 Simon Called Peter 204
Kennington, Eric 185

Ker-Seymer, Barbara 35–7, 45, 239, 257
Kerstein, Lincoln 281
Keverne, Richard
 William Cook–Antique Dealer 37
Keynes, John Maynard 69, 142, 150, 224
King, Viva 37, 197, 251
Knight, Laura 195
Knights, Winifred 217
Knoblock, Edward 223
 Room and Book 223
Knollys, Eardley 29
Knox, James 224
Kochno, Boris 99, 110, 283, 290
Kokoschka, Oscar 184
Krazy Kat 94, 98, 120

Laboureur, Jean-Émile 217
Lamb, Henry 25
Lambert, Constant 17, 30, 51, 68, 69, 98, 105, 257,
 287, 298
 Rio Grande 298–9
 Romeo and Juliet 287
Lamé 10, 18, 19, 273
Lathom, 3rd Earl of (Edward Bootle-
 Wilbraham) 29, 146
Lancaster, Nancy 9, 10, 160
Lancaster, Osbert 1, 13, 40, 72, 115, 180, 203, 293
Lanvin, Jeanne 11, 170
Larcher, Dorothy 176, 185
Laurencin, Marie 38, 41, 49, 50, 52, 59–61, 63, 94,
 131, 170, 195, 217, 220, 291
Laver, James 278
 'Girls of Nineteen Twenty Six' 279
 Love's Progress 49
 Nymph Errant 110
Lawrence, David Herbert 2, 25, 51, 112, 115, 133
Lawrence, Gertrude ('Gertie') 27, 81
Lear, Edward 122, 131
Leavis, Frank Raymond 66, 72
Leavis, Queenie 101, 118
Le Corbusier (Charles-Édouard Jeanneret) 2, 4, 8,
 17, 50, 53–7, 90, 91, 138, 144, 168, 175, 176, 178,
 181, 194, 208, 218
 Beistegui penthouse 8, 9, 11, 144
 Porte Molitor 152
 Vers une Architecture 143
 Villa Savoye 142
Lee, Vernon (Violet Paget) 73, 164
Léger, Fernand 70, 170, 171, 176, 229, 284, 285
Le Nôtre, André 161
Lepape, Georges 60
Lesbianism 35–6, 41–9, 63, 128–30, 132, 144, 206,
 250, 257, 291, 293
Levinson, André 105, 281
Levy, Julien 131, 173, 235
Lewis, Cecil Day 101, 102, 124
 The Beast Must Die 102
Lewis, Clive Staples 133, 135

 Out of the Silent Planet 134
 Perelandra 135
Lewis, Wyndham 68, 70, 72, 78, 84, 112, 113
 The Apes of God 78
 The Childermass 131
Lhote, André 229
Light and lighting 10, 55, 56, 79, 81, 94, 138, 148, 157,
 233, 239, 286–7
Lindsay, David 136
 A Voyage to Arcturus 134–5
Lindsay, Norah 158, 161, 163, 253
Lilies 38, 124, 151, 166, 167, 198, 221, 242, 267,
 268, 275
Lillie, Beatrice 44, 94
Lissim, Simon 172
Little Tich (Harry Relph) 96, 97
Lloyd George, David 89, 166
London 19, 34, 36, 40, 44, 52, 69, 70, 79, 82, 83, 89,
 90, 94, 95, 173, 184, 186, 235
London Group 185
Loos, Adolf 4, 7, 53
Lopokova, Lydia 69, 150, 298
Lorimer, Robert, Sir 212
Lorrain, Claude 300
Losch, Ottilie ('Tilly') 190, 239
Lowinsky, Ruth
 Lovely Food 273
Lowinsky, Thomas 273, 274
Loy, Mina 41, 193
 Lunar Baedeker 115
Lubetkin, Berthold
 Highpoint Two 140, 152
 The Wilderness 151
Lucite 193
Lurçat, André
 Villa Guggenbuhl 143
Lurçat, Jean 175, 176, 182, 193
Lutyens, Edwin 160, 161
 Campion Hall 213, 215
 Monkton House 144–5, 152
Luxe pauvre 82, 169, 173, 184

Maar, Dora 6
McBean, Angus 240–1, 254, 255, 261, 262
McGrath, Raymond 137
 Finella 146–50, 152, 233
 Glass in Architecture 150
Macgregor, Helen 195, 236, 262
McGuinness, Norah 53
Machen, Arthur 100, 101, 131, 133
 The Green Round 133
McKay, Claude 119
Mackenzie, Compton 3
 Extraordinary Women 42
McKibbin, Ross 120
McKnight Kauffer, Edward 199
Maclaren, Denham 17, 178
MacLiammóir, Micheál 209

Macneice, Louis
 I Crossed the Minch 125
 Letters from Iceland 125
McNeill, Dorelia 251, 254
Macpherson, Kenneth 3
Macqueen, Sheila 272
Mae West Lips sofa 10, 144
Magritte, René 99, 248
 La Trahison des Images 248
Mahon, Denis, Sir 84
Mainbocher (Maine Rousseau Bocher) 65
Magnasco, Alessandro 83, 84, 213
Magnasco Society 82, 146
Magnitogorsk 92–3
Makeup 28, 262–5, 270, 283
Mancini, Antonio 71
Mancini, Bruna 91
Mann, Florence ('Dolly') 144, 211
Mannin, Ethel 49, 254, 281
Mansfield, Katherine 51
Mare, André 61
Marbury, Elizabeth 61–2, 263
Marie Antoinette, Queen 63, 163, 257
Marinetti, Filippo 287
Markova, Alicia 106
Marlborough College 27, 125
Marsh, Sir Edward 24, 25, 29
Marx Brothers 94, 98
Marx, Enid 169, 185, 195
Marx, Karl 6
Mascara 124, 264, 265
Masculinity 2, 5, 56, 115, 118, 124, 126, 174, 188, 245
Masefield, John
 The Box of Delights 135
 The Midnight Folk 135
Masks 151, 180, 259–63, 297
Massine, Léonide 69, 284
 Parade 103–4, 105, 282, 285, 286, 287, 294, 297
 The Rake 109
 Zéphyre et Flore 260
Masson, André 250
Masterman, Charles Frederick Gurney 16
Matheson, Hilda 224
Matisse, Henri 25, 60, 145, 168, 171, 174, 176, 194
Mauclair, Camille 169
Mauer, Otto, Father 212
Maufe, Prudence 185
Maugham, Somerset 44
Maugham, Syrie 1, 32, 38, 51, 64, 145, 151, 173, 175, 185, 186, 188, 197, 198, 211, 221, 273, 274
Mauriès, Patrick 2, 80
Maxwell, Elsa 33
Medgyes, Ladislas 193
Meière, Hildreth 217
Mendl, Elsie, Lady (Elsie de Wolfe) 49, 61–5, 187, 188, 190, 220, 268
Messel, Oliver 32, 196, 200, 201, 261–2, 273
 Zéphyre et Flore 260

Metzinger, Jean 171
Mickey Mouse 94, 98, 120
Milhaud, Darius 108
 Le Boeuf sur le Toit 108, 298
 La Création du Monde 105, 261, 298
 Saudades do Brasil 298
Miller, Lee 6, 234–5, 245, 247
Mills, Florence 109
Minaudière 265
Minelli, Vincente 107
Minotaure 246, 247, 249
Miró, Joan 176
 Romeo and Juliet 288
Mirrlees, Hope 6
 Paris 116, 126
Mirrors 10, 20, 58, 63–4, 75, 79, 80, 81, 82, 151, 157, 180, 182, 184, 186, 188, 190, 192–3, 198, 199, 201, 224, 271, 300
Misogyny 44, 46, 117, 132, 248
Mitchell, Gladys
 A Speedy Death 102
Mitchison, Naomi
 The Corn King and the Spring Queen 115
Mitford, Nancy
 Highland Fling 71, 199
 Love in a Cold Climate 32, 243
 The Pursuit of Love 190
Mitoraj, Igor 11
Modernism 4–5, 7, 11–12, 16, 17, 39, 44, 74, 91–3, 99, 112, 137–8, 157, 178, 181, 201, 202, 204, 218, 233–4, 244, 245, 254, 282, 287
Modigliani, Amadeo Clemente 70, 79
Moffat, Curtis 51, 185, 239
Mondrian, Piet 218, 220
Montegufoni 70, 72, 75
Moore, Doris Langley 268
Moore, Henry 14, 214
Moore, Olive
 Spleen 48
Morgan, Evan, Viscount Tredegar 123
Morrell, Lady Ottoline 20, 25, 69, 79, 98, 150, 164, 166, 251–2, 253
Morris, Cedric 221
Moss, Marlow 250
Mortimer, Raymond 50, 178, 181–2, 218
 The New Interior Decoration 181, 220
Mother of pearl 10, 14, 193
Mount Temple, Muriel, Lady ('Molly') 151, 152, 190, 191, 275
'Munichismus' 102, 104
Murals 151, 217–19, 221–7, 254, 295
Murdoch, Iris 112
Murphy, Sara 252, 273
Murray, John Somerset 235
Musée de l'Homme (Trocadéro) 259–60
Muthesius, Hermann 162
 Das Englische Haus 143

Myrbor 176
Mythic method 113, 117

Nan Kivell, Rex 29
Nash, John 150
Nash, Paul 4, 12, 14, 17, 24, 131, 150, 178, 180, 185, 190, 228, 254, 284
 Room and Book 17, 179
Nast, Condé 50, 52, 187
Négritude 105
Neoclassicism 1, 4, 79, 104, 115, 294
Neo-romantics 81, 173, 174
Nevinson, Christopher Richard Wynne 11, 78
Newbolt, Henry, Sir 216
New Negroes 119
New York 50, 61, 63, 64, 94, 169, 187, 193, 199, 222, 234, 264
New York City Ballet 281
Nichols, Beverley 28, 29, 30, 39, 44, 98
 Crazy Pavements 37, 72, 263
Nichols, Robert 205
Nicholson, Benjamin ('Ben') 4, 177, 214, 228, 284
Nicholson, Christopher ('Kit') 144
Nicholson, William 109, 223
Nicolson, Harold 162, 165
Nijinska, Bronislava 291
 Les Biches 99, 289, 291–2, 293, 299
Nijinsky, Vaslav 96, 98, 236, 282, 283, 284, 288, 290–1
 Après-Midi d'un Faune 98
 Diary 288
 Jeux 288
Noel, Conrad, Rev. 211–12
Novello, Ivor 24, 29, 32, 44, 192

O'Casey, Sean
 The Silver Tassie 108, 109
Oceanic art 7, 20, 259
Olivier, Edith 25–6, 27, 29, 30, 35, 76, 227, 241, 257
 The Love Child 132
Oppenheim, Meret 170
 Le déjeuner en fourrure 170
Orientalism 283
 Hassan 292
 Kismet 223
Owen, Wilfred 68
Oxford bags 124, 255
Oxford University 26, 27, 40, 72, 73, 74, 84, 101, 118, 133, 213, 256
Ozenfant, Amédée 170

Page, Russell 158, 160, 167
Pan 132–3
Paquin, Jeanne 288
Paris 3, 8, 19, 40, 41, 50, 63, 71, 89, 102, 108, 118, 133, 170–2, 183, 193, 223, 228, 239, 256, 259–60, 283, 284, 286, 289
Paris flea market 14, 19, 175

Parties 11, 23, 31, 33, 35, 45, 49, 64, 68, 69, 81, 82, 127, 132, 146, 150, 199, 224, 239, 243, 256–7, 258, 261, 269, 270, 291
Patronage 6, 11, 19, 23–37, 41, 52–3, 68, 70, 79, 80, 109, 115, 146, 168, 171–2, 173, 174, 175, 176, 181, 183, 193, 205, 208, 212, 216, 226, 230, 238, 239, 253, 254, 261, 281, 284–5, 289, 294, 302
Patten, Alfred Hope 208
Pavlova, Anna 16, 98
'penny dreadfuls' 70, 100
Perriand, Charlotte 179
Philipson, Maya ('Winkie') 197
Phillips, Randall 190
 The House Improved 178
Philpot, Glyn 133, 204, 206, 212, 221, 222, 226, 227, 228, 229
Photography 6, 11, 27, 30, 34, 35, 36, 44, 140, 159, 172, 173, 185, 193–4, 195, 199, 222, 233–43, 251, 262
Picabia, François 105, 170, 184, 246
Picabia, Gabrielle 169, 246
Picasso, Pablo 2, 60, 70, 79, 81, 103, 104, 168, 169, 170, 171, 176, 214, 220, 248, 254, 259–60, 278, 282, 284
 Antigone 260, 289
 Les Demoiselles d'Avignon 259
 L'Enfant au Pigeon 187
 Parade 103–4, 105, 282, 285, 286, 287, 294, 297
 Le Train Bleu 285, 289, 299
 Tricorne 285
Pick, Frank 23
Pierrot 97, 261
Pilkington, Heather 36
Pinsent, Cecil Ross 142, 165
Piper, John 68
Plas Newydd 186, 299–302
Plaster 10, 72, 82, 144, 173, 186, 198
Playfair, Nigel 15
Plunket Greene, Olivia 37
Poiret, Paul 50, 61, 168, 170, 174, 195, 245, 283, 288
Polari 120
Polunin, Vladimir and Elizabeth 285
Pollen, Daphne 217
Pollock, Jackson 174
Popular art 13, 70, 104
Popular culture 5, 12, 37, 40, 44, 74, 94–102, 104, 105, 108, 113, 114, 120, 128, 138, 286, 288, 294, 298
Potter, Beatrix 122
Porter, Cole 192
 Nymph Errant 110
 Wake Up and Dream 109
Port Lympne 146, 158, 163–4, 166, 199, 224, 226, 227, 228
Portmeirion 143–4, 207
Portobello Road Market 14
Postmodernism 17

Poulenc, Francis 108, 170
 Les Biches 291–2, 293, 299
 Les Masques 293–4
Pound, Ezra 25, 68, 112, 113, 114, 115, 283
Powers, Alan 139, 141, 143, 146, 150
Powys, Theodore Francis 134, 297
Pozzo, Andrea, Fr, SJ 8, 226, 299
 Gesù, Rome 11, 226
 Sant'Ignazio, Rome 226, 299
Pritchard, Matthew 24
Procter, Doris ('Dod') 195
Proust, Marcel 40
Pruna, Pedro 70
Pryde, James 223
Publicity 15, 66–8, 115, 118
Punch, Mr 97, 104

Queen Mary's Dolls' House 271
Queerness 2, 5, 10, 16, 33, 47, 64, 74, 77, 121, 124,
 140, 143–4, 153, 167, 174, 212, 221, 290, 294
Quennell, Peter 116, 128, 293
Quilter, Roger 109
Quinn, John 60

Radiguet, Raymond 108
Raffalovitch, André 206, 212
Raine, Kathleen 204
Rainey, Gertrude Malissa ('Ma') 44
Rainey, Lawrence 116
Rambert, Marie 26–7, 30, 110, 293
'Rappel à l'ordre' 101–2, 103
Rateau, Armand-Albert 192
Rattigan, Terence 44
Rault, Jasmine 56
Ravilious, Eric 151, 177, 226, 227
Ray, Man 234, 239, 246, 247, 249, 250, 259
 Observatory Time 234
Read, Herbert 131
Reed, Christopher 6, 17, 18, 39, 174
Regency style 14, 25, 78, 148, 193, 223
Reilly, Jim 4
Reinhardt, Max 31, 200, 201, 260
 Helen! 201
 The Miracle 260
Reitlinger, Gerald 175, 272
Renishaw Hall 76, 164, 238
Repton, Humphrey 160
Revue Nègre 106
Revues 31, 103, 109, 201
Rhys, Jean 125
Richards, James Maude
 Castles on the Ground 180
Richardson, Dorothy 41, 51, 113, 125
Ricketts, Charles 77
Rietveld, Gerrit
 Schröder House 178
Rimsky-Korsakov, Nicolai
 Le Coq D'Or 284

Ripolin 53, 57, 74, 184, 197
Ripon, Lady (Constance Gwladys Robinson) 69
Roberts, William 70
Robeson, Paul 119
Roche, Serge 145, 186, 192
Rococo 8, 14, 15, 20, 186–7, 188, 192, 229, 274
Roger, Neil ('Bunny') 3, 264
Romano, Giulio 300
Rose, Sir Francis 29
Rosenberg, Léonce 171
Rosenberg, Paul 60, 195
Rothenstein, John 254
Rothenstein, William 51, 254
Rothermere, Lord (Harold Harmsworth) 69
Roualt, Georges 204, 214, 284
Rouché, Jacques 157
Rubber 184, 192
Rubens, Peter Paul 174, 184
Rubinstein, Helena 19, 61, 188, 193, 264
Ruhlmann, Jacques-Émile 182

Sackville-West, Edward, 5th Baron Sackville
 33, 205
Sackville-West, Victoria, Lady Sackville 9, 19, 79,
 163, 187
Sackville-West, Victoria ('Vita') 19, 42, 43, 163, 165
St Augustine's, Queens' Gate, Church of 209
St Joan of Arc, Farnham, Church of 212
St Magnus Martyr, Church of 209
St Peter's, Morningside, Church of 212
St Saviour's, Hoxton, Church of 209
Saki (Hector Hugh Munro) 29, 121, 132
Salmon, André 60
Sandby, Paul 223
Sands, Ethel 9
Sargent, John Singer 71, 206
Sassoon, Philip, Sir 146, 153, 158, 163, 166–7, 199,
 224, 226, 267
Sassoon, Siegfried 26, 40, 124, 238
Satie, Erik
 Parade 103–4, 105, 282, 285, 286, 287, 294, 297
 Relâche 105
Sauguet, Henri 110
Sayers, Dorothy 101, 204
 Murder Must Advertise 37
 The Nine Tailors 102
 Strong Poison 15
 Whose Body 101
Scheerbart, Paul 138–9
Schenkar, Joan 41
Schervashidze, Alexandr, Prince 70, 285
Schiaparelli, Elsa 8, 65, 80, 169, 173, 183, 245,
 246, 249
Schlumberger, Jean 170
Schrijver, Herman 9, 178, 181, 182, 196
 Decoration for the Home 182
Scott, Geoffrey
 The Architecture of Humanism 142, 165

Scott, John Murray, Sir 163
Sculpture 7, 78, 140, 163, 176, 214
Sedding, George Elton 209
Seicento paintings 72, 73, 81, 83
Seldes, Gilbert 109
Selfridges 217
Sem (Georges Goursat) 279, 280
Sert, Josep Maria 184, 199, 223–4, 226, 284
 La Légende de Joseph 223
Sert, Misia 184, 193, 288–9
Severini, Gino 71, 78
Shadows 54, 56, 132
Shakespeare, William 114
 A Midsummer Night's Dream 272
 Twelfth Night 43
Shaw, George Bernard 33, 61, 227
 Too True to be Good 260
Shchukin, Serge Ivanovitch 168, 174
Shells 8, 10, 14, 82, 182, 199
Sheringham, George 222
Siebel, Victor 267
Silver 10, 61, 72, 75, 76, 79, 80, 81, 82, 116, 148, 188,
 193, 199, 233, 234, 235, 240–2, 261, 271, 294
Silver, Kenneth 102
Simmel, Georg 15, 18
Simpson, Wallis, Duchess of Windsor 236, 237, 272
Sinclair, May 205
Singer, Winnaretta , Princesse de Polignac 41
Sissinghurst 57, 162–3, 201
Sitte, Camillo 93
Sitwell, Edith 3, 27, 28, 30, 33, 34, 41, 42, 51, 66–8,
 72, 75, 78, 84–5, 108, 205, 213, 237, 238, 251, 253,
 255, 296
 Façade 31, 68, 70, 74, 79, 259, 295–6, 299
Sitwell, George, Sir 71, 75, 83, 85
 On the Making of Gardens 164
Sitwell, Georgia 27, 51, 256
Sitwell, Ida, Lady 27, 71, 267–8, 277
Sitwell, Osbert 9, 26, 28, 30, 64, 66–81, 83–4, 110,
 121, 122, 235, 238, 283
 Belshazzar's Feast 68
 The First Shoot 69
Sitwell, Sacheverell 3, 26, 27, 28, 30, 51, 66–84, 110,
 121, 202, 235, 238, 256, 266, 267, 285, 294
 German Baroque Art 72, 75, 82, 299
 The Rio Grande 68, 298
 Southern Baroque Art 72–4, 84
 The Triumph of Neptune 70
Sitwells 1, 17, 30, 34, 66, 84, 104, 167, 197, 213, 294
Smith, Bessie 121
Smith, Florence Margaret ('Stevie') 118, 126, 128, 204
 Novel on Yellow Paper 126
 Over the Frontier 127
Soby, James Thrall 173
Society of Saints Peter and Paul 208, 209
Sontag, Susan 74
Sorel, Cécile 18–19
Soutine, Chaim 70

Spanish Civil War 15, 203
Sparke, Penny 46, 63
Spencer, Stanley 4, 24, 25, 195, 204, 254
Spender, Stephen 243
Spry, Constance 41, 211, 221, 267, 268, 270–6
Spurling, Hilary 174
Stabler, Phoebe 151
Stamp, Gavin 142, 144, 145
Stein, Gertrude 10, 41, 50, 51, 66–7, 194, 238, 245
Stein, Michael 194
Stein, Sarah 171, 194
Stevenson, Colin 207
Stewart, Aimée
 Nine Till Six 44
Stourton, James 83
Strachey, Lytton 115, 241, 294
Stravinsky, Igor 2, 11, 284, 289
 Ballet of the Elephants 11
 Firebird 283
 Fireworks 286
 Histoire du Soldat 297
 Les Noces 283, 289–90
 Pulcinella 104
 Le Sacre du Printemps 272, 283, 288, 289, 290
Streatfeild, Philip 28–9
Strychacz, Thomas 113, 117
Summerson, John 138, 143
Surrealism 6–7, 51, 74, 78, 81, 92, 98–9, 108, 110, 131,
 144–5, 169, 173, 195, 199, 220, 234, 235, 236, 245,
 246–9, 260, 274, 287–8, 296
Symonds, Mary 211

Tanguy, Yves 99, 184
Tapestry 76, 174, 175–6, 182, 184
Tati, Jacques 96
Taut, Bruno 139
Tchelitchew, Pavel 20, 34, 68, 72, 78, 81, 84, 173
 Ode 261, 287
Tennant, David 34, 239, 256, 257
Tennant, Stephen 1, 28, 30, 34, 36, 188, 227, 241,
 242, 256, 257, 264, 267
Terry, Emilio 8, 144, 173, 198
Textiles 38, 76, 174–7, 180, 185, 211
Thayaht (Ernesto Michahelles) 170
Thomas, Dylan 68
Thomas, Edna 44
Thomson, Virgil 10
Thornton-Smith, Ernest 185, 187
Thrillers 37–8, 100–1
Tickner, Lisa 5
Tiepolo, Giambattista 75
Tilden, Philip 146, 150, 165–7, 223
Todd, Dorothy ('Dody') 1, 42, 45, 51–2, 60, 66, 79,
 178, 181, 218, 293
 The New Interior Decoration 181, 220
Tolkien, John Ronald Reuel 135
 On Fairy Stories 101
 The Hobbit 134

Tonks, Henry 225
Transatlantic liners 3, 33, 217, 246
 Île de France 217
 Olympic 234
 Queen Mary 217
 Titanic 234
Traquair, Phoebe 217
Travers, Martin 209, 211
Travers, Pamela Lyndon 135
Tree, Herbert Beerbohm 36, 97
Tree, Iris 36, 253
Tree, Ronald 160
Trefusis, Violet 146
Triolet, Elsa 170
Trompe l'oeil 8–9, 10, 144, 182, 187, 190, 192, 200,
 209, 226, 240, 246, 274, 299
Troubridge, Una, Lady 206
Troy, Nancy 58, 168
Tucker, Sophie 44, 52
Tudor, Anthony 26, 30
Tunnard, Christopher 157, 159–60
 Gardens in the Modern Landscape 160
Tyrrell, George, SJ 206
Tzara, Tristan
 D'un certain automatisme du goût 249

Uhde, Wilhelm 195
Unit One 219, 295
Upward, Edward 133
 Journey to a Border 127
Utrillo, Maurice 70

Valandon, Suzanne 70
Van der Rohe, Mies 53, 194
Van Dyck, Anthony 236
Vanity Fair 47, 50, 234, 246
Vanne, Marda 52
Van Ravesteyn, Sybold 58
Van Vechten, Carl 37, 119, 122
Varo, Remedios 125
Vaughan, Herbert, Cardinal 212
Velarde, Francis Xavier 208
Venetian blackamoors 8, 11, 20, 62, 80, 82, 184,
 186, 188
Venice 28, 31, 73, 75, 79, 188, 289
Vernet, Claude Joseph 300
Versailles 19, 62, 63, 160, 161
Victoriana 14, 70, 77–8, 189, 199, 237, 273
 Staffordshire figures 34, 274
Vic-Wells Ballet 110, 298
Vionnet, Madeleine 170, 246, 247
Vlaminck, Maurice de 70
Vogue 14, 18, 34, 36, 40, 44, 47, 50, 51–2, 60, 65, 66,
 70, 78, 150, 181, 203, 233, 234, 236, 245, 246,
 247, 250, 258
Vogue Regency 146, 151, 175
Von Sternberg, Josef
 The Docks of New York 298

Waddell, Helen
 Peter Abelard 204
Wadsworth, Edward 217, 220
Wain, John 136
Wainwright, H. L. 233
Wakefield, Norris 144
Walker, A'Lelia 264
Walker, C. J., Madame (Sarah Breedlove) 264
Wall Street Crash 108, 172, 177, 258
Walsingham, Church of Our Lady 208
Walton, Allan 185, 192
Walton, William 25–6, 27, 28, 51, 68, 110, 256,
 295, 297
 Façade 295, 297, 299
 The First Shoot 69–70
'Warlock, Peter' (Philip Hesletine) 69
Warner, Sylvia Townsend 297
 Lolly Willowes 133
 Summer Will Show 122
Warren, Dorothy 195
Watson, Peter 29
Waugh, Evelyn 15, 24, 35, 122, 204, 212, 213
 Brideshead Revisited 116, 204, 228
 Decline and Fall 37, 131
 Edmund Campion 254
 Scoop 31, 228
 Vile Bodies 15, 37, 122
Weaver, Harriet Shaw 25
Webb, Geoffrey 18
Wellesley, Dorothy, Lady 224
Wellesley, Gerald (7th Duke of Wellington) 146
 'Portland House' 146, 194
West, Katharine Ann ('Nan') 217
West, Rebecca 51
Wharton, Edith 65, 184, 187
Whistler, James McNeil 227
Whistler, Laurence 164, 225, 299
Whistler, Rex 16, 26, 30–1, 68, 187, 225, 226, 227–8,
 229, 256, 261, 262, 291, 299–302
Whiteness 7, 8, 53, 55, 57, 74, 81, 116, 140, 151, 193,
 197–201, 220, 234, 236, 270
Wigley, Mark 140
Wilde, Dorothy ('Dolly') 50, 83
Wilde, Oscar 39, 40, 43, 61, 64, 121, 124,
 206, 212, 221
 Salome 54
Wilding, Dorothy 199, 240
Wilkinson, Norman 185, 221, 270–2
Williams, Charles 25, 133, 134, 136, 204
Williams-Ellis, Clough 3, 179
 Portmeirion 143–4
Wilson, Angus
 No Laughing Matter 82
Winter, John 140, 141
Wölfflin, Heinrich 2
Wollen, Peter 91, 248
Wood, Christopher 110, 287
Woolf, Leonard 42

Woolf, Virginia 41, 69, 113, 116–17, 138, 244, 251
 Orlando 42–4, 131, 245
 Three Guineas 127
Wren, Christopher, Sir 209
Wright, Frank Lloyd
 'Fallingwater' 141
Wyld, Evelyn 176
Wyndham, Olivia 29, 36, 44, 238–9, 267

Yeats, William Butler 260

'Byzantium' 94
'Yevonde, Madame' (Edith Plummer) 240, 241
Yourcenar, Marguerite 54, 123, 205

Zamyatin, Yevgeny
 We 53
Zborowski, Leopold 70
Zebra hide 63, 151
Ziegfeld Follies 107
Zinkeisen, Anna and Doris 3, 217, 228, 229